MURALISM WITHOUT WALLS

MURALISM

Illuminations: Cultural Formations of the Americas
John Beverley and Sara Castro-Klarén, Editors

WITHOUT WALLS

RIVERA, OROZCO, AND SIQUEIROS IN THE UNITED STATES, 1927–1940

Anna Indych-López

UNIVERSITY OF PITTSBURGH PRESS

Publication of this book has been aided by grants from:

The Wyeth Foundation for American Art Publication Fund of the College Art Association

The University of Pittsburgh, School of Arts and Sciences, Office of the Dean

President Gregory H. Williams and Dean J. Fred Reynolds of the City College of New York (Junior Faculty Research Awards)

The City University of New York PSC-CUNY Research Award Program

The Association for Latin American Art Dissertation Award

Published by the University of Pittsburgh Press, Pittsburgh, Pa., 15260

Manufactured in the United States of America

Printed on acid-free paper

10 9 8 7 6 5 4 3 2 1

Library of Congress Cataloging-in-Publication Data

Indych-López, Anna.

 Muralism without walls : Rivera, Orozco, and Siqueiros in the United States, 1927–1940 / Anna Indych-López.

 p. cm. — (Illuminations: cultural formations of the Americas)

 Includes index.

 ISBN-13: 978-0-8229-4384-6 (cloth : alk. paper)

 ISBN-10: 0-8229-4384-0 (cloth : alk. paper)

 1. Mural painting and decoration, Mexican—20th century—Public opinion. 2. Rivera, Diego, 1886–1957—Criticism and interpretation. 3. Orozco, José Clemente, 1883–1949—Criticism and interpretation. 4. Siqueiros, David Alfaro—Criticism and interpretation. 5. Art and society—United States—History—20th century. 6. Public opinion—United States. I. Title.

 ND2644.I53 2009

 751.7'309720973—dc22 2009024352

Para Angel y Emilio

CONTENTS

ACKNOWLEDGMENTS

This book would not have been possible without several generous subventions from President Gregory H. Williams and Dean J. Fred Reynolds of the City College of New York. I would also like to thank Moe Liu d'Albero, Colin Chase, and my many students at CCNY and the Graduate Center who challenge and inspire me. The College Art Association's Wyeth Foundation for American Art Publication Grant made the color reproductions possible.

In the course of researching and writing this book, I have relied on the expertise and generosity of numerous advisors, colleagues, friends, and family. I am grateful to the following individuals in the United States and Mexico: Eduardo Abaroa, Alejandro Anreus, Alejandra Carrillo, John Charlot, Rosa Collel, Abraham Cruzvillegas, Renato González Mello, Geaninne Gutierrez Guimaraes, Daniel Guzmán, Adriana Konzevik, José Kuri, Guisela LaTorre, Dana Leibsohn, Katherine Manthorne, Monica Manzutto, Jordana Mendelson, Diane Miliotes, Harper Montgomery, Gabriel Pérez Barreiro, Luis Pérez-Oramas, James Oles, Luís Felipe Ortega, Bruce Pearson, Alejandra Peña, Roberto Portillo, Isabel Portillo, Maria Portillo, Itala Schmelz, Mary Schneider Enriquez, Kenneth E. Silver, Will Smith, Alice Stevenson, Sofia Táboas, Roberto Tejada, Mónica de la Torre, James Wechsler, Tomás Ybarra Frausto, and Raúl Zorrilla.

Several individuals were particularly essential to the research and writing process, and I would like to acknowledge them here. I owe an especially great debt of gratitude to Lynda Klich, who helped me to refine ideas and pro-

vided essential intellectual support at every step; and to Anne Leader, a most generous colleague, who encouraged me to submit a portion of this manuscript to the *Art Bulletin* and provided invaluable guidance on the book proposal and several drafts of articles. Miriam Basilio, Claudia Calirman, Mary Coffey, Deborah Cullen, Vanessa Davidson, Leonard Folgarait, Esther Gabara, Adele Nelson, Gabriela Rangel, Carla Stellweg, and Adriana Zavala are all colleagues in the field who inspire me and on whom I have relied for their expertise on numerous occasions.

This project began at New York University's Institute of Fine Arts, where I received the wise counsel and generous mentorship of Edward J. Sullivan, Robert Lubar, Linda Nochlin, Rob Storr, and Jonathan Brown. I am very grateful to the institute for years of financial support during my graduate studies. My debt to Edward J. Sullivan extends many years back to my undergraduate studies at NYU. It is he who inspired me to study Latin American art and who has provided crucial support ever since.

Numerous institutions provided grants that enabled me to conduct further research and to revise this manuscript: the Association for Latin American Art's Dissertation Award; several Professional Staff Congress–CUNY Research Awards, the Getty Research Institute Library Fellowship, the Mellon Fellowship given by the Harry Ransom Humanities Research Center, University of Texas at Austin; and the Jean Charlot Foundation Fellowship. I appreciate the kind and generous assistance of the many archivists at these various institutions, especially Bronwen Solyom, curator, Jean Charlot Collection.

I extend my heartfelt thanks to the numerous picture lenders, rights holders (archival and image based) and in particular would like to acknowledge Susannah Glusker, Peter Glusker, and John Charlot.

Many of the ideas contained herein were developed in the course of preparing conference presentations and article submissions. I am grateful to Stacie Widdifield and Emily Umberger for the Emerging Scholars panel at the College Art Association annual conference in 2005, to Marguerite Mayhall for organizing a panel at a Middle Atlantic Council of Latin American Studies (MACLAS) conference, and to the board of MACLAS for awarding me the James Street Prize for best article, and to Eve Sinaiko and Lory Frankel at CAA/*Art Bulletin* and Marc Gotlieb, former editor of *Art Bulletin*.

Gloria Kury originally shepherded this project at the University of Pittsburgh Press, and I greatly appreciate her support and advice in its early stages. At the University of Pittsburgh Press I am grateful to Peter Kracht, editorial director, and the series editors, John Beverley and Sara Castro-Klarén. Joshua Shanholtzer graciously took on the project after the initial stages and played a pivotal role in helping to obtain the CAA publication grant. I am thank-

ful to Ann Walston for her beautiful design, to Maureen Creamer Bemko for her copyediting skills; and to Alex Wolfe, production editor; Bob Schwarz, indexer; Maria Sticco, publicist; and Lowell Britson, marketing director, for all of their generous assistance.

I would also like to thank the two anonymous readers who offered substantial and invaluable comments. Their clarifications and questions served to strengthen and add nuance to my arguments. I greatly appreciate their thoroughness, thoughtfulness, and the great care and time they dedicated to offering constructive criticism. I also greatly appreciate the editorial acumen of Anna Jardine, who whipped this manuscript into shape. In addition, I would like to thank John Blanpied and Kris Bierfelt for assistance with copyediting and Juliana Kreinik for her crucial assistance with clearing archival permissions.

Most of all I am eternally grateful to my extended family, who consistently offer me love, support, and guidance and inspire me every day, especially my parents, Marsha, Michael, and the Cuttita and the López families. I have dedicated this book to Angel López, whose insights, love, and friendship mean the world to me, and to our son, Emilio Indych-López, with whom I cannot wait to share the world.

MURALISM WITHOUT WALLS

I

INTRODUCTION

The Circulation of Mexican Muralism in the United States

The Mexican muralist movement emerged after a decade of violence and civil strife, from 1910 to 1920, when political and cultural leaders attempted to consolidate the social ideals of the Revolution, among them being the educating of the populace and the forging of a nationalist consciousness. To this end, artists such as Diego Rivera, José Clemente Orozco, and David Alfaro Siqueiros exploited the public mural as an instrument of social and cultural transformation. At the same time, they exported their production in both mural and small-scale form to the United States, where their nationalistic imagery captured the imagination of the art-viewing public in the late 1920s and the 1930s. In the United States, interest in the imagery displayed on the public walls of Mexico coincided with a broader popular fascination with Mexican culture.

Most of the museum-going public in the United States, however, could not examine these murals in Mexico directly. Portable frescoes, large- and small-scale easel paintings, works on paper, and photographic reproductions were vital in transmitting the Revolutionary rhetoric of Rivera, Orozco, and Siqueiros to U.S. audiences. Though they initially rejected the easel picture as "bourgeois," the muralists embraced the economy of small-scale media as a strategy for obtaining mural commissions in the United States.[1] The fo-

1

cus here is what Francisco Reyes Palma has called "transplanted" muralism, which came to the fore during a dynamic historical period when smaller-scale works had to speak for murals and capitalist patrons courted the Revolution's artists.[2]

The exportation of Mexican muralism to the United States entailed several seemingly paradoxical yet interrelated phenomena: the potential for smaller works to stand in for monumental murals, the ability of Mexican muralists to project nationalist imagery in a transcultural dialogue, and the capacity of U.S. viewers to reconcile these paradoxes within the sociopolitical context of hemispheric relations. While some scholars have referred to the "enormous vogue of things Mexican" in this era, the specific strategies, processes, and networks by which the muralists both engaged and resisted "south of the border" culture have yet to be theorized properly.[3] At stake is the question of how U.S. perceptions of Mexican cultural identity inflected the creative processes of the muralists, their politics, and the aesthetic and social histories of their murals.

During the 1920s, Rivera, Orozco, and Siqueiros painted monumental mural cycles in high-profile government buildings in Mexico's capital. The period of post-Revolutionary struggle featured an overwhelming cultural nationalism, the problem of national consolidation, and eventually the formation of the state. As the Mexican government and the post-Revolutionary elite codified their own version of national history, they called on indigenous peoples, the mestizo, folk culture, popular and native traditions, and pre-Columbian mythology to assert Mexico's own brand of hybrid modernity. Artists and intellectuals participated in the construction of a national iconography, and in so doing, many colluded with this state-sponsored aesthetic *indigenismo*.

Like their political counterparts, artists and intellectuals represented a factionalized community rather than a coherent "movement" and often proposed competing definitions of national identity. The socially committed art of the muralists competed with other practices as well as more internationally oriented, cosmopolitan vanguards such as *estridentismo* (a movement that joined artists and poets in an attempt to renovate Mexican culture through the iconography of modern technology).[4] Further, the so-called *tres grandes* of muralism argued bitterly among themselves and fought publicly to assert their individual and distinct visions of Mexico.[5] Although early responses to the murals in Mexico were negative and critics condemned them and their depictions of native peoples as "ugly," the institutionalization of muralism quieted the early public outcry, transforming the movement into a monumental national art form. International recognition helped to homogenize muralism and the claims of Revolutionary and cultural nationalism.

At various times throughout the late 1920s and the 1930s, Rivera, Orozco, and Siqueiros established long-term residence in the United States. During their stays, they created a variety of murals in nongovernmental contexts, such as the luncheon club of the Pacific Stock Exchange in San Francisco (Rivera, 1930–1931); the cafeteria of Pomona College in Claremont, California (Orozco, 1930); and the private home of filmmaker Dudley Murphy in Los Angeles (Siqueiros, 1932). Unlike the monumental cycles painted on several floors of such grand buildings as the Escuela Nacional Preparatoria (National Preparatory School) or the Secretaría de Educación Pública (Ministry of Education) in Mexico City, the murals in the United States were primarily single-paneled, in private or relatively inaccessible settings, and not part of a larger decorative scheme or a specific governmental platform. While the Mexico City murals were made for the elite urban classes of the capital and their accessibility is debatable (Mary K. Coffey has argued persuasively on this subject), they were more open to the public than, for instance, Rivera's mural for the private lunch club of a stock exchange or Orozco's mural confined to the student cafeteria of a private college.[6] Whereas in the United States these artists sometimes used the Mexican themes or imagery of social revolution that had been codified in their earlier murals in Mexico, most of their U.S. murals featured iconography adapted to the particular circumstances and environments of the commissions—the power of modern industry that inspired Rivera or the mysticism and classicism of the Delphic Circle that Orozco embraced.[7] The comparatively smaller and fewer murals in the United States by Rivera, Orozco, and Siqueiros featured principally atypical imagery lacking the cultural nationalism that had come to be expected of the three painters. For that reason, these works did not play a significant role in the reception of muralism in the United States.[8]

The exportation of Mexican muralism to the United States was emblematic of this period during which the muralists developed their Revolutionary language and reconsidered their artistic strategies in an effort to reach international audiences. Exhibition culture and circulation networks within the United States profoundly affected Mexican muralism, dictating a dependency between the murals and the portable works created for U.S. audiences on the one hand and the artists and their new patrons on the other. Portable works with Mexican subject matter by Rivera, Orozco, and Siqueiros were featured across the United States in group gallery shows. In these exhibitions, modern Mexican art was often displayed alongside pre-Columbian objects, as well as folk arts and crafts, thereby introducing the public to the work of the muralists within the context of a broader commercial interest in ancient artifacts and tourist objects. How, one might ask, could U.S. audiences understand

Mexican muralism without seeing the murals? And how was it possible to exhibit muralism without murals?

When the Revolutionary images by Rivera, Orozco, and Siqueiros circulated in the United States, socially engaged art rivaled abstraction as an alternative form of modernist expression. During the turbulent 1930s, the nationalistic imagery of the artists played into hemispheric concerns about "Americanism." Yet there was also a rural, depoliticized, and folkloric vision of Mexico in the United States, and it intensified the expectations of the general public, the demands of institutional patrons, and the critical reception of the artists' work. Orozco and Siqueiros were wary of such folkloric interpretations, but, like Rivera, they often altered their imagery to accommodate new audiences.

In the 1920s, not long after news reports in the United States about the Mexican Revolution had broadcast the image of a war-torn, violent bandito culture, the radical and politicized subject matter of the muralists proved distasteful to some. In an effort to make Mexican art more palatable to U.S. viewers, institutions such as the Museum of Modern Art (MoMA) were complicit in wider attempts to use it as a tool of cultural diplomacy. The well-documented appropriation of Latin American, and specifically Mexican, art for political purposes has eclipsed and overdetermined discussions of U.S.–Mexican cultural relations. It has also obscured a systematic evaluation of the aesthetic practices and networks developed between the two countries and of the position of muralism within the socially engaged modernism of the decade. As U.S. viewers grew increasingly aware of muralism, the task of willfully depoliticizing it became more difficult. The divide between the public's original expectations about Mexican art and their willingness to understand the artistic goals behind it grew narrower. By exploring the decisive shift in how Mexican muralists were understood in the United States, this study questions assumptions about the hegemony of U.S. cultural institutions and their ability to use Mexican culture to serve ideological and political interests. In doing so, it aims to reconstitute the politics of Latin American and modern art history.

A number of considerations have motivated this reevaluation: the need to challenge art historical accounts that codify artistic production into discrete categories of media and geography; the desire to debunk myths of cultural prestige that have hampered a more refined understanding of how Mexican art came to prominence in the United States in the 1930s; and the goal of providing an alternative vision of cultural modernity that incorporates modern Mexican art into the unfolding story of international modernism. While this study does address the work of some well-known artists, it primarily features an aspect of muralism that is rarely discussed. The literature on Mexican mu-

ralism is extensive, and some might think exhaustive, yet I resist traditional accounts of the murals by arguing that these works cannot be adequately understood without an examination of attendant small-scale works. That category includes works on paper created for export by Orozco; three major exhibitions of Mexican art in the United States; and the manipulation of a new medium—the portable fresco. With this focus, one can weigh the cultural activities of the muralists against the public responses to their production, as well as the cultural politics of modern Mexico and the United States. My approach suggests the extent to which transnational dialogues about the urban and the rural, abstraction and figuration, and nationalism and internationalism fashioned Mexican modernity.

Central to this project is the concept of canon formation and an understanding of how Rivera, Orozco, and Siqueiros came to dominate the art historiography of the period. I hope that my telling of this story will encourage others to amplify it.

The period between Orozco's arrival in the United States in 1927 for his second prolonged stay and the Museum of Modern Art's ambitious exhibition, "Twenty Centuries of Mexican Art," in 1940, was one in which Rivera, Orozco, and Siqueiros were active in the United States. Orozco's longest residence in the United States was from 1927 to 1934.[9] Rivera arrived in San Francisco in 1930 and traveled between Mexico and the United States intermittently throughout the decade, as did Siqueiros.

During these thirteen years, art patronage in Mexico and the United States differed significantly. The lack of an art market in Mexico made artists dependent on state sponsorship and income from work sold in the United States. The private Galería de Arte Mexicano in Mexico City did not open until 1935, and even then, the majority of its clients were from the United States. After an initial period of optimism and cooperative spirit during the Álvaro Obregón administration (1920–1924), many of the government commissions for art during the Plutarco Elías Calles regime (1924–1934) went to Rivera. Orozco came to the United States partly out of necessity. He had to earn a living, and so once public-sector employment in Mexico was destabilized, he received a small subsidy from Mexico's Secretaría de Relaciones Exteriores (Ministry of Foreign Relations) to establish himself in New York.[10] Rivera came to the United States by way of his growing fame and a mural commission in San Francisco. Without the system of patronage that operated in Mexico, without the availability of government commissions in the United States, the muralists relied solely on individual clients, promoters, writers and critics, gallerists, curators, museum directors, and wealthy patrons. U.S. government sponsorship did play a small role in the promotion of Mexican art, however,

when the American Federation of Arts, a national agency with semiofficial capacity in the absence of a central arts program, sponsored the "Mexican Arts" exhibition of 1930–1932. Significantly, the exhibition was financed not by the government but by the private Carnegie Corporation.

Several pivotal figures promoted modern Mexican art and artists in the United States in the period preceding that under discussion here. The artist, gallerist, and exhibition organizer Marius de Zayas was key in bringing modern art to New York. He was first associated with Alfred Stieglitz's Gallery 291 and later launched the magazine *291*. De Zayas went on to found his own galleries, the Modern and the De Zayas, and Rivera's first showing in the United States was at the Modern Gallery in 1916. Besides exhibiting the most advanced art from Europe, de Zayas maintained a permanent display of African and Aztec sculpture. He often showcased modern art alongside indigenous art from Africa and Mexico. In October 1916, he juxtaposed works Rivera had painted in Europe with pre-Columbian objects from Mexico. At this early date, then, U.S. viewers were exposed to the art of Rivera as well as the pre-Conquest art of Mexico in the context of modernism.

One of the most influential and significant *animateur*s of Mexican culture in the early 1920s was the poet José Juan Tablada, who lived in New York from 1920 to 1936. Beginning in 1923, under the auspices of Mexico's Secretaría de Relaciones Exteriores, this strident cultural nationalist organized conferences and exhibitions and wrote many articles about Mexican art that were issued in the United States. In 1923, he published both the first English-language article devoted to the work of Rivera and an article in *International Studio* that sought to "point out to the U.S. public the most prominent Mexican artists" of the day.[11] The following year, he introduced the public to the work of Orozco and laid the groundwork for New York's reception of his drawings of the Mexican Revolution by calling the artist, to Orozco's chagrin, "the Mexican Goya."[12] It was Tablada who encouraged Orozco to come to New York, telling him in early 1927 that he had many admirers in New York "only because they have seen the pictures of yours that I possess." He also mentioned to Orozco an invitation he had received from the director of the Brooklyn Museum to organize an exhibition of Mexican painters in which Orozco "would have the place that he deserves."[13] Tablada encouraged the young caricaturist Miguel Covarrubias to come to the United States as well and assisted in promoting his work when he arrived in 1923. As a result of Tablada's efforts, Covarrubias's caricatures appeared in *Vanity Fair* and the *New Yorker,* and Alfred A. Knopf published several collections of his portraits. Covarrubias was the first Mexican artist to achieve mainstream success in the United States. Tablada continued his crusade into the 1930s, after the muralists and other Mexican artists had arrived

in the United States. In addition to these activities, Tablada wrote a weekly column, "Nueva York de día y de noche" ("New York by Day and by Night"), for the Mexican newspaper *El universal,* which provides invaluable firsthand testimony to the Mexican presence in New York in the 1920s and early 1930s.

A number of prominent figures followed Tablada in promoting Mexican culture in the United States: Anita Brenner, Frances Flynn Paine, Alma Reed, Abby Aldrich Rockefeller, René d'Harnoncourt, Carl Zigrosser, Walter Pach, and Lewis Mumford, among others. Many of the figures involved in one way or another with the muralists—Rockefeller, Mumford, Juliana Force, Charles Sheeler, Edith Halpert—were also interested in American folk art. Art professionals in the United States forged a national identity in the arts by developing a theory of a "usable past," and their interest in Mexican art showed similar concerns. The Museum of Modern Art (and thus the Rockefellers) played a significant role in the promotion and exhibition of the muralists' work.

With the considerable differences between art patronage in the United States and Mexico, the terms "public" and "private" assume different meanings in each context. Renato González Mello has discussed at some length the conceptual and epistemological questions at the heart of the muralists' production in the United States.[14] This book, in turn, considers the very public life of private paintings and works on paper by the muralists in the United States during this period.

I do not attempt to trace the influence of the muralists on artists in this country, and therefore I do not examine U.S. artists' responses to their work. I look instead at institutional patronage, collecting practices, the artists' own motivations, and the critical reception of their work primarily in the popular press and in specialized art journals. In measuring the impact of the muralists on the popular cultural imagination of the United States, I analyze the mainstream interpretation of muralism presented in art periodicals, daily newspapers, and contemporary criticism. Because there are no oral histories or contemporaneous accounts from the general public, I necessarily refer to museum-goers, art viewers, and art critics at various presses. A discussion of the reception of muralism in the United States would ideally take into account its distinct and varied communities of viewers: for example, Mexican American audiences in the Southwest, midwestern viewers, and a more elite element of the New York public.[15] Yet, just as Mary Coffey has stated in regard to the Mexican context, there is no record from the 1930s in the United States of "any popular reception like the kind we find today in [visitor] surveys or 'reader responses.'"[16] While critics do not necessarily define public opinion, they clearly mold it, respond to it, and can often be an accurate, albeit not absolute, gauge of it. In relying on critical rather than popular reception, I follow the defini-

tion of "public" Thomas Crow used in reference to eighteenth-century French painting, whereby the public is understood as a "representation of the significant totality by and for someone. A public appears, with a shape and a will, via the various claims made to represent it." Rather than suggest the "meaningful degree of coherence in attitude" that Crow assumes in the Parisian context, I attempt to account for the complexity of diverse audiences in the United States by examining, for example, the divergent beliefs of art critics such as Henry McBride, a defender of conservativism, and Elizabeth McCausland, a socially conscious writer and activist, both of whom wrote extensively about Mexican art and artists.[17] Like Helen Langa in her crucial study of printmaking in New York in the 1930s, I understand critical reception as historically situated claims and work from the premise that by considering reception we may "see [how these works] resonate within their historical conditions of production [and] circulation" and speculate "about elements ignored or avoided by contemporary . . . audiences that later viewers might interpret differently."[18] I deliberately seek to illuminate the social historical context through reception. Nevertheless, I also use historically situated claims in order to rethink questions of canon formation and to view works of art as part of an ongoing historical process.

Despite the complexities of diverse audiences my examination reveals coherence in the expectations for a particular notion of Mexicanness from various U.S. publics. An analysis of the exhibition culture surrounding muralism in the United States and its attendant responses lays bare the constructs of perception about what constitutes Mexicanness. Given muralism's specific intent to reach an audience (mass or elite, domestic or foreign), I explore how images circulate and how institutions, artists, and exhibition culture fabricated Mexicanness. I also explore the extent to which Mexicanness was expressed, understood, and exploited in the 1930s. The politics of cultural production, dissemination, and reception lie at the heart of this project.

In order to deconstruct the U.S. interpretation of Mexican muralism and modernity, I have organized this study in roughly chronological order. Subsequent chapters center on an exhibition or a series of works and move outward to consider the various networks (museum and gallery exhibitions, popular magazines, private collectors) for dialogues about muralism, despite the relative absence of murals. I also position muralism as a prime example of the alternative modernisms that flourished during the late 1920s and early 1930s. By capturing a historical moment when Mexican muralism first exploded on the scene in the United States, I appraise the artists' own vantage points and strategies, as well as those of art institutions and the public, in the promotion of muralism. I thus examine the shifting claims made on Mexican mural-

ism and clarify the concept of "the public" for murals in the United States. Instead of surveying U.S. fascination with Mexican culture in general, this book focuses on the capacity of U.S. perceptions to affect the very production of Mexican art.

Orozco was not only the first muralist to arrive in the United States but also the first to accommodate his production for export to the north. He did so in the series *Los horrores de la revolución,* a group of works on paper that Orozco began in Mexico for U.S. clients. Further developed in response to U.S. reactions to the artist's production, *Los horrores* was the first body of work that he exhibited in New York, and it is a critical link between his famous Escuela Nacional Preparatoria murals in Mexico City and the murals he would produce in the United States. Under the political pressures of the post-Revolutionary regime and after negative reactions to the violent imagery, Orozco elaborated and reconfigured this series, altering his work to accommodate both the expectations placed on a Mexican artist and the vicissitudes of the commercial marketplace in the United States.

Mexican art and muralism gained popularity in the United States largely because of the "Mexican Arts" exhibition that was organized by the American Federation of Arts and that traveled to fourteen U.S. cities between 1930 and 1932. Dwight Morrow, the U.S. ambassador to Mexico at the time, conceived the exhibition, and it included work by Rivera, Orozco, and Siqueiros. Curated by René d'Harnoncourt, it sought to trace "authentic" Mexican culture through the simultaneous display of colonial, folk, and modern art. The early and contemporary folk art accounted for the show's success; the three muralists' paintings, with such subjects as workers, soldiers, and heroes of the Revolution, proved to be an ill-fitting conclusion to the exhibition and received unfavorable reviews.

The "Mexican Arts" exhibition appeared at a time when U.S. audiences were becoming aware of artistic developments in Mexico. The exhibition allowed them to view—firsthand, rather than in reproduction—large-scale easel pictures by the muralists. Yet the search for common American cultural origins, which in part had prompted the exhibition, colored its portrayal of Mexican nationalist art. The show presented modern Mexican art as a simplistic expression of rural folk values, and it essentially erased all signs of the political nature of the muralists' production. In the end, "Mexican Arts" stripped the modern Mexican aesthetic of its Revolutionary connotations by reducing it to a romanticized illustration of the supposedly harmonious, rural character of Mexico. This biased promotion of artisanal, rural, and traditional values as "authentically" Mexican made the show quite popular, but it also elided the contribution of the muralists. By establishing a popular expectation

of "simplicity" and folk values in modern Mexican art in the early 1930s, the exhibition created an inauspicious environment for the development of muralism. With the precedent of the exhibition, the U.S. publics' responses to the muralists' work showed marked tensions between the rural and the urban.

In December 1931, while "Mexican Arts" was making its eleventh stop, at the Art Institute of Chicago, a large retrospective of the work of Diego Rivera opened at the new Museum of Modern Art, offering New York museumgoers an unprecedented glimpse of his work to date. Murals, in short supply in "Mexican Arts," claimed center stage at MoMA, as Rivera created eight portable fresco panels for the exhibition. This medium was a new one developed by the artist, and five of those panels received considerable critical attention. The five panels distilled the more politicized imagery of Rivera's murals in Mexico. U.S. viewers had complex reactions to both the muralist's subject matter and his formal technique. I argue, unlike most other authors, that MoMA's attempts to depoliticize the work of the muralists were not successful and that the critics' rejection of Rivera's "watered-down" portable frescoes indicates that the public had begun to reach more informed conclusions about Mexican muralism. The artist's unsuccessful attempts to replicate the conditions, practice, and imagery of muralism through the surrogate of the portable fresco influenced the next big exhibition of Mexican art in the United States, an exhibition whose organizers also grappled with the problem of how to present the work of the muralists to U.S. audiences.

Despite Rivera's crisis with the portable fresco format, MoMA commissioned another movable mural, this one by Orozco, for that next big exhibition, entitled "Twenty Centuries of Mexican Art" (1940). Orozco had taken note of the criticisms leveled at Rivera's panels, and his portable fresco, *Dive Bomber and Tank,* more closely approximated the scale and viewing conditions of public mural painting. Larger than Rivera's earlier portable frescoes, *Dive Bomber* was made up of six interchangeable panels that could be read in various configurations, in the same way that the nonlinear narrative of certain mural cycles in Mexico carries over from wall to wall. Critics observed that in comparison with Rivera's 1931 panels, *Dive Bomber* appeared less like a fragment of a mural ripped out of its context. By using formal manipulation and abstraction as metaphors for the construction of vision in general, Orozco summoned the experiential conditions of viewing a mural, and his portable fresco communicated the goals of Mexican public mural painting much more effectively than did Rivera's earlier work. By evaluating the differences between Orozco's movable mural and Rivera's MoMA panels, I show how the critical responses to the muralists' work affected the evolution of the portable medium and Mexican muralism in general. Despite its shortcom-

ings, "Twenty Centuries of Mexican Art" offered a more historically grounded "explanation" of muralism than did "Mexican Arts." The public perception of Mexican muralism in the United States had matured sufficiently by the end of the 1930s to reconcile the political interpretations and the specific formal concerns of public mural painting.

By charting more than a decade of Mexican muralism in the U.S. cultural sphere, this book locates the production of Rivera, Orozco, and Siqueiros within the political, sociocultural, and aesthetic histories of modernism in the Americas. By weighing public reactions to their work during the cultural rejuvenation of the late 1920s and the 1930s, it also reviews our understanding of U.S.–Mexican cultural relations and seeks to expose the contradictions of the "enormous vogue for things Mexican."

The border between the two nations continues to be fraught with competing, tangled histories. In light of that tension, this book analyzes the emergence of national cultural identities as one of many responses to the process of modernization in the Americas during the early twentieth century. In identifying the ways in which the U.S. public came to comprehend muralism in the 1930s, and the specific visual strategies used alternatively to convey and to downplay cultural nationalism, this study provides an opportunity to understand the fears and expectations that tumultuous change and transculturation pose for two neighboring nations locked in a tense interdependence.

2

HORRORES

The armed phase of the Mexican Revolution (1910–1920), in which competing political forces ended up forging the modern Mexican state, preceded an equally heated and contradictory era of reconstruction (1920–1940). Mexico's civil war, the first social revolution of the twentieth century, promoted radical agendas such as agrarian reform, land distribution, and socialist education. Mythologized as a popular uprising of the masses, the Revolution in fact represented heterogeneous class allegiances and ideologies. Francisco Madero, Venustiano Carranza, Francisco (Pancho) Villa, Emiliano Zapata, and other Revolutionary leaders differed in their proposals for reform and often had to compromise their ideological positions for the sake of political expediency. Arising from this factionalized and bloody conflict, the modern Mexican state destroyed key elements of Porfirio Díaz's positivist regime (in which foreign capital controlled large segments of the Mexican economy) to forge a nation predicated on a delicate balance between modernity and tradition, the rural and the urban, the local and the universal, the masses and the elites. The post-Revolutionary era authenticated the struggles of the armed phase and consolidated the inchoate social program into a seamless and redemptive cultural nationalism. Post-Revolutionary society remained contentious, as intellectual elites strove to realize their political ideals and competed to have their

vision of the nation and the Revolution legitimized. Although few of the aims of the Revolution were ever actually attained, post-Revolutionary elites manufactured the illusion of reform and a unified vision for the sake of nation-building.

During the entire period of the armed struggle, Mexico's northern border remained open. Maintaining good relations between Mexico and the United States remained a pragmatic concern for both countries: the revolutionaries depended economically on exports to the United States, and U.S. business interests feared a nationalized Mexican economy. Reacting to the upheaval of the Revolution, U.S. officials and private interests attempted to shape the course of the civil war throughout the decade. With contradictory reports from the south and stories of banditos and savage violence, the predominant image of Mexico during the second decade of the twentieth century was of a "backward" nation, a land without laws. Having created a "public-relations disaster," in the words of historian Claudio Lomnitz, the Revolution had to be redeemed through cultural diplomacy. The exportation of muralism and Mexican cultural nationalism to the United States served this purpose, but the shifting and contested meanings of the Revolution in both countries made cultural diplomacy in the late 1920s a tricky game.

When the muralists arrived in the United States, Mexican cultural nationalism embodied a set of contradictions for the public: its ties to the Revolution remained a source of social and political unease, yet it could also be mythologized as an exciting artistic renewal. Diego Rivera's romanticized native themes and depictions of timeless, pure, harmonious Indians glorified the achievements of the Revolution (fig. 1). In the United States, his idealized images of indigenous populations fed into a growing concern for common American cultural origins marshaled for the sake of a unique, local, alternative modernity that would rival the various manifestations of the avant-garde in Europe. José Clemente Orozco, who did not mythologize native populations in this way, presented a more conflicted image of society (fig. 2). His vision was incompatible with expectations about Mexican art as well as a burgeoning pan-American art movement. It also paralleled societal/political fears of Mexicanness resulting from U.S.–Mexican border conflicts and a historical relationship tainted by racist attitudes and policies.

Orozco, along with David Alfaro Siqueiros, witnessed the civil war first-hand, while Rivera remained in Europe for almost the entire period.[1] Only Siqueiros really fought in the Revolution. Orozco was not deeply involved in either the military or the ideological aspects of the Revolution. With only one arm, he would not have been a very effective fighter, and as a humanist with a profound distrust of political parties, alliances, and demagoguery, he was

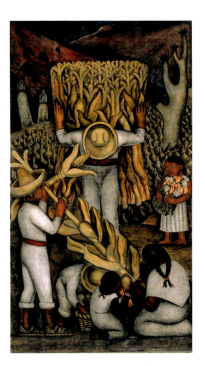

FIG. 1. *(left)* Rivera, *The Corn Harvest,* 1923–1924. Fresco. Secretaría de Educación Pública, Mexico City. © 2008 Banco de México Diego Rivera & Frida Kahlo Museums Trust, Av. Cinco de Mayo no. 2, Col. Centro, Del. Cuauhtémoc 06059, México, D.F. Photograph by Schalkwijk / Art Resource, New York.

FIG. 2. *(below)* Orozco, *Political Junkheap,* 1924. Fresco. Escuela Nacional Preparatoria (Colegio de San Ildefonso), Mexico City. © Artists Rights Society (ARS), New York / SOMAAP, Mexico City. Photograph by Schalkwijk / Art Resource, New York.

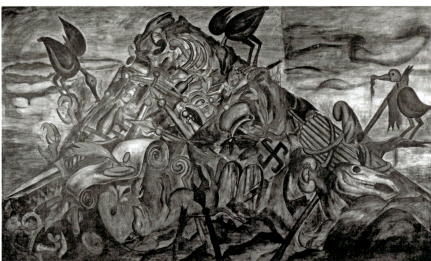

more of an observer. In 1915, when the painter Dr. Atl (Gerardo Murillo) rallied other artists to side with the conservative Constitutionalist forces of Carranza against Villa and Zapata, Orozco joined him in the retreat toward Veracruz. In Orizaba, he worked as an illustrator for the Carrancista newspaper *La vanguardia,* continuing his earlier production of political caricatures for Mexican weeklies such as *El ahuizote.* In a passage from his autobiography, Orozco

 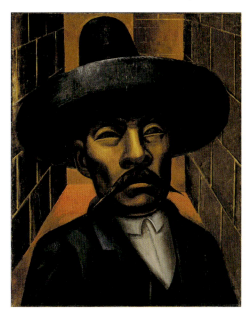

FIG. 3. *(left)* Rivera, *Emiliano Zapata,* 1928. Fresco. Secretaría de Educación Pública, Mexico City. © 2008 Banco de México Diego Rivera & Frida Kahlo Museums Trust, Av. Cinco de Mayo no. 2, Col. Centro, Del. Cuauhtémoc 06059, México, D.F. Photograph by Schalkwijk / Art Resource, New York.

FIG. 4. *(right)* Siqueiros, *Zapata,* 1931. Oil on canvas. Hirshhorn Museum and Sculpture Garden, Smithsonian Institution, Washington, DC. Gift of Joseph H. Hirshhorn, 1966. Photograph by Lee Stalsworth.

writes, "I played no part in the Revolution, I came to no harm, and I ran no danger at all. To me the Revolution was the gayest and most diverting of carnivals."[2] Orozco's lived experiences in the Revolution colored his pessimistic worldview and provided explosive visual material from which he would selectively draw to express his profound and universal vision of human struggle and suffering. Whereas Rivera often invented a Revolutionary past that never existed and Siqueiros attempted to materialize visually the goals of the socialist revolution, Orozco did not "trust revolutions or glorify them," since he had "witnessed too much butchery. Only a fool like Rivera who was in France during the Mexican revolution can carry on about revolution."[3] In all of their works with the Revolution as theme, Rivera and Siqueiros rarely represented actual warfare, depicting for the most part commemorative scenes (figs. 3 and 4), whereas Orozco produced "the clearest and most penetrating images" of a

"revolution frozen halfway, drowned in blood and increasingly dominated by bureaucracy and corruption."[4] Although they all produced images of the Revolution, each of the muralists participated differently in this defining event of their time. Their distinct social and political viewpoints as well as their divergent experiences with the civil war led to profound rivalries and informed their iconography and production. Orozco's observations and memories of the war would form the basis for *Los horrores de la revolución,* the series that marked his debut in the United States and situated him as the Revolution's foremost visual interpreter in the United States.

The Iconography of *Los horrores*

The seemingly endless violence of the civil war in Mexico spills out in Orozco's raw yet delicate ink-and-wash drawings, known upon their commission as *Los horrores de la revolución* and later retitled *Mexico in Revolution.* Commissioned by Anita Brenner, a writer, journalist, and energetic supporter of Mexican artists, and produced between 1926 and 1928 specifically for export to the United States, the series began as six drawings meant to illustrate a book about the Revolution to be published in the United States. Orozco continued the series in a variety of drawings, lithographs, and easel paintings with the Revolution as their subject. This expressionist drama, filled with images of death, mourning, tyranny, execution, looting, and mass slaughter, is a universal condemnation of war set within the context of the Mexican Revolution; it constitutes the first extended attempt by one of the muralists to adapt his production for an audience north of the border.

Orozco's work depicts a range of debauchery, human folly, and macabre war activities in which the Revolution is presented as a leaderless, formless, and destructive process. The figures depicted are neither straightforwardly good nor evil, and neither the Zapatistas nor the Carrancistas are spared Orozco's wrath. His vision of the Revolution as violent, bloody, and tumultuous is exemplified by *The Battle* (1928; fig. 5), in which armed troops clash in a conflict that has no victor. A conglomeration of amorphous body parts and brandished weapons, the scene is a swirl of rough combat. Except for offering sombreros and northern-style felt hats that distinguish Villistas/Zapatistas from Constitutionalists, Orozco presents an anonymous mob, brutal, out of control—civilization's disintegration incarnate. The crude draftsmanship, purposefully resisting the academic and classical ideal, uses the expressive properties of the quick sketch to underscore the theme of debased humanity. The Revolution is but one of many barbaric forces afflicting mankind. To convey the message of universal suffering in this drawing, and the entire series, Orozco focuses on bodily injury. Within the rhetorical terms of national dis-

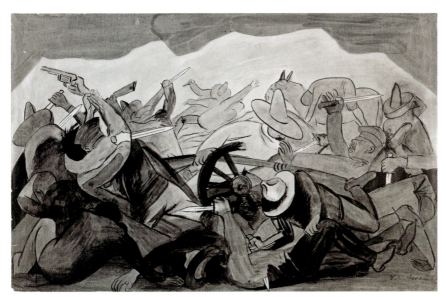

FIG. 5. Orozco, *The Battle*, 1928. Ink on paper. Museo de Arte Alvar y Carmen T. de Carrillo Gil, Mexico City. © Artists Rights Society (ARS), New York / SOMAAP, Mexico City. Photograph by Javier Hinojosa.

course, he evokes a fragmented body politic that reflects the contentious and factionalized nature of the civil war and post-Revolutionary society.

One of the lesser-known works from the series, *The Rape* (fig. 6), typifies Orozco's horrific vision of the Revolution. The scene is the ransacked parlor of a house. A soldier mounts a half-naked woman and pins her to the floor by her arms and hair, perpetuating the violation committed by other figures leaving the room; another soldier, disheveled and viewed from behind, lifts his pants to cover his buttocks, while a shadowy figure exits through the parted curtains at the right. Bottles of alcohol, as well as the soldiers' hats, a rifle, and a cane, are strewn about the floor. A chair teeters, a painting and a hanging mirror have been knocked askew, and the glass door of the armoire is shattered. The dynamic zigzag lines representing reflections in the mirror and the armoire door heighten the tension and volatility. This is one of the more narrative scenes of the series, and in its focus on the ravaged body—in this case, the defiled female body—it visualizes the destructive force of the Revolution.

Another drawing from the series, *El ahorcado (The Hanged Man)* (fig. 7), concerns the aftermath of battles, specifically, corporeal devastation. In addition to presenting imagery that disturbs, the drawing upsets expectations through formal means. A corpse hanging from a telephone pole anchors the upper portion of the composition, while two dead figures slump in the foreground; their rifles, pointing at opposing angles, frame the scene above. A

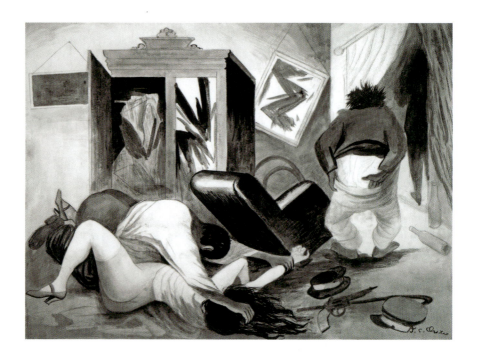

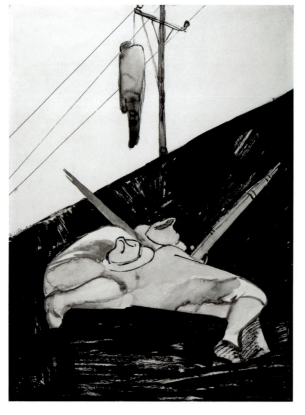

FIG. 6. *(above)* Orozco, *The Rape*, 1926–1928. Ink on paper. Philadelphia Museum of Art. Purchased with the Lola Downin Peck Fund from the Carl and Laura Zigrosser Collection, 1976. © Artists Rights Society (ARS), New York / SOMAAP, Mexico City.

FIG. 7. *(left)* Orozco, *El ahorcado (The Hanged Man)*, 1926–1928. Ink on paper. Museo de Arte Alvar y Carmen T. de Carrillo Gil, Mexico City. © Artists Rights Society (ARS), New York / SOMAAP, Mexico City. Photograph by Javier Hinojosa.

diagonal expanse of black wash encroaches on the two figures, their slightly demarcated details carved out of the roughly scored patch of darkness. The bodies hover in the flat area of black wash, seemingly suspended in midair against the vastness of a long wall. The hanging corpse crowns the composition as the telephone lines parallel the movement of the diagonal ground. The expanding blackness, which presses the entire composition up to the picture plane, collapses figure-ground relationships and destabilizes the viewer. The composition is a series of contrasts that further upset visual and iconographic coherence: the verticality of the hanged corpse opposes the horizontality of the foreground figures; strict rectilinearity is balanced by diagonals and curves; and positive and negative space are negotiated through stark juxtapositions of black and white. Orozco narrates the violence of the Revolution with a simple, even brutal, economy.

These drawings of dreadful events and acts, like others in the series, are unprecedented visualizations of the upheavals of the Revolution. Presenting an insider's view not only of the agony of civil war but also of the confusion and competition for power among factions, the series depicts the Revolution more explicitly and succinctly than any other mural by Orozco or that of any other artist. Through Orozco's focus on the body and corporeal devastation, the Revolution, painted on many public walls in Mexico, finds perhaps its most primal visual form in these small-scale, intimate drawings.

Origins of the Series

The individual *Horrores,* as well as all of Orozco's nonmural work related to the Revolution, are rooted in his Mexican murals of the mid-1920s, specifically the panels of the Escuela Nacional Preparatoria (ENP). Painted in two phases with interruptions, this mid-1920s mural cycle is located in what was the most important secondary school in Mexico and covers three stories of corridor walls, parts of the stairway walls, and the stairwell vaulting of an eighteenth-century baroque colonial building.[5] The first and second floors were painted in 1923–1924, when Orozco, like many Mexican artists, was still searching for a visual language appropriate for state-sponsored monumental public art and post-Revolutionary society. Unhappy with the results (and the reactions to his first efforts), in 1926 he repainted the majority of the first-floor panels from this experimental stage, which reflected the broader lack of political and stylistic cohesion in Mexican society and culture. Of the original panels on the first floor, only two are extant; the second-story panels, however, remain intact. The third-floor panels are later in composition, dating to 1926. Many scholars have distinguished between the early and later periods by noting the stylistic and iconographic changes from Renaissance-inspired

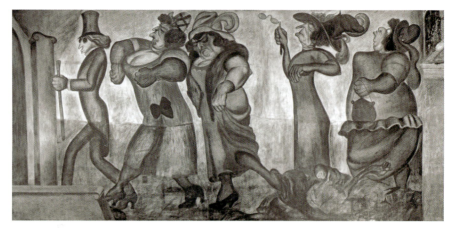

FIG. 8. Orozco, *The Rich People,* 1924. Fresco. Escuela Nacional Preparatoria (Colegio de San Ildefonso), Mexico City. © Artists Rights Society (ARS), New York / SOMAAP, Mexico City. Photograph by Schalkwijk / Art Resource, New York.

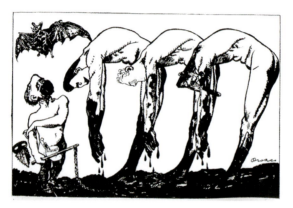

FIG. 9. Orozco, "Los neo-serviles," from *El ahuizote,* October 7, 1911. © Artists Rights Society (ARS), New York / SOMAAP, Mexico City.

traditional allegories (such as *Maternity,* an original panel from the first floor), to busy figural arrangements with distortions and the irony of political cartoons (as on the second floor), to Revolutionary subjects differentiated by a restrained monumental classicism and an expressive alternative modernity (e.g., the third-floor works and the repainted panels on the first).

The caricatural style of the second-floor work (fig. 8) has its basis in Orozco's extensive experience with political cartoons (fig. 9). In his lampooning of Mexican society in such panels as *The Rich People,* Orozco employs dark humor, figural distortion, and social critique. The rich are bloated, grotesque figures with exaggerated features and gestures indicative of their moral turpitude. While Orozco's radical critique of Mexican elites reflects the influence of the Communist Party on mural art of the early 1920s, he used the same

techniques to satirize Revolutionary leaders in his early political cartoons for such reactionary publications as *El ahuizote*. The ENP murals reflect Orozco's ideological cynicism and his deep roots in the art form of caricature.

By blurring boundaries between fine art and vernacular culture, between image and word, and by rendering elevated subjects, such as historical scenes or portraits, with crude techniques or media, caricature occupies a specific narrative niche. Engaged as it is with the popular, and relying as it does on cheap materials and alternative methods of distribution, caricature revels in a form of public discourse marked by disruption, dissonance, transgression, and provocation. Orozco adapted its strategies and modes for the second-floor ENP panels, specifically in a "grotesque realism" that emerges in heightened form in the small-scale production.[6] Although his cartoon production—either enlarged on the walls of the ENP or in its original mass-distributed form—did not always depict the Revolution, the conventions of caricature are at the root of *Los horrores*. In addition to the conceptual framework, some of the themes Orozco first tackled in his political cartoons—violence, corruption, death, mourning—appear as well in the Revolution series.

The later period of Orozco's ENP work evinces a consolidation and refinement of Revolutionary subjects. He monumentalizes the Revolution as a series of huddled masses of women, soldiers bidding farewell, and workers with rifles (fig. 10), avoiding the crowded compositions of the ENP's second floor. Spare scenes focus on psychological moments of sacrifice and hardship, as when a family sits and watches a building burn in the background. Featuring simpler figural arrangements, less irony, and a grander scale, this new style first appeared in Orozco's mural at the Escuela Industrial, Orizaba, in 1926 (fig. 11), during an interruption of his work at the ENP, and subsequently gained currency.

Accommodating the monumentality of the murals in a small format, the *Horrores* drawings carry forward some of the general themes begun on the third floor of the ENP and in the school at Orizaba. Themes of farewell, such as preparation for or return from battle, the forms of a gravedigger and torn maguey plants, nonspecific architectural shapes as backdrops—these and other elements are repeated in the drawings. Some drawings directly appropriate the thematic concerns and specific imagery from the murals; for example, the huddled peasant women and the man lying on his side in the foreground of the *Ruined House* (fig. 12) echo similar figures in the ENP panel titled *The Family* (fig. 13). Most of the drawings, however, eschew the tranquil imagery of the third-floor ENP panels, which forgo overt violence in favor of intense psychological drama.

In order to understand the iconographic and ideological shifts between

FIG. 10. *(above)* Orozco,
The Farewell, 1926.
Fresco. Escuela Nacional
Preparatoria (Colegio de San
Ildefonso), Mexico City. ©
Artists Rights Society (ARS),
New York / SOMAAP,
Mexico City. Photograph by
Schalkwijk / Art Resource,
New York.

FIG. 11. *(left)* Orozco,
Social Revolution, 1926.
Fresco. Escuela Industrial,
Orizaba. © Artists Rights
Society (ARS), New York
/ SOMAAP, Mexico City.
Photograph by Schalkwijk /
Art Resource, New York.

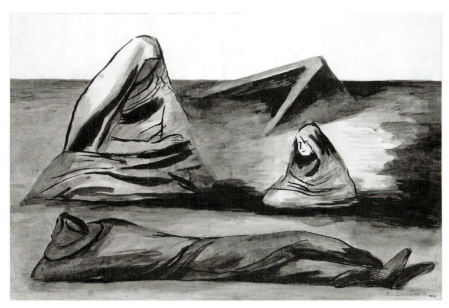

FIG. 12. Orozco, *Ruined House*, 1926–1928. Ink on paper. Albertina Museum, Vienna. ©
Artists Rights Society (ARS), New York / SOMAAP, Mexico City.

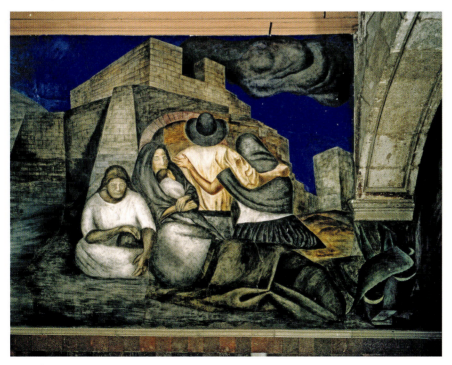

FIG. 13. Orozco, *The Family*, 1926. Fresco. Escuela Nacional Preparatoria (Colegio de San
Ildefonso), Mexico City. © Artists Rights Society (ARS), New York / SOMAAP, Mexico City.
Photograph by Schalkwijk / Art Resource, New York.

the ENP murals and the *Horrores* images properly, we must first examine the circumstances and context of their production. The unpublished diaries of Anita Brenner reveal the origin and development of the *Horrores* series. Her entry of September 6, 1926, states, "Saw Orozco. He says he is all mixed up and does not know what's what in painting. He has been quite ill. He suffers a great deal. But he is doing beautiful work. I am going to get him to do a group of 'revolution' drawings. Pretext of customer—He wouldn't sell them to me."[7] According to Brenner, the artist Manuel Rodríguez Lozano informed her that Orozco was in economic straits and asked if she could assist him in some way. As she related to Jean Charlot in 1947, Brenner set out to help and came up with the idea for the series. That idea grew out of her interest in Orozco's political caricatures, specifically, those created for the Mexican periodical *L'ABC,* those "showing so much power and compassion and vividness in relation to recent Mexican history."[8] Brenner suggested that she and Rodríguez Lozano "invent a mythical gringo who was writing a book about the Revolution, and who wanted illustrations." Brenner continued,

We told Orozco that this gringo would like to buy six black and whites about the Revolution, but that he was away at the moment and had left me with the money to pay with, at the same time stating he was willing to take whatever I suggested. This mythical gringo was me, of course, and I think I borrowed the money, because I am sure I didn't have it. It was necessary to invent him, naturally, because we were afraid Orozco would not have taken the money from me, even in exchange for work. . . . Orozco had the whole pent-up volcano of his experiences and his feelings in the Revolution in these. What happened also was that he himself got so interested in what he was doing that he continued with the idea after the six originals were done, as I remember the series came to something like 30 or 40.[9]

As the architect for the series, Brenner controlled the early creation, exportation, and circulation of the drawings, which were begun in Mexico but were intended for an audience north of the border. At the time of the commission, Brenner—who was born in Mexico but grew up and studied in the United States—was busy preparing a book on Mexican art that would eventually be her magnum opus, *Idols behind Altars.* When Brenner says, "This mythical gringo was me, of course," she means not simply that it was she who was behind the commission but also that in a sense she was the "gringa" client writing a book and commissioning work about the Revolution. Even though *Idols* is not about the Revolution, it is steeped in Mexican lore, folk customs, and history. And while she used the mythical U.S. patron as a pretext for Orozco to execute the drawings because she feared he would not take money from her, the basis of the commission remained the same. Brenner, of course, had her own book in mind when commissioning the drawings.[10]

As with all of her writings about Mexican art and culture, Brenner organized, wrote, and published *Idols* for a U.S. audience. Beginning in the mid-1920s, she actively promoted Mexican culture to an English-speaking audience through the various articles she contributed to art journals and mass media in the United States. In addition, she was preparing her book for publication, organizing a large exhibition of Mexican art, and promoting the work of individual Mexican artists across the border. Almost all of Brenner's projects engaged a U.S. frame of reference as she attempted to familiarize U.S. audiences with Mexican culture. In early 1926, while working on the essay that would provide the framework for *Idols,* Brenner wrote, "Last night the Ren ["Mexican Renascence"] article shaped out. Have yet to finish it—Indeed sweated blood over it—due to length (very short) unfamiliarity with audience and their lack of knowledge of Mexico."[11] Like her other projects, Brenner's planned (yet never realized) exhibition of Orozco's Revolution scenes was crafted for display in the United States.

Whether created in Mexico City or in his apartment in New York City, all of Orozco's *Horrores* drawings were made for a U.S. audience. Although the exact number of drawings in the series is uncertain, Brenner's diaries mention thirty-four before her departure for New York in early September 1927. She brought the "bulk of the Revolution set" with her to New York in the hope of exhibiting it.[12] Finding a public forum for the series was her intention from the beginning; after seeing the first two drawings, she wrote in her diary, "I am trying to persuade him to do enough for an exhibition."[13] Although the series began as a fake commission, Orozco must have been aware of Brenner's intervention, and he continued to develop the series. A few months after her departure, he himself left for New York but apparently took no work with him. On December 18, Brenner recorded in her diary, "Orozco arrived this morning . . . in very good spirits, and with not a single canvas, drawing, nothing but a small suitcase!" Many of his early watercolors had been deemed "immoral" and destroyed by U.S. Customs officials on his first trip to the United States in 1919. Fearing that agents might once again confiscate his work, he entrusted the series to Brenner. Charlot, who left Mexico for New York in October 1928, brought "a few remaining 'horrors' and large charcoal studies for the frescoes." According to him, Orozco added only a few new drawings to the series in New York and made replicas of some of the early drawings.[14] Taking into account the replicas made, one may estimate that Orozco produced approximately fifty-five to sixty drawings in all.[15]

Despite the clear circumstances of their patronage and creation, the *Horrores* images are often mistakenly dated to the time of the Revolution. Charlot confirmed in 1949 that the drawings were made to order between 1926 and

1928, yet many writers continue to assume that they are contemporaneous with the events depicted.[16] One source of this misapprehension is a 1932 book, *José Clemente Orozco.* The book's introduction was written by U.S. journalist Alma Reed, who became Orozco's agent. In the book she states that the artist based the *Mexico in Revolution* series on sketches done between 1913 and 1917. Reed, without Orozco's objection, we presume, insisted on the existence of the sketches because they testified to Orozco's being one of the artists to have actually made art at the time of the Revolution. Antedating the drawings to establish them as contemporaneous with the events they depicted would make him appear to be among the first artists to work with specifically Mexican imagery in the Revolutionary era. The rivalry between Orozco and Rivera also fueled the misdating. Despite the general confusion surrounding the dating, it seems certain that there were no such sketches and that their existence was invented to authenticate the series. Orozco may have encouraged such perceptions, telling Eva Sikelianos, founder of the literary Delphic Circle (whose goal was to revive classical Greek culture) and wife of the Greek poet Angelos Sikelianos, that "in Mexico, we learn to work under all conditions—sometimes behind the barricades or dodging missiles on the walls."[17] Orozco invoked his Revolutionary pedigree at a time when it was convenient for him to be seen, in his new context, as an artist-soldier painting and sketching in the trenches. Reed must have overlooked the curiosity of Orozco's statement, for the fighting was firmly in the past by the time the muralists painted any walls. Perhaps Orozco suggested they were making art in the midst of the armed struggle not only to impress his hostesses but also to give greater credence to his drawings.

Telling stories, sometimes tales of excess about the Revolution, was a cultural practice with which Orozco was familiar. Brenner had witnessed the armed struggle firsthand; her diaries and two of her best-known publications, *Idols behind Altars* and *The Wind That Swept Mexico,* recount the Revolution from direct experience.[18] And her diaries trace how, in a ritualistic fashion, various friends who lived through the civil war would come together to share their memories. Orozco was one of many who related his particular experiences: "[Orozco] told me also of when he and Atl during the revolution, took Orizaba. They looted the churches and established newspapers."[19] The more detailed accounts in her diaries reflect the informal post-Revolution cultural practice of *testimonio,* as in the entry for December 26, 1925:

Galván came, and we talked Mexico—Stories of the revolution. Impressed by the tale he tells of a[n] Aqua Indian he saw—alone after his side was defeated—both legs shot away, left arm hanging by a piece of skin, and shooting with right and teeth—jaw shot away, & still worked with gun until he went limp—dead. Brings

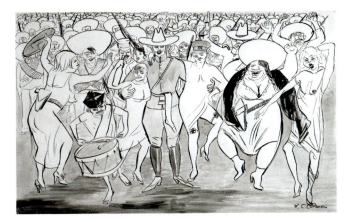

FIG. 14. Orozco, *La Cucaracha I*, 1926–1928. Ink on paper. Museo de Arte Alvar y Carmen T. de Carrillo Gil, Mexico City. © Artists Rights Society (ARS), New York / SOMAAP, Mexico City. Photograph by Javier Hinojosa.

back those things I saw . . . train of wounded, bugles in the night, sound of wheels carrying men to be executed—Fights of [soldiers'] wives & groans of gangrened . . . fat general eating hardboiled egg with his knife . . . barrels of blood-soaked cotton, dung heaps of it . . . young bull torn apart by howling men tugging each at a leg of the roaring, bawling beast.[20]

Such accounts epitomize the propensity for embellishment in war testimonials and seem remarkably familiar in light of Orozco's drawings. An inventory of horrors in diaristic prose, Brenner's reminiscences resemble those written twenty years later by Orozco in his autobiography. In the middle to late 1920s, when artists and friends telling stories of the Revolution filled Brenner's home, Orozco was a frequent visitor. He surely absorbed the prevalent narrative mode. Beyond the literary account, however, Brenner's catalogue of violence and tragedy, which Orozco later visualized, reads as caption text for the *Horrores* drawings themselves.

From Brenner's diary, we learn that the exchange between her and Orozco was more formal than ideas absorbed in friendly conversation. It seems that, in addition to conceiving the idea for the series, Brenner was instrumental in passing on themes for individual drawings. Seven months after she developed the initial idea for the commission, Brenner's diary entry indicates she was "visiting Orozco at the Prep . . . and gave him a note of ideas for 'horrores.'"[21] If the *Horrores* had been based on sketches made in the barricades, Brenner would not have needed to provide him with ideas for the series. Indeed, she had a fascination with songs such as "La Cucaracha," the "marching tune, the hymn even, of . . . the Constitutionalists," and it is the subject of three drawings by Orozco.[22] The Cucaracha drawings (for example, fig. 14), which depict soldiers dancing and cavorting orgiastically, represent Orozco's vision of the

Revolution as a farcical spectacle. The drawings begin with a background of revolution and string together images of a collective memory. This sort of cultural reconstruction and historical memory prepared Orozco for the task of creating the *Horrores,* and it was thus a series informed by others who had also witnessed the Revolution. When Orozco traveled to Orizaba for his mural commission at the Escuela Industrial in 1926, he returned to the place where he had experienced the war and seen many horrors. In a letter written in March of that year, Dr. Atl, with whom he had originally traveled to Orizaba, wrote to Orozco, "I would like for you to gather your impressions of Orizaba, so that you can write them down when you are here."[23] Brenner's and Dr. Atl's interventions in the series reflect its constructed rather than spontaneous nature and reveal it as part of a broader cultural practice of collective storytelling, historical memory, and lived experiences associated with a society in turmoil.

Seriality

In Orozco's drawings one can detect a discursive approach to history. The *Horrores* images display a historical consciousness not simply of specific events but also of the process of history itself. At times it even appears that their very subject is history itself rather than the Revolution. The serial nature of the drawings facilitates such a reading. Executed in spurts according to the demands of the original commission as well as shifting patrons and contexts, the drawings reflect serial narration, which is cumulative rather than linear. Though they constitute a series, no overarching story is told and there are no central protagonists. Despite the customary practice of reading the drawings as historical illustrations, a certain lack of clarity associated with their episodic nature frustrates any precise journalistic reading. Orozco disavows narrative minutiae in favor of a broader historical exegesis. Archetypal figures such as soldiers, peasants, and mothers predominate, yet there are no specifically individualized characters. In addition, his figures are not straightforwardly good or evil. Orozco does not seem to take the side of any particular group in the factional struggle—a practice that has its roots in his political cartoons for the Carrancista periodical *La vanguardia,* for which he produced anti-Carranza satires. Just as he transgressed political boundaries as a satirist, in the *Horrores* Orozco depicted the Revolution as a leaderless, disorganized, and destructive process. The drawings propose history itself as a cycle of revolutions, and neither the Zapatistas nor the Carrancistas are spared Orozco's wrath. For him, revolutions are "not necessarily pro anything; they are denials of what currently exists, of an unacceptable present."[24] A lack of specificity and resolve dooms the horrors and violence of the civil war to eternity.[25] The

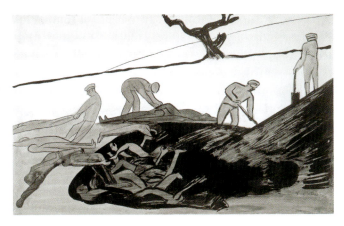

FIG. 15. Orozco, *Common Grave*, 1926–1928. Ink on paper. Museo de Arte Alvar y Carmen T. de Carrillo Gil, Mexico City. © Artists Rights Society (ARS), New York / SOMAAP, Mexico City. Photograph by Javier Hinojosa.

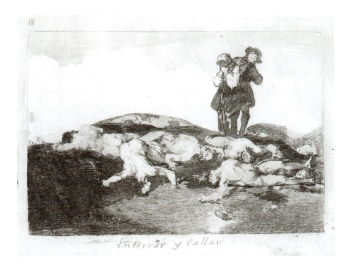

FIG. 16. Francisco de Goya y Lucientes, *Bury Them and Say Nothing* (plate 18 from *The Disasters of War*), c.1810–1812. Etching. British Museum, London. Photograph by British Museum / Art Resource, New York.

atemporality of the series, a by-product of the ENP murals, makes it a universal condemnation of war.

The *Horrores* drawings are associated with another famous war series known for its gloomy and cynical outlook: Goya's *Disasters of War* (printed in 1863). Brenner cultivated this association through the commission.[26] Like Goya, Orozco is concerned with the destruction and upheaval of war, and he visualizes a concept of history by which humanity is doomed to repeat its errors. The *Horrores*—with their images of executions and corpses piled high, their scenes of mobs and looting—propose that people change little over time; only the variables and circumstances around them are altered. A lack of belief in progress, in effect, disavows the possibility of transformation. The inevitability of death is the subject of both Goya's and Orozco's series, and both focus

on human devastation. Orozco's *Common Grave* (fig. 15) and Goya's etching *Enterrar y callar (Bury Them and Say Nothing)* (fig. 16) both depict mass killing, with bodies strewn across a barren landscape. The disintegration and brutality that Goya visualizes are more abstract in Orozco's drawing, where soldiers fill a black hole with barely delineated corpses. Orozco takes to the extreme the bodily abjection suggested by Goya and abstracts the corpses into flat outlines. Without bone to give them form, they seem mere geometric shapes, twisted and arranged at will. Though in all of Orozco's drawings the corpses remain faceless and anonymous, one barely distinguishable from another, the bodies heaped up in *Common Grave* have not even the markings of uniforms or any other distinguishing features. In the Goya etching, two figures bear witness and respond to the horrid scene, which seems to offer no hope of escape from the corpses covering the landscape. Orozco conveys the anonymity and certainty of death by focusing instead on the work of the soldiers as an ongoing process, one without beginning or end. *Common Grave,* like many drawings in the series, depicts masses of figures extending the scene beyond the boundaries of the picture plane and thereby suggesting a doomed eternity.

The structure of *Los horrores*—as an accumulation of vignettes—reveals an acute temporal consciousness. Narrative unfolds episodically; characters, gestures, and elements repeat yet continually change in some manner. The nature of the drawings as a series of memories reinforces this fragmented quality and the impression of chaos. The mythic status of the Revolution in the popular consciousness of the nation—a nation of storytellers—finds a visual equivalent in these serial drawings.

Visual *Testimonio*

The *Horrores* exist somewhere between historical document, reportage, and artistic fiction. Their raw power and energy derive from the violence and tragic pathos that unfold in stark black-and-white vignettes. The monochromatic palette enhances the journalistic mood. Yet many drawings in the series are highly abstracted, and others invent locales, figures, and situations. The nonspecificity of certain drawings, the desolate backgrounds, the anonymity of some figures, and the use of archetypes—the general, the soldier, the *soldadera* (one of the female soldiers who took up arms during the Mexican Revolution)—elevate the *Horrores* to the level of "art" and distance the series from mere illustration. Interpretations of the drawings invariably negotiate their status as historical document or art.

In *Idols behind Altars,* the *Horrores* appeared in a historical section describing the Revolution, not in the chapter devoted to Orozco. Mexican art historian Justino Fernández stated that the drawings "cannot be more authentic . . .

and today have become historical documents of great value."[27] Charlot argued, however, that Orozco's antirealism disengaged the series from a strict chronology: "This unphotographic strain made him paint delicate watercolors with women for a theme while before his eyes the revolution staged its bloodiest tableaux. In 1925 [sic], with peaceful reconstruction deemed just around the corner, while politicos exchanged pistol holsters for fountain pens and their horses for swivel chairs, Orozco's paradoxical retina chose to relive in brusk [sic] black and white the colorful episodes of an earlier decade."[28] By removing Orozco from the clutch of mere reportage, the correct dating enables the series to maintain its historical value without being tagged as mere illustration. In other words, the drawings are authentic and make claims to accurate depiction without necessarily becoming documents. Octavio Paz suggested this when he insisted the series mediated between document and testimony: "Almost entirely free of ideology, these works are genuine *testimony,* in a way that the photographs of the era are not. Yet another confirmation of the falseness of a modern idea: photos and reportage, save for exceptional instances, are documents but not testimony. Genuine testimony combines understanding with truthfulness, what is seen with what is lived and relived by the imagination of the artist."[29] By emphasizing testimony over document, Paz reclaims the subjectivity and artistic license of the series (and in the process eschews the discursive nature of documents and photographs). For him, the drawings are not transparent carriers of truth or untainted or unfiltered historical reconstructions but aesthetically constructed products of lived experience, memory, and imagination.

The artistic autonomy that Paz ascribes to the *Horrores* and the contention surrounding the drawings' status relate to several wider concerns: the role of witnessing and historical agency in broader narratives of the Revolution and in the very development of Mexican art; the ways in which images of the Revolution—specifically, photographic images—shaped Mexican modernity and reflected debates about artistic and national identities; and the "paradox of documentary," which, according to Jordana Mendelson, is "enlisted by institutions for the authentication of history and embraced by the avant-garde as a challenge to these same institutional claims."[30]

The *Horrores* drawings must be understood in relation to a larger context of witnessing and Revolutionary *testimonios*.[31] The stories told at Brenner's house, as well as her own reminiscences about the Revolution in her diaries and published writings, have parallels in other forms of cultural practices, especially literary production. *Los de abajo* (*The Under Dogs*), by Mariano Azuela, is considered the "most powerful story of the Revolution." Written as a description of combat based on the author's own experiences, the novel was

FIG. 17. Orozco, *The Hanged Man* (illustration for Mariano Azuela's *The Under Dogs*), 1929. Ink on paper. Robert L. and Sharon W. Lynch Collection © Artists Rights Society (ARS), New York / SOMAAP, Mexico City. Photograph by Douglas M. Parker Studio.

first published in serial form in 1915.[32] Azuela's novel represents a standard middle-class view of the Revolution shared by intellectuals such as Orozco—a mixture of disdainful despair at and morbid fascination with the sheer carnage of the civil war. Orozco's vision of the Revolution as an inevitable, natural upheaval dovetailed with the plot and characters of the novel. Demetrio Macias, one of Azuela's characters, asks, "What are we fighting for? That's what I'd like to know."[33] Orozco and Azuela shared the belief that the one certainty of the Revolution was death and that the specifics of the civil war—programs, leaders, factions—mattered little in the face of an oppressive, inescapable human catastrophe. It was not until 1924–1925, after the Revolution and during a controversy over the existence of either a modern novel tradition or a national literary tradition in Mexico, that Azuela became known as the "novelist of the Revolution."[34] The belated recognition and popularity of the novel indicate that Mexican intellectuals needed to codify their Revolutionary experiences in the postwar era. In 1929, the novel was published in English, with illustrations by Orozco based on the original *Horrores* (fig. 17). Azuela's novel and Orozco's drawings form part of the broader cultural practice consolidating the Revolution, institutionalizing cultural memory, and forging national art forms. The interpretation of Orozco's drawings as *testimonio* has its source, then, in larger cultural debates and practices.

FIG. 18. Hugo Brehme, "Emiliano Zapata, Caudillo of the South." Silver gelatin. Fototeca Nacional del INAH. © inventory number 656936. CND. SINAFO-Fototeca Nacional del INAH.

Iconography of the Revolution

From the beginning of the Revolution, photographers served as chroniclers of the civil war, and photography played a defining role in the struggle.[35] There was a popular need for documentation, and leaders quickly enlisted photographers to visually and symbolically codify the popular armed uprising. Francisco Madero, who led the initial revolt against Porfirio Díaz, first used photography to publicize his campaign by promoting a cult of personality. The rebel leaders—Zapata, Villa, Carranza, and Obregón—all followed suit. Photographic images of Villa and Zapata, perhaps the best known, have become icons of the Revolution. Hugo Brehme's celebrated photograph of Zapata holding a rifle and wearing a *charro* costume (fig. 18) is recalled frequently in the works of Mexican artists in the post-Revolutionary era. Rivera used the image as a basis for his veiled portrait of the Revolutionary in *Zapatista Landscape* (1915), a cubist still life/landscape painted in the safety of Paris after the artist read newspaper accounts of the civil war. Most famously, Pancho Villa manipulated public opinion and raised funds for weapons by selling his story to U.S. reporters and Hollywood filmmakers; the result was *The Life of General*

Villa (1914), supervised by D. W. Griffith. Apart from battle scenes and Villa's "repertory of spectacular forms of death," the photographs of him and Zapata are mostly commemorative images.[36] Their generally ragged appearance and the preponderance of cartridge belts and raised rifles notwithstanding, such portraits offered viewers iconic, formal, and decorous portraits of the leaders—images that were antithetical to Orozco's vision of the war yet were emblematic of the Revolution.

Other forms of imagery, however, which focused specifically on bloody battles and violence, surfaced after the outbreak of the war. U.S. photographers—including Walter Horne, Robert Dorman, Otis A. Aultman, Homer Scott, and William Heartfield—many on assignment for newspapers, recorded the uprisings and events of the Revolution, especially the border skirmishes, for U.S. audiences. From the vantage point of El Paso, photographers and spectators were able to observe battles across the border in the Ciudad Juárez area. Along the border and atop the highest building in El Paso, space was "made available for a fee to accommodate the ever larger groups of curiosity seekers" who gathered to witness the fighting. The Juárez-area skirmishes, as well as those in Tijuana in 1911, the U.S. invasion of Veracruz in 1914, and Pershing's punitive expedition of 1916, produced frenzied interest among the general public in the United States—and among soldiers stationed along the border. Images of fighting found their way into popular picture postcards representing apparently arbitrary violence in Mexico (figs. 19 and 20).[37] These blatantly propagandistic images, meant to justify the United States' increasingly militaristic stance toward Mexico, fueled nationalism north of the border and perpetuated the stereotype of Mexicans as violent bandits. The focus on the atrocities of war in these images served the U.S government's desire to sway public opinion. Although the majority of such imagery was produced by U.S. reporters and journalists for U.S. audiences, a few Mexican photographers also distributed such imagery.

In 1911, Agustín Victor Casasola, a former personal photographer to Porfirio Díaz, founded the Agencia Fotográfica Mexicana, the first Mexican photo news agency, primarily in reaction to the presence of the international press in Mexico. By purchasing photographs from Mexican photographers, longtime international residents, foreign photojournalists, and even amateurs, Casasola was able to build an archive of imagery that covered the spectrum of the Revolution—its leaders, battles, victories, losses, and victims. Casasola not only compiled images but also distributed them to the foreign press and displayed them in his shop window in Mexico City. He recuperated the photographic archive of the newspaper *El imparcial* when it went out of business in 1917 and published from it, along with the photographs he had

FIG. 19. "The Dead on Battlefield, Juarez, Mexico." Postcard of the Mexican Revolution. Collection of Leonard A. Lauder.

FIG. 20. "The Dead Laying [*sic*] as They Fell After First Battle at Agua Preita [*sic*], Mexico." Postcard of the Mexican Revolution. Collection of Leonard A. Lauder.

FIG. 21. Agustín Victor Casasola, "Tropas federales al mando de Carlos Rincón Gallardo" ("Federal Troops on March by Orders of Carlos Rincón Gallardo"), 1914. Fototeca Nacional del INAH. © inventory number 6345. CND. SINAFO-Fototeca Nacional del INAH.

gathered for his *Álbum histórico gráfico de la revolución* in 1921. While Casasola is associated with the formal portraits of the leaders of the Revolution (including the Brehme image of Zapata, which was once attributed to him), some of his most celebrated photographs depict the masses of anonymous followers of Madero, Zapata, and Villa readying themselves for battle, marching, or riding on horseback (fig. 21). The focus is on drama, action, and energy. Casasola's archive contains images of wounded soldiers and executions taken by a number of photographers (fig. 22), but as a whole it concentrates less on excessive violence than did the postcards marketed to U.S. audiences.

Through this photographic production, distribution, and consumption, Casasola and his agency were instrumental in developing a visual culture of the Revolution, one that is assumed to be a faithful journalistic and historical record. Rooted in a tradition of documentary photography, the images provided audiences in Mexico, especially in Mexico City, with supposedly objective transcriptions of the events of the civil war. Many of the images, however, were constructed—by both participants and spectators: bribes guaranteed front-row vantage points and ideal lighting conditions for executions, dispersed dead bodies would be rearranged for effect, and leaders would stop action and pose for the cameras. Despite the constructed nature of the pho-

FIG. 22. Agustín Victor Casasola, "Transportation of the Wounded," February 1913. Fototeca Nacional del INAH. © inventory number 687578. CND. SINAFO-Fototeca Nacional del INAH.

tographs, their social efficacy lay precisely in their ability to bear witness to events far away, to transmit knowledge, and to make political claims. Catering to many who witnessed history unfolding, the images were crucial in relaying a traumatic memory and forging a new sense of cultural identity. As visual representations of a collective memory and lived and imagined experiences, the photographs produced a national aesthetic and iconography. In doing so, they shaped political convictions and fashioned Mexican modernity as a heady mix of technology, violence, and modernization.

Whatever their claims to the truth, all photographs are constructed, and all modern conflicts are wars of images and propaganda. As many scholars have elaborated, the photographic documentation of the U.S. Civil War, the Paris Commune, World War I, and the Spanish Civil War offers vivid pictures of the horrors of battle—as is true of all war photography. The Mexican Revolution differed from those conflicts in its lack of a specific political program or organizing principle. The vast archive of photographic imagery related to the Mexican Revolution offered an opportunity to make sense of a complex social conflict but at times reinforced the impression of chaos and the nature of the Revolution as a contradictory and incomprehensible succession of isolated movements.

At the conclusion of the armed struggle and the inception of national reconstruction, in 1921, Casasola's *Álbum histórico gráfico* appeared in print but did not prove successful, and only the first of six projected volumes was published. The events depicted were no longer newsworthy, and Mexico was "sick of civil war and revolutions. People wanted to forget the 'lost' decade, the deaths, and the violence."[38] In reference to the representation of violence as aesthetic spectacle, Carlos Monsiváis and Susan Sontag have written that although witnessing violence incites fear, the proliferation of images of suffering can desensitize or anesthetize viewers.[39] Another element, though, was the construction of Revolutionary imagery in Mexico. In the immediate post-Revolutionary era, with the creation of a new national government, there was an urgent need to reject violence and focus on the achievements and triumphs of the war. Instead of producing direct representations of the armed uprising, artists struggled in the early postwar years to develop a visual language based on the "disciplinary" principles of Minister of Public Education José Vasconcelos, who initiated the mural program.[40] The memory of the violent episodes Casasola documented did not appear in these public murals but resurfaced in a private commission—Orozco's *Horrores* series. Octavio Paz sought to distinguish Orozco's drawings from the journalistic photos of the Revolution, concerned that their aesthetics would be undervalued. Yet the role of documentary in Orozco's drawings is better addressed not by distinguishing between them and the photographs of the Revolution but by offering a comparative reading between the drawings, Orozco's mural cycle at the ENP, and the broader artistic practices of the mid-1920s.

Through their focus on corporeal violence, the *Horrores*—unlike the murals—posed several challenges to post-Revolutionary society. Although the *Horrores* relate to the third-floor ENP murals (and to *The Trinity* and *The Trench,* both on the first floor), they propose a very different view of the Revolution.[41] To begin with, there is some confusion as to what, precisely, the third-floor murals represent; their temporal location, and whether they depict images from before or after the Revolution, is unclear. Some have suggested that the panels represent post-Revolution scenes because of their apparent emphasis on rebuilding, the empty farm fields, and the tired gravedigger, all of which suggest the need to "deal with the effects of the Revolution in the country at that time."[42] Others see the panels as depicting primarily scenes that occur *before* the Revolution—leave-taking and preparations for battle.[43] Most agree, however, that the panels collapse the present with the past and suggest a simultaneity of events. Painted during the post-Revolutionary era of consolidation, the ENP murals are scenes *of* the Revolution, yet they evoke a temporally abstract notion of the civil war. The Revolution is evoked by the

FIG. 23. Orozco, *Revolutionaries*, 1926. Fresco. Escuela Nacional Preparatoria (Colegio de San Ildefonso), Mexico City. © Artists Rights Society (ARS), New York / SOMAAP, Mexico City. Photograph by Schalkwijk / Art Resource, New York.

characters depicted and the general mood, but the narratives remain ambiguous. Are the soldiers returning from or preparing for battle (fig. 23)? Are the women mourning dead family members or empty fields (fig. 24)? Are the peasants and workers saying good-bye or returning home (fig. 25)? *The Trench, The Trinity,* and *Revolutionaries* are the only scenes in the ENP panels where armed struggle is even suggested, and then it is simply by the inclusion of weapons. Just one of these panels, *Revolutionaries* (fig. 23), is part of the cohesive third floor; *The Trench* and *The Trinity,* on the first floor, anchor the entire mural program with their formal composition and Revolution-themed subject matter, yet they are often treated separately because of their distinct location. They also are the most frequently reproduced panels. The rest of the six panels on the third floor suggest the Revolution through more oblique means: the implicit sacrifices of war, the separation of families, and the impact on the land. As Leonard Folgarait has commented, armed struggle, indeed struggle

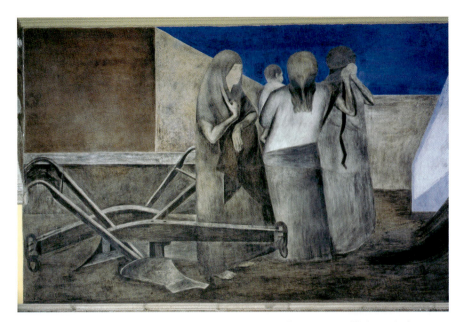

FIG. 24. Orozco, *Women,* 1926. Fresco. Escuela Nacional Preparatoria (Colegio de San Ildefonso), Mexico City. © Artists Rights Society (ARS), New York / SOMAAP, Mexico City. Photograph by Schalkwijk / Art Resource, New York.

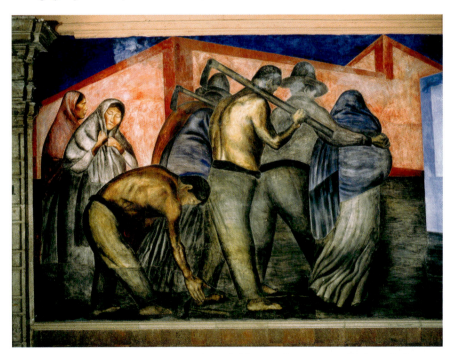

FIG. 25. Orozco, *Workers,* 1926. Fresco. Escuela Nacional Preparatoria (Colegio de San Ildefonso), Mexico City. © Artists Rights Society (ARS), New York / SOMAAP, Mexico City. Photograph by Schalkwijk / Art Resource, New York.

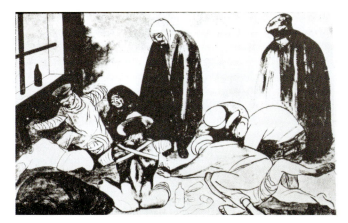

FIG. 26. Orozco, *Mutilated*, 1926. Ink on paper. Location unknown. © Artists Rights Society (ARS), New York / SOMAAP, Mexico City.

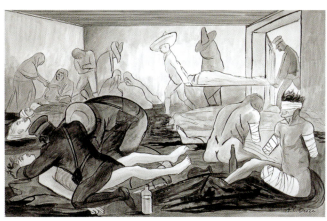

FIG. 27. Orozco, *Wounded*, 1928. Ink on paper. Museo de Arte Alvar y Carmen T. de Carrillo Gil, Mexico City. © Artists Rights Society (ARS), New York / SOMAAP, Mexico City. Photograph by Javier Hinojosa.

in any sense of the word, is not depicted.[44] Orozco's unified statement about the civil war exhibits "less dynamism and direct action"; a "sober strength and restrained emotional appeal are present; muted drama, accent on rebuilding and not on revolt, on pity and not on anger . . . the sense of subdued emotion, the rigidly controlled structure and balance of the compositions, the three dimensional clarity of the individual forms, and the serene strength of the blue background and the gray figures before it are a summing up of Orozco's classical phase."[45] This representation could not be further from the realities of the *Horrores* images.

While the Revolution scenes at the ENP manifest an understated sense of drama, controlled emotion, and also a static quality, the *Horrores* drawings represent sheer brutality; they are tragic, expressive, aggressive, abject. They present "a world dominated by executioners and their victims" and graphically depict blood, body parts, intense drama, emotional *and* physical suffering, and overt action.[46] The carnage of the Revolution is enacted on the human body; the body is depicted as vulnerable, fragmented, dislocated.

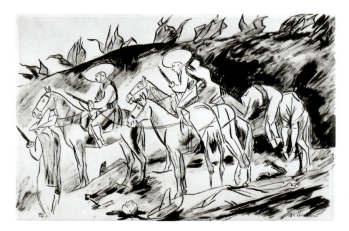

FIG. 28. Orozco, *Dead Comrade*, 1926–1928. Ink on paper. Museo de Arte Alvar y Carmen T. de Carrillo Gil, Mexico City. © Artists Rights Society (ARS), New York / SOMAAP, Mexico City. Photograph by Javier Hinojosa.

Among the drawings that display corporeal devastation most explicitly are *Mutilated* (fig. 26) and *The Wounded* (fig. 27), with their images of temporary field hospitals filled with soldiers who have been disfigured or lost limbs. Hovering above the injured in *Mutilated* are two standing figures, their dark cloaks evocative of the Grim Reaper. An endless cycle of violence is implied by the latest body being carried through a door in *The Wounded*. Vestiges of human bodies, men with triple and quadruple amputations, are juxtaposed with figures crying out in agony, their ravaged state seemingly immutable.

The articulated forms of *Dead Comrade* (fig. 28), with spiky agave plants marking the upper hill, echo the jagged overall pattern of the drawing. Out of the mass of lines that delineate the hill, we see pieces of a body at the feet of horses. A hand, a leg, and a head are strewn about to the left of a sombrero, while what seems to be the rest of the body is slumped to the lower right. Above it, other dead Zapatistas are draped over a horse.

Heaps of dead bodies abound in the drawings. *Battlefield No. 1* (fig. 29) shows bodies at the bottom of a hill crowned by the image of a torn maguey plant. The bodies are so flat they seem to lack any bones; they become mere amorphous masses of flesh around the hill. The drawing includes a Zapatista sombrero that sits in volumetric repose before the formless bodies. A similar composition, *Under the Maguey* (fig. 30), contains two figures beneath the spiny plant. A sharp knife held in the stiff hands of the central corpse, the focus for the image, mimics the sharp, tactile sharp leaves of the maguey above it. The dead body to the right in *The Destroyed House* (fig. 31) has been stabbed in the back with a knife, and the scene of violation to the left almost mirrors the one depicted in *The Rape* with its conglomeration of fragmented body parts. Other drawings strewn with corpses are *War* and the related *Casa Quemada,* while *El fusilado* shows a body being carried away on a stretcher.

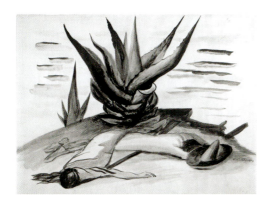

FIG. 29. Orozco, *Battlefield No. 1*, 1926–1928. Ink on paper. Museo de Arte Alvar y Carmen T. de Carrillo Gil, Mexico City. © Artists Rights Society (ARS), New York / SOMAAP, Mexico City. Photograph by Javier Hinojosa.

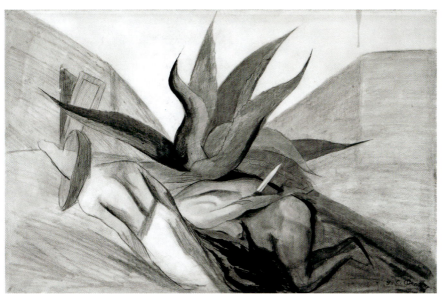

FIG. 30. Orozco, *Under the Maguey,* 1926–1928. Ink on paper. Museo de Arte Alvar y Carmen T. de Carrillo Gil, Mexico City. © Artists Rights Society (ARS), New York / SOMAAP, Mexico City. Photograph by Javier Hinojosa.

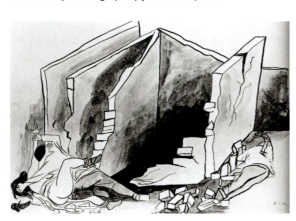

FIG. 31. Orozco, *The Destroyed House,* 1926–1928. Ink on paper. Location unknown. © Artists Rights Society (ARS), New York / SOMAAP, Mexico City.

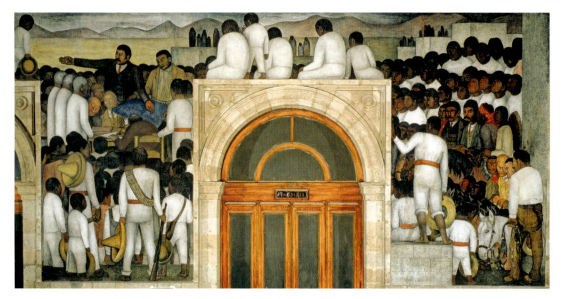

FIG. 32. Rivera, *Distribution of the Land*, 1923–1924. Fresco. Secretaría de Educación Pública, Mexico City, Mexico. © 2008 Banco de México Diego Rivera & Frida Kahlo Museums Trust, Av. Cinco de Mayo no. 2, Col. Centro, Del. Cuauhtémoc 06059, México, D.F. Photograph by Schalkwijk / Art Resource, New York.

The events that Orozco depicts in this series, or in his easel paintings of the Revolution for that matter, are not the traditional images of Revolutionary activities imagined in the works of Rivera. Land is not being distributed (fig. 32), educational reform is not being implemented, and industrial workers are not cooperating with peasants, all of which are depicted in images Rivera produced in 1923 for the Secretaría de Educación Pública, the heart of Vasconcelos's administration in Mexico City. The early murals in Mexico eschewed direct representation of armed struggle or warfare, and some artists, Rivera for instance, concentrated on promoting cultural nationalism based on the reappraisal of native populations and traditions.[47] Yet even Orozco and Siqueiros, who did not espouse Rivera's *indigenismo* or folkloricism, chose not to represent Revolutionary activity in their public murals. The circumstances of the mural commissions prohibited such imagery, which would have given the impression of an ongoing conflict fraught with internecine ideological battles. In the wake of state-sponsored cultural renovation, the Revolution had to appear as though it had reached a successful conclusion. Accordingly, the ENP murals do not rely "on explicit historical representation [or] on the presentation of past documents or pronouncements, but . . . concentrate on the body as a potent, manipulable, and ritual prone vehicle." The absence of pain and wounds in Orozco's depictions of the Revolution, or even the emphasis on

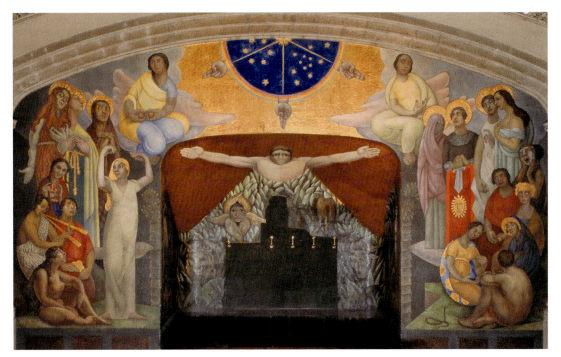

FIG. 33. Rivera, *Creation*, 1922–1923. Encaustic and gold leaf. Anfiteatro Bolívar, Escuela Nacional Preparatoria (Colegio de San Ildefonso), Mexico City. © 2008 Banco de México Diego Rivera & Frida Kahlo Museums Trust, Av. Cinco de Mayo no. 2, Col. Centro, Del. Cuauhtémoc 06059, México, D.F. Photograph by Schalkwijk / Art Resource, New York.

integral bodies in Rivera's *Creation* (1922; fig. 33), also at the ENP, reflects the "need to deny the civil war its own terms." The real horrors of the Revolution, "if brought back with graphic certainty[,] would be a perhaps too powerful deterrent to the myth of the peaceful post-Revolution."[48] The savagery of the Revolution was ultimately rewritten as a story of national redemption.

In contrast to the type of civil war imagery emblazoned on Mexican walls in the early 1920s, the sheer brute force and violence of the Revolution was what Orozco visualized. At face value, both the ENP murals and the *Horrores* drawings are scenes of the Revolution, yet they offer diametrically opposed visualizations of the war. In the *Horrores,* as a series, the Revolution is bloody and violent. Physical carnage and pain, effaced in the ENP murals, are visually compelling in the drawings. Weapons, wounds, bodily suffering, less emphasized in the murals, are indeed "brought back with graphic certainty" in the drawings. Workers are whipped by a majordomo, passengers on a train are held up at knifepoint, houses and churches are looted, victims kneel before a firing squad, and armed forces clash head-on in a battle that will have no victor. The drawings are explicit, both descriptively and in terms of histori-

cal representation, in a way the murals are not. The writer José Juan Tablada vividly suggested that blood continued to flow from the drawings, smoke from the fires was immobilized in them, and the acrid odors of the battle endured.[49] Their graphic potency made viewers relive the Revolution, whereas the ENP murals had a temporal ambiguity; the scenes depicted in the drawings are clearly of the Revolution, not before or after. It is thus not surprising that they were mistaken for sketches made in the field. They elicit visceral reactions; Anita Brenner admitted that the "marvellous ink and wash drawings—revolution stuff. I've never seen anything like it—*Twisted me inside out.*"[50] War, in all its guises, is portrayed brutally in these drawings. The *Horrores* reveal the Revolution's darker side; moreover, they contradict the ENP murals, which summon ambiguous images of the Revolution.[51]

Made for Export

In an era when the Revolution needed to be legitimized, then, Orozco's critique could be developed only in small-scale drawings meant for export, not in large murals for the residents of Mexico City. Octavio Paz has described, in reference to the *Horrores,* how Orozco "made mock of the Revolution as an idea and found it repellent as a system and horrifying as a power."[52] The critical capacity of the drawings and their historical and political claims were possible solely within the context of private patronage. Unlike the public murals, the *Horrores* drawings constitute a dissidence and transgression that could be elaborated only for the new intended audience. The drawings "could be shown only in New York City, far away from the Plutarco Elías Calles regime. They represent a reminder of the immediate past, of the sacrifices that had been made for the Revolution and the shift during the new generation, when Revolutionaries became politicians."[53] The institutionalization of the Revolution precluded any public presentation of the drawings in Mexico and made them subversive. It was the shift to a new audience that made the development of the series possible.

Brenner and Orozco, aware of the implications of such anti-Revolutionary material, realized the dangers involved in producing the *Horrores.*[54] The artist had Brenner take the drawings across the border, and Charlot smuggled the rest of them into the United States along with Orozco's "milder brand of art," not because he was afraid they would be destroyed for their "immorality" by customs agents, as his *House of Tears* drawings were in 1917, but because their violent imagery was too palpable. Moreover, he had to move them out of Mexico, where it was too dangerous for them to be in his possession. In August 1927, days before her departure for New York, Brenner wrote,

Orozco told me that Atl went to see him and said that he just *had* to see those drawings everybody was talking about, and O[rozco] told him that he would ask me, but that he understood that all was not well between us—Atl et moi. Atl said that not at all, he had always admired me, etc. and wanted to know me better, and that he thought probably [artist] Nahuí [Olín] was to blame for the erroneous impression. So O[rozco] reminded him that he had written a lot of Anti-Semitic stuff, and Atl said that that had nothing to do with it. So Orozco laughed, and asked me what about it, and if it weren't that Atl is such an hablador [bigmouth] and so little to be trusted it would be all right but until I get those things safely over the border I shan't rest easy.[55]

It is evident from Brenner's diary entry that the drawings had gained a certain notoriety in Mexico City's artistic circles and that Brenner carefully controlled who saw them. Orozco's former mentor, Dr. Atl, one of the people who may have stimulated the idea for the series and who was responsible for Orozco witnessing the Revolution, was denied access to the drawings for fear he might talk about them too readily.[56]

The power of the drawings to effect intense emotive responses—their capacity to make viewers experience the Revolution viscerally—has led to speculation about their social function. In the United States the *Horrores* are seen as a force for political change. Calling them "little 'painted bibles,'" Alma Reed interpreted them as moralistic tales, "perfectly sure of themselves, unshaken in their demand that we abandon the ways of the jungle—now!"[57] Many critics linked the great emotion and compassion Orozco elicited in these drawings to a higher moral concern.[58] For others, the drawings were an effective way to reach the masses, for they were based on a tradition already established by José Guadalupe Posada. Bernard Myers writes that "Orozco had a definite utilitarian purpose in mind whereas Goya's *Horrors of War* [*Disasters of War*], though executed during the time of the Napoleonic wars in Spain, were really done for a private purpose, to express his own personal reactions to war. . . . Orozco's work on the other hand was done for immediate and practical use."[59] The drawings, however, were never meant for a Mexican audience—they could be presented to viewers only in the United States. Because of the political implications of the drawings, Brenner, aware of the complex political situation in Mexico and as a firsthand observer of the development of the series, proposed another reading: "One might also conclude from his Revolution sketches that all Mexico buried its guns because of Orozco. But if a truthful picture could annihilate this might have been his suicide long since. The fact is that by means of pictures he purposes to remove nothing except the pressure on his nerves."[60] While Reed and other U.S. promoters interpreted the drawings as manifestos, Brenner suggested they served a more personal, ca-

thartic function for the artist. As the drawings were made, Orozco delivered them to Brenner, who held on to them until they were brought to the United States. Unlike Orozco's caricatures for the newspapers, these images were not intended, as some have indicated, for immediate public consumption. They were destined, from their inception, for an audience north of the border, far removed from post-Revolutionary political realities. That the intended audience for the series was a U.S. one suggests that social change was not the point. Perhaps filling a void left by his ENP murals, Orozco's drawings unleashed a storehouse full of emotion and provocation that had been repressed in the murals. Their distant destination allowed for the expression of emotion yet limited their ability to bring about social change. Moreover, the drawings' middle-class attitude toward the Revolution precludes the idea that Orozco desired to effect any particular change with his series. Though these images demonstrate a compassion for the oppressed and are an invective against social injustice, Orozco did not aim to direct behavior because he did not think such a thing was possible. The point of the series, in fact, is that we are condemned to be subject to a power beyond our control.[61]

Knowing that Orozco's drawings could not fulfill a politically redemptive function, Brenner nonetheless sought to make them socially and politically useful.[62] Because of their transgressive nature in Mexico and the destabilization of their political context upon exportation to the United States, she understood that they would not result in direct political change once exhibited or distributed. For her, they served a more mythical, universal, and humanistic transformative function. Other commentators interpreted Orozco's view of history as pessimistic, but Brenner insisted on the drawings' ability to make one believe in redemption.[63] In reference to *Los de abajo,* she also demanded a more positive reading. "Too rapid a foreign reader," she stated, "will mistake fatigue for futility, and his shocked nerves may not permit him to sense below the carnage an inarticulate text that these men who were killed to no immediate practical purpose and who died in charred crops without realizing that they were part of a great spiritual change were not less heroic because they were not underwritten with idealistic post-revolutionary social dogma."[64] Brenner asserts that in the subtext of Azuela's "fatalistic prose" the characters are indeed heroic, despite their damning vision. From her linking of Orozco to Azuela, we can infer that Brenner believed that Orozco's message was redemptive as well. Although neither author nor artist produced a positive view of the Revolution (in the manner of Rivera), she contends, it does not necessarily follow that their vision rendered the struggle hopeless. Brenner's interpretation of the series, and of the entire conflict, was, then, at odds with Orozco's own defeatist vision.

Anita Brenner's Cultural Strategies and Responses
North of the Border

Although the *Horrores* images engage universal ideas of history, time, war, and human suffering, the Mexican Revolution remained the pretext of the commission as well as the basis of Brenner's analysis of Orozco's work. Her essay published in *The Arts* in 1927 introduces Orozco as a "rebel" within the context of the destruction brought by the Revolution.[65] For Brenner, that watershed event "did not change the material life of Mexicans but . . . made possible a liberated narrative; it . . . changed their 'ideology.'"[66] As Mexico was constructing a national mythology in the wake of the Revolution, Brenner identified with that process and took an active part in the history-making, focusing on *indigenismo,* cultural nationalism, and *mestizaje.* As a girl during the Revolution, she had fled to Texas with her family; there they received reports of the civil war. Her return to Mexico in 1923, at age eighteen, coincided with the golden age of Mexican muralism and the peak of Jewish migration to the country. During this exciting and turbulent era, Brenner felt that "the world was beginning" and that she herself was embarking on her own personal journey, attempting to reconcile Jewish and Mexican life. The Revolution and its attendant cultural nationalism wiped away old notions of national identity and allowed her to negotiate her transnational identity and promote the socially engaged art with which she sympathized.

Brenner's interest in the Revolution and in socially engaged art led her to develop a close relationship with the painter Francisco Goitia at the same time she was promoting the work of Orozco. Goitia, who had witnessed the Revolution while serving as a staff artist for General Felipe Ángeles, is thought to have been one of the first Mexican artists to depict events of the Revolution.[67] Goitia's works, such as *Baile revolucionario,* are in many respects precedents for the *Horrores.* Scholars have noted the similarities between Goitia's easel pictures and Orozco's work, specifically the ENP panels, but the correspondences between the two artists are better understood by considering Brenner's patronage, the broader context of witnessing, and the formation of a visual iconography of the Revolution.[68]

In 1912, Goitia returned to Mexico after eight years in Europe, where he had studied such painters as Goya. The *Disasters of War,* in particular, had a strong influence on him. Soon after returning to Mexico, Goitia joined Pancho Villa's army. In 1915, after Álvaro Obregón defeated Villa's forces, Villa's General Ángeles advised the artist to go to Mexico City. He went home instead, to Zacatecas, but in 1918, he ventured to the capital, where he was introduced to Manuel Gamio, head of the Mexican Department of Anthropology. Gamio hired Goitia to make sketches of Indians from various regions of Mexico, as

FIG. 34. Francisco Goitia, *Landscape of Zacatecas*, c. 1920s. Oil on canvas. Museo Nacional de Arte, Mexico City.

part of his ethnographic and archaeological research project, which centered on his study of San Juan Teotihuacán.

 After doing sketches in Teotihuacán around 1925, Goitia followed Gamio's instructions to prepare drawings of Zapotec Indians in Oaxaca. By the mid-1920s, he had settled in Xochimilco, south of Mexico City, where he lived on a small pension from the Secretaría de Educación Pública. An eccentric and solitary character, he lived in a small hut. Goitia was not a prolific artist, and what little work he did produce often took many years to finish.[69] Many of his paintings were made from direct observation—of models and staged scenes—and reflect the deep suffering and pain of the Mexican people.

 Goitia's gruesome depictions of hanged cadavers in works such as *Landscape of Zacatecas I* (fig. 34) and *Landscape of Zacatecas II*, both circa 1920s, call to mind Orozco's *El ahorcado (The Hanged Man)* (fig. 7). The simplified forms of soldiers and *soldaderas* dancing in Goitia's *Baile revolucionario* relate to two *Horrores* drawings (*Cucaracha No. 3* and *Battle*) and to the repetition of such figures throughout Orozco's Revolutionary material. The theme of a wake, treated by Orozco numerous times, is the subject of one of Goitia's

FIG. 35. Francisco Goitia, *Tata Jesucristo*, 1926–1927. Oil on canvas. Museo Nacional de Arte, Mexico City.

best-known paintings, *Tata Jesucristo* (1926–1927; fig. 35).[70] Contemporaneous with the ENP murals, this painting by Goitia depicts two female mourners. Their simple, monumental forms fill the entire canvas and must have inspired similar scenes in Orozco's third-floor ENP panels. Goitia's gloomy outlook has been likened to Orozco's pessimistic view of history.

Several of Goitia's canvases with themes of the Revolution, like the two *Landscape at Zacatecas* works, have traditionally been dated to the period of the civil war. Though the artist witnessed numerous scenes that are reflected in his paintings, it may be that most of the Revolutionary works were executed much later. As with Orozco's *Horrores,* Goitia scholars desire to impute documentary status to his works, yet we know that Goitia relied on models and often staged scenes for his paintings. While he may have begun paintings during the war—only to finish them years later—it seems unlikely that he completed any large canvases in the midst of the war.[71]

In the mid- to late 1920s, Brenner developed close relationships with both Orozco and Goitia. She supported their work and provided monetary assistance when possible.[72] As Susannah Glusker has noted, they are two of the four artists most mentioned in Brenner's diaries, and Brenner devotes a con-

siderable amount of attention to both in *Idols behind Altars*.[73] She first mentions Goitia in her diaries in November 1925, perhaps soon after the two initially met, and he remains a haunting presence throughout.[74] She writes, "Goitia still in my consciousness—Haunts me like the idea of Saint Francis, whom I think he resembles. That joyousness and gentleness and irrationality. I would like to be permitted to keep him, but such service as I could render would hinder him. Of what importance publicity or a sold something when he is beyond all that? To help him is to presume—I should like to be helped by him. I know too much and have not learned enough, and also I am too reasonable for now."[75]

Brenner noted that Goitia "speaks of the revolution which interests him as a subject more than any other, and whose spirit is his constant theme." That spirit is what attracted her to his work, and it is one she developed in her own writings. A young witness to the Revolution, she became one of its many chroniclers. Most of her writing about post-Revolutionary Mexican art is informed by the struggles of the Revolution.[76] The similarities between Goitia and Orozco can be explained by the filter of Brenner, who had an intense relationship with each; her relationship with Goitia may have directly affected Orozco's output. As each artist shared ideas with her, consulted her on future plans, and swapped war stories, he gave the Revolution visual form. Brenner fulfilled various roles in her association with each artist—conduit of ideas, producer of meaning, and publicity manager. Though it remains unclear whether Goitia and Orozco knew each other well, they certainly knew about each other through Brenner. They did meet at least once, at Brenner's house. She noted that they were both there to consult with her, and she recorded the chance meeting exuberantly as "What a moment!"[77]

When Goitia gave Brenner a copy of *Baile revolucionario,* she immediately placed it beside a Revolutionary-themed painting that Orozco had made for *Idols behind Altars*.[78] "They hold up very well," she commented. "Orozco sustains itself. After all, a good painting is like a chemical—it does not destroy another good one, even though the other be smaller." Though the comparison is intuitive, it is one that Brenner had been cultivating; Goitia would be the standard by which Orozco would be compared. Brenner added, "As near Goitia as Orozco could be imagined. I mean as near the all-inclusiveness of Goitia—though heaven deliver me from wanting Orozco to be other than he is."[79]

By 1928, when Brenner's relations with Orozco had become severely strained, she wrote that "revolution in its *fullest* sense was incarnate" in Goitia's work, while Orozco "expresses the bleeding aspect of the Revolution." Reflecting about this breakdown in the artist-patron relationship years later,

Alma Reed described Orozco's anger with Brenner and her writing on the so-called "Mexican Renaissance"; the artist believed that Brenner had emphasized his political caricatures at the expense of the great ENP murals.[80] Though Brenner may have intentionally snubbed Orozco, her diaries reveal that her remarks did not signal a change in her assessment. As noted above, Brenner considered Goitia an all-inclusive artist, capable of displaying a full range of emotions in his work. In the end, Orozco's vision of the upheaval remained bloody, an estimation to which the *Horrores* testify.

The *Horrores* commission and Brenner's support of Orozco and Goitia fell within her larger aim to instill an awareness of Mexican art north of the border. She had been planning the manuscript that would become *Idols behind Altars* since 1925 and always spoke of the exhibition of Mexican art she would bring to New York. She calculated every move, shielding artists from the grasping of critics and promoters, and she protected her vision from the onslaught of other interested parties. Describing the visit of the writer Ernestine Evans, Brenner stated, "It is getting to be a repetition and a vulgarization, this Mexico business. I shall get my stuff off my chest and go elsewhere, I think—too much noise of too many discoverers will be *aturdiendonos* [confusing us] here shortly."[81] She tried desperately to prevent others from seeing the photographic documentation of artworks she had gathered with the help of Edward Weston and Tina Modotti, in hopes of preventing the release of the photographs until the book was published. She complained when Modotti showed Evans some of the pictures and sought legal advice when Modotti eventually gave them to Evans.[82] Brenner wanted to be the one to introduce these artists to the public in the United States, and she had carefully cultivated relationships in order to effect their "virgin debut." Thus, when she worried about showing Dr. Atl the *Horrores* drawings, perhaps, in addition to shielding the political radicality of the drawings, she was protecting the material from premature release that might affect her position as the intermediary.

Before leaving for New York accompanied by crates filled with Mexican art and crafts, Brenner made sure she signed letters of agreement with both Orozco and Charlot, making her their exclusive representative.[83] Once she arrived, she showed the *Horrores* to numerous gallerists, dealers, and critics with the hope of securing an exhibition for the series. The drawings were not well received. Later she recalled, "At that time, the Mexican painters were so little known that I got a rather odd reception, and it was pointed out to me that these things weren't really art, they were drawings and cartoons suitable for the *New Masses,* and I was seriously advised by an art dealer who is now one of the Orozco 'discoverers' to take them to that magazine."[84] Orozco may not have been well known, but Brenner's arrival in the United States with his

drawings came after her October 1927 feature article on his work in *The Arts*. Furthermore, José Juan Tablada had been actively promoting Orozco's work since 1924, with the "Mexican Goya" article in *International Studio* (March 1924), an exhibition (with caricatures by Miguel Covarrubias and wax sculptures by Luis Hidalgo) at the Whitney Studio Club that same month, and an exhibition of his *House of Tears* watercolors in March 1926. Tablada had also been showing Orozco's work to collectors and was planning an exhibition of Mexican art at the Brooklyn Museum in which the artist would attain "the place he deserved." According to Tablada, Orozco had a great number of admirers in New York, and he encouraged Orozco to come to the city.[85]

As Brenner relates, the New York art community considered the *Horrores* drawings to be merely political caricatures, not fine art. J. B. Neumann of the New Art Circle questioned their aesthetic status and told Brenner that they were "insulting to lovers of pure art." Frank Crowninshield told her that they "of course [are] not *Vanity Fair* stuff."[86] Even though Pierre Matisse liked some of the work Brenner showed him, according to her, he disparaged the drawings—and all Mexican art—as documentary. The gallerist Charles Kraushaar was not interested in the drawings and asked Orozco for related paintings instead. Appalled by their subjects, Kraushaar suggested that the canvases were not suitable for the U.S. public and that Orozco should paint something else.[87] Orozco would later heed his advice and adapt his work to the new milieu by painting more lighthearted themes.[88] Even Walter Pach, who had met Orozco in Mexico in 1922 while lecturing on modern art at the Universidad Nacional Autónoma de México (UNAM) and had included his watercolors of prostitutes in the 1923 annual exhibition of the Society of Independent Artists in New York, found the drawings unappealing. Pach, one of the first U.S. critics to write about contemporary Mexican art, had praised its nationalist aesthetic.[89] Though he later paid tribute to Orozco's art and proclaimed that "we shall add his name to the roll of the great men of our time," Pach found Orozco's drawings of the Revolution "heretical" and "not pure art, but illustrative."[90] Attuned to the style and subject matter of cubism and European modernism, New York gallerists must have considered Orozco's macabre subjects and expressive style contrary to the aesthetic tastes that were in vogue. The dominance of abstract styles at the time was one of many factors that played into the skewed reception of his drawings.[91] While the easel paintings that Orozco produced in the United States—with their street scenes, vaudeville imagery, and skyscrapers—had parallels with works in the precisionist, regionalist, and urban scene styles characterized by images of modern city life, leisure activity, and industry, Orozco's gruesome *Horrores* made even Reginald Marsh's depictions of lower-class life in New York (fig. 36) seem picturesque by com-

FIG. 36. Reginald Marsh, *Death Avenue*, 1927. Oil on canvas. Whitney Museum of American Art. Felicia Meyer Marsh Bequest. © 2008 Estate of Reginald Marsh/Art Students League, New York/Artists Rights Society (ARS), New York. Photograph © 2001 Whitney Museum of American Art.

parison. There were few U.S. precedents for such intensely violent imagery as that of Orozco, who admitted to Carl Zigrosser of the Weyhe Gallery that "his pictures depicting dead bodies looked different to him when he saw them in New York from when he had painted them in Mexico."[92]

Even for those members of the art community who were already interested in Mexican art and promoting it—Walter Pach, for one—Orozco's brutal scenes of war ran counter to the expectations for art produced in Mexico—expectations based on the prominence in the United States of paintings by Rivera, such as *Flower Day* (1925; fig. 37), which promoted an idealized *indigenista* vision and won a prize in Los Angeles. In comparison with Rivera's contrived utopian scenes, Orozco's drawings must have seemed too firmly rooted in reality to the New York art establishment.

The *Horrores* drawings received a positive response from the Anderson Galleries, and Brenner deposited a few of them at the Weyhe Gallery on consignment, but no exhibition organized by her ever materialized.[93] To mainstream New York art galleries, the subject matter of the drawings was suitable for the radical magazine *New Masses*, which editorially espoused socialist ide-

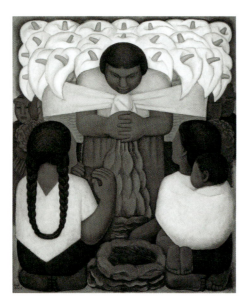

ology, not for the gallery or collector's wall. Indeed, Orozco's drawings looked very similar to a political caricature that U.S. artist Stuart Davis had submitted to *The Masses,* forerunner of *New Masses,* in 1914 (fig. 38). While it disturbed Brenner that New York dealers questioned the status of Orozco's drawings as art and that they would be relegated to the pages of a radical magazine as illustrations, *New Masses* was the first venue to which she appealed to feature the series. She withheld reproducing them in the *Arts* article of October 1927, which focused on the ENP panels, yet she seems to have heeded the dismissive advice of dealers by writing about Orozco in the January–February 1928 issue of *New Masses.* When J. B. Neumann told her the drawings were not pure art, Brenner replied that she "had no doubt about what they were." She knew, in other words, that they *were* art—art of the type she was actively promoting: narrative with a social function. For Brenner, *New Masses* was not a debasement but a logical venue for Orozco's oeuvre.[94]

Founded in 1926 by writers and intellectuals interested in both an artistic and a literary renaissance in the United States, *New Masses* expressed a radical political agenda tied to labor. The revolutionary art supported by the magazine included works of social criticism as well as formally innovative abstraction. From the outset, though, most of the artwork published in it concerned the lives and struggles of workers (fig. 39).[95] The evolution of the magazine's aesthetic policies epitomized the leftist debates of the 1930s that pitted abstract art against social realism. Given Brenner's own literary aspirations, bound to her progressive politics and her desire to promote a certain type of Mexican

FIG. 38. *(left)* Stuart Davis, "Restoring the Peon to the Land," political caricature from *The Masses*, April 1914.

FIG. 39. *(right)* Jan Matulka, "I see where Babe Ruth draws down seventy thousand a year. . . . " From *New Masses*, April 1927. Courtesy of the Tamiment Library and Robert F. Wagner Labor Archives, New York University.

art—heroic, narrative, social realist—*New Masses* suited her interests more than Orozco's. The artist, who throughout his life fought against any kind of political affiliation, believed that the *New Masses* article portrayed him as a communist. He was also concerned that his inclusion in such a magazine would merely reinforce U.S. notions of Mexican art as being political, carical-tural, and folkloric. Furious at Brenner, Orozco told her he "never want[ed] anything published there again."[96] He was from the start wary of Brenner's sympathies, and after reading her first article on the Mexican Renaissance, he beseeched her to abandon the idea of writing a monograph on his work and to exclude him from *Idols behind Altars*.[97] His objection stemmed from her estimation of Rivera as "leader" of the muralists; in Orozco's eyes, it was perhaps the most egregious error a critic could make. Brenner responded that the article had been written more than a year earlier, when she, like everyone else, had been duped by Rivera's propaganda and had not yet had the pleasure of meeting Orozco and becoming familiar with his work.[98] Her letter must have appeased him, because four months later she was commissioning the *Horrores*.

Throughout his career, Orozco alienated many friends with his para-noia about Rivera, and his general hostility led him eventually to quarrel with almost every supporter.[99] After a few years of more than cordial relations,

Orozco began to feel betrayed by Brenner, in part because he thought she had slighted him when he first arrived in the cold and alienating city of New York. More important, it resulted from Orozco's general paranoia that Brenner had turned away from him, toward Rivera and the cultural, aesthetic, and ideological camps that he represented.[100] The day after Orozco saw the *New Masses* article, he wrote Brenner a special delivery letter requesting that all of his work be returned and demanding that she not "do anything about [it] anymore." In the letter, he referred to her as a "propagandist."[101]

During the ensuing months, Orozco increasingly linked Brenner to Rivera and his "Mexicanist propaganda" machine and doubted her manner of presenting his art to the U.S. public. The exhibition of Mexican art that she organized at the Rockefeller-funded Art Center with the help of Frances Flynn Paine only worsened matters. On February 23, 1928, Orozco wrote to Charlot, criticizing the exhibition, Brenner, the threat of Rivera, and the dubious "Mexican fashion."[102] Orozco vehemently opposed what Helen Delpar has called the "enormous vogue of things Mexican" and resisted the folkloricism that made Rivera a popular media figure and a successful artist in the United States. Subjects that Orozco illustrated in Mexico from a distinct perspective—"Indians," "revolution," and "the syndicate"—were transformed in the United States into markers of a romanticized and generalized *indigenismo* that Orozco sought to reject. Though Brenner's rhetoric changed little from her previous publications, it now seemed to Orozco to be tainted by a commercialized and vulgar Mexicanism that had developed in the United States in relation to Rivera. Despite his protests against the new Mexican vogue, Orozco realized that he might need to accommodate his work to this viewpoint in order to make a living. As he told Charlot in a letter in July 1928, "Decidedly, this 'folklore' business is lucrative . . . for the 'sharpies'—and there's still more to be gained from it, you'll see." He understood that his success in the United States depended on the elaboration of a particular kind of Mexican subject matter in his work. Thus, the *Horrores* drawings were decisive in his formulation, a simultaneous sidestepping and embracing of *mexicanismo*—what Renato González Mello has termed a "heterodox Mexicanism"—to enter artistic circles in the United States.[103]

While Orozco created the drawings for an audience supposedly removed from the historical realities of the civil war in Mexico, those realities still had an impact on the art's reception in the United States. Several factors contributed to this cool response. The drawings were deemed too depressing, and their formal execution was contrary to contemporary aesthetic tastes. Further, years of anti-Mexican rhetoric in the U.S. press and strained relations between the two countries arising from events of the Revolution produced an

inhospitable climate for the drawings' debut north of the border. Whatever their anti-Revolutionary status in Mexico, in the United States, the drawings perpetuated the public image of Mexico as a violent, war-torn culture.

Orozco's work too closely resembled U.S. press coverage of the Mexican Revolution. The postcards depicting the period's violence were avidly circulated and collected in the United States during the early years of the civil war, so one might assume that Orozco's drawings would have been received well in New York. Several realities made that plausible assumption false. First, as soon as the United States entered World War I, the frenzy for the postcards died down. Next, it was one thing for the general public to consume these postcards in the 1910s and another matter entirely for art viewers to acquire drawings of Revolutionary violence a decade later. Finally, the same curiosity seekers who enjoyed the postcards—most of whom lived through or witnessed the border struggles or were relatives of soldiers who sent the cards home— were not the patrons at Marie Sterner's gallery, the New York venue where the series was first publicly displayed. Yet those very same postcards, among other factors, cemented cultural stereotypes and perceptions of the Mexican Revolution that lay behind the initial negative reactions to Orozco's series. For the New York art community, then, who had not been the intended audience for the postcards but was nonetheless aware of the newsworthy information they contained, Orozco's *Horrores* treaded too closely to mass media images of violence. Precisely for this reason, the drawings were considered documentary and illustrative and needed to be transformed to be considered fine art.

Brenner, by her own admission, was naïve about how the art world functioned in New York, and before long Orozco was contemplating other means to make his mark.[104] He came to the United States in search of new walls to serve as his canvases, and he needed to sell work in order to survive as an artist and provide for his family.

By April 1928, Orozco had already distanced himself from Brenner and the *Horrores,* writing to Charlot in the aftermath of the Art Center exhibition that he had not "had anything to do with caricatures, magazines, or other lesser absurdities" and had proceeded instead "directly to formal painting, galleries, dealers, painters, etc."[105] Even in Mexico, although he had been praised for the satirical and political caricatures he produced for newspapers in the 1910s and 1920s, Orozco had attempted to dissociate himself from his mass media production and often denied his authorship of some of these caricatures. González Mello has suggested that "if he didn't like being seen as a cartoonist, his . . . drawings permitted him to mix the stylistic devices of his cartoons with those of his academic training," thereby "transcend[ing] the categories of 'high and low.'"[106] Orozco himself articulated the problem, chal-

lenging U.S. professor and author Laurence Schmeckebier to determine at "what point caricature begins and at what point it ends. In other words: Why a given figure is caricature and why some other is not."[107] It should be remembered that it was Brenner's interest in Orozco's satirical work that prompted the idea for the *Horrores*. Though the series remained separate from his political caricatures, some of the drawings retained more caricatural elements than others, perhaps in part because of Brenner's influence. With the initial reception of the series in New York, Orozco's artistic production was again associated disparagingly with debased political caricature, and he believed he had to abandon the drawings, in their current state, in order to become critically and financially successful in the United States. He aspired to grander genres and venues than those proposed by Brenner, even though he was experimenting with one of the "lesser absurdities"—lithography—as a viable means of reaching a mass audience in the United States, proven successful by such Mexican artists in the United States as Miguel Covarrubias.

In late June 1928, Brenner showed the *Horrores* to Alma Reed, who became "enchanted" with them.[108] They appealed to Reed's and Eva Sikelianos's moral outrage at the human savagery of war in general. As Reed recounts in her monograph on Orozco, the brutal themes of the *Horrores* were also "unfortunately interwoven" with her intimate life, which was directly affected by Revolutionary violence when her fiancé, Felipe Carrillo Puerto, a political reformer and the governor of Yucatán, was assassinated in early 1924, a few days before their scheduled wedding. Having seen Orozco's images, Reed resolved to "help the Mexican painter pursue his career in the United States."[109] She introduced him to her circle of friends at the "Ashram," the nickname for the seventh-floor apartment at 12 Fifth Avenue that she shared with Eva Sikelianos. Orozco was quickly absorbed into the activities of the Ashram, which served as the headquarters of the Delphic movement.[110] Over the course of the summer, he established residency there, painting a few days a week. By late September, Reed and Sikelianos had arranged for a display of the series at their apartment. Though the informal show was limited to guests at the Ashram, it was the first time the drawings were shown as a series. Several of Orozco's new canvases with New York subjects, a group of his Mexican paintings, and photographs of the ENP murals complemented the display.

Shortly thereafter, Reed brokered the first truly public display of the drawings, at the Marie Sterner Galleries, located at 9 East Fifty-seventh Street. The two-week exhibition launched the season at the gallery to virtually no reviews.[111] José Juan Tablada remarked on gallery visitors' reactions to the drawings in his "Nueva York de día y de noche" ("New York by Day and by

Night") column for the Mexico City newspaper *El universal*. With regard to the violence of the images, one guest asked him, "Why do Mexicans do this?" Tablada responded, "It isn't Mexicans who do this, dear lady, but all men. . . . Have you forgotten the hecatombs of the World War?"[112] Visitors to the gallery were interpreting the drawings according to the then ubiquitous stereotype of Mexicans as vile and violent bandits. Reed later argued that "it was obvious . . . fashionable Manhattan had not yet developed an interest in Mexican tragedy—or in tragedy of any nationality. . . . Most of the guests expressed considerably more interest in Mrs. Sterner's collection of Biedermeier furniture than in Orozco's portrayal of revolutionary violence. . . . Her gallery, in its rococo Nile green and gilt décor, proved to be an incongruous setting for his virile creations."[113] The incongruity of the setting, one of New York's most exclusive galleries, was compounded further by the display of Orozco's drawings alongside work by six French artists, including the more sedate Matisse and Forain. The gritty scenes of war and alternative modernism must have seemed incompatible with French modernism. Orozco, however, saw it differently. He told Charlot, "They had to put Forain and the others in another room because of the *explosive* quality of the Mexican things."[114]

While en route to Greece, Sikelianos took the series to Paris and displayed it at Fermé la Nuit, a teahouse, gallery, and bookshop, in late February 1929. Now the series received its first extended critical attention, though it had been mentioned in a few U.S. newspaper and journal reviews. The exhibition of the series in Paris provoked an article in a Mexican daily accusing Orozco of denigrating his country. The journalist lambasted the drawings and cited concerns that Orozco was promoting an image of Mexico as a violent and destructive country.[115] Given such reactions, Orozco's and Brenner's fears about how the drawings could be interpreted were apparently warranted. The perception of the work as anti-Revolutionary led it to be considered anti-Mexican and politically dangerous. The Mexican establishment, fighting to maintain legitimacy, focused its concerns on the ways the Revolution was perceived within international circles. In *Idols behind Altars*, Brenner commented, "The . . . series is occasionally erroneously said to discredit Mexico, but this opinion comes as a rule from Mexicans disqualified as art critics and mistaken as to the implications in the foreign mind of the passion and tragedy revealed by the artist."[116] Orozco's series gave corporeal form to the Revolution as a tragic and disastrous encounter. The documentary power of the black-and-white drawings perhaps made some believe that the Revolution continued as a bloody battle; one Parisian critic thought Orozco had been exiled to the United States and had witnessed these scenes of destruction as he crossed the border. Such a notion,

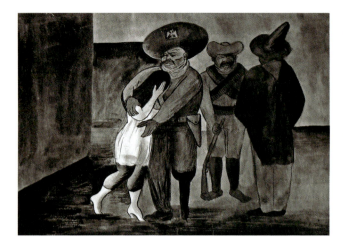

FIG. 40. Orozco, *The General's Wedding*, 1926–1928. Ink on paper. Museo Franz Meyer, Mexico City. © Artists Rights Society (ARS), New York / SOMAAP, Mexico City.

that the Mexican civil war was still being fought on the ground, countered the Revolutionary government's hegemonic claims. Although the physical battles had ended, the Revolution was indeed still being fought ideologically.

Cognizant of these political issues, Brenner worried from the beginning about the drawings' reception in the United States. Her article in the January–February 1928 issue of *New Masses* was to reproduce a drawing now known as *The General's Wedding* (fig. 40). A letter from one of the magazine's editors, Egmont Arens, indicates that Brenner must have had concerns about this particular drawing. Arens suggested to Brenner that she did not "need to worry about the General," as it would "prove inoffensive." He also suggested naming the picture *The Bandit's Return* or *The General's Return,* so that all the viewer "will get out of it is that his [meaning the bandit's or general's] wife is weeping on account of his wooden leg."[117] Brenner still believed that the image would prove offensive and wanted to delete it. In the drawing, the weeping woman looks very much like a figure from Orozco's watercolor series depicting prostitutes. An armed but shoeless soldier stands behind the general with a *campesino* beside him, his back turned toward the viewer. The barren walls reinforce the desolation and bleakness of the scene and universalize the setting. Brenner seems to have been concerned with the weeping woman, perhaps because the image represents an abduction/rape, and because Orozco's watercolors of prostitutes had been seized by U.S. Customs officials on his first trip to the United States in 1917. In the more explicit version of this drawing, *The General and the Girl,* the woman is naked; both Brenner and Orozco may have feared that such imagery would be interpreted as pornography. The drawing ultimately did not appear in the article, apparently replaced at the last moment.[118] This episode, besides demonstrating the stricter definitions of pornography north of the border, points to the possibilities for misinter-

pretation of the drawings and the easy manipulation of their meaning for an uninformed audience. The imposition of individual titles might change the perceived meanings and individual drawings might acquire distinct significance when seen out of context, separated from the series as a whole. Despite Arens's suggested titles for the drawing of the general and the weeping woman, it was eventually given its completely misleading current title.

Reed supplied the individual titles of most of the *Horrores* drawings (as well as most of Orozco's canvases from this period). She recounted affixing titles, with the artist's approval, to thirty-three of the forty-five drawings reproduced in her 1932 book.[119] *The General's Wedding* was among those she titled. For years the drawings in the series had existed simply under the umbrella title *Los horrores,* which Brenner had conceived.[120] The only individual titles the drawings had had before Reed's naming them were those Brenner had provided in the *New Masses* article, some of which were inflected with Marxist sentiment: *The Protector of the Lowly, The Oppressor Must Go!* and so on. Brenner's titles contrasted greatly with the nonspecific, bland titles Reed assigned—*Adiós* and *Three Women*—which completely depoliticized them.

Before its inauguration at the Marie Sterner Galleries as *Mexico in Revolution,* the series was referred to (as it continues to be) by generic descriptive titles—the wash drawings of the Revolution, for example, or scenes of the Revolution, or black-and-white drawings of the Revolution. Brenner's charged proposal, *Los horrores de la revolución,* was abandoned. Its new title lacked the overtly tragic connotation, and the more generic name could appeal to commercial interests in the United States. The change of name perhaps also reflects a desire to lessen the association with Goya's *Disasters of War,* as well as the doom and gloom prevalent in much of Orozco's oeuvre.

The title *Mexico in Revolution* stands out for suggesting an ongoing process, as if the country would forever be in revolution. A subtle yet revealing shift in descriptive titles—from scenes *of* the Revolution to scenes *in* the Revolution—transforms civil war from an event to a state of being. An active preposition links past, present, and future. Such an active title appropriately describes a series that is conscious not only of historical events but also of the process of history itself. Yet with a curious ahistoricity—this is no clear reference to *the* Revolution—the new title reflects an atemporality that recalls the ENP murals. Even the linguistic shift from Brenner's forceful *Horrors of the Revolution* to the more benign *Mexico in Revolution* did not make the series any more palatable. Though Sterner's title emptied the series of its immediate visceral significations, a more drastic measure was needed if the *Horrores* images were to gain more widespread appeal in the United States.

A Graphic Intervention

Soon after his arrival in the United States, Orozco started making lithographic versions of *Horrores*. After adjusting to the mechanisms of the New York art world, he contemplated a plan of action. In February he wrote his wife, Margarita, that he had bought the materials necessary for lithography, as it seemed to be a medium that sold well.[121] By March, he had begun to experiment, and he wrote Margarita about the many possibilities the medium afforded:

To make small things like drawings, watercolors, prints, lithographs, etc. This is the path I have chosen for now because in the first place it is serious art . . . and also it is a medium which sells easily because of its size and price . . . and moreover it can have exposure all the time, not only here but in the miles and miles of galleries in all of the American cities. . . . With prints and lithographs you can also make very important exhibitions at the best galleries, you can reproduce them in the press and receive remuneration, etc. . . . [O]f course you need to have a reputation, a name, fame, to sell your work, but I have faith that I will have it. I'm already beginning to be known.

Orozco's earlier complaints to Charlot rejecting the "lesser" genres notwithstanding, the artist saw lithography as an immediate solution to his financial problems and as a long-term strategy to give him the exposure needed to provide him with mural commissions in the United States. He told his wife that if "the 'horrores,' were printed instead of drawn," he "would have already sold many." Thus, with the idea of conquering the art scene, Orozco began lithographic versions of the *Horrores*.[122]

Only those drawings that bear a more direct relationship to the ENP murals—the more classic, serene, less brutal scenes—were turned into lithographs. The real "horrors"—the drawings graphically depicting violence, bodily injury, and blood—were repressed. In effect, with the change in title for the exhibition, and, afterward, the isolation of individual drawings from the entire series, and the choices to promote certain images through lithography, the series became palatable to a broader audience. Recognizably Mexican attributes, some of which might be emblematic of the Revolution—peasants, maguey plants, soldiers—were emphasized, but the series would be sanitized, cleansed of the horrific details of civil strife and struggle, in order to make its commercial debut in the United States a commercial success.

Orozco's first experiment with lithography resulted in the print *Vaudeville in Harlem,* a scene of the urban demimonde that is not at all related to the *Horrores*. By September 1928, the Weyhe Gallery had included *Vaudeville* in its catalogue of published prints, as well as a new lithograph, *La bandera (The Flag;* fig. 41), that the artist based on an earlier drawing (fig. 42).[123] In *New Masses,* Brenner had titled the drawing *The Flag Bearer,* emphasizing the hu-

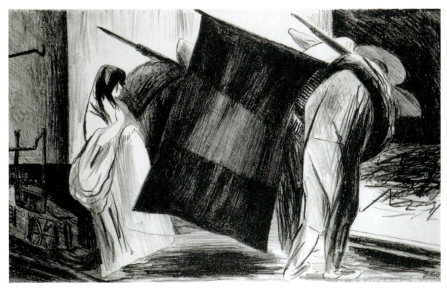

FIG. 41. Orozco, *La bandera (The Flag)*, 1928. Lithograph. Museo de Arte Alvar y Carmen T. de Carrillo Gil, Mexico City. © Artists Rights Society (ARS), New York / SOMAAP, Mexico City. Photograph by Javier Hinojosa.

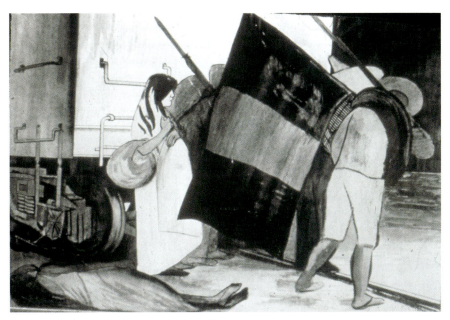

FIG. 42. Orozco, *The Flag*, 1928. Ink on paper. Anita Brenner Estate. © Artists Rights Society (ARS), New York / SOMAAP, Mexico City.

man element and human agency. Reed's Spanish title shifted attention from the figures to the flag itself. The lithograph departs from the drawing in several significant ways. Orozco cropped the somber image of dejected soldiers and *soldadera*s walking across train tracks with bowed heads while one carries a large flag, and he eliminated the supine figure splayed across the railroad tracks in the lower left foreground. The lithograph focuses instead on the group of walking figures, which was skewed slightly to the right in the drawing, so that the huge flag is now at center. Because Orozco expunged the dead figure and cropped the composition, the central figures now fill most of the composition. The formal changes monumentalize the figures and make the flag overwhelm the composition, occupying a third of the image. In the drawing, the flag was part of a broader narrative; the transformed image suggests nationalistic sentiment. The meanings conjured by the lithograph deviate significantly from the critical stance and anti-Revolutionary fervor of the drawing and the series as a whole.

Orozco made lithographic versions of four drawings from the *Horrores* series; after *La bandera* came *Requiem* (1928), *Ruined House* (1929), and *Rear Guard* (1929). Though these three remained more faithful to the original drawings, the more mild imagery of the originals did not necessitate the cleansing that *La bandera* underwent. All three images relate closely to the murals on the third floor of the ENP. *Requiem* (fig. 43), like *Rear Guard* (fig. 44), depicts the backs of mourners and reflects the general mood of the third-floor murals The huddled forms of the peasant women and the foreground figure of the man lying on his side in *Ruined House* (fig. 45) echo similar figures in *The Family* (fig. 13). The departing backs of soldiers and *soldadera*s in *Rear Guard* parallel those of the ENP *Revolutionaries* panel (fig. 23). The somber, brooding tone of these images is more tranquil and pensive than the mood in those of the *Horrores*. Margaret Breuning, writing for the *New York Evening Post,* found *La bandera* and *Requiem* "dramatic, yet without any forcing of medium or emotional appeal." The four *Horrores* images received more critical approval as lithographs than as drawings. As Breuning observed, lithography was "obviously the only idiom which could convey these original conceptions directly to us."[124]

Orozco's four reworked *Horrores* found immediate critical and commercial success and brought the series out of the darkness. The American Institute of Graphic Arts chose *Requiem* as one of the fifty best prints of 1928. Walter Pach, who only a year earlier had considered the *Horrores* images heretical, was the juror who helped make the selection.[125] An exhibition of these fifty top prints traveled to various cities around the country, and the Weyhe Gallery asked for fifty copies of Orozco's lithograph, which started selling at

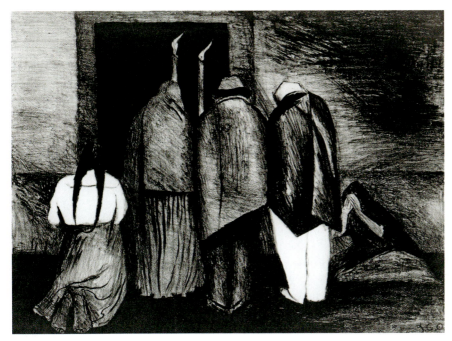

FIG. 43. Orozco, *Requiem,* 1928. Lithograph. Philadelphia Museum of Art. Gift of Henry P. McIlhenny, 1943. © Artists Rights Society (ARS), New York / SOMAAP, Mexico City.

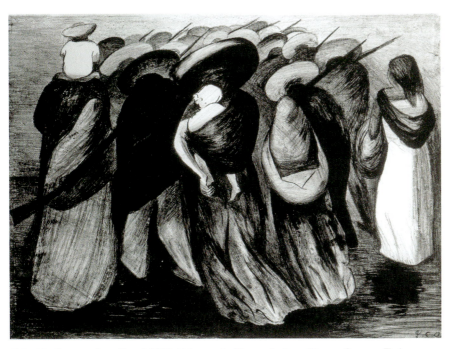

FIG. 44. Orozco, *Rear Guard,* 1929. Lithograph. Museo de Arte Alvar y Carmen T. de Carrillo Gil, Mexico City. © Artists Rights Society (ARS), New York / SOMAAP, Mexico City. Photograph by Javier Hinojosa.

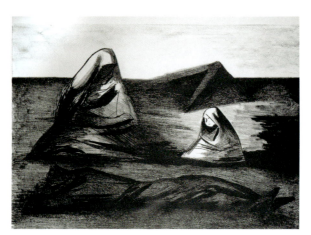

FIG. 45. Orozco, *Ruined House*, 1929. Lithograph. Museo de Arte Alvar y Carmen T. de Carrillo Gil, Mexico City. © Artists Rights Society (ARS), New York / SOMAAP, Mexico City. Photograph by Javier Hinojosa.

twenty dollars each.[126] Orozco himself noted that "with time they would be worth more. . . . This lithograph has been a stupendous success, everyone has liked it and the newspapers have spoken very well of it. With the copies that had been sold previously, *Requiem* has produced more than $400 dollars for me . . . and if this is with only one lithograph, imagine the day that many have such success."[127]

By April 20, 1929, Orozco could write that "the success continues! The Weyhe Gallery is going to buy lithographs for the sum of $780, and they want me to make more lithographs, which could mean several thousand dollars. I have made only three lithographs in all the days of my life, and they have already given me fame and money." In June, Charlot wrote to the photographer Edward Weston: "You probably heard of Clemente Orozco and his 'triunfos.' It seems to have gone to his head a little and he stepped widely on the toes of his before-the-applauses friends, this is to say Anita [Brenner] and me."[128] In July, *Requiem* appeared in a group print exhibition at the Metropolitan Museum of Art, along with Charlot's *The Tiger Hunter* and prints by old and modern masters such as Michelangelo, Dürer, Brueghel, Rembrandt, Picasso, and Matisse. At the end of the year, Orozco exhibited drawings from the *Mexico in Revolution* series, along with a dozen lithographs, at the Art Institute of Chicago.[129]

Orozco realized that if he was to achieve the attention in the United States that he desired, he needed photographs of his Mexican murals for publicity purposes, for possible exhibition, and for reproduction in art magazines to complement the wide distribution of his lithographs.[130] Even before his first exhibition in New York, he told Charlot, "You will see how important the photos of our much talked of murals are going to be." He forwarded instructions to Tina Modotti in Mexico via Charlot, asking that specific pictures be taken of the ENP murals. He even sent diagrams showing the position of the camera and the angles from which he wanted certain panels photographed.[131] At one

point, Alma Reed suggested sending the photographs to various architectural firms in New York in the hope of acquiring mural commissions. Orozco then asked Charlot and Modotti to emphasize the *"architecture as principal subject"* of the photographs.[132] The images became essential to his entire mural project in the United States.

Modotti's photographs established a direct visual link between the murals in Mexico and the lithographs the artist made in the United States. In 1929, the U.S. public was familiar only with Orozco's small-scale work—the *Horrores* drawings and two groups of easel paintings—and the murals were known solely through a smattering of reproductions. By April, Orozco had exhibited 113 works, among them 43 *Horrores* drawings and his first three lithographs (*Vaudeville in Harlem, La bandera,* and *Requiem*), at the Art Students League in New York. The exhibition included paintings with both Mexican and New York subjects, preliminary sketches, and the Modotti photographs of the murals. This mini-retrospective afforded the public its first glimpse into the entirety of Orozco's oeuvre to that date. Although the lithographs and photographs serve as visual conduits to the murals, the public grew interested in seeing the murals themselves. In a review titled "Orozco and Revolution," a *New York Times* critic stated, "It is perhaps generally felt in America that Orozco's black-and-white work is stronger than his work in color, but this feeling might to some extent be altered were one able to see the murals themselves." In a review of a later exhibition, Edward Alden Jewell noted, "It is not possible to get Orozco at full length in an exhibition of this sort. Above all, one needs the frescoes, which cannot be transported. Next, one needs the stirring black-and-whites."[133] According to Jewell and other critics, Orozco's graphic work, not his easel paintings, was the best thing after the murals. Margaret Breuning found that his easel painting "shows none of the flexibility of line or subtlety of patterns of light which are so striking in his lithographs." The *New York Herald Tribune* critic remarked in a review of the May 1932 exhibition "Mexican Graphic Art" at the Weyhe Gallery that "the art of Orozco gains its truest expression in black and white." Other critics noticed the lithographs' relation to the murals. One reviewer commented, "In Orozco's 'Requiem' the monumental quality is that of the artist's murals."[134]

The photographs Modotti took also provided material for Orozco to develop his lithographic series.[135] He made another fourteen prints in the United States, eight of which would directly appropriate imagery from the ENP murals: *Soldados mexicanos* (1929) and *Manos entrelazadas* (c. 1931), *Manos, Aflicción, Franciscano, Soldadera, Cabeza de campesina,* and *Tres generaciones* (all 1929). *Soldados mexicanos* (fig. 46) copied imagery more directly from the *Revolutionaries* panel of the ENP murals (fig. 23), which had served as an inspiration

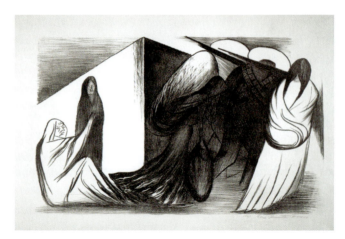

FIG. 46. Orozco, *Soldados mexicanos*, 1929. Lithograph. Museo de Arte Alvar y Carmen T. de Carrillo Gil, Mexico City. © Artists Rights Society (ARS), New York / SOMAAP, Mexico City. Photograph by Javier Hinojosa.

for *Rear Guard* as well. *Soldados mexicanos* is, in fact, a compromise between the ENP mural panel and an easel painting of the same subject from 1926, *Soldaderas,* now in the collection of the Museo de Arte Moderno, Mexico City. Just as Orozco recycled images within the *Horrores* series, he continually re-worked various Revolutionary themes and images. The grouping of figures seen from behind, which synthesized the iconic image of the Revolution he achieved at the ENP, seems to have been of particular interest.

The ENP panel details that Orozco had specifically requested Modotti to photograph became lithographs over the course of the next two years. Among those panels that were of use to him were "Soldaderas (group), Paz (group) . . . Franciscan, close-up." He also asked for "a good detail of the head of *La Madre* and the Boy."[136] From the *soldaderas* group (now known as *Women;* fig. 24), Orozco made the lithograph *Soldadera* (fig. 47), which is based on a detail of the figure to the left of the group in *Women*. The lithograph known as *Tres generaciones* replicates three figures from the left side of the mural panel *Paz* (now known as *The Family* [fig. 13]).[137] The iconic imagery of the Franciscan panel easily translated to the lithograph *Franciscano*.

The prints, in effect, served as synecdoches for Orozco's Mexican mu-rals and afforded the U.S. public a taste of their imagery. These distilled im-ages also expanded the scope of Orozco's reach beyond New York. The group of lithographs reproducing details of the ENP frescoes were exhibited at the Courvoisier Gallery in San Francisco in June 1930 and, the following October, at what is now the Los Angeles County Museum of Art, Exposition Park.[138] The exhibitions in California coincided with the dedication of Orozco's *Pro-metheus* mural at Pomona College outside Los Angeles and served as guides to a public increasingly interested in the artist's mural production.

In late July 1930, Orozco and Reed, accompanied by the writer Alfred

FIG. 47. Orozco, *Soldadera*, 1928. Lithograph. Museo de Arte Alvar y Carmen T. de Carrillo Gil, Mexico City. © Artists Rights Society (ARS), New York / SOMAAP, Mexico City. Photograph by Javier Hinojosa.

Honigbaum, visited Edward Weston in Carmel, California. Anita Brenner had introduced Weston to Orozco in 1926 during the photographer's second trip to Mexico.[139] Later, when Weston was back in California, he lamented that he had had only brief contact with Orozco in Mexico; he was delighted with the news that Orozco would be visiting him in Carmel. In his daybook on July 21, Weston noted that "Orozco brought a number of his new lithographs. Stark beauty, stripped of all frosting. The very bones, the quintessence revealed, structural and emotional. No compromise in Clemente Orozco." The Denny-Watrous Gallery in Carmel exhibited the lithographs, together with Weston's photographs of his murals.[140] In 1931, Reed informed Weston that "[Orozco's] prestige increases daily, and the collectors are now getting very busy. We sold two of his paintings this week, and many lithographs."[141]

As Reba Williams has noted, Orozco "discovered lithography . . . for himself . . . and brought samples of his prints to the Weyhe Gallery after he made them." In other words, no one commissioned him to make these lithographs. It was his own idea and, according to Brenner, "a beautifully sound eventual solution (mass production, wide distribution) via lithographs and engravings."[142] In the autumn of 1929, shortly after Orozco first essayed making prints, Carl Zigrosser of the Weyhe Gallery encouraged Diego Rivera to make lithographs for the gallery.[143] Following Orozco's lead, Rivera eventually made lithographs that appropriated imagery from his Mexican murals. Siqueiros, too, encouraged by Brenner and Charlot, made a lithograph based on a fresco panel in

Mexico.[144] It was with Orozco, then, that the movement toward mass distribution of the muralists' images began. Printmaking became a means by which the muralists could supplement their income, especially during the difficult times of the Depression. Moderately priced, limited-edition works, printed by George Miller and distributed by Weyhe, were sold to collectors and members of the public who otherwise could not afford easel paintings.[145]

Orozco's decision to turn to printmaking to break into the U.S. market anticipated the rise in print collecting at mid-decade, which was characterized by "two distinct and politically opposed developments": "the inauguration of ambitious commercial schemes for selling modern American prints to a national middle-class audience through mail-order advertising" and "the emergence of a local market of leftist viewers and collectors who were attracted rather than repelled by social viewpoint subjects."[146] Although the merchandising of popular prints that would appeal to "mass" tastes did not begin in earnest until 1934, innovative art dealers such as Zigrosser who showed experimental modern prints set the stage in the 1920s for the print explosion of the 1930s. Orozco's initial prints, a prescient undertaking, were part of this broader cultural initiative to transform fine-art printmaking.

While Orozco's prints were less politicized than the original murals on which they were based, by the mid-1930s, a broader political shift in the United States allowed graphic work with more ostensibly radical subjects to emerge. At a time when thirty branches of the John Reed Club, a leftist cultural organization, were established across the country, Orozco explored racial violence in his print of a lynching scene (fig. 48). In *Hanged Men,* which he created for a portfolio issued by the Contemporary Print Group—ten artists, most of whom made socially critical prints and were part of the American Scene school of artists—the specific attention to racial violence was a first in Orozco's production. Many of his paintings were socially engaged and critical—images depicting Depression-era poverty and general misery. Orozco was not politically committed in the mold of other artists—such as Harry Sternberg or Hale Woodruff—who later depicted lynching scenes (fig. 49) nor truly invested in the issue. Nonetheless, as Renato González Mello has elucidated, the iconography that Orozco explored in the United States—in print or painted form—indicates the tension between the "world scene and the 'American scene.'"[147]

In October 1929, Alma Reed's Delphic Studios opened its doors. Though Orozco had forged something of a partnership with Reed on their first encounter, the terms of her promotion of his work were formalized that fall; the gallery itself was to be a showcase for Orozco's work. Eventually, a room in the rear of the gallery held a permanent display of his art. He had achieved

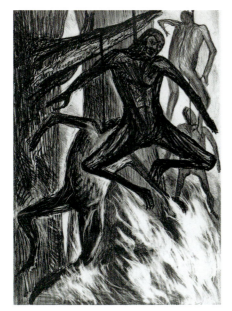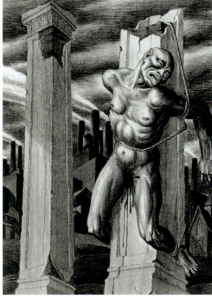

FIG. 48. *(left)* Orozco, *Hanged Men*, 1933. Lithograph. Philadelphia Museum of Art. Purchased with the Lola Downin Peck Fund from the Carl and Laura Zigrosser Collection, 1975. © Artists Rights Society (ARS), New York / SOMAAP, Mexico City.

FIG. 49. *(right)* Harry Sternberg, *Southern Holiday*, 1935. Lithograph. Whitney Museum of American Art. Purchased with funds from the Lauder Foundation, Leonard and Evelyn Lauder Fund. © 1998 Whitney Museum of American Art. Photograph by Geoffrey Clements, New York.

a modicum of success with the distribution of the prints in the U.S. market, but the Weyhe Gallery, the principal venue for the lithographs, was soon competing with Delphic Studios.[148] As Orozco became more involved with her gallery, Reed was able to secure exhibitions and mural commissions for him. Although he continued to make socially engaged prints, his attention turned briefly to the mythological and neoclassical ideas being circulated by Reed and Eva Sikelianos.

In 1933, Brenner was still writing about Orozco and the *Horrores* drawings. By this time, however, she felt betrayed by the path the artist had chosen. His material success, she believed, compromised his status as a Revolutionary artist. Brenner noted that the meaning of the *Horrores* series was necessarily changed by its commercial context in the United States. In fact, she thought that the entire Delphic Studios period, even the whole U.S. period, represented a point of departure in Orozco's development as a socially engaged artist:

It was necessary for a new gallery to open for Orozco to hang in the temples of art but once hung, these same sketches [the *Horrores*] achieved the commer-

cial dignity of great works of art. Then their character set up contradictions and implications which for commercial purposes must be explained away somehow. Successfully enough, to make of Orozco himself a contradiction: a successful revolutionary artist.

This conflict set up in the artist a struggle between that which was contained in his Mexican work and that which contained success, as is clearly revealed in the erratic departures of the work done after his first experience of being a lion, on condition of being a tame one. Confusion and conflict push form and content into a wind of chaotic mysticism which can be superficially explained with a surreal-iste label, but which is nevertheless strange—see *Broken Columns*[149]—to a painter whose line of development from social critic and political insurgent—in action as well as in expression—to revolutionary muralist nowhere contains the material for such departures.

But the possibility of the conflict which has been causing them, and which is yet unresolved was indeed contained in this, that Orozco, throughout his insurgency, seems nevertheless to have been in his own mind a free agent, a more than sympathetic spectator but still always a lone man committed to neither side of the class struggle.[150]

In the end, Brenner realized that Orozco never militated in the ranks of the Left. The artist she knew in Mexico, the Orozco of the Revolutionary struggle, had changed or, more accurately, had never existed. Although his future political alliances (namely the Liga de Escritores y Artistas Revolucionarios, or League of Revolutionary Writers and Artists) suggest that he never fully abandoned fighting for social justice, Brenner sought political commitment where there was only distant observation.[151] Her opinion of Orozco and his work in 1933 differed drastically from her statement in *New Masses* in 1928: "To divide his personal, national, emotional, ideological contribution from his vehicle, the purely plastic manner of his search, is a confusion, and false. He himself has struck a balance."[152] Although she did not state it outright, Brenner implied that the unresolved conflict of the *Horrores* remained the artist's inability to live up to the Revolutionary ideals of the series and of the patron herself. That confusion was further complicated by Orozco's willful reconfiguration of the drawings and his accommodation to a more benign "Mexican" identity to develop and circulate the series in the commercialized environment of the United States. In the late 1920s, the public in neither Mexico nor the United States was ready for Orozco's horrific portrayal of Revolutionary violence or his alternative modernism.

3

MEXICAN CURIOS

The paradoxes of Mexicanism that Orozco faced in the United States in the late 1920s grew increasingly tense with the transnational circulation of Mexican art in the following decade. By the early 1930s, the U.S. public's expectation of cultural nationalism from Mexican art had affected not only exhibitions, coloring them with art that expressed sentiments of the popular and the native, but also assumptions about the rural character of the nation. As the cultural prestige of the muralists expanded, their heterogeneous versions of socially engaged modernism conflicted, sometimes violently, with a burgeoning Americanism that had seized on ideas of continental roots.

The entry of Mexican muralism and radical public art into the transnational dialogue complicated an already conflicted and contested terrain. The historically strained relations between the two countries prompted unique questions of patronage and cultural diplomatic efforts that colored the reception of Mexican muralism and the fashioning of Mexican modernity in the United States. What were the roles of modernity, modernism, and the rural in this transnational dialogue? How did artists and viewers respond to their roles in these arenas? How did Mexican nationalism intersect with American exceptionalism? And how did the recovery of folk art on both sides of the border by artists, collectors, and institutions direct the display of politically charged and socially engaged art by Mexican artists and the muralists?

The "Mexican Arts" Exhibition

In October 1930, several months after Orozco placed the finishing touches on his *Prometheus* fresco at Pomona College in Claremont, California—the first mural by a Mexican artist to be painted in the United States—the large touring exhibition titled "Mexican Arts" opened at the Metropolitan Museum of Art in New York (fig. 50). It was touted as the "first authentic and vivid representation of Mexican art to be shown abroad."[1] The exhibition, which traveled the United States for two years under the aegis of the American Federation of Arts, included colonial decorative art, folk art, and modern art.[2] The majority of the twelve hundred objects displayed fell under the rubric of folk art and served as the principal attraction, at times overshadowing the modern art also on display. By conflating five hundred years of Mexican art history into a single trajectory that privileged a collective "Mexican unconscious," the exhibition presented the more politicized and Revolutionary work by the Mexican muralists within the context of a folklorist, nativist vision of Mexico, thereby reinforcing the exhibition's nationalist agenda. Though not the first show of its kind, it was the largest and most comprehensive by that time, and it set a precedent for the way Mexican art would be exhibited in the United States throughout the century.[3] Examining this exhibition and the uneasy alliance forged between Mexican folk art and Mexican modern art provides an opportunity to deconstruct early appraisals of muralism across the United States. Situating the exhibition in a variety of discursive practices of the early 1930s, including reevaluations of pan-Americanism, nativism, and a decorative art tradition in the United States, allows for a broader understanding of the promotion of Mexican art in the United States and the construction of a specifically "American" ethos in the early 1930s.

By 1930, the museum-going public in the United States had gained familiarity with both Orozco's and Rivera's works. As noted in the preceding chapter, Orozco had attracted attention with several small exhibitions around the country, his series of lithographs, and the permanent display of his work at the Delphic Studios. The mural commission at Pomona College provoked greater interest in his art. Rivera, who arrived in San Francisco five months after Orozco completed the *Prometheus* mural, was even better known than his compatriot, as a result of major exhibitions in New York and Los Angeles throughout the 1920s. By the end of the decade, Rivera had won the Fine Arts Gold Medal from the American Institute of Architects, an award engineered by Dwight Morrow, the U.S. ambassador to Mexico who was also the primary force behind the "Mexican Arts" exhibition.[4]

Rivera's international prestige developed from not only his exhibitions in

FIG. 50. General view of the "Mexican Arts" exhibition at the Metropolitan Museum of Art, New York, 1930. Photograph courtesy the Metropolitan Museum of Art.

the United States but also the legacy of his Mexican murals, which circulated across the United States in photographic reproduction. U.S. artists and reporters traveled south of the border to witness firsthand the founding of a new mural movement and came home with personal accounts of artistic activities in Mexico. Photographs of the murals were essential if U.S. viewers who did not travel to Mexico were to learn more about muralism. *Art Digest, Creative Art,* and other periodicals often ran lengthy articles on Rivera and Orozco in the early 1930s; the January 1929 issue of *Creative Art,* devoted to the "development of art in Mexico," focused on Rivera and included numerous reproductions of his murals at the Secretaría de Educación Pública (SEP) in Mexico City and the Escuela Nacional de Agricultura (now known as Universidad Autónoma Chapingo). Mass-market magazines such as *Fortune* introduced readers to the work of the muralists. In 1929, Ernestine Evans published the first monograph in the United States documenting Rivera's mural production, and it helped spread knowledge of the artist's work to new audiences.[5] In all of these publications, the Mexican murals loomed as the artistic products that the U.S. public needed to know in order to understand the artists and the movement properly.

Conceived from the start as a nationally touring exhibition, "Mexican Arts" appeared at an important historical juncture, when U.S. audiences were first becoming aware of artistic developments in Mexico, yet it came before Rivera had painted any murals in the United States and on the heels of Orozco's first U.S. commission. Siqueiros, the youngest of the "big three" muralists and the most politically active, had just returned to art after a hiatus of several years spent working with labor unions in Jalisco and engaging in political activities in South America; he had had comparatively little exposure in the United States.[6] Before 1930, New York and California were the principal centers for displaying work by Rivera and Orozco. "Mexican Arts" enabled U.S. audiences who had seen their work only in reproduction to view large-scale easel pictures by these three artists. For Rivera, Orozco, and Siqueiros, the exhibit's potential to reach new audiences was its primary benefit.[7]

Rivera's Portable Fresco

In 1930, Rivera had completed the first so-called portable fresco panel in the history of Mexican muralism: *Market Scene,* a stand-alone 4-by-3½-foot plaster-covered slab of concrete with an exact copy in fresco of a small detail from his monumental mural cycle at the Palacio de Cortés in Cuernavaca (fig. 51). He intended to paint another movable fresco panel exclusively for the "Mexican Arts" exhibition but exhibited *Market Scene* instead.[8] The inclusion of a portable fresco as a stand-in for a mural was crucial in the context of the first major traveling exhibition meant to introduce audiences to the homegrown art of Mexico. A unique medium invented by Rivera (and later manipulated by Orozco) and developed for the display and circulation of Mexican muralism in the United States, the portable fresco allowed artists to demonstrate the technique of fresco and, ostensibly, the iconography of public mural painting. For two years, then, at a time when Rivera was in the United States and actively executing murals, the fragment served as a surrogate for his mural production as viewers in cities across the country presumably familiarized themselves with the fresco technique, public wall painting, and the iconography of Revolutionary Mexican art.

While a mural is a painted wall or ceiling, a fresco—the specific medium revived by modern Mexican artists—is an ancient Mexican and European form of mural painting that involves the application of pigment to wet or fresh plaster on walls. Portable frescoes, unlike standard frescoes, are not conceived within a specific architectural setting. Instead, construction of the large-scale panels begins with a heavy steel frame, then a latticework substrate covered with concrete and, finally, several layers of plaster. As such, portable frescoes break with the traditional, academic concept of the mural as a form of wall

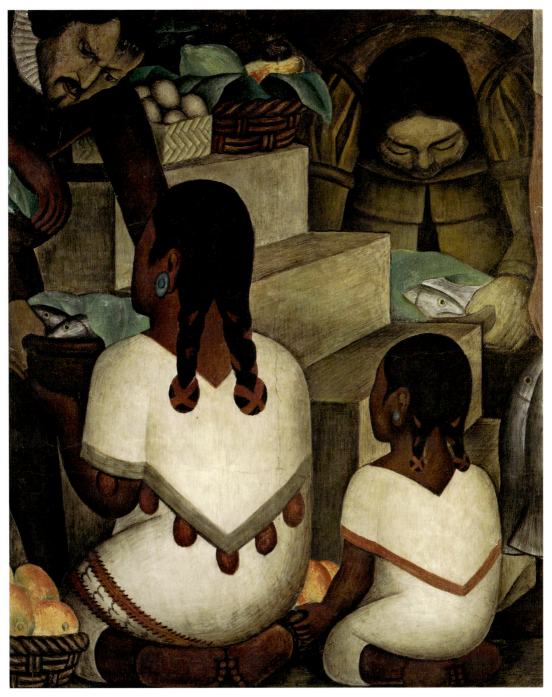

FIG. 51. Rivera, *Market Scene,* 1930. Portable fresco. Smith College Museum of Art, Northampton, Massachusetts. Gift of Mrs. Dwight W. Morrow (Elizabeth Cutter, class of 1896). © 2008 Banco de México Diego Rivera & Frida Kahlo Museums Trust, Av. Cinco de Mayo no. 2, Col. Centro, Del. Cuauhtémoc 06059, México, D.F.

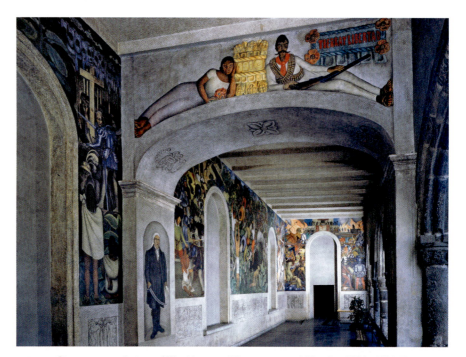

FIG. 52. Rivera, general view of *The History of Cuernavaca and Morelos*, 1930–1931. Fresco. Palacio de Cortés, Cuernavaca. © 2008 Banco de México Diego Rivera & Frida Kahlo Museums Trust, Av. Cinco de Mayo no. 2, Col. Centro, Del. Cuauhtémoc 06059, México, D.F.

decoration and necessarily reject the Mexican elaboration of the mural as a form of social expression dependent on government buildings for mass public communication.

Market Scene illustrates unique questions of patronage behind the "Mexican Arts" exhibition. When Elizabeth Morrow commissioned the work in 1930 as a birthday present for her husband, Dwight, it was to commemorate the diplomat's patronage of Rivera and the mural cycle that Morrow had left to the city of Cuernavaca as a gift when he departed his post as ambassador.[9] The Cuernavaca mural cycle, painted in 1930, is more than 104 feet wide and presents a sweeping view—a continuous, linear narrative of the history of Cuernavaca and the state of Morelos, from the Spanish Conquest in 1521 until the agrarian revolt led by Emiliano Zapata in 1911 (fig. 52). Critical of colonial power and the subjugation of Mexico's native populations by Spanish rule, the cycle is also informed by its singular setting in a colonial building that was once the home of the conquistador Hernán Cortés.

Rivera's fresco isolates one part of the complex narrative at Cuernavaca. The source panel, in its entirety, depicts the construction of the Palacio de Cortés (fig. 53). *Market Scene* depicts an Indian woman and child as they bring

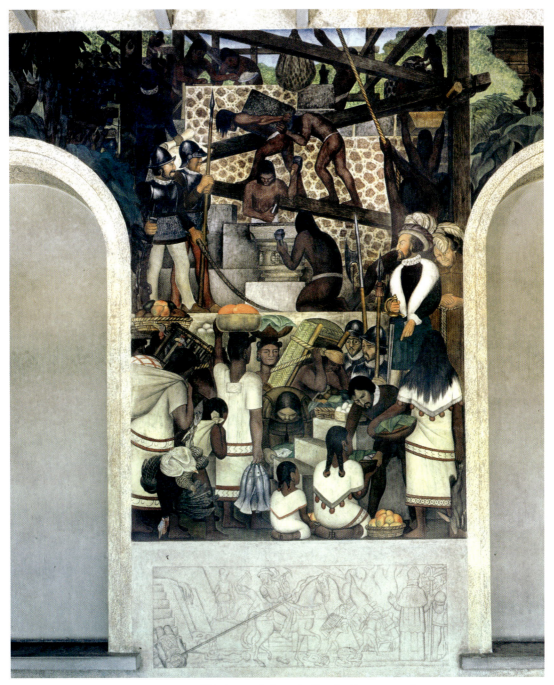

FIG. 53. Rivera, *Constructing the Palace*, 1930. Fresco. Palacio de Cortés, Cuernavaca. ©
2008 Banco de México Diego Rivera & Frida Kahlo Museums Trust, Av. Cinco de Mayo no.
2, Col. Centro, Del. Cuauhtémoc 06059, México, D.F.

tribute, in the form of the first fruits of the harvest and containers of fish, to the Spanish conqueror. The figures are seen from behind, their feet tucked under their buttocks, a pose intended to illustrate their subjugated position and one found repeatedly in Rivera's representations of Indians in murals and easel paintings (as in his 1925 work *Flower Day*, Los Angeles County Museum of Art, and in scores of paintings of calla lily vendors). A staircase cuts diagonally across the composition, leading the viewer from the child holding a basket of fruit to the male figure at the top. The mother proffers her wares, a bowl of fish, to the Spanish figure, who looks down at her from the upper left corner. The axial movement focuses attention on the specific economic exchange—a detail that conjures deep pathos and an important ingredient of Rivera's Marxist version of Mexican history.

As a fragment of the original image, the portable fresco evokes an elaborate and perturbing network of hierarchical relationships and gestures of giving and receiving, perhaps a condensed and knowing representation of Rivera's relations with the Morrows. Beginning with the narrative of the original mural panel and its attendant historical context, the Spaniards provide the gift of civilization in the guise of the Palacio de Cortés. The Morrows, in turn, bestow on the city of Cuernavaca the gift of Rivera's genius, and the Mexicans are happy beneficiaries of both. Rivera's creativity is returned to Dwight Morrow as a birthday present that commemorates his own gift giving. The multilayered historical process of sugarcoating colonial policies with a presumed posture of cultural benevolence resonates at the narrative level with the very specific economic exchange between the figures represented in the scene. By making Morrow's commission of the Cuernavaca mural cycle present through synecdoche, *Market Scene* becomes not only an example of Rivera's fresco technique but also a marker of the complex questions of patronage behind the "Mexican Arts" exhibition and the promotion of Mexican art in the United States. Rather than bring to the fore aspects of Rivera's politicized public wall painting, the Morrow fragment merely illustrates the ambassador's diplomatic efforts.

Mexicanness and the Continental Politics of the Exhibit

The impetus behind "Mexican Arts" coincided with Ambassador Morrow's broader political objectives in Mexico. When he arrived in October 1927, the nation was in the midst of a religious civil war (known as the Cristero War, 1926–1929), and there were continued threats of imperialist aggression from its neighbor to the north. Morrow's predecessor, James Sheffield, had threatened military intervention on behalf of U.S. oil companies operating in Mexico. Those companies wanted to be exempt from nationalization of the

petroleum industry, which the new Mexican constitution would initiate. In contrast to his predecessor's intimidation tactics, Morrow, who had been a corporate lawyer, a partner in the J. P. Morgan banking firm, and a civic-minded member of charity, academic, and political organizations, sought instead to resolve the political and economic conflict through subtle negotiation and respect for national sovereignty. Though his banking and corporate connections elicited a certain amount of justified suspicion, his ability to reconcile the petroleum regulations quickly through diplomacy earned him the respect of both Mexican and U.S. leaders. Besides easing the issue of vested property rights, Morrow smoothed out relations between U.S. industrialists and the Calles regime by settling agrarian, labor, and judicial disputes. As a "sympathetic" ambassador, Morrow wielded unprecedented influence in Mexican politics at a time when the reactionary and conservative Callistas tightened their grip on power. By 1930, his seemingly subtle yet heavy-handed involvement in Mexican affairs had led many critics to suggest that Morrow's diplomatic style was merely a disguised form of U.S. imperialism. One critic in particular later stated, "Coincident with [Morrow's] presence in Mexico the life went out of the revolution."[10]

Although scholars and historians debate the actual extent of Morrow's reach into Mexico's internal affairs, no doubt remains that the idea for an exhibition of Mexican art dovetailed with his diplomatic tactics in the political arena. Through the promotion of Mexican culture, Morrow could publicly demonstrate his deep respect and affection for the Mexican nation and secure the trust of government leaders and the elite. Several years before the elaboration of Franklin Delano Roosevelt's Good Neighbor policy, Morrow single-handedly conscripted the arts to appease growing tensions between the United States and Mexico.

As Anthony Lee has argued, Morrow was able to achieve reconciliation between U.S. corporations and the Callistas in part by robbing the Partido Comunista Mexicano (PCM) of its most important and internationally famous artist member, Diego Rivera.[11] Already wavering in allegiance and shifting his priorities during a year in which the Callista regime declared the PCM illegal, Rivera continued to compromise his affiliation with organized leftism because he was increasingly associating with several U.S. capitalists, Morrow in particular. In the same month that the PCM expelled him for a second time, Rivera accepted Morrow's commission for a mural in the Palacio de Cortés in Cuernavaca, further damaging his already tenuous relationship with the party.

Anticipating his departure from the ambassadorship, Morrow wished to make a gift to Mexico that would reflect his political career, his love for

Mexico, and his deep attachment to his Cuernavaca home, Casa Mañana. William Spratling, an architect from New Orleans who had been living in Mexico and had assisted the Morrows with remodeling Casa Mañana, stated that he had suggested that Morrow commission a mural from Rivera. Up to then, the Morrows' interest in Mexican art was limited to popular, folk, and colonial objects; their tastes expanded when they became patrons of Rivera and Orozco.[12] Their foray into the contemporary mural movement signaled a much more public engagement with Mexican art and the ideology of nationalism and also represented a further loosening of Rivera's ties to the PCM.

Though the Morrows met Rivera briefly in July 1929, the artist did not formally accept the Cuernavaca commission until September, around the same time the "Mexican Arts" exhibition was taking more concrete form.[13] Morrow's patronage of both cultural events coincided with his discovery of the political expediency of culture. The Palacio de Cortés mural commission served his political ends, as did the traveling exhibition of Mexican art, which he enthusiastically promoted in the name of diplomacy. Rather than mention politics overtly, René d'Harnoncourt later described the exhibition "as a means of international understanding." Intended to remedy Mexico's tarnished reputation in the United States, the exhibition and the promotion of Mexican art in the United States represented an attempt by Morrow and other diplomats "to change or influence somewhat the image of Mexico that was held by a majority of people [in the United States] by showing something positive. . . . By and large when people talked about Mexico they . . . talked about vandals, generals, diseases, cockroaches and so on. . . . It would be a very good idea . . . to show some of their aesthetic achievements."[14]

The desire to transform the negative image of Revolutionary Mexico was rooted in Morrow's strategy for protecting his country's property rights south of the border: using culture as a diplomatic tool.[15] A comprehensive exhibition of art that idealized and promoted Mexico's rural and Revolutionary national culture would, the organizers hoped, counter negative stereotypes generated by the violence of the Revolution.[16] With the impending threat of the Mexican government's application of Article 27 of the constitution, which affected agricultural, mining, and oil properties in Mexico belonging to capitalists in the United States, Morrow enlisted the support of private industry in his cultural-diplomatic endeavors. Behind all of this goodwill lay the sponsorship of the Carnegie Corporation, which had economic interests in Mexico in the form of a consortium of mines.[17]

Morrow's strategy of promoting Mexican culture to serve political, economic, and ideological interests had already been attempted by the Mexican government itself. In 1915, years before the administration of Álvaro Obregón

and the attendant cultural policies of José Vasconcelos, Venustiano Carranza had considered putting art into the service of his newly formed government. Given Woodrow Wilson's reluctance to grant recognition to the new Constitutionalist government, Carranza ordered that a group exhibition of works by Mexican painters be organized to tour the United States. As Jean Charlot noted, Carranza knew well "the corrective propaganda value of art at a moment when Mexico's military was becoming internationally notorious."[18] In the end, the works were shown in Mexico City in May 1916, but they never traveled to the United States as originally intended.[19] From the beginning of the civil war in Mexico, government officials used Mexican visual culture to shore up relations between the two countries. Such a grand scheme for an exhibition would, however, require the patronage of U.S. industrialists and collaboration between the two nations.

Rivera's *Market Scene* and the "Mexican Arts" exhibition signaled a shift in political, cultural, and economic relations between the United States and Mexico in the late 1920s and early 1930s. In addition to its large scale and extensive travel itinerary, "Mexican Arts" hit the road with the imprimatur of several powerful U.S. institutions as well as that of the Mexican government. Formally organized and shepherded by the American Federation of Arts, the exhibition was funded entirely by the Carnegie Corporation.[20] A relatively exorbitant project given that the Depression was raging, it had a budget of fifty thousand dollars for the first year alone. René d'Harnoncourt, who eventually curated the details of the exhibition, speculated that such a budget represented "probably the largest grant in the art field ever given for one specific exhibition" at that time.[21] Rounding out the group of political and economic heavyweights to whom Morrow turned was his longtime business associate Robert de Forest, president of the Metropolitan Museum of Art.[22]

To this confluence of power brokers, bankers, and financiers in the United States, Morrow added the support and cooperation of Mexican government officials, including his close friend Moisés Sáenz, the influential former undersecretary of Mexico's Secretaría de Educación Pública (1925–1930), who had attempted to integrate Indians into contemporary Mexican society through the establishment of rural schools. By means of his government contacts, Morrow successfully secured the loan of many works from Mexico's national and local museums as well as the permits needed to transport the materials. The majority of the objects in the exhibition, however, came from private collections in the United States and Mexico.[23] Homer Saint-Gaudens, director of the Department of Fine Arts at the Carnegie Institute of Pittsburgh and son of the sculptor Augustus Saint-Gaudens, was dispatched to Mexico in November 1929 to make the necessary arrangements for the exhibition; he later

initiated the first contacts with U.S. museums to organize a touring schedule. Although Morrow had hoped to expedite the planning so that the exhibition could open in the winter, Saint-Gaudens suggested they wait a year.[24] Once he arrived in Mexico, d'Harnoncourt, a count of Franco-Belgian and Czech origins who had emigrated from Austria and was a close friend of the Morrows, assisted with the preparations. Shortly thereafter, he was selected to be the curator of the exhibition. D'Harnoncourt's extensive knowledge of Mexican popular art, both its production and its history, as well as his familiarity with a network of prominent collectors and his international pedigree, made him an ideal candidate to organize and curate "Mexican Arts."

D'Harnoncourt had come to Mexico in early 1926, when the breakup of the Austro-Hungarian Empire resulted in the expropriation of his family's estate by the Czechoslovakian government. Subsequently, he became an art advisor and purchasing agent for wealthy U.S. collectors of Mexican folk art. In addition to collecting antiques for oil executives such as William Green, he sold pre-Columbian and contemporary art through the curio shop of Frederick Davis, which was housed at the Sonora News Company. D'Harnoncourt's main passion was Mexican popular art—ceramics, lacquerware, and textiles produced by rural artisans—which he energetically sought out on visits to remote villages in the Mexican countryside.[25] He helped Elizabeth Morrow decorate Casa Mañana and worked with the Secretaría de Educación Pública in the effort to revive the folk art industry and to promote the broader movement of ethnic cultural nationalism based on Indian aesthetics.[26] D'Harnoncourt's experiences in Mexico and his alliances with the Mexican intelligentsia helped fashion the conceptual framework and curatorial logic of "Mexican Arts."[27]

The exhibition was divided into two parts, one showcasing fine art and the other, decorative or applied art, and it was organized according to medium and genre. Though Morrow and de Forest may have originally intended to exhibit colonial painting, Saint-Gaudens reported from Mexico that it was considered "second rate Spanish painting, devoid of local character."[28] He viewed colonial decorative art as imaginative and much more reflective of a "genuine" Mexican spirit than an assimilation of foreign models, and he thus included examples of it in the exhibition.

At the heart of the exhibition lay the problem of cultural specificity—of what was inherently Mexican or not. The nationalist logic of the exhibition was best summed up in d'Harnoncourt's introductory catalogue essay: "This is an exhibition of Mexican arts, not of arts in Mexico. . . . We are concerned here with the presentation only of such works of art as are an expression of Mexican civilization . . . a Mexican interpretation of Mexico." Under this logic, masterpieces of colonial and academic painting and *talavera de Puebla* became

irrelevant to Mexico's cultural development.[29] Privileging Indian culture over the influence of Europe, the exhibition conformed to the ethnic cultural nationalism that Mexican intellectuals and government officials had outlined in the early 1920s.

In contrast to education minister Vasconcelos's emphasis on mestizos and on his belief in the redemptive power of European culture to cultivate the indigenous classes, members of the cultural elite such as Rivera, Manuel Gamio, Moisés Sáenz, and Dr. Atl celebrated Mexicanness as a nativist, indigenous identity. Although these intellectuals departed from the moralistic rhetoric of Vasconcelos, which imagined a superior race that possessed the supposed purity and impulses of Indian culture and the knowledge of Western culture, they too were concerned with constructing the true essence of Mexican nationality and ostensibly unifying the nation and its diverse populations in the wake of the Revolution. Gamio initiated the campaign, arguing that folk arts "preserved a native tradition and embodied a harmonious integration of Hispanic and Indian forms and techniques." The valorization of Indian aesthetics became the primary means by which official *indigenismo* "sought to incorporate Indian communities into modern Mexico."[30] While, for Vasconcelos, the mestizo embodied national consciousness, which was a view based on his own upper-middle-class upbringing, members of the Mexican elite promoted a Mexican identity vested in folklore and in rural, indigenous culture, an identity that was deemed to be a collective unconscious, despite deep differences in race, class, and ethnicity across the country. Though populist in intent and less elitist than the *mestizaje* of Vasconcelos, *indigenismo* was still predicated on a paternalistic, modernizing nationalism that hoped to assimilate the Indian into national and urban society.

The exhibition's idealistic exaltation of rural and Indian culture has its origins in this sort of broader cultural movement and state agenda in Mexico. An advisory committee comprising the same government officials and intellectuals who formulated the platform of ethnic cultural nationalism was established to help orient the exhibition. Dr. Atl served as nominal codirector of the exhibition, although d'Harnoncourt later stated that the artist did little but attend the opening of the exhibition in Mexico City in June 1930.[31] D'Harnoncourt had close relationships with many members of the Mexican intelligentsia who shaped the nationalist rhetoric, and he elaborated the details of the exhibition in accordance with ideas circulating at the time. The separation of fine and applied arts served as a formal mechanism by which d'Harnoncourt could make a tenuous distinction between "conscious" and "unconscious" expressions of national characteristics or, more aptly, Indianness. Today, we might say that modern artists appropriated popular culture

to their own ends. Yet in 1930, "Mexicanness" was an intellectual construct imposed on the rural makers of folk art; this imposition in effect turned them into collective vessels of nationalistic sentiment.[32]

Frances Flynn Paine and the Marketing of Mexican Folk Art

In addition to understanding the "Mexican Arts" exhibition as a palpable display of cultural diplomacy and an attempt to assuage fears about modern art evoking Mexico's Revolution, it is necessary to situate its nationalist rhetoric within several competing and emergent discourses of the 1920s, especially the role of decorative arts and autochthonous material culture in shaping U.S. and Mexican national identities. As an exhibition that focused on colonial decorative and contemporary popular art, "Mexican Arts" was indelibly colored by the "Exhibition of Popular Arts," which had been organized by the artists Roberto Montenegro, Jorge Enciso, and Dr. Atl in Mexico City, in conjunction with events commemorating the centennial of national independence in 1921. A landmark exhibition, it was the first to champion the aesthetic value of Mexican crafts of all kinds, and it codified—with the support of the Secretaría de Relaciones Exteriores—the relationship between Indianness, Mexicanness, and popular culture. The valorization of rural aesthetics and the recovery of popular art as an unmediated innate expression of *mexicanidad* intersected with urban intellectuals' appraisals of modernity and a constructed cultural nationalism. The catalogue to the exhibition, written by Dr. Atl, provided a curatorial framework for d'Harnoncourt. As d'Harnoncourt would later do, Dr. Atl organized his catalogue first by medium, then by region. Many of the objects reproduced in Dr. Atl's catalogue also appeared in "Mexican Arts." Behind both exhibitions lay the claim that the aesthetic value of popular art lay in its rejection of European values and Western visual traditions. Dr. Atl's emphasis on "Indianness, spontaneity, authenticity, collective subconscious, manual industries, and premodernity" served as a foundation for the introduction of Mexican popular art to U.S audiences.[33]

Though the 1921 exhibition remained within Mexico's borders, its success led, in 1922, to the first major exhibition of Mexican folk art in the United States. U.S. writer Katherine Anne Porter helped organize the exhibition in Los Angeles and wrote its accompanying catalogue, *Outline of Mexican Popular Arts and Crafts*. The exhibition consisted of approximately five thousand objects and was sponsored by Mexico's Secretaría de Industria, Comercio, y Trabajo (Ministry of Industry, Commerce, and Labor). Organized at a time when the United States refused to recognize Obregón's government because the Mexican government insisted that the nation retained ownership of valuable mineral rights even if foreign companies were granted mining permits, the exhibition

was intended as a binational public relations initiative. The United States did formally recognize Obregón's election in August 1923. His proclamation that Article 27 of the 1917 constitution could not be applied retroactively perhaps did more to placate U.S. investors than did the rather inconsequential exhibition of Mexican folk art. The Los Angeles exhibition, however, set an example for future endeavors about how Mexico's national culture could be invoked for political purposes.[34] It also established a precedent for pairing Mexican folk art with modern art in an exhibition intended solely for U.S. audiences.[35]

The revival of the craft industry intersected with U.S. cultural promotion of things Mexican. Private parties also supported the efforts of government officials in both countries, and these cultural promoters in the United States had ties to big business. Among those promoters was Frances Flynn Paine. Born in Laredo, Texas, Paine had lived in Mexico for many years because her father, a U.S. businessman, maintained extensive economic interests there.[36] Two weeks after the press announced Morrow's new ambassadorship to Mexico, Paine sent him a detailed letter that perhaps planted seeds for the "Mexican Arts" exhibition. In her letter, Paine indicated that, because she was a foreigner, her special interests in Mexican culture allowed for more cordial personal relationships while she lived in the country. With the idea of applying this theory more broadly, she set herself up as an *animateuse* of Mexican culture, becoming a dealer or agent of popular art in the hope of bringing about better relations between the United States and Mexico. Paine's desire to develop a market for Mexican folk art in the United States was rooted in the idea of cultural goodwill.[37]

In her promotion of Indian crafts, Paine adapted a model already established by Mexican intellectuals such as Gamio and by the government-sponsored revitalization of the craft industry.[38] Her intention was for Mexicans to "work out their economic independence through their Arts."[39] In Mexico, Gamio had intended to modernize craft production and, in so doing, to bring artisans into modern, urban national society. Pro-Indian economics focused on the assimilation of indigenous artisans into a new, consolidated post-Revolution culture. Paine applied the same logic to the context of transnational capitalism, extending market considerations beyond Mexico's borders.

To effect her plan, Paine cultivated relationships with the most elite power brokers in the United States, including the Rockefellers and the Morrows, and planned an exhibition at the Art Center, the Rockefeller-funded venue.[40] With a five-thousand-dollar grant from the General Education Board of the Rockefeller Foundation, she visited thirty towns in Mexico to purchase folk arts and crafts for the exhibition, which traveled around the country after its debut in New York.[41]

In October 1927, two months before Paine left for Mexico to gather the objects for the exhibit, Anita Brenner arrived in New York with crates of popular and modern Mexican art. Brenner, armed with the support of the Mexican government, intended to mount a large exhibition that would showcase the work of Orozco, Charlot, and Francisco Goitia, among others, in the United States. Within days of her arrival, the artist Rufino Tamayo, who was scheduled to have an exhibit at the Art Center in November, introduced the two to each other.[42] Paine suggested to Brenner that they combine their efforts and incorporate the material Brenner had brought from Mexico into Paine's Rockefeller-funded exhibition. After using her connections to liberate Brenner's crates from U.S. Customs, Paine worked out a partnership.[43] According to *Art Digest,* Paine was organizing "a monster exhibit of Mexican stuff, general and complete," to display "the handicrafts of Mexico" alongside modern paintings and sculptures, but the continuing violence of the Cristero War delayed Paine's return to New York until mid-March 1928. Thus, the exhibition of folk art she had been collecting was rescheduled to take place after the modern art show.[44] According to Orozco, the modern art exhibition was amateurish, badly organized, and poorly received by critics. Both he and Rivera's wife, Lupe Marín, complained about the installation, particularly the prime space accorded to works by other Mexican artists, such as Máximo Pacheco, Antonio Ruíz, and Roberto Montenegro. Even Brenner, who was optimistic at first, realized the show was a critical and popular misfire. She described reactions of "violent dislike, almost anger, even . . . frothing [at] the mouth." As the exhibition continued through January, she concluded that "people continue to be more or less violently affected." By February she had determined that "the Mexican show . . . isn't going well," perhaps because of the poor selection of works.[45]

Despite the de facto separation of the two exhibits, inevitable links were made between them, which was Paine's intention from the outset. Orozco lamented that modern Mexican painting was offered as a preamble to the hyped exhibit of folk art and that the whole endeavor was tainted by its commercial aspirations.[46] He wrote to Charlot, "I can tell you that the only purpose of the show is to sell trinkets of 'Mexican folk art,' a commercial enterprise, for which our pictures have merely served as advertising posters." In a letter to Charlot's mother, Orozco said that Paine had "deceived everyone in Mexico and is apparently a very smart businesswoman."[47] An exhibition announcement, in which Rivera and Orozco were mentioned as "the world's foremost contemporary artists," emphasized the commodity exchange value of folk art. Indeed, the Art Center stated that it "hopes and believes the American people will not only admire but *buy* the output of these splendid craftsmen," in

essence equating the production of the modern artists with that of the folk artisans.[48]

Paine's cultural project had, from the beginning, aspirations for economic development. By creating a market for folk objects in the United States, she hoped to enable Indian artisans to achieve economic independence. Despite a rough start, in which delays in transport, the fragility of the pieces, the remoteness of the artisans, and what she called their "natural indolence" all constituted obstacles to profitable trade, her persistence and elite contacts led to several notable outcomes in the commercial realm.[49] Paine's noble yet paternalistic desire to save the Indian artisans through a transnational trade network necessarily obscured the modernist production on display. In the report Paine sent to Alon Bement, director of the Art Center, after the exhibition, she neglected to mention modern art and clarified instead that the purpose of the exhibition "was to bring about the introduction of the Applied Arts of Mexico into the United States."[50] Although in her correspondence Paine often distinguished between fine and applied art, more often than not critics referred to the exhibition as a show of Mexican art in general.[51] Neither Paine nor the Art Center subscribed to the hierarchy of fine art and craft. Nonetheless, rather than subverting normative aesthetic conventions and hierarchies by exalting the unsophisticated, the embrace of folk art in this venture merely buttressed U.S. expectations and pervasive stereotypes of Mexicans as backward and unrefined. With attention diverted from modern art to the sale of folk artifacts, the Art Center became a northern version of Frederick Davis's curio shop.

Modern artists associated with Paine's endeavors were uncomfortable with having folk and modern works sharing the same stage. Rufino Tamayo brought Brenner the gossip alleging that she was "a U.S. spy" and that all her "so-called love and interest in Mexico and Mexican art" was in Brenner's words *para tapar el ojo*"—to pull the wool over one's eyes.[52] Brenner's alignment with Paine's project—a broader and more comprehensive attempt to commercialize Mexican art, especially crafts—caused her to be viewed with suspicion.[53] Though Brenner was genuinely interested in promoting Mexican art in the United States, after dealing with Paine and the Art Center she became disillusioned with the marketing aspect of the project. Brenner withdrew from such projects and then concentrated on *Idols behind Altars,* art criticism, and other writing endeavors.[54] As for Paine, although Rivera and Orozco were initially wary of her overtures, as she gained more cultural influence they recognized that they could benefit from her connections. Paine brokered Rivera's retrospective at the Museum of Modern Art in 1931. And while he vociferously railed against the commercial and folklorist vision of promoters like Paine, Orozco was not completely opposed to controlling his own fate as a Mexican

artist in the United States. He warned that Charlot, with the savvy manipulation expected of the self-promoter Rivera, "got $15,000 from Rockefeller, supposedly to promote the folk art of Mexico. Decidedly, this 'Folklore' business is lucrative . . . for the 'sharpies'—and there's still more to be gained from it, you'll see."[55]

In her quest to formalize her folk art business, Paine called on the benefactors who were crucial in the promotion of Mexican art in the United States and who supported the Carnegie exhibition. She received further economic support from John D. Rockefeller Jr. and the Rockefeller Foundation.[56] Since Rockefeller did not make grants to individuals, he encouraged her to incorporate her venture. She therefore established the Paine Mexican Arts Corporation, which imported crafts from Mexico, and promptly received a grant for three consecutive annual contributions of five thousand dollars.[57] After approaching Dwight Morrow and receiving his assistance with the Art Center exhibition, Paine tried to convince Elizabeth Morrow—knowing of her interests in Mexican folk art—that one solution to Mexico's "interesting" problems was the formation of a collection of folk art that could be permanently displayed in museums in the United States.[58] By the end of 1928, Paine had established permanent headquarters on the second floor of the Art Center building, where she devoted a small gallery to a display consisting mostly of applied arts but with a few fine art works as well.[59] Although Dwight Morrow had contributed five hundred dollars to the Art Center exhibition and had facilitated the acquisition and shipment of works from Mexico to New York, Paine had trouble persuading the Morrows to contribute more funds. They feared that Paine's for-profit corporation would jeopardize Dwight Morrow's political interests in Mexico.[60] Not until Paine created the nonprofit Mexican Arts Association, which was separate from her own for-profit corporation, did the Morrows come on board.[61]

While Mexican officials credited "Mexican Arts" with the renewed interest in and sale of *"objetos de 'Arte Mexicano,'"* U.S. organizers of the exhibition attempted to distance it from the government's commercial aspirations and Paine's economic development plans.[62] Frederick Keppel, president of the Carnegie Corporation and acting director of the American Federation of Arts, emphasized the exhibition's historical importance rather than its market potential: "Suffice to say, it is not . . . a sales exhibit. Its purpose is to familiarize Americans with the art of Mexico, particularly its older art in which the Spanish element and the Indian element are singularly combined, so as to make it in many senses an art in itself."[63]

Keppel's emphasis on mestizo culture as the defining characteristic of Mexican aesthetics diverged from the *indigenismo* of Gamio and Dr. Atl and,

through them, d'Harnoncourt. It also signaled the initial rift between the Mexican elite's promotion of folk art and early U.S. perceptions and expectations. Edward Robinson, the director of the Metropolitan Museum of Art, had to be persuaded to accept the exhibition proposal for "Mexican Arts" because he considered Mexican art to be "highly deplorable."[64] When Homer Saint-Gaudens submitted the initial plan, both Robinson and Robert de Forest objected to the inclusion of contemporary Indian crafts, such as toys, masks, and costumes. They questioned the suitability of such items for an art museum, especially one as prestigious as the Metropolitan. Robinson and de Forest did not share d'Harnoncourt's aestheticization of Mexican folk objects; they believed these items were examples of "social development" rather than "art."[65]

Unlike Paine, who encouraged a kind of tourist trade through her pleas for economic development, d'Harnoncourt railed against the supposed bastardization of folk arts into tourist commodities. He feared that turning these folk art objects into tourist trinkets might rob them of their quaintness and therefore their authenticity.[66] One of d'Harnoncourt's principal concerns in relation to folk art was that artisans "keep on doing quality work in spite of the decadence forced on them by their tourist trade." Gamio, too, considered outmoded techniques and practices in the craft industry to be a sign of degradation and deemed them a hindrance to the modernizing impetus of the post-Revolutionary Mexican state. By distinguishing between tourist craft and artisanal production of supposedly high quality, d'Harnoncourt reinforced aesthetic hierarchies between the commercial and the ostensibly "authentic," which accorded with broader efforts to define the Mexican nation. Though Paine was also interested in historic preservation, her sometimes costly exportation of fragile Mexican artifacts led her to be more concerned with achieving a durable product that would not incur damage in transit to the United States.[67] D'Harnoncourt, on the other hand, alarmed that various regional techniques—like the *rayado* (incised) and *dorado* (gilded) designs found in lacquerwork from Olinalá—were disappearing because of the tourist trade, encouraged local artisans to copy antique pieces to ensure the survival of those styles. While traveling around the United States with the "Mexican Arts" exhibition, d'Harnoncourt suggested to audiences that "the Mexican artist produces art for himself[,] not for his market," and that that "is what gives it a freshness and a naiveté."[68] Clearly, though, the local artisans were no longer producing art for themselves, and while d'Harnoncourt might have temporarily dissuaded them from producing for the tourist market, they simply shifted gears and catered to the needs of his elite group of collectors—not a mass tourist market but a market that nonetheless aesthetically valorized the objects as markers of national identity.[69]

In addition to setting the stage for the "Mexican Arts" exhibition and its attendant cultural discourses, the commercial interests of Paine's endeavors and the transnational craft trade of the late 1920s and early 1930s are significant in that they provide a historical context for later efforts by the government (in particular, Fondo Nacional para el Fomento de las Artesanías, known as Fonart [National Fund for the Promotion of Folk Art]) and private sector (Banamex) in Mexico to promote folk art.[70] Furthermore, the transnational trade created a steady demand for folk art, numerous alliances between indigenous and modern art, and a solid link between art, artists, and the marketplace.

With her promotion of Mexican folk art, Paine also hoped to stimulate design in the United States.[71] She published articles in U.S. decorating magazines about Mexican tiles, colonial architecture, and lacquerware, among other subjects.[72] Her efforts were most visible in the arena of contemporary design, where Mexican crafts were increasingly used as elements in interior decoration. Paine furnished two companies, Cheney Silk and American Encaustic Tile, with Mexican designs for their products, and the Metropolitan Museum of Art exhibited the tiles in October 1928. She also purchased twelve hundred feather-work plaques and had them framed, then shipped them to Abercrombie & Fitch, Ovington's, B. Altman, and other stores to be sold as cocktail trays. As a direct result of the Art Center exhibition, which prominently featured a set of *equipales*—armchairs from Sayula, Jalisco, with cowhide seat and back, and interwoven wood latticework on the bottom—John Wanamaker placed a two-thousand-dollar bulk order for the chairs and matching tables, to be sold in his store's furniture department. Of her efforts, Paine said, "I am trying to demonstrate [not only] that Mexico . . . can contribute to our cultural life through sending us her own work but that her arts are a logical source from which the U.S. may draw inspiration for our designs."[73] Her desire to change interior design tastes in the United States made Mexican folk arts fashionable within elite circles and among upper-middle-class consumers who frequented department stores.

Paine's market-oriented approach to showcasing Mexican art meshed with the ways in which the department store itself had become the primary means for the consumption of visual images and modern art in the United States in the early part of the century. As William Leach has written, "It was in the department stores, not in the museums, that modern art and American art found their first true patrons." Robert de Forest himself told a group of department store executives, "You are the most fruitful source of art in America."[74] Some years earlier, the Gimbel brothers, inspired by the "Armory Show" of 1913, had showcased work by Cézanne, Picasso, and Braque in their stores across the country, while Carson Pirie Scott in Chicago exhibited works by

artists associated with the ashcan school. Wanamaker would rotate paintings from his personal collection in Philadelphia—Titians, Turners, Constables—and send them for display in his New York store. He disavowed the common museum practice of "salon style" installation and instead arranged for more "breathing space" between paintings so that they would seem like the commodity objects that were actually for sale.[75] Although in the earliest decades of the century art was used as an enticement within the display strategies of department stores, by the 1930s R. H. Macy's and other stores featured their own galleries, with the art on display being for sale. In part because of Paine's efforts, exhibitions of modern Mexican art were regularly featured at Macy's in the late 1930s.[76]

An Alliance of Origins

Paine's desire to incorporate the aesthetics of Mexican folk art into U.S. design sensibility and the department store's increasing importance as an aesthetic space paralleled other developments within the burgeoning American art scene.[77] A growing interest in U.S. colonial furniture, decorative arts, and primitive paintings prompted construction of the separate American Wing at the Metropolitan Museum of Art. The new wing opened in 1924 and had sixteen period rooms displaying antiques in re-created colonial settings (fig. 54).[78] By presenting both fine and applied works of art within their re-created original surroundings rather than as objects on display in a museum, period rooms encompassed both ethnographic and commercial display strategies. Although department stores immediately copied the Metropolitan's period rooms, the museum's rooms were based on furniture display rooms already developed as commercial prototypes.[79]

In her study of modern art and national identity in America between the wars, Wanda Corn has traced several cultural projects that place the opening of the Metropolitan's American Wing in its artistic and sociohistorical contexts.[80] It is precisely at this time that U.S. industrialists, fueled by a zealous sense of patriotism and a xenophobic, racist nativism, began intensively collecting colonial objects and early American decorative arts. Their desire to assert the uniqueness of the U.S. experience relative to that of the European and to preserve what they perceived as a homogeneous American identity in the face of a growing and diverse immigrant population resulted in such theme-park historical collections as Henry C. Mercer's museum of American tools, founded in Doylestown, Pennsylvania, in 1916; John D. Rockefeller Jr.'s Colonial Williamsburg in Virginia, begun in 1926; Henry Francis du Pont's period rooms in Delaware, begun between 1928 and 1932 and now known as the Winterthur Museum; and Henry Ford's Greenfield Village, near Detroit,

FIG. 54. Bedroom from Hampton, New Hampshire (Shaw House), 1740–1760, as installed and furnished in the American Wing at the Metropolitan Museum of Art in 1924. Photograph courtesy the Metropolitan Museum of Art.

begun in 1928 and opened to the public in 1939. In contrast to the politically conservative overtones of the colonial revival movement, which, according to Corn, "mythologized the founding fathers" and sought to "Americanize foreigners," an Americanism to be used toward different ends was proposed by a circle of revisionists who promoted the notion of a "usable past."[81] Cultural critics such as Lewis Mumford and Van Wyck Brooks (who published an essay on the usable past in the *Dial* in 1918), curators and museum professionals such as Holger Cahill, Juliana Force, and Lloyd Goodrich, and private dealers and collectors such as Edith Halpert and Abby Aldrich Rockefeller invoked the American past as a viable framework on which to build a new modernist idiom. They argued that their nationalism differed, in Corn's words, from the "moral romancing of the past they attributed to museum antiquarians, colonial revivalists and zealous groups like the Daughters of the American Revolution. . . . They wanted to throw out received history, proclaiming it genteel and sterile." Artists such as Charles Sheeler began to collect American folk art, consciously looking at marginal subcultures, such as the Shakers, in contradistinction to the "Anglo-Saxon rhetoric or pronounced patriotism and nativism of period rooms." Mumford, like the antiquarians, isolated Ameri-

can expression from European tendencies but advocated a modernist vision in painting, specifically, an abstract formal style that disavowed the realism of the Hudson River school. Force supported American modern artists with her founding of the Whitney Studio Club (which eventually became the Whitney Museum of American Art) at her apartment at 10 West Eighth Street, where modern art shared a space decorated in ornate Victoriana. Such an idiosyncratic pairing of the modern with an outdated mode became the hallmark of Halpert's Downtown Gallery, where she rebelliously "promoted folk art as if it were modern."[82] (Abby Aldrich Rockefeller was one of her primary patrons for both modern and American folk art.) Though the revisionists distanced themselves from the preservationists by insisting on the present functionalism of an American past within a modernist credo, both camps espoused a nostalgic vision that blurred the line between their supposedly distinct appraisals of American artistic expression. As Corn notes, Sheeler "sensed the thin line between his own activities as a collector touting the aesthetic and plain-style craftsmanship of American antiques and those of the establishment that so often spoke of the inherent goodness or moral qualities of old ancestral things."[83] Nonetheless, artists' embrace of American folk art was rooted less in the nativist rhetoric of preservationists and more in the desire to seek out an alternative American modernism.

The evolving discourses of Americanism in the 1910s, 1920s, and 1930s overlapped neatly with the nationalist expressions of post-Revolutionary Mexican society that were being promoted and circulated in the United States. Among the American revivalist ranks—such as the Rockefellers, Force, Halpert, and Mumford—were those who were also intimately involved with the promotion, sale, and collection of Mexican art. Abby Aldrich Rockefeller collected both colonial Mexican furniture (which had been purchased in Mexico by Paine) and American folk art from the nineteenth century. Eschewing historical accuracy in favor of a generalized Americana, she placed both the furniture and the folk art collections in Colonial Williamsburg, John D. Rockefeller Jr.'s eighteenth-century Virginia restoration.[84] Force exhibited Orozco's work in the early Whitney Studio Club exhibitions, and she was later the first patron in the United States for his *Horrores* series. Halpert also handled Orozco's work in late 1928 and then featured his new paintings of New York subjects in a solo exhibition at the Downtown Gallery in 1929. Mumford was an enthusiastic supporter of Orozco after controversy erupted over his Dartmouth College mural cycle, *Epic of American Civilization*, which has panels that critique the academic establishment, American Puritanism, the standardization of modern society, and the dangers of nationalism. In his essay published in the October 1934 issue of the *New Republic*, Mumford defended Orozco's

mural as consistent with a complex liberal New England tradition. For Mumford, the New World discourse evident in the artist's *Epic of American Civilization* was a "cosmopolitan" manifestation of local regionalism. Mexican artists such as Orozco and Rivera not only provided a nationalist model for an emerging American cultural renaissance but their artistic production in the United States also legitimized American artists' own search for identity as part of a hemispheric initiative.

This cultural pan-Americanism was promoted by intellectuals, artists, collectors, and government officials on both sides of the border.[85] Rivera offered a nationalist model for an emerging American cultural renaissance, and his output in the United States legitimized its artists' search for an identity as part of a hemispheric initiative. Pan-Americanism, a movement toward social, economic, military, and political cooperation among the nations of the Americas, was advanced primarily by government officials, but intellectuals, artists, and collectors on both sides of the border also embraced it.[86] As part of this broader effort, Rivera glorified an indigenous past in Mexico, a past that, according to the logic of pan-Americanism, came to be viewed as a common heritage for the entire continent. The shared desire on the part of artists of the United States and Mexico to sever ties with Europe brought attention to the Indian cultures of the American continent and challenged the primacy of early European civilizations within a Western historical narrative. For intellectuals and artists in the United States and Mexico, this myth of origins was crucial in defining cultural identity.

As adherents to cultural pan-Americanism sought unifying aspects between nations, their approach also represented an attempt to move beyond the restrictive boundaries and reductive tendencies of nationalist discourses. Yet many such boundaries and attitudes persisted, and the specificities of local cultures became simplified and homogenized.[87] Cultural pan-Americanism also had roots in political and economic policies that favored capital coming from the United States. Those roots extended back to the Monroe Doctrine in the nineteenth century, when it seemed that pan-Americanism would protect the continent from European imperialism; in reality, pan-Americanism was cited as justification for U.S. interventionism in Latin America. Ambassador Morrow's policies in Mexico were an outgrowth of this larger historical trend, and the Rockefellers' cultural interests in Latin America were certainly tied to the financial vicissitudes of their company, Standard Oil.[88]

The "Mexican Arts" exhibition came to the Metropolitan Museum of Art only six years after the American Wing opened. Financed by Robert and Emily de Forest, the new wing exemplified the more politically conservative elements of the Americanist zeitgeist. The emphasis on formal high style and

FIG. 55. The Almodington Room, as originally installed in the American Wing at the Metropolitan Museum of Art in 1925. Photograph courtesy the Metropolitan Museum of Art.

individual pieces situated the de Forests' collecting practices within those of a number of wealthy individuals who donated their holdings in the hope of promoting the values of American antiquity. Designed by R. T. H. Halsey, the galleries were sparse and austere, emphasizing antiquarian as well as Founding Fathers' values (fig. 55). Unlike the preservationists, and departing from Halsey's design, however, the de Forests espoused the idea of a unified American hemisphere.

Robert de Forest was an avid collector of Mexican arts and crafts. He first visited Mexico in 1903 and met the U.S. archaeologist and anthropologist Zelia Nuttall, who had been actively researching Mexican antiquities since the 1880s.[89] As a result of their travels in Mexico, the de Forests envisioned a permanent gallery at the Metropolitan dedicated to Mexican art. With such a permanent display in mind, they began collecting colonial Mexican ceramics, specifically, *talavera de Puebla,* with Nuttall's assistance. In 1911, Emily de Forest donated part of the collection to the Metropolitan. In a letter to the museum, written at the time of her donation, she stated, "The collection is important, in my opinion, not only as representing an artistic ceramic development, but, more particularly, as representing such a development in America.

It seems to me to form a part of a collection representing the arts of Mexico which I hope will sometime be fully represented in the Museum, as an American Museum."[90]

Not only did the de Forests view Mexican decorative art as an American art form but they also deemed it the responsibility of American museums such as the Metropolitan to display the arts of Mexico. Although the museum devoted a gallery to their collection of ceramics, the de Forests still envisioned a permanent display that would present various phases of Mexican decorative arts. With this in mind, Robert de Forest provided Nuttall with discretionary funds to amass such a collection.[91] Problems with export permits prevented him from obtaining the objects that Nuttall had purchased in Mexico, however. In October 1927, needing a solution to liberate the de Forests' collection from storage, Nuttall recommended lending the objects to the Morrows, who had recently arrived in Mexico City and were in the process of furnishing the U.S. Embassy.[92] De Forest used this opportunity to tell Morrow of his idea for a Mexican exhibit and politely asked for his cooperation in gaining possession of his collection by the end of Morrow's ambassadorship. Elizabeth Morrow, with Nuttall's assistance, sorted through the collection and borrowed a few objects, including a painted screen, to "beautify" the rooms of the embassy. But her husband delayed the matter of securing export permits from the Mexican government; the protection of cultural property had become a more sensitive topic in official circles in light of recent scandals.[93]

De Forest's various exchanges with Morrow regarding the export rules that kept his property in Mexico and his desire to see a Mexican gallery in the Metropolitan perhaps compelled him to develop the plans for Morrow's "Mexican Arts" exhibition.[94] De Forest's wish to liberate his furniture from Mexico echoed the broader set of circumstances that generated the exhibition—a diplomatic/cultural interchange ultimately concerned with the protection of U.S. interests and private property in Mexico.[95] The question of export permits highlights the extent to which state cooperation is essential in transnational exhibitions of any kind, particularly in the case of Mexico-U.S. relations. The same diplomacy and networks that ensure commercial links (related to oil, for example) are consistently exploited to stimulate other connections (such as art exhibitions). As has been amply discussed by other scholars, reliance on these networks throughout the twentieth century generated a multitude of "official" exhibitions spurred by diplomatic arrangements such as the North American Free Trade Agreement. For many years Mexico has been one of the few Latin American countries with a developed support system in the United States. This system includes Mexican cultural institutes, which often have knowledgeable staff members well connected to local art circles, and the Mexican

consulates, which frequently provide additional funding. This support system usually becomes something of a default or backup mechanism when funds are depleted and cultural institutions need programming. In many cases, exhibitions are scheduled according to broader government initiatives, such as festivals or symposia, merely to take advantage of financial capital, which necessarily affects the critical capacity of such exhibitions. By examining the curatorial rationale and display strategies of such exhibitions, we can unravel the presumed efficacy of cultural diplomacy.

In addition to establishing a Mexican gallery at the Metropolitan, de Forest advocated a touring exhibition of Mexican art. In August 1929, after hearing of Morrow's intention to mount an exhibition in the United States, de Forest wrote the ambassador, reminding him of his own interest in Mexican art. Unaware that the details for Morrow's exhibition had already been arranged, de Forest delineated his own efforts, which he hoped would mesh well with Morrow's plan.[96] He remained interested in securing for the Metropolitan a representative Mexican collection for permanent display. De Forest emphasized that "this was my original idea and is still my desire." In the same letter, he suggested "getting together a loan collection for circulation among our different American museums," and he recommended Frances Flynn Paine as a possible conduit.[97] Like Morrow, de Forest was a patron of Paine's Art Center exhibition, from which he had purchased a number of works. Paine later obtained a larger group of similar items from among which de Forest could make further purchases.[98]

In the end, the "Mexican Arts" exhibition did not include the de Forest collection of Mexican ceramics. Despite Robert de Forest's contention that "the art of Mexico is sufficiently distinguished from the art of Spain by its admixture of Mexican motives to have a place of honor in an American museum," for d'Harnoncourt, *talavera de Puebla*, with its origins in Muslim Spain, was not sufficiently "Mexican" for his nationalist curatorial paradigm.[99] Unlike the de Forests, d'Harnoncourt was not interested in the complex tensions of *mestizaje* that such Mexican cultural products embodied. The pan-Americanism trumpeted by the de Forests and their collection of Mexican decorative arts did not fit within the strict categorization of the exhibition and Morrow's broader agenda.

Though the de Forests' early (pre-Revolution) interest in Mexican decorative arts must have influenced the Morrows as they began to collect Mexican popular and colonial art, their practices differed in many ways. From the beginning, the de Forests collected examples of Mexican pottery as museum artifacts and amassed the collection with a didactic vision of interjecting Mexican arts into an American art narrative. The Morrows, in contrast—and Eliz-

abeth in particular—purchased native handicrafts and colonial objects not as collectors' items but according to the utilitarian needs of the home.[100] In turn, through the example of Casa Mañana, the Morrows encouraged the collection of Mexican crafts for use in interior decoration, an idea that merged with Frances Flynn Paine's efforts. In an article for *House Beautiful* in 1931 (fig. 56), Paine gave U.S. readers a glimpse into the spaces of the Morrows' Cuernavaca home and praised the mixture of colonial and contemporary Indian crafts.[101] Like the de Forests, the Morrows also collected glazed *talavera* ware, as well as other colonial objects that drew on European sources, but they balanced these with ceramic works that suggested the blending of Spanish and Indian sources, such as Mexican lacquerware, and objects made by Indians at local markets for barter or for the tourist trade, examples being *sarape*s or earthenware.[102] As the Morrows settled in at the embassy and acclimated themselves to a new culture and environment, and as Dwight Morrow developed his diplomatic policy, their collection of popular arts visually sealed their embrace of the typically Mexican. The disparity between these two modes of collecting and display impinged on the presentation at the Metropolitan Museum of Art: there, folk culture staked out terrain within a "venerable" history of European decorative art, and modern art evoking the Revolution was caught in the crossfire.

Exhibiting "Mexicanness"

The genesis of the "Mexican Arts" exhibition was thus an intricate confluence of institutions, collectors, dealers, and genres as well as intellectual, socio-cultural, and diplomatic backgrounds. Department store aesthetics, interior design, pan-Americanism, Paine's market motives and pro-Indian economic activities, the de Forests' and the Morrows' collecting practices, and powerful corporate and cultural patronage are some of the forces that came together in the late 1920s to tell the story of art in Mexico for the U.S. public. How could muralism and its modernist aesthetics and politicized subject matter function within the narrative of the exhibition, and how would they function in the midst of these broader discursive practices?

Modern Mexican art is defined by the marriage of European form with content culled from autochthonous culture, often Indian subject matter. Absorbing the lessons of European experimentation—expressionism, cubism, modern classicism—modern Mexican artists forged an art that was national in content and modern in form and technique. By the early 1930s, state-sponsored artistic practice had shifted away from Vasconcelian mestizo universalism to official *indigenismo* and more populist rhetoric (for example, the Rivera murals at the Secretaría de Educación Pública). Orozco and Siqueiros, however, individually condemned the aesthetics and ideology of official *indigenismo*. Orozco deplored the emphasis on Indian origins and championed mestizo and universal culture. He detested the illustration of "the odious and degenerate type of the common people that is generally taken as a 'picturesque' subject to please the tourist or profit at his expense . . . the ridiculous '*charro*' and the vapid '*china poblana*.'" Furthermore, he believed that to confuse "painting in its higher forms" with "minor folk art" was to commit a grave error.[103] Nonetheless, he willingly participated in an exhibition that merged so-called high and low arts at a time when it served him to espouse a "Mexican" orthodoxy. Siqueiros, too, criticized *indigenismo* within modern Mexican art as being a too-narrow nationalism. By 1932 (at the end of the "Mexican Arts" exhibition tour and after his experiences in Los Angeles, where he painted, among other things, the pointedly expressive *Tropical America* mural), Siqueiros had rejected the vogue for Mexican folklore as a product of foreign tourism and U.S. imperialism, and he characterized the popular folk artworks as "Mexican curios." He favored direct political action and public monumental art based on a universal aesthetic of plastic values—that is, experimentation in technique and form.[104]

In late 1930, when "Mexican Arts" debuted in New York, Mexicanness as a concept—though entrenched in notions of the rural, the popular, the indigenous—was still debatable as an aesthetic. At the same time that the Mexican

government sought to codify cultural nationalism, the terms of Mexicanness shifted within artists' own production. Mexican modernity was a battleground on which the state, individual artists, critics, and foreign travelers asserted their positions. The exhibition arrived at the moment when distinct entities and movements asserted competing claims. Over this cultural mix, U.S. officials and promoters favored a folkloric vision of Mexico that ostensibly offered respite from the burdens of U.S. industrialism. The terms constituting Mexicanness, therefore, were simplified for museum-going audiences in the United States.

According to Carl Zigrosser, director of the Weyhe Gallery, "It was easy for [d'Harnoncourt] to assemble the objects of applied art; for years he had been traveling all over the country gathering just such material. But collecting the modern paintings was a more difficult matter. It required all his tact and diplomacy to persuade the artists to join one single exhibition. . . . But René's mediation prevailed, and for the first time in history all the painters showed under one roof."[105] Zigrosser's comments illustrate the contentious nature of aesthetic production at the time and indicate the tensions inherent in the display of modern Mexican art, specifically in transnational dialogues.[106] The roster of painters included in the exhibition was diverse, but Rivera and Orozco enjoyed a privileged place on that roster from the outset. In his initial outline, Homer Saint-Gaudens reported, "Two excellent artists are Rivera and Orosco [sic]. The other painters . . . I have seen . . . are not of high importance."[107] An extended summary presented to potential venues noted that both Orozco and Rivera would be represented by "five oils or approximately thirty feet of wall space" and that Orozco was "second in importance only to Rivera" for the modern Mexican painters section.[108] Later, in an article that appeared in *International Studio* and coincided with the opening of the exhibition in New York, d'Harnoncourt praised the two muralists as leaders of a movement that had by then been christened the "Mexican Renaissance."[109] While most of the other modern painters were represented by only one or a few works each, the exhibition featured nine works by Rivera and eleven by Orozco. At the Metropolitan, Rivera and Orozco each had his own wall or section in the exhibition, thus setting their work apart from the rest. Rivera's prominence not only paralleled his broader cultural prestige but also corresponded to his other interests in the exhibition; he was both a member of the special advisory board and a lender (of folk art objects and one of his own drawings).[110] According to Alma Reed, Orozco selected which of his works to display, but she does not mention his involvement in the hanging. Siqueiros contributed only three small pictures, which were grouped with works by painters relatively unknown in the United States (fig. 57). Since it was unusual at the time for the muralists

FIG. 57. Siqueiros paintings (second grouping from left) on display in the "Mexican Arts" exhibition at the Metropolitan Museum of Art in New York, 1930. Photograph courtesy the Metropolitan Museum of Art.

to participate in exhibitions together, "Mexican Arts" fueled an intense rivalry between Rivera and Orozco.[111] D'Harnoncourt corroborates the competitive atmosphere Reed described by recounting how Rivera had watched him hang the exhibition in Mexico City and "became so outraged at the sight of so many Orozcos that he came back at night and rehung the show so that his pictures had the whole main wall; the others he put in the corners."[112] At the Art Center exhibition, too, the artists had jockeyed for position. While d'Harnoncourt exercised control over the folk and colonial art sections, his hands-off approach in the modern painting section exemplified the overarching dynamics of the exhibition: the curator's subordination of modern art to folk art and the promotion of Rivera and Orozco over other Mexican artists in the United States.

In the year leading up to the exhibition, Rivera worked on Morrow's Cuernavaca commission and on the murals at the Palacio Nacional in Mexico City. In addition to these efforts, he had embarked on a new series of paintings and sketches based on Tehuantepec themes. Four out of Rivera's nine works in the "Mexican Arts" exhibition contained subject matter related to the people and customs of Tehuantepec; these were images that would conceivably have fit the broader themes of the exhibit and the official *indigenismo* the exhibition supported. The most prominent of these works (although it was not part of the new series of 1930 but had been painted two years earlier) was *Baile en Tehuantepec* (*Dance in Tehuantepec*; fig. 58), which directly appropriated imagery from his famous mural cycle at the Secretaría de Educación Pública. It is based on *La Zandunga* (fig. 59), one of two mural panels depicting popular southern dances and located on the north wall of the first level of the Patio

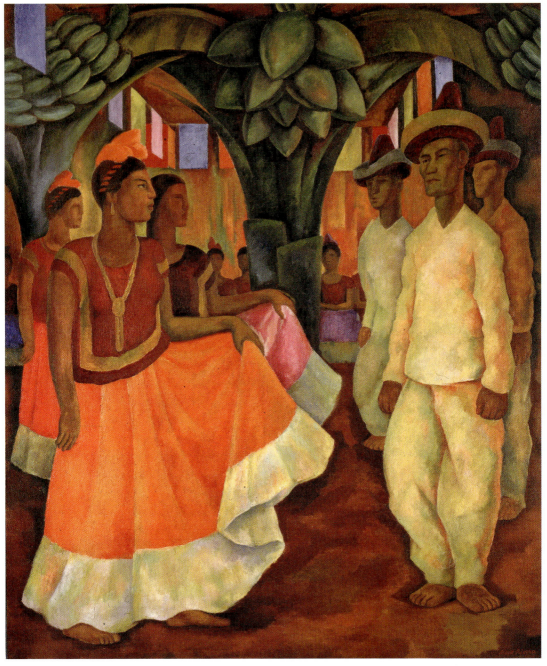

FIG. 58. Rivera, *Baile en Tehuantepec,* 1928. Oil on canvas. Private collection. © 2008 Banco de México Diego Rivera & Frida Kahlo Museums Trust, Av. Cinco de Mayo no. 2, Col. Centro, Del. Cuauhtémoc 06059, México, D.F. Photograph courtesy Sotheby's.

FIG. 59. Rivera, *La Zandunga*,
1923–1924. Fresco. Secretaría de
Educación Pública, Mexico City.
© 2008 Banco de México Diego
Rivera & Frida Kahlo Museums Trust,
Av. Cinco de Mayo no. 2, Col. Centro,
Del. Cuauhtémoc 06059, México,
D.F. Photograph by Schalkwijk / Art
Resource, New York.

de las Fiestas.[113] As an illustration of a colorful social ritual of the Mexican people, the painting, as well as its subject, promoted indigenous American cultural values.

Baile en Tehuantepec is an exceptionally large work—more than 6½ feet tall by 5¼ feet wide—making it an easel painting with all the ambitions of a mural painting. Like the mural panel on which it is based, *Baile* depicts three traditionally clad native couples engaged in the Zandunga, a folk dance from the area of Tehuantepec. As in the mural, the figures are separated by gender and arranged in a staggered fashion, and the Tehuanas wear their vividly colored local dress and traditional gold necklace.[114] But there the similarities end. By representing each of the men and women in various positions of the dance (an update of the Judgment of Paris trope from Greek mythology), the mural provides a greater sense of movement than does the easel painting, with its more static figures. In the latter, the nondescript, masklike faces are turned in profile, appearing to look intently at each other. Rivera's focus on the sensual interaction of the couples' gazes runs counter to a description of

the dance by Frances Toor, the U.S. promoter of Mexican folk culture who founded the magazine *Mexican Folkways*. She states, "The Tehuanas . . . do a simple waltz step . . . without deigning to look at their partners."[115] In the easel painting, the men stand stiffly with their hands at their sides; in the mural, they hold the more accurate posture of the dance—arms wrapped behind and hands together, resting at the buttocks. The women raise their skirts toward the men, a more coquettish gesture than in the mural, where they hold out both ends of their elaborate dresses equally, not nearly as insistently as in the easel picture. Rivera suggests flirtation by compressing the space between the two sets of figures, creating more intimacy between them. Whereas the center of the mural is empty, in the easel painting it is dominated by a large banana tree with its protruding, bulbous buds hovering above and between the two groups. Bunches of more fully formed bananas caress the outer edges of the painting and angle toward the center, to where the women's and men's gazes meet beneath the swollen buds.

The formal construction of each painting underscores the differences between them, as described above. With its more open, loose brushwork and its use of Cézannesque *passage,* the easel painting presents a more fluid atmosphere than does the mural, with its more rigid, stylized, and closed forms. The bodies of the figures are also more rounded and volumetric in *Baile en Tehuantepec,* while the bright, varying shades of the *papel picado* (paper cut into elaborate designs and used during festivities) hanging in the background—absent in the mural—add even more liveliness to a scene already characterized by a high-keyed palette. Rivera replaces the rectilinear architectural enclosure in the mural panel with tropical flora, the trunks of the banana trees standing in for the slim wooden columns of the portico. He thus removes the scene from the civilized space of the dance hall to a more "natural" and "primitive" outdoor setting. Besides the row of seated women waiting to dance in the middle ground, all other activities found in *La Zandunga,* where the dance is set within a broader social context, disappear from the easel painting. More figures populate the mural scene, where they seem to gather for a meeting in the left background and sit at a table to eat, while silhouettes of huddled women congregate in the far background. The easel painting focuses on the monumentalized dancing figures, capturing a moment of tension as the men and women lock gazes. While there is nothing overtly sexual about *Baile,* the changes made from the mural—the lush, tropical setting with its suggestive vegetation; the more libidinal palette; interactions between the figures; and loosened pictorial construction—endow it with sexual innuendo. The faceless figures, evoking a romantic, timeless world, convey eternal values and traditions of the abstracted *indio.*

According to Toor, "The translation of [Z]andunga in the Spanish diction-ary is—'gracefulness, elegance, winsomeness, allurement, fascination"—at-tributes of the dance that Rivera emphasizes.[116] If the SEP panel presents a romanticized vision of Tehuantepec by focusing on its indigenous folk cus-toms—namely, one of its best-known regional dances—its adapted coun-terpart deliberately exoticizes its subject even further. Rivera replaces the populist modernism of the mural panel with a *costumbrismo* (a style popular at the turn of the twentieth century, which rendered native subjects in a pic-turesque manner) redolent of the Spanish painter Ignacio Zuloaga. Fluctu-ating between this nineteenth-century everyday realism and the modernism of Cézanne, *Baile en Tehuantepec* frames essentialized racial and social types within a modernist sensibility.

Rivera supplemented the Indian types of *Baile en Tehuantepec* with other paintings of indigenous figures from the same region. The central figures of *Baile* appear again, reduced and isolated, in two other works: *Head of a Te-huana* and *Head of a Man from Tehuantepec*. These anonymous portraits copy the central dancing couple in the foreground of *Baile*. The works by Rivera included in the "Mexican Arts" exhibition represent a gallery of isolated indig-enous types. All of the works—apart from the mural fragment—depict a sin-gle figure, or two figures, in abstract, nondescript settings and thereby elevate them to the status of native icons. Rivera's abstraction of the Mexican Indian was buttressed in the exhibition by the wax sculptures of Luis Hidalgo. His works were of caricatural Mexican "types"—*Mexican Virgin, The Optimist, The Pessimist, The Guitar Player, Juana,* and *Pancho*—and were humorous works that enjoyed critical acclaim and commercial popularity in the United States in the 1920s.[117] They combined the humor and satire of popular Mexican tra-ditions, such as *pulquería* (tavern) painting, and José Guadalupe Posada's en-gravings and broadsheets with an updated *costumbrismo*. Displayed under glass bell jars on a long table between the two facing sections of Rivera and Orozco works (figs. 60 and 61), Hidalgo's figures reinforced Rivera's more aes-theticized types as well as the ethnographic aspect of the installation.

Whereas Rivera's works, despite their historical and temporal specific-ity, suggested a seamless correspondence with the rest of the "Mexican Arts" exhibition, Orozco's and Siqueiros's contributions contradicted its *indigeni-sta* themes and folkloric content. The three works by Siqueiros in the exhibi-tion, all dated February 1930, are products of his exile in Taxco.[118] *Two Indian Women, Mother and Child,* and *Troop Train* (fig. 62) are part of a cycle of works that he conceived as "a portrait of Mexico," with scenes of desperation, sadness, and tragedy that bore thematic and formal resemblance to Orozco's third-floor Escuela Nacional Preparatoria (ENP) murals and to some of the scenes from

FIG. 60. The "Mexican Arts" exhibition installation at the Metropolitan Museum of Art, New York, 1930. The Rivera section was on the north wall (right). Photograph courtesy the Metropolitan Museum of Art.

FIG. 61. The "Mexican Arts" exhibition installation at the Metropolitan Museum of Art, New York, 1930. The Orozco section was on the south wall (left). Photograph courtesy the Metropolitan Museum of Art.

FIG. 62. Siqueiros, *Troop Train*, 1930. Oil on canvas. Private collection. © Artists Rights Society (ARS), New York / SOMAAP, Mexico City.

the *Horrores*.[119] Perhaps as a result of seeing Orozco's work in New York in the summer of 1929, Siqueiros turned to subjects related to the ongoing events of the Revolution. In hiding and in need of money, he may have realized there was a market for such imagery. By this time, preparations for the "Mexican Arts" exhibition were in full swing, and his works must have been considered for inclusion.

Troop Train is unique in the oeuvre of Siqueiros: it is the only time the artist, who, like Orozco, participated in the Revolution but was actually an active soldier, depicted a martial scene. His other images related to the Revolution, like his various homages to Zapata or even *Two Indian Women,* invoke the heroes and participants of the civil war without representing warfare or armed struggle. *Troop Train* depicts a train cutting through a stylized landscape bordered by mountains on one side and by fields on the other. Soldiers stand defiantly on top of the train cars as though marching against the speed of the train. Movement is suggested by the thick black smoke emanating from the engine, paralleling the horizontal lines of the train itself and the meandering wall in the foreground of the picture. Brilliant passages of red move the eye from the sky beyond the mountains to the firing sparks of the train wheels, to the abstracted slender wedge of the train cars, and finally to the subtle highlights in the field. Formally, the picture is a study of contrasting shapes and forms. The sinuous curves of the mountains mirror the sculpted forms of the

FIG. 63. Agustín Victor Casasola, "The Convoy of General Obregón Leaves Mexico City for the Center of the Republic," March 1915. Fototeca INAH. © inventory number 31883. CND. SINAFO-Fototeca Nacional del INAH.

fields, while the jagged edges of the mountaintops, haystacks, and trapezoidal wall echo the staccato forms of the attenuated soldiers. Though at first glance the picture might seem to represent a scene of Revolutionary progress, Siqueiros's painting is, as José Juan Tablada notes in his review of the "Mexican Arts" exhibition, an apocalyptic image.[120] The train enters the scene from the right and appears to go on forever as both cars and figures diminish in size beyond the picture frame. The viewer knows neither where the train is going nor where it has come from, and it appears that its journey is neverending. The soldiers, too, line up in infinite numbers for a task that is insurmountable. The abstracted shape of the wall that dominates the foreground, resembling so many of the nondescript walls featured in Orozco's *Horrores* and the third-floor ENP murals, comes to an abrupt end at the left of the composition.

Troop Train thus presents a timeless scene of Revolutionary activity, one overlaid with a sense of dread and doom. Siqueiros's other contributions to the exhibition have an equally tragic and expressive aura, conveying the sadness and desperation resulting from his political and artistic disenfranchisement. A month after he created these works, he was expelled from the Partido Comunista Mexicano, and in August, he was incarcerated in Lecumberri prison for having participated in an illegal May Day march. His release in November 1930 came with the condition that he leave Mexico City and abandon political organizing, and he was exiled to Taxco with Blanca Luz Brum. In conjuring despair and Revolutionary activity, Siqueiros's paintings provided visual counterpoints to the rest of the exhibit. A painting like *Troop Train* must have summoned well-known images of the Revolution, such as those depicted in the many photographs of soldiers on rail cars that Agustín Victor Casasola disseminated (fig. 63).

Unlike the contributions of Siqueiros and Rivera, more than half of Orozco's works shown in "Mexican Arts" related to his mural production: four studies for the ENP murals; an oil painting, *Peace*, which is a variation of the mural panel *The Family* from the ENP; and *Zapata* (fig. 64) which, at nearly six feet in height, manifested all the ambition and conviction of muralism. Earlier in 1930, two figures from the *Family* panel of the ENP murals had served as Orozco's inspiration for a lithograph, *Three Generations*. As described previously, it was the last in a series of lithographs Orozco executed that year in which he appropriated iconographic elements, mostly individual figures, from the ENP murals. By isolating expressive figures within the bounds of the paper, these lithographs successfully convey the classic harmony and monumentality of the murals. Unlike the lithograph *Three Generations*, which is a direct copy of the three figures to the left in *The Family*, the oil painting *Peace* is a variation on the entire panel. Orozco uses fewer figures to convey the same narrative and replaces the arch-inscribed brick building behind the figures in the mural with a windowless structure in the painting. The central couple suggests futility and pathos; locked in an embrace, they turn their backs to us to face this overwhelming monumental architectural block while a still figure (based on Orozco's gravedigger from the ENP) lies across the foreground.

The first subject Orozco explored for the "Mexican Arts" exhibition was one he had not elaborated since his days as a caricaturist. In the 1910s, he had depicted the Revolutionary Emiliano Zapata as a treacherous leader of the Mexican peasantry. Having finished his representation of Prometheus in the Pomona College mural, Orozco returned to the equally titanic figure of Zapata, who was at that time being sanctified by the Mexican Left as an icon. As Tablada noted in his review of the exhibition, Rivera had depicted Zapata at the SEP as an "individual hero . . . as if . . . singing a sentimental tenor's aria." He continued, writing that "the same Zapata, conceived by Orozco, in the Metropolitan's admirable painting, how he really is, more than a man, humanly imperfect, an incontrastable and redemptive social force . . . such an idea assumes a terrible grandeur in Orozco's canvas and seems to deepen and expand the Metropolitan Museum's hall toward the tragic regions of the human drama of the heroic epic of Aeschylean terror."[121] Like all of the rebel figures that appear repeatedly throughout Orozco's work, his Zapata is a tragic, ambivalent hero figure caught up in violent upheaval. Orozco himself clearly linked Zapata to Prometheus when, upon finishing the pictures for the Metropolitan, he wrote to Jorge Juan Crespo de la Serna, a Mexican artist working in Los Angeles who facilitated the Pomona commission, that his painting of the Revolutionary leader was "something like a fragment of the Pomona mural."[122]

FIG. 64. Orozco, *Zapata*, 1930. Oil on canvas. The Art Institute of Chicago. Gift of the Joseph Winterbotham Collection, 1941.35. © Artists Rights Society (ARS), New York / SOMAAP, Mexico City.

The painting portrays Zapata in the doorway of a peasant's home. The blue sky beyond the entrance draws the viewer's attention to the imposing figure, who is crowded to the left and in front by soldiers. In the foreground, two peasants fall to their knees with outstretched arms, marking Zapata's entrance as a moment of intense drama. A knife blade points directly at Zapata's eye, heightening the tension, and looming shadows accentuate the dark and muted palette. The terror and fear evoked by the painting, especially by the chorus of gestures of the kneeling figures, contrasts with Rivera's representation at the SEP, where Zapata is a martyr.[123]

This canvas depicting Zapata contrasted significantly with a small oil study for the painting, now in the Museo de Arte Carrillo Gil collection (fig. 65).[124] The study barely delineates the figures as crude and archaic forms. Zapata's face is a barbaric mask in comparison with the more stoic, defeated-looking visage of the Metropolitan version. The blood red hue of Zapata's scarf is

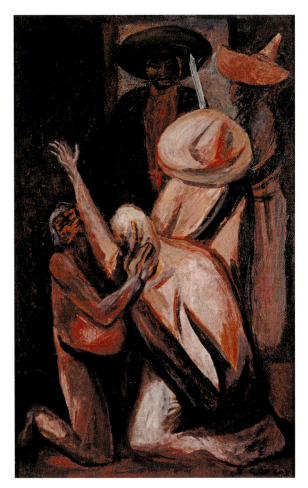

FIG. 65. Orozco, *Zapata*, 1930. Oil on canvas. Museo de Arte Alvar y Carmen T. de Carrillo Gil, Mexico City. © Artists Rights Society (ARS), New York / SOMAAP, Mexico City. Photograph by Javier Hinojosa.

muted by white tones in the finished painting. The knife blade, which already points toward Zapata in the study, takes on more aggressive meaning in the finished painting; apart from drawing attention to the figure, the blade pierces his face.[125] But perhaps the most significant difference between the two versions is how the doorway frames Zapata. In the large-scale painting, the sky beyond the opening is lightened in color, illuminating the space around Zapata, and the top of the doorway has been shortened so that it does not extend beyond the picture frame. With this contrasting shape of light color—primarily a compositional device—Zapata is surrounded by a kind of secular halo visibly absent in the study; he was thus reformulated in the painting as an iconic figure.[126]

Both versions depict what John Hutton describes as "a barely contained violence and emotional frenzy," and both are marked by ambivalence of meaning. In both versions, it is unclear whether the peasants are Zapata's help-

less victims or his followers.[127] Yet Orozco's antihero, neither clearly good nor overtly evil, definitely appears as more demonic and vengeful in the study. His features are visibly softened for the Metropolitan version, in which he is a haloed savior conveying what Reed calls a "hieratic concept."[128] While still suggesting terror and violence, Orozco tamed his initial vision of Zapata for the "Mexican Arts" exhibition and its U.S. audience.

In order to take on Rivera in the context of the United States, Orozco needed to legitimate his own status as a "Mexican" artist. As Renato González Mello has pointed out, it was Orozco himself who at various points during his artistic development in the United States hastened to consolidate his "Mexican" image. He did so with the *Horrores* images, for example, when he made them more consistent with the nationalism that was expected of them.[129] Given the motivations attributed to Orozco's participation in the exhibition, it seems evident why he chose to execute a trilogy of Mexican subjects for "Mexican Arts." In February 1930, he had exhibited at the Delphic Studios new work that "reflected his synthesis of modern trends."[130] Moving away from these esoteric and universal subjects that he had begun to explore earlier in the year, Orozco exhibited two older canvases—*Revolution* and *El muerto*—and returned to familiar ground with the three canvases made for the "Mexican Arts" exhibition. Despite the favorable critical reception of the Delphic Studios show, only two paintings from it were chosen for "Mexican Arts": the surreal *Manikins* and *Échate la otra,* which did conform to the "Mexican" themes of the other selections. On February 19, 1930, Orozco wrote Crespo de la Serna, "I feel the need . . . to propagate, as much as possible, our now famous *pulquería* painting, the best in the world."[131] Unlike large museum exhibitions such as "Mexican Arts," gallery exhibitions generally functioned as a space for experimentation. For the more public venue, Orozco deliberately reinvented his Mexicanness.

"Mexican Arts" at the Metropolitan Museum of Art

Photographs of the installation at the Metropolitan Museum of Art (fig. 66) show that the exhibition was housed in one large hall (at that time, a space set aside for loan exhibitions) divided into three sections by two sets of temporary walls set at perpendicular angles to the permanent walls. This layout allowed d'Harnoncourt to group the objects into three spatial categories of equal dimensions: popular art, colonial decorative art, and modern painting and sculpture (fig. 67).[132] Thus, while there were many more colonial and folk objects included than modern paintings, the space devoted to the modern section necessarily made it an equal third of the exhibition. Relying on a mixture of institutional display conventions—ethnographic/anthropological, salon/

FIG. 66. General view of the "Mexican Arts" exhibition at the Metropolitan Museum of Art, New York, 1930. Photograph courtesy of the Metropolitan Museum of Art.

FIG. 67. Diagram of the "Mexican Arts" exhibition layout, Metropolitan Museum of Art, New York, 1930.

museum, and trade fair/market/department store—the installation reflected a turning point in d'Harnoncourt's career: from that of his past experiences with Davis's curio shop to his future activities at the Indian Arts and Crafts Board of the Department of the Interior and with the Museum of Modern Art. With plates, textiles, and masks crowding the walls, as well as pottery, figurines, baskets, and toys jumbled together on multitiered tables and in vitrines, the historical and folk art installation was a cross between a European curiosity cabinet and a Mexican *mercado*.[133]

The table with Hidalgo's figurines under bell jars, which recalled natural history specimens on display, provided a transition from the modern art to the other sections of the exhibition. The installation of modern paintings was neater, unencumbered by artifacts strewn across tables, but still crowded with pictures stacked at times in rows of four. At several points, sculptures

vied for attention from their low-level floor pedestals beneath the paintings. Rivera's *Market Scene* rested on a low table/pedestal, presumably so that the fresco technique would be visible (see fig. 60). By removing the painting from the wall, though, d'Harnoncourt effectively equated the portable mural with artifacts displayed on tables—lacquered bowls and boxes, pottery, basketry, toys—and thus dissociated it from public wall painting, rendering it yet another "folk" product for export from Mexico. In the process, he aligned the representations of native women selling their wares in the painting with other objects in the exhibition, as if the women were conducting business within the real spaces of the museum.

Among the clutter of the other sections hung two large paintings whose dimensions approached the scale of history painting: Rivera's *Baile en Tehuantepec* and Orozco's *Zapata* (see figs. 60 and 61). Although their large format would seem to have afforded them a privileged space away from the market atmosphere, their size was undercut by their placement on the wall in the manner of the *sarape*s hung elsewhere in the exhibition. High on the walls, mostly vertical in orientation, the textiles reached beyond the upper edges of the temporary walls so that they were visible from any angle in the room. Like the *sarape*s, the two paintings by Orozco and Rivera were vertically oriented and also extended above the partitions.[134] The rhythmic pattern created by this arrangement, whereby the paintings visually echoed the *sarape*s, established a formal continuity between the folk textiles and modern easel pictures. Extending the formal metaphor into cliché, the paintings could thus be interpreted as the very fabric of Mexican identity and culture.[135]

The chaotic presentation led one critic to comment, "It was a veritable confusion of Mexican arts, like a country fair in its arrangement, but without any of the local colour which enlivens a real country fair. Fine Diego Riveras, all too few, were skied; fine pottery jars were on the floor. It gave one the intimate feeling of having been allowed in the gallery before the curators had started to arrange it, before the judges had eliminated a mass of insignificant clutter."[136] In a departure from standard practice, the exhibition had primarily natural illumination, from a large skylight that pierced the ceiling. This feature surely added to the atmosphere of an open-air market. A review in the *New York Herald Tribune* noted, "This autumn, by our good fortune, a gay hint or two of the *puesto*s [market stands] is visible right here in New York." The same review lamented the absence of regional artisans normally at work in the market stands and suggested that a few well-stocked *puesto*s be sent to New York some holiday season. Albert Franz Cochrane of the *Boston Evening Transcript* called the display at the Metropolitan "a huge toy shop thronged with visitors."[137]

Although all museum installations have their roots in commercial display strategies and share in the aesthetics of consumption, the criticism aimed at the "Mexican Arts" installation stemmed from the incongruous display of "low" art within a museum devoted to preserving canonical high culture and, more significantly, from the lack of a standard for exhibiting and displaying folk art in general in the United States.

The Metropolitan Museum of Art was the venue for one of the first exhibitions to showcase American decorative arts, specifically, American furniture made before 1815—the "Hudson-Fulton Celebration" of 1909. Unlike "Mexican Arts," however, it highlighted elegant individual pieces, thus presenting early American design as high style. The installation was sparse and austere, and it led to the permanent display of early American decorative arts at the museum. The period rooms of the American Wing continued the tradition of presenting vernacular American objects in a formal, uncluttered manner; the "Mexican Arts" exhibition was a marked departure from such precedents in terms of the installation designs and their implicit ideologies. Whereas Halsey's period rooms told the story of the white merchant classes of the eastern seaboard, d'Harnoncourt showcased humble objects made by disenfranchised Indian artisans.

D'Harnoncourt's exhibition paralleled the alliance of folk and modern art advocated by U.S. artists and collectors, most notably Charles Sheeler, an alliance just coming into prominence. The embrace of folk art, a lineage of crafted goods made by anonymous Americans perceived to have a modern sensibility, signaled not only puritan values but also a return to a plainness, simplicity, and functionalism that appealed to modern sensibilities. This less traditional and politically conservative view of Americana was only beginning to take shape publicly, and it engaged an inherently national dialogue developing in the United States. Although the promotion of Mexican crafts accompanied efforts to assert the independence of the American continent from Europe by identifying supposedly authentic native practices untainted by "foreign influences," Mexico's modernity was forsaken in favor of correlations with the presumed American values of simplicity and humbleness.

There were few precedents for exhibiting folk art in the late 1920s and early 1930s. The first public exhibition of American folk art was "Early American Art," held in February 1924 at Juliana Force's Whitney Studio Club, with objects selected by Henry Schnakenburg. It included "naïve engravings, velvet paintings, portraits, cigar store Indians, a ship's figure head, brass bootjack, and pewter sewing bowls." This exhibition was not received well. Critics complained that it presented "odds and ends of a not very early decorative art" and "inexpensive junk" not suitable for refined tastes.[138] This early presentation

FIG. 68. Installation view of the "American Folk Sculpture" exhibition at the Newark Museum, Newark, New Jersey, 1931–1932. Photograph courtesy of the Newark Museum Archives.

was followed by exhibitions at the Dudensing Gallery in February 1925, the Harvard Society for Contemporary Art in October 1930, and the Newark Museum in November 1930 and October 1931 (curated by Holger Cahill). The first exhibition in Newark, "American Primitives," focused on painting, perhaps in recognition of the negative responses to the Whitney Studio Club show, and the follow-up exhibition in Newark was "American Folk Sculpture." Despite their anonymity and perceived lack of sophistication, the primitive paintings revealed ties to European visual traditions. "American Folk Sculpture," however, suggested a "truer and more indigenous expression" of Americanness, that is, a lack of training and attention to "foreign schools." In the selection criteria for the sculpture exhibition, Cahill championed "aesthetic quality" and not only excellent craftsmanship but also "value as sculpture."[139] Both "American Primitives" and "American Folk Sculpture" established the precedent of aestheticizing these objects, thus creating a canon for folk art within the United States. With objects displayed discreetly on pedestals and within vitrines, the simple installation design of the Newark exhibitions conformed to high art conventions (fig. 68). In *American Folk Art: The Art of the Common Man in America, 1750–1900,* the catalogue for the 1932 Museum of Modern Art exhibition, Cahill acknowledged that folk art had been the province

of historical societies: there were "few pieces of American folk art in public [art] collections at that time."[140] Although the sculpture exhibition presented vernacular objects such as duck decoys and weathervane roosters, removing them from the realm of material culture and privileging style and connoisseurship over use liberated them from their status as functional commodities or "inexpensive junk." By contrast, the overcrowded "Mexican Arts" installation inadvertently reinforced the assumptions, perceptions, and expectations of folk art production that institutions in the United States were only starting to abandon.

"Mexican Arts" straddled the high art–material culture divide by presenting functional objects within a space normally reserved for high art. With this sort of presentation, the exhibition approximated the rebellious attitudes and curatorial rationales of Edith Halpert and Juliana Force, who upended established hierarchies by mixing and equalizing previously incongruous styles (modern and Victorian). Their exaltation of the unsophisticated, however, occurred in a setting not quite as public as the Metropolitan Museum. Furthermore, although the pairing of Victoriana with modern art had constituted a chronological or stylistic dissonance, in the case of "Mexican Arts," the alliance of modern with folk styles of art served merely to strengthen a sense of timelessness and historical continuity.

Reception

"Mexican Arts" garnered a significant amount of interest, but the commentaries often concentrated on the diplomatic efforts of the show. Though it was by far the largest painting in the exhibition, *Baile en Tehuantepec* received scant attention in the hundreds of national newspapers and journals that reviewed the touring exhibition.[141] Those reviews that delved into the aesthetic and historical questions surrounding the exhibition often appropriated verbatim extracts from d'Harnoncourt's many writings, in which he almost never singled out any modern artist or work.[142] In these writings, d'Harnoncourt provided many more details about Mexican popular arts than modern painting, perhaps because of his greater familiarity and experience with the former. Although in one article he stated that the modern paintings were "selected to give a diversified and comprehensive review of the present-day activity of the Mexican artist," his brief descriptions present contemporary artistic practice as a unified movement.[143] By not naming names, d'Harnoncourt treated the modern artists like the anonymous regional artisans represented in the rest of the show.

According to Sarah d'Harnoncourt, "The contemporary art section was very much a part of the exhibition from the beginning."[144] Yet, to judge from

René d'Harnoncourt's writings, from the installation of the exhibition, and from its reception, the modern works served to illuminate the folk art on display. The works by Orozco and Rivera could not be seen on their own terms because they were incorporated into the broader narrative of promoting the values of popular arts and crafts. Within this framework, modern Mexican art was an extension of Indian folk art and crafts, not just in iconography but in formal style as well. D'Harnoncourt suggested that the frescoes glorified "Mexican subjects in a Mexican way."[145] For him, the rural artisans, the makers of the popular objects, were embodied in the Indian types parading through the paintings by Rivera, Siqueiros, Orozco, Mérida, Covarrubias, and others.

The rhetoric surrounding the exhibition echoed d'Harnoncourt's sentiments. Modern paintings were discussed as ciphers through which the folk artifacts could be understood, and the artists themselves were linked to the rural peasants. For example,

In the more sophisticated and calculated art of Orozco, Rivera, Castellanos, and their compatriots, the simple peasant work finds amplification. . . . To comprehend the full significance of the crudely painted gourds, lacquer boxes, woven baskets, and rough pottery jars, it is necessary to see them through the eyes of Mexico's revolutionary painters, Orozco, Rivera, Castellanos, Mérida, and their peers.

It is their sympathetic understanding which makes the revolutionary painters true interpreters of their people. They . . . possess similar qualities of spirit.[146]

New York Times critic Edward Alden Jewell promoted d'Harnoncourt's view of modern artists as counterparts to anonymous regional artisans: "Inescapable as one passes from water jars to religious symbols, from children's toys to the work of great artists like Rivera and Orozco, is the sovereign spirit of anonymity." *New York Herald Tribune* critic Royal Cortissoz suggested Rivera's sole aesthetic accomplishment was his "alliance with that native well-spring of energy which we have identified in the anonymous potters."[147]

Despite the national attention it received, "Mexican Arts" drew very little commentary about modern art in general and the works by Orozco, Rivera, and Siqueiros in particular. The last went virtually unnoticed; Orozco and Rivera received but a few glowing appraisals.[148] For some, Orozco's works exhibited a raw energy and power, while others suggested that his dark, turbulent canvases spoiled the "spirit of friendliness" evident in the rest of the exhibition. Comparing the two artists, a reporter from the *Detroit News* offered the following: "[Rivera] records the doings of the marketplace, of the festive dance, even the poor in their dooryards, with directness and simplicity but without

the note of tragedy [of Orozco]."[149] Rivera's works—far less contentious than Orozco's and Siqueiros's and more in keeping with the folkloric values of the rest of the exhibition—elicited comments that the exhibition was "strikingly colorful" and "the gayest show you can possibly imagine."[150]

Despite various nods to muralism in the exhibition—the preparatory sketches, large-scale works, mural copies, and mural fragment—critics argued that one needed to travel to Mexico to see the real Mexican mural renaissance.[151] They specifically lamented the inadequate representation of Rivera in this regard. Helen Appleton Read of the *Brooklyn Daily Eagle* complained, "Diego Rivera must always be inadequately represented in any traveling exhibition, since his best work is mural painting." Margaret Breuning of the *New York Evening Post* also believed that "Diego Rivera's work cannot be known without seeing his great murals."[152]

Needless to say, the traveling exhibition was not exactly a suitable forum for muralism. As discussions of muralism occurred more frequently in the United States, exhibition organizers and artists worked to overcome this inherent limitation. One solution was the portable mural panel.[153] Another was large-scale photographic reproductions of murals.[154] One problem with "Mexican Arts," however, besides the fact that it was a traveling exhibition, was the inadequacy of the enterprise itself to properly frame a discussion of the muralists' production. Orozco had completed the first Mexican mural in the United States several months before the exhibition's opening in New York, yet it seems never to have been mentioned in conjunction with "Mexican Arts," even when the exhibition traveled to Los Angeles, not far from Claremont and the *Prometheus* mural at Pomona College. During the two-year period in which the exhibition traveled around the United States, Orozco unveiled his mural at the New School for Social Research and Rivera completed murals at the San Francisco Stock Exchange and the California School of Fine Arts— none of which produced a mention in the critical reviews of "Mexican Arts."[155] In many ways, muralism was a ghostly presence in the exhibition itself. The exhibition catalogue describes the four mural studies for Orozco's ENP murals and Rivera's study for his cycle at the Secretaría de Salubridad y Asistencia in Mexico City merely as drawings. Without wall labels or a catalogue essay to discuss them, these studies were displayed in an aesthetic vacuum. Some critics were not pleased with the paintings from the outset. Margaret Breuning commented that they were the "least felicitous feature [of the exhibition] as a whole, for the Mexican artist seems to have a reversion to murals, and alas! walls can not be transported casually hither and thither. Moreover, the work of Charlot, Orozco, Carlos Mérida, Pacheco and many other artists represented

here has been shown more comprehensively through exhibitions already held in local galleries, so that these examples prove rather disappointing."[156]

Perhaps as a result of such critiques, d'Harnoncourt finally addressed the question of murals in 1932. He suggested that the easel paintings could in fact be seen as replacements for the murals: "Fresco painting in Mexico has also exerted a great influence over easel paintings. Any exhibition of the works of the younger artists in Mexico has in subject matter, color and ideology—and almost in treatment—the life depicted in the frescoes." But it was too little, too late. At a crucial time, when the exhibition could have provided a forum for the muralists' production and advanced the possibilities for public mural painting in the United States, it merely—as James Oles has put it—"grease[d] the wheels of diplomacy."[157]

Breuning claimed in her review that the exhibition did little to increase the New York art-viewing public's knowledge of modern Mexican art in light of the many gallery exhibitions that had already featured their work. But what was the response to the exhibition in the rest of the country? From the beginning there was overwhelming national interest in the exhibition and some desire to extend its tour. Because the American Federation of Arts and d'Harnoncourt were overwhelmed with requests from institutions around the country to host the exhibition, they filled the itinerary for one year with the hope that it could continue for a second year.[158] The Carnegie Corporation provided additional funds, and on February 27, 1931, Morrow secured permission from the Mexican government to circulate "Mexican Arts" for another year.[159] According to Frederic Allen Whiting, head of the American Federation of Arts, the revised schedule had been decided "in consultation with Mr. Morrow, and the [venues] selected from among a great many applicants, as the best . . . from the standpoint of a better understanding with Mexico."[160] When the exhibition traveled to Albuquerque, the governor of New Mexico requested that it also be sent to Santa Fe, a stronghold of the Native American craft revival.[161] The tour dates were already set, however, and the governor's request could not be granted. Other cities highlighted their successful efforts to receive the show. For example, "After visiting ten other cities, the collection has reached St. Louis. . . . It was only due to the persistent efforts of Meyric Rogers, director of the [City Art Museum] that St. Louis was included in the itinerary since as its fame grew, requests for the exhibition were received from forty-eight different cities."[162]

At each venue, the exhibition broke attendance records; the statistics were enthusiastically reported in newspapers across the country. In Boston, the Mexican consul general estimated four hundred people visited the exhibi-

tion during the week and seven hundred on Sundays.[163] In San Antonio at the Witte Memorial Museum, six thousand people attended on one Sunday—"the largest attendance yet to be had"—and the following Sunday a new attendance record was set when more than eighty-five hundred visited the exhibition.[164]

D'Harnoncourt had speculated that "Mexican Arts" enjoyed great success in New York in part because of a link to the celebrated aviator Charles Lindbergh: he had married Dwight Morrow's daughter, Anne, and the couple's first public appearance after their wedding in New York was at the opening of the exhibition. Institutions in border cities such as El Paso, meanwhile, attributed interest in the exhibition to their large Mexican populations, although no accounts survive to document any specific reactions.[165]

In New York, the critics may have been familiar with the work of the modern art painters, but some of the rhetoric surrounding the exhibition in other parts of the country hinted that non–New Yorkers were less aware of these artists' production and more satisfied with the regional handicrafts exhibited. In Los Angeles, according to Arthur Millier, "In general, the handicrafts were received better but nonetheless it was surprisingly large the number of people who reacted to seeing for the first time the works of the revolutionary painters in Mexico." Mrs. Malcolm McBride, an active collector of Mexican art at the time, wrote Erhard Weyhe that "the Mexican exhibition is here at the Cleveland Museum now and interests me very much indeed though the pictures are so strong and primitive in their character that they are rather strong meat for a good many people here." In Houston, one commentator explained that "the applied arts appeal more directly than the fine arts because they are more understandable. They also are the truer form of self-expression of the Mexican people as a whole."[166]

"Mexican Arts" attempted to reconcile the primarily rural character of Mexico with modernist aesthetics. Yet in the end, the huge popularity and success of the exhibition were due mostly to its promotion of the artisanal, rural, and traditional values of popular art. In New York, an observer noted the enthusiastic response to the exhibition and the concomitant folkloric craze when he told Anita Brenner, "The town is slowly turning Mexican on us. We shall all be sleeping on *petates* yet."[167] Following d'Harnoncourt's example in his own writings, reporters and critics around the country routinely focused more of their attention on the popular art section than on the modern painting.[168] Decorative arts and handicrafts were the most favorably received aspect of the exhibition, and the popular press was inundated with enthusiastic responses to Mexico's "primitive" national culture. The success of the exhibition did little to strengthen the modern painters' position in the United States,

however, and even less to promote Mexican muralism. Not a single mural commission resulted from the exhibition, but the response to Mexico's crafts was so great that the American Federation of Arts circulated a smaller selection of 325 folk art objects from the original assemblage just four months after the first tour ended.[169] This time around, modern art was cut altogether from the exhibition program so that only the picturesque and quaint products of native artisans would appear.

Stoked by the "Mexican Arts" exhibition and the attendant interest in Mexico's folk culture, the theme of the urban/rural dichotomy in U.S. life took on heightened importance as intellectuals sought moral and spiritual renewal. In the face of increased modernization, writers and activists such as Stuart Chase looked to Mexico for spiritual guidance. A *Study of Two Americas,* his 1931 romantic idyll that proposed a return to simpler times and a more "authentic" peasant culture, had its visual roots in the exhibition's promotion and exaltation of traditional culture. "Mexican Arts" showed Americans that the art of the country was a "natural expression of a naïve, beauty-loving, and imaginative people."[170]

The stated purpose of "Mexican Arts" was to project a new image of Mexico, one far removed from the land of "beggars, bandits and revolution," as it had come to be known.[171] In the end, this negative image was merely replaced, and in some ways bolstered, by an image of the country as primitive, rural, and picturesque. In many ways, the exhibition did not change public opinion in the United States about the neighbors to the south, as is most evident in negative representations of Mexico in Hollywood films from the 1930s, such as *The Girl of the Rio* (1932), *Viva Villa* (1934), or *The Gay Desperado* (1936).[172] Instead, "Mexican Arts" served to promote the tourist trade and reduce Mexican culture to accents of local color and design in American home decoration. Malcolm Vaughan, writing in 1935 for the *New York American,* attributed the craze for Mexican decorative ensembles in the 1930s in part to the "Mexican Arts" exhibition:

If you doubt that our art museums influence the home, consider the results of two New York museum exhibitions on the taste of the public. Five years ago the [Museum of Modern Art] held a great show of Mexican paintings and the Metropolitan gave us an enormous display of Mexican craftwork. Not long thereafter dealers' galleries began to exhibit Mexican paintings and prints; several department stores added a counter of Mexican pottery, glassware and gourd ornaments such as had been on view at the Metropolitan, and then numerous little shops about town touched up their show windows with decorative objects of Mexican craftwork.[173]

And in 1939 Frances Toor noted,

Since [the "Mexican Arts"] exhibition the Mexican handcrafts have acquired an amazing popularity. It has come with the enormous increase in the number of U.S. tourists coming to Mexico. They take them back literally by the carload. As a result innumerable popular art shops have been established in the larger cities, situated in tourist centers, and the production has grown by leaps and bounds. But the demand for the Mexican handcrafts in the U.S. has not stopped with the tourists. At first small shops were opened there and now the largest and most important department stores are carrying them. . . . This enormous growth in the volume of business in the popular arts must of necessity have its effects on both the craftsmen and the crafts.[174]

But the boom in the Mexican crafts business did not economically benefit the Indian artisans as Frances Flynn Paine had intended. According to Toor's paternalistic views, artisans failed to profit from the increased interest in their products not because of the harsh inequities of an underdeveloped economy dependent on U.S. investment but because they supposedly were not innately good at conducting business: "The Mexican indian has never been a good bargainer. . . . He does not know the value of time in a handmade object, and is glad to obtain a little above the cost of his raw materials."[175] D'Harnoncourt's attempts to resist tourist trade aesthetics by idealizing Mexican folk art merely replaced one set of hierarchical values (high versus low art) with another (the notion of authenticity).

Although d'Harnoncourt was well intentioned, his desire to promote a positive image of Mexico effectively erased all signs of the turbulence, unrest, and oppression that shaped the country's history and its economically disenfranchised position. D'Harnoncourt's vision of Mexico at this time, a perspective wholly reiterated by the ethos of the exhibition, reflected a detached, aristocratic view: "Mexico was really terribly exciting around 1928 and 1929; the nation's whole intelligentsia felt very strongly that this was a period of great social and artistic and intellectual revival. Add to the fact that things were so picturesque—a lot of little revolutions were going on—and the result was a rather interesting unrest."[176] Only someone far removed from the harsh realities of the Revolution could find it scenic and quaint.

Always the amiable diplomat, d'Harnoncourt was a most effective envoy for an official exhibition such as "Mexican Arts." He was a magnificent storyteller who seized the opportunity to bring life to his adventures in Mexico. While preparing the exhibition, he wrote to Elizabeth Morrow, "I just returned from a most exciting trip into the interior of Michoacán where I found material for the exhibit and for the shop and such an amount of legends and sto-

rys [*sic*] that I just can't wait to exploit them some way."[177] Those legends and stories found their way into the narrative of the exhibition; engrossed by the disparity between d'Harnoncourt's noble heritage and his ventures into the little-known territories of Mexico's interior, the press repeated endless tales of Count d'Harnoncourt's romantic and exotic trips by horse-drawn carriage, oxcart, or mule into the most remote regions of the country. Less concerned with the actual labor that went into the production of the artifacts, reporters focused instead on the incongruous image of an aristocrat carrying pottery on his back while riding a donkey.[178]

In the end, the exhibition never surpassed the confines of d'Harnoncourt's storytelling. In a tribute to him, Carl Zigrosser summed up his particular talents in a way that explicates the ideology and dynamics of the "Mexican Arts" exhibition. Describing a talk d'Harnoncourt gave on José Guadalupe Posada's Mexico, Zigrosser noted,

D'Harnoncourt did not project all of Posada's Mexico: he played safe and said nothing about oppression and revolution, except for a reference at the very end. . . . Playful irony, comic bits, and genuine *vacillada* [were the] keynote[s] of his own *Weltanschauung*. He looked at life as a charming spectacle and saw only those things which were amusing and charming. *He never challenged, he entertained, and people liked him for it.* It is curious that with his aristocratic background he should understand so well and be sympathetic with—yet always with the slightly superior attitude of finding it amusing—the little man, the petit bourgeois, the Indio with his burden, the plight of the individual.[179]

It was the search for common American cultural origins that prompted one of the first large-scale exhibitions of Mexican art and informed its portrayal of modern Mexico as timeless, rural, and picturesque. The history of the exhibition demonstrates how a very defined circle of writers and wealthy patrons brought Mexican art to the attention of the U.S. public, for reasons that were hardly disinterested: Morrow's diplomatic efforts, Paine's economic interests, a burgeoning nationalism in the United States, and the Mexican government's own attempts at national consolidation. Mexican muralism and politicized public painting were lost in that shuffle.

4

MURAL GAMBITS

In December 1931, while the "Mexican Arts" traveling exhibition made its eleventh stop at the Art Institute of Chicago, a large retrospective exhibition of the work of Diego Rivera opened at the new Museum of Modern Art (MoMA), offering New York's museum-going public an unprecedented glimpse of the muralist's production to date. Murals, ignored in "Mexican Arts," reclaimed center stage at MoMA, as Rivera created eight portable fresco panels expressly for the exhibition.

Between 1930, when Rivera arrived in the United States, and the opening of his exhibition at the MoMA, he had completed three murals in the San Francisco area: *Allegory of California* (1930) at the Pacific Stock Exchange, *Still Life and Blossoming Almond Trees* (1931) for the Sigmund and Rosalie Meyer Stern residence, and *Making a Fresco, Showing the Building of a City* (1931) for the California School of Fine Arts. Whereas *Making a Fresco* prompted fervent public scrutiny in the local newspapers, the other two frescoes remained thoroughly private commissions in secluded spaces, limited in their potential to attract wider audiences.[1]

Less than six months after returning to Mexico from San Francisco in 1931, Rivera came back to the United States as the first artist after Henri Matisse to have a MoMA exhibition devoted solely to his work. His exhibition at the preeminent museum represents one of the most significant events of the

1930s through which to examine not only his appeal to audiences in the United States but also the way Mexican muralism came to be understood by and exhibited and promoted to U.S. residents. Because Rivera's murals in Mexico had attracted considerable attention in the United States, patrons and critics labored to understand the artist's significance.[2] Portable frescoes intervened as conduits through which the public grappled with the artist's legacy, therein establishing a critical dialogue between the murals produced in Mexico and the artist's production in the United States.

Preparing the Wall

In the year leading up to the retrospective at the Museum of Modern Art, several events set the stage for Rivera's debut in New York. In November 1930, before he even began the murals at the Pacific Stock Exchange and the California School of Fine Arts, an exhibition at the California Palace of the Legion of Honor welcomed him to San Francisco. This first large-scale exhibition in the United States devoted to him included more than 180 works—oil paintings, drawings, watercolors, sketches for frescoes—and filled three floors of the Legion of Honor building.[3] Rivera's commission for the Pacific Stock Exchange had engendered a local controversy because of the artist's communist ideology; in addition, some Bay Area artists had argued that, given the depressed economic times, the commission should have been awarded to a local artist. Lloyd LaPage Rollins, the Legion of Honor's new director, decided to exploit "the free advertising occasioned by this dispute." Seeking to make his first exhibition as director especially interesting, Rollins decided to "take advantage" of the Rivera controversy "to arouse local interest."[4] From the outset, then, controversy defined Rivera's transnational appeal.

At this point, the artist's international prestige, formed by the legacy of his Mexican murals, also compelled the need for new strategies of display and circulation. As soon as Rivera began exhibiting widely in the United States, the absence of murals posed a problem. In looking behind the scenes of his first retrospective exhibition, and many exhibitions that followed, one can see that curators and museum directors relied on photographic substitutes to take the place of immobile murals. At the Legion of Honor exhibition, seventeen photographs stood in for the Secretaría de Educación Pública murals, fourteen photographs by Manuel Álvarez Bravo served as proxies for Rivera's recently completed Palacio de Cortés cycle in Cuernavaca, and another three photographs allowed his Chapingo murals to be viewed, augmenting the already large body of work on display.[5] Although Rivera had originally suggested that Rollins exhibit his drawings for the grisaille frieze painted below the frescoes in the Palacio de Cortés, it remains uncertain whether they were included.[6] It

seems likely that Rollins would not have considered the drawings appropriate stand-ins for the mural cycle, since they documented less prominent portions of the overall narrative scheme. Photographic reproductions of the central panels served as more definitive surrogates for the Mexican murals.

Photographs of the murals were essential in other contexts as viewers in the United States learned more about muralism. While periodicals such as *Art Digest* and *Creative Art* often ran lengthy articles on Rivera and Orozco in the early 1930s, even magazines such as *Fortune* introduced readers to the work of the muralists.[7] In all of these publications, the Mexican murals stood out as the artistic products with which the public needed to contend in order to understand the artists and the movement properly. Then, too, promoters of Mexican art in the United States, such as Frances Flynn Paine—purchasing agent for the Rockefellers—actively pursued mural commissions for Rivera by exploiting large-scale photographic reproductions. For the international division of the Fourth Biennial Architectural and Allied Arts Exposition, for example, held at the Architectural League in New York from April 18 to April 25, 1931, Paine made use of photographs of Rivera's Cuernavaca frescoes.[8] Through photographic reproductions, promoters attempted to generate interest in the artist and, at the same time, unwittingly provided an opportunity for viewers in the United States to engage in a dialogue about the artist's leftist politics.

While praising the "passion, eloquence, and beauty" of the mural panels in his review of the Architectural League exhibition, the conservative critic Henry McBride considered Rivera's association with radical politics "dangerous." He cautioned young painters in the United States about the risk of using Rivera as a role model, claiming that "the most dangerous tribute that can be paid to such [an artist] is that of imitation."[9] McBride's warning reinforces Rivera's position in the United States in the 1930s as an artist of substantial yet questionable appeal because of his radical politics. Before Rivera arrived in New York, his presence in San Francisco "marked the beginnings of a debate about the complex relationship between murals, the left, and the public."[10] With the rising importance of art among those on the Left in the United States, Rivera's U.S. reception became part of a broader dialogue about the social role of the artist, the conflict between Marxist politics and modernist aesthetics, and the fate of public art.

It was at this moment, when photographic substitutes perhaps highlighted Rivera's problematic status as a gifted but radical painter, that the Museum of Modern Art decided to mount a major retrospective exhibition. Given his reputation, it is important to examine how, when organizing its retrospective, the museum attempted to disengage the muralist from the clutch

of radical politics by championing his aesthetic innovations and downplaying the politicized, Revolutionary nature of his subject matter. In this effort, the portable fresco intervened—unsuccessfully—as both an artistic and a political strategy.

Rivera's Gambit

From the initial planning stages, murals created especially for the exhibition were to be the central feature of Rivera's retrospective. A year before the exhibition opened, *Vogue* had reported, in an article about the artist's murals in Mexico, that he would paint "a series of fourteen-foot canvases" for the Museum of Modern Art retrospective.[11] In November 1930, when this announcement appeared, Rivera had recently completed *Market Scene,* the first portable fresco panel in the history of Mexican muralism (discussed in chapter 3). The execution of this portable panel certainly provided the artist and exhibition organizers at MoMA with the idea of creating more for his New York retrospective.

The director of the Weyhe Gallery, Carl Zigrosser, eagerly anticipated Rivera's retrospective. A few months before it opened, he wrote to William Spratling, an architect from the United States who had established residence in Mexico and who acted as mediator between Rivera and Zigrosser, asking about the material Rivera was to exhibit:

Do you know what will be in the Modern museum show? Do you think Diego could be persuaded to paint some more children's portraits? We would be willing to buy some more portraits. What about Diego's assurance that we were to be his New York agents, when Mrs. [Frances Flynn] Paine comes horning in like that. Any possibility of buying part of the Modern Museum show? Please try and find out if he has any portraits ready for the show and whether there are to be any cartoons or colored drawings of the frescoes (which is another thing I talked about and commissioned him to do). Any fragments of real frescoes also would interest us.[12]

Zigrosser, restless to become Rivera's agent in the United States and to profit from that association, specifically sought out marketable children's portraits and fresco-related products from the artist. Aware of the need to make the frescoes "available" to the market in the United States, he proposed distributional formats, such as fresco fragments and colored sketches of murals, that could convey the imagery of the Mexican murals and be sold as one-of-a-kind, independent works of art.

From the beginning of the publicity campaign for its exhibition, the Museum of Modern Art promoted the movable frescoes as the main draw. Once Rivera arrived in New York, MoMA's orchestration—having the muralist

FIG. 69. Rivera painting *Liberation of the Peon* in a studio in the Heckscher Building for inclusion in his retrospective at the Museum of Modern Art, New York. © The Museum of Modern Art/Licensed by SCALA / Art Resource, New York.

paint the panels on location in a makeshift studio on the sixth floor of the museum's headquarters in the Heckscher Building (fig. 69)—turned out to be a highly publicized performance that sparked even greater interest in the murals. Though Rivera did not paint in public, as Orozco would nine years later for another exhibition, "Twenty Centuries of Mexican Art," critics, reporters, and other insiders visited the museum to see Rivera's progress.[13]

Several critics considered Rivera's performance at MoMA unprecedented. Dorothy Dayton, writing for the *New York Sun,* commented, "The unusual thing about this exhibit is that Mr. Rivera is going to run up the work for it while he is in New York. . . . His exhibition at the Museum of Modern Art will be . . . the first one ever held in New York which was 'made to order.'"[14] Besides painting works expressly for the exhibition, Rivera did so on location within the walls of the museum—but not, of course, *on* the walls—and he painted in true fresco, a medium seldom used at the time.[15] Critics commented on how quickly he finished eight large frescoes—a "prodigious pictorial stunt."[16] All of these factors drew attention to the artist's presence at the Museum of Modern Art, even before the exhibition opened. Because only five murals were ready in time for the opening in December, Rivera's performance continued to generate publicity for the exhibition as reporters visited his studio in the early days of January 1932. A second opening unveiled three more frescoes.[17]

The Painting Coat

The eight large-scale panels (all about five by eight feet) fell into two series, one regarding Mexican history and the other on New York industry. Of the former, four panels recycled and distilled the more political imagery from Rivera's murals in Mexico, including *Agrarian Leader Zapata, Sugar Cane,* and *The Knight of the Tiger* (*Indian Fighting*), all adaptations of Cuernavaca panels, and *Liberation of the Peon,* a reproduction of a fresco from the Secretaría de Educación Pública. The fifth panel, *Uprising,* was an original composition, but its theme echoed murals from the third floor of the SEP. The New York series—consisting of *Frozen Assets, Electric Welding* (*Electric Power*), and *Pneumatic Drilling*—comprised new scenes inspired by Rivera's firsthand observations of industry and labor in the United States.

Critics focused on the Mexican-themed murals; as the *New York Post* art critic Margaret Breuning elaborated, they were the "most engrossing, since it is upon [Rivera's] original statements of these themes that his reputation rests as a great mural painter." Thus, Breuning continued, portable frescoes purported to provide the museum-going public with the opportunity to assess Rivera's frescoes, "which figure so strikingly in the tales of returning travelers" to Mexico.[18] In other words, Rivera's international cultural prestige depended on his Mexican mural production and the elaboration of a nationalist imagery; viewers in the United States eager to see directly both the scale of the murals and their Mexicanist iconography snubbed the New York–themed portable murals as idiosyncratic divergences from his typical oeuvre. Moreover, in what amounted to xenophobic rhetoric, critics argued that a Mexican artist unfamiliar with New York and the United States could not adequately depict the city.[19]

Rivera's reworkings of his murals in Mexico for the retrospective, especially *Agrarian Leader Zapata, Sugar Cane,* and *Liberation of the Peon,* represent radical departures from the original scenes.[20] He made numerous iconographic changes to the portable frescoes based on Mexican murals. Although I agree with past assessments that changes were made to aestheticize and depoliticize the murals, more significant is the critical reception of these works. Analyzing that response allows us to assess the new meanings produced by these alterations.

Agrarian Leader Zapata (fig. 70) is a detail of a large fresco in the Palacio de Cortés in Cuernavaca (fig. 71), the same cycle from which Rivera appropriated imagery for his portable fresco *Market Scene.* The original Zapata panel depicts "a group of motifs symbolizing the Indian condition following Spanish colonial rule in Mexico," including images of campesinos hanging from gallows, families grieving, and others fleeing villages.[21] The detail fragment

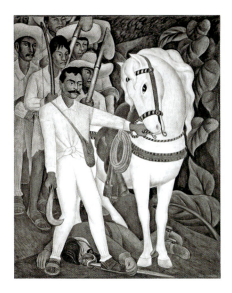

FIG. 70. *(left)* Rivera, *Agrarian Leader Zapata,* 1931. Portable fresco. The Museum of Modern Art, New York. Abby Aldrich Rockefeller Fund. © 2008 Banco de México Diego Rivera & Frida Kahlo Museums Trust, Av. Cinco de Mayo no. 2, Col. Centro, Del. Cuauhtémoc 06059, México, D.F. Digital image © The Museum of Modern Art/Licensed by SCALA / Art Resource, New York.

FIG. 71. *(right)* Rivera, *Zapata* detail (left side of arch) from *The History of Cuernavaca and Morelos,* 1930. Fresco. Palacio de Cortés, Cuernavaca. © 2008 Banco de México Diego Rivera & Frida Kahlo Museums Trust, Av. Cinco de Mayo no. 2, Col. Centro, Del. Cuauhtémoc 06059, México, D.F. Photograph by Schalkwijk / Art Resource, New York.

created for the U.S. audience eschews these violent and tragic scenes and instead focuses on the figure of Zapata and his white horse.[22] In contrast to the tense historical moment of the original fresco, the mural fragment elicits a sense of tranquility, enhanced by the scene's tropical setting. An overall schematized design and decorative elements, such as the horse's accoutrements, contribute to Zapata's transformation from Revolutionary peasant leader to aestheticized icon. Depoliticized, dehistoricized, fragmented, and isolated, the image of Zapata is ripped out of the broader historical context that the original mural elaborates.[23]

While each of the Mexican-themed portable panels represents a departure from its original source, *Sugar Cane* (fig. 72) best illustrates the distinction between the portable panels and the murals, as well as the public dialogue this opposition provoked. Rivera based the panel, measuring approximately 4½ by 8 feet, on *Slavery in the Sugar Mill* (fig. 73), a portion of a fresco at the Palacio de Cortés in Cuernavaca that is three times the size of the portable

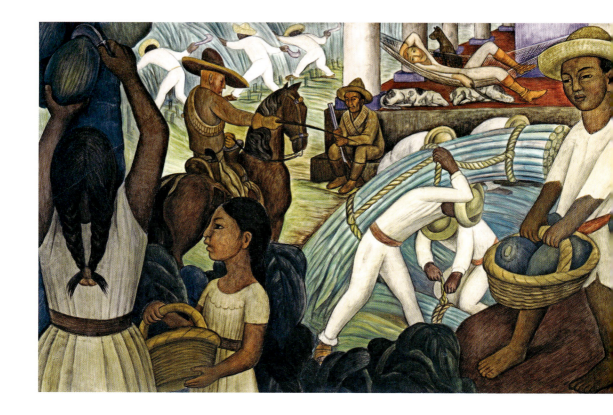

FIG. 72. *(above)* Rivera, *Sugar Cane,* 1931. Portable fresco. Philadelphia Museum of Art. Gift of Mr. and Mrs. Herbert Cameron Morris, 1943. © 2008 Banco de México Diego Rivera & Frida Kahlo Museums Trust, Av. Cinco de Mayo no. 2, Col. Centro, Del. Cuauhtémoc 06059, México, D.F.

FIG. 73. *(opposite)* Rivera, *Slavery in the Sugar Mill,* detail from *The History of Cuernavaca and Morelos,* 1930. Fresco. Palacio de Cortés, Cuernavaca. © 2008 Banco de México Diego Rivera & Frida Kahlo Museums Trust, Av. Cinco de Mayo no. 2, Col. Centro, Del. Cuauhté-moc 06059, México, D.F.

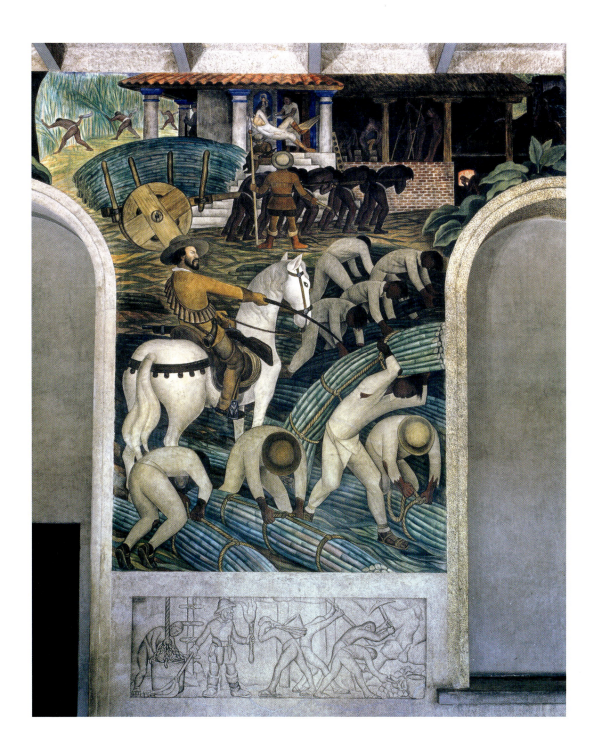

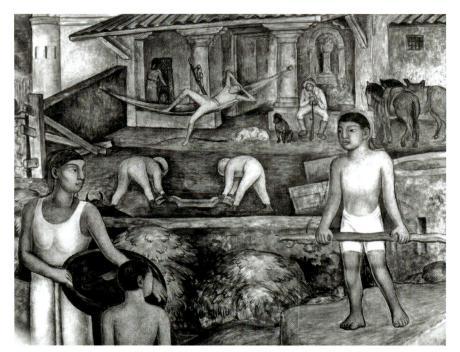

FIG. 74. Rivera, *Plantation,* 1928. Fresco. Secretaría de Educación Pública, Mexico City. © 2008 Banco de México Diego Rivera & Frida Kahlo Museums Trust, Av. Cinco de Mayo no. 2, Col. Centro, Del. Cuauhtémoc 06059, México, D.F. Courtesy Jean Charlot Collection, University of Hawai'i at Mānoa Library.

panel. *Slavery* is part of the same monumental mural cycle from which Rivera appropriated imagery for *Market Scene. Slavery* itself recycles imagery from one of Rivera's previous murals; the background scene of a plantation owner languishing in a hammock is a detail found in the *Plantation* panel on the stairway between the first and second floors of the Secretaría de Educación Pública (fig. 74).

Of all of the portable panels Rivera produced, *Sugar Cane* underwent the most radical alteration from its original source.[24] To begin with, the shift in title from a proclamation of brutal oppression (*Slavery in the Sugar Mill*) to the "safer" reference to the harvested product (*Sugar Cane*) displaced attention from the labor and violence that support the economic infrastructure of the plantation. Next, most of the compositional and iconographic changes reflect Rivera's attempt to merge imagery from *Slavery in the Sugar Mill* with the background scene of the *Plantation* panel from the SEP. The ensuing shift from a vertical to a horizontal format is partly the result of Rivera's reverting to the composition of *Plantation,* which conformed to the spatial requirements of the stairwell wall; at the same time, it is significant that this format is associated with panorama and landscape painting. The format isolates the scene

from the larger narrative by associating it with the more innocuous genre of *costumbrista* painting.

To accommodate this orientation and merging of two mural panels, Rivera reduced from eight to four the number of hardworking peasants who cart heavy bundles of sugarcane—their rounded backs conforming to the weight of the bundles—and relegated them to the middle ground. In the original fresco, the clothes of the peasants in the lower right foreground are markedly weathered, torn, and tattered, strengthening Rivera's Marxist critique of the subjugation endured by rural workers under colonial rule, whereas the same figures in the portable fresco wear crisp, clean white garb.[25] He also considerably reduced in size and prominence, and displaced to the middle ground, the foreman, who is mounted on a horse overseeing the peasants. Rivera updated the foreman from a colonial figure to a contemporary *hacendado*.[26] The group of ten naked Indians pulling a heavily loaded cart and monitored by a guard with a pointed spear disappears altogether, as does the mill with workers in the refinery. The plantation owner still languishes in his hammock, but without the icon of the Virgin above his head or the Indian woman serving him food, details that add to the social discourse of the original. The guard watching the peasant workers in the field in the upper left-hand corner of the mural has been replaced in the fragment by an attentive watchdog. Rivera most drastically and incongruously altered the scene by adding several prominent figures to the foreground: a large woman cutting fruit from a papaya tree, accompanied by a girl holding a soon-to-be-filled basket and a boy carrying a basket full of freshly cut papayas—figures that recall rather than replicate similar ones in the *Plantation* scene of the SEP. The pastiche of incongruous elements from disparate mural panels displaces the image of brutality found in the Cuernavaca panel and transforms the portable fresco into a picturesque genre scene, while the panoramic view accommodates the normative conventions of landscape painting.

The Knight of the Tiger (fig. 75), the third and last reproduction of a mural from the Cuernavaca cycle, is an almost exact replica of a detail from the north wall depicting a battle between Aztecs and Spaniards for possession of the city of Cuernavaca (fig. 76). According to Stanton Catlin, the original detail depicts an Indian warrior "in the garb of a Tiger or Jaguar Knight . . . *ready* to stab an armored conquistador whom he has pinned to the ground."[27] The presence of blood on the jagged stone knife, as well as the weapon's position in both the original and the fragment, however, suggest that the Indian fighter has already impaled the conquistador. From a complex and dense narrative of one clash during a battle, Rivera has chosen a simple detail that symbolizes the struggle between Aztecs and Spaniards. Bound by the picture's

edge, the figures fill the composition and bring the action close to the picture plane. Besides these compositional strategies, the foreshortened perspective of the armored conquistador and the frightening stare of the skinned jaguar head viscerally confront the viewer with the depiction of violence. In Rivera's usual style, he combines an understanding of traditional perspective with a flat, two-dimensional treatment of the surface to create a hybrid modernism that formally reinforces the tension of the scene.

An aggressive if somewhat iconic image, *The Knight of the Tiger* did not suffer the same type of radical alteration and depoliticization as other panels. Although scenes of bloodshed were censored from the other frescoes, the hostility in this one remained. The historical implications of the scene were overlooked, perhaps because museum officials considered the work illustrative of a distant past rather than a threatening symbol of contemporary conflicts. As Anthony Lee has argued, Rivera's mural cycle at Cuernavaca focuses almost exclusively on episodes dating from the period of the Spanish Conquest; the artist recasts regional history as a concrete example of class struggle and broader turmoil.[28] Linking the *History of Cuernavaca and Morelos* in the Palacio de Cortés in Cuernavaca with the mural cycle at the Palacio Nacional in Mexico City, on which Rivera worked simultaneously, Lee states that the dialogue between the two cycles reveals how Rivera distills the Marxist subtext of the Palacio Nacional in Cuernavaca "to make manifest history as a ceaseless but also clear struggle: between oppressors and the oppressed, Spanish conquistadors and the Aztec people, the Catholic Church and the converted heathen, plantation owners and sugar cane worker, colonizers and revolutionaries." By extracting and condensing the leftist content of the Palacio Nacional mural, Rivera attempts to solidify his socialist commitment.[29] *The Knight of the Tiger* as a direct copy of a scene from the Palacio de Cortés in Cuernavaca and condensation of Rivera's Palacio Nacional mural is also a knowing symbol of historical oppression. While the other portable frescoes fell victim to depoliticization, the isolation of this iconographic element in *The Knight of the Tiger* works (counterintuitively) to intensify Rivera's updated anticolonialist attack.

Despite its straightforward message of armed resistance, *The Knight of the Tiger* received little attention. The smallest of the eight portable frescoes Rivera produced for MoMA, it is significantly smaller than some of the artist's large easel paintings, such as *Baile en Tehuantepec,* which was displayed in New York the previous year. The few critics who did provide brief descriptions of the fresco did not look very closely at it and never mentioned its negotiation of the sweeping historical themes present in the mural cycles in Cuernavaca and the Palacio Nacional. The symbolic narrative and Marxist view of history remained a coded and buried reference and thus escaped mention.[30]

FIG. 75. *(left)* Rivera, *The Knight of the Tiger,* 1931. Portable fresco. Smith College Museum of Art, Northampton, Massachusetts. Purchased with the Winthrop Hillyer Fund. © 2008 Banco de México Diego Rivera & Frida Kahlo Museums Trust, Av. Cinco de Mayo no. 2, Col. Centro, Del. Cuauhtémoc 06059, México, D.F.

FIG. 76. *(right)* Rivera, *The Battle of the Aztecs and Spaniards* (detail), 1930. Fresco. Palacio de Cortés, Cuernavaca. © 2008 Banco de México Diego Rivera & Frida Kahlo Museums Trust, Av. Cinco de Mayo no. 2, Col. Centro, Del. Cuauhtémoc 06059, México, D.F.

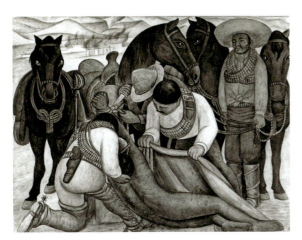

FIG. 77. *(left)* Rivera, *Liberation of the Peon,* 1931. Portable fresco. Philadelphia Museum of Art. Gift of Mr. and Mrs. Herbert Cameron Morris, 1943. © 2008 Banco de México Diego Rivera & Frida Kahlo Museums Trust, Av. Cinco de Mayo no. 2, Col. Centro, Del. Cuauhtémoc 06059, México, D.F.

FIG. 78. *(right)* Rivera, *Death of the Peon,* 1923. Fresco. Secretaría de Educación Pública, Mexico City. © 2008 Banco de México Diego Rivera & Frida Kahlo Museums Trust, Av. Cinco de Mayo no. 2, Col. Centro, Del. Cuauhtémoc 06059, México, D.F. Photograph by Schalkwijk / Art Resource, New York.

Liberation of the Peon (fig. 77) is the only adaptation of a scene from the Secretaría de Educación Pública (fig. 78). Reduced in size and changed from a vertical to a horizontal composition, the MoMA fresco shifts the placement of figures and elements so that the mounted soldier to the right now stands in front of his horse and the burning hacienda and mountain range in the background are crowded in the upper left. Rivera made other subtle changes as well: the expression of the grieving soldier's face, which now appears more stoic, and the removal of the rifle and sickle at lower left and right, respectively. The narrative—the peasant's release from a life of drudgery—is visually and ideologically linked in its original context with another panel depicting the revolutionary freedom provided by education.[31] While some art historians have concentrated on the formal changes made, the fresco's dissociation from companion panels is most significant. The isolation of scenes is an ontological and methodological predicament at the heart of Rivera's portable fresco project—a problem that did not go unnoticed by the critics.

The Rough Coat

An understanding of muralism's dissemination in the United States is predicated on the assertion that U.S. cultural institutions corrupted the radical potential of the works to convey politicized messages to their viewers. The summary above acknowledges these intents. As others have suggested, the Museum of Modern Art attempted to defuse Rivera's radical, communist politics by encouraging formal alterations and decontextualizing the Mexican murals.[32] Yet scholars fail to consider the critical responses to these changes. A cursory glance at reviews indicates that these machinations were not accepted. Instead, critics noted precisely how the panels resembled "samples torn from their original settings" and likened them to enlarged "easel pictures" that rejected the social grounding of muralism. The ineffectiveness of the portable fresco precipitated negative responses, and critics were exceptionally attuned to the aesthetic and ideological problems inherent in the medium. I would argue that the ideology of cultural diplomacy failed to alter in any substantial way the meanings produced by muralism.

For instance, Breuning, who had by December 1931 reviewed many exhibitions of Mexican art in New York galleries and institutions, judged the adapted frescoes to be lacking in inspiration. Like other critics, she considered the shift from the architectural setting to the museum wall questionable. "The lofty ceilings and vistas of the great buildings in which the murals were carried out presented quite different problems [from those presented by] these small panels on gallery walls," she wrote in the *New York Evening Post*. She mourned not only the absence of architecture but also the loss of "the colorful

background of Mexico to heighten their significance." In the end, the fresco panels remained merely "fragments of a great work."[33]

Helen Appleton Read, who had written about Rivera's murals in Mexico for *Vogue* a year earlier, recognized that, beyond the formal manipulations inherent in the translation from monumental wall painting to hanging picture, the adaptations skewed the complex matters of patronage surrounding the murals and ultimately represented a fractured vision. She noted that her reaction to the panels could not compare with her emotional response to the originals (which she had seen in situ) and added that the panels gave only a "hint" of the artist's abilities.[34]

For Paul Rosenfeld of the *New Republic,* the absence of the architectural setting signified the loss of serial narration and monumentality essential to public wall painting. He deemed the portable frescoes less convincing in their portrayal of Mexican history as a direct result of the change in context:

Rivera's great frescoes in [Mexico City] and in Cuernavaca are serial, and are said to build up with a monumentality unequaled by mural painting since Tiepolo and Luca Giordano decorated church and palace ceilings. They are bibles of the Mexican conquest and the revolution, communicating the deeds, sufferings, and aspirations of the Mexican people through characteristic shapes and colors; and the narrative is one of their main interests. Hence, intrinsically vigorous, courageous, and brilliant as the adaptations . . . made by Rivera for his New York exhibition are, they are fragmentary, bare of the effects secured them by their settings and continuities.[35]

The critics, writing for diverse publications with distinct audiences—here ranging from a daily newspaper, to a general-interest and fashion magazine (*Vogue*), to a modern, liberal journal—overwhelmingly concurred that fresco fragments appropriating imagery from the Mexican murals were not a viable substitute for the "real thing." Viewing the MoMA exhibition as an opportunity to see firsthand the art of the celebrated painter, a reporter from the *Chicago Evening Post,* a newspaper striving for mass readership, lamented that

Mexico's foremost painter has been a curious case here—famous, and at the same time practically unknown. . . . However, we have had to take this art and this eminence more or less on faith, having had little but the fanfares of writers and the inadequacies of printed reproductions to go on. . . . Grateful as we are for the effort, we must admit that it is not the whole mountain which has moved, but only isolated peaks. For the samples of fresco, torn from their companions and from the original settings, which must mean so much to them, remain "samples," out of place and isolated in their present environment. . . . For all its comprehensiveness, for all the service it performs in bringing a widely known and still little known art to our doors, this exhibition leaves us with the feeling that to under-

stand the real stature of Rivera, we must visit Mexico, to see his finest achievement, his frescoes, in place.[36]

The transformations in form and context upset the readings of the portable frescoes. The critical appraisals highlighted how the experimental panels eschewed continuity, narrative, monumentality, and history and were therefore inadequate surrogates for Rivera's radical public art. Critics recognized—in part because of all of the media attention Rivera's murals in Mexico had garnered—that within the framework of the project of Mexican muralism, the ancient artistic method was more than a technique: it was a paradigmatic mode with great aspirations toward a reconciliation of content and form.

The critical reception of Rivera's frescoes indicates that the efforts to depoliticize Rivera and his production did not succeed. A few critics still considered Rivera a controversial figure who "would starve here, under the Statue of Liberty, unless he could learn to paint the dying nymphs that are the mainstay of our great architects."[37] Even though *Agrarian Leader Zapata,* for example, is ripped from a larger narrative that portrays more graphic scenes of violence, Rivera did not remove the menacing machete from the peasant leader's hands, or the dead body of the enemy over which he stands.[38] One commentator described Rivera's portrayal of Mexico as violent, specifically commenting on the scenes of brutality in *Zapata* and *Sugar Cane:* "A violent, bitter Mexico in striking contrast with the indolent gay land described in current best sellers is depicted in primitive color against the walls of the Museum of Modern Art. . . . Diego shows the fantastic agrarian and revolutionist, Zapata, and his followers trampling down the oppressors of the peons; shows the whip-driven drudges of sugar plantations slaving under the indolent eyes of a very white occupant of a hammock."[39]

Edward Alden Jewell also recognized the social significance of *Sugar Cane,* describing the panel as "brilliantly successful, with the owner of the plantation indolently stretched in his hammock while an overseer on horseback prods laborers to unremitting toil." The *New Yorker* reported the larger Mexican-themed frescoes are all "scenes from the violent history of Mexico."[40] Such responses indicate that the changes made to the fresco did not completely neutralize the aggression of the original narrative. Some critics were able to see the violence behind the picturesque additions, since the *costumbrista* scene of a mother and her children picking papayas, though in the foreground, is displaced to the side, while the plantation scene hovers in the middle. Rivera relegated the scene depicting the exploitation of the peasants to the middle ground and reduced the figures in size and number, yet the exploitation imagery remains centralized. The disparity between the bucolic scene in the foreground and the oppression of the peasants in the central middle

FIG. 79. Rivera, *Frozen Assets*, 1931. Portable fresco. Museo Dolores Olmedo Patiño, Mexico City. © 2008 Banco de México Diego Rivera & Frida Kahlo Museums Trust, Av. Cinco de Mayo no. 2, Col. Centro, Del. Cuauhtémoc 06059, México, D.F. Photograph by Schalkwijk / Art Resource, New York.

ground, therefore, led to varying assessments of the panel and disagreement with regard to its meanings.

As some of these assessments suggest, Rivera's exhibition at MoMA elicited more careful and thoughtful responses to his work than had the "Mexican Arts" exhibition a year earlier. One article merged a critical appraisal of the MoMA exhibition with a description of Rivera's mural for the California School of Fine Arts and noted that "at the Modern . . . may be seen currently the original pencil and tempera sketch for the mural," despite the fact that the catalogue lists this drawing incorrectly as a sketch for the San Francisco Stock Exchange.[41] Responses to the portable frescoes suggest that the critics had grown sensitive to the conceptual, aesthetic, and ideological implications of muralism.[42]

Although the retrospective broke MoMA attendance records, surpassing even the record for the earlier Matisse exhibition, the portable frescoes were a critical failure. Rivera may have intended for them to "demonstrate what was being done in fresco in Mexico," but the critics complained that the Mexican-themed frescoes did not offer a semblance of the original murals.[43] The new composition *Uprising* received very little attention but was often considered in conjunction with the Mexican frescoes, while the critics mostly panned the frescoes with New York imagery.[44] As Lee states, "Rivera's work always belonged to an argument about his foreignness on the American, nationalist art scene." U.S. critics found Rivera's Mexican subjects more authentic and reacted defensively to his portrayals of U.S. society, specifically his critical portrayal of Depression-era New York, *Frozen Assets* (fig. 79), the panel of

FIG. 80. Rivera, *Electric Welding*, 1931–1932. Portable fresco. Mr. and Mrs. Marcos Micha Levy, Mexico. © 2008 Banco de México Diego Rivera & Frida Kahlo Museums Trust, Av. Cinco de Mayo no. 2, Col. Centro, Del. Cuauhtémoc 06059, México, D.F.

the three New York subjects that received the most attention. Henry McBride complained, "Oh, we don't lack material, but you can see it is not good stuff for strangers. It takes someone who has known us before and after to employ it adequately."[45] The other two panels, *Electric Welding* (fig. 80) and *Pneumatic Drilling,* scenes of welders at a General Electric plant and drillers in the process of excavating the foundation for the new Rockefeller Center, received scant but mostly favorable attention.[46] Critics viewed them merely as visual celebrations of U.S. industry, rather than as elaborations of Rivera's view that industrial progress is a prerequisite for proletarian revolution.

The artist himself suggested several practical reasons for including portable frescoes in the exhibition, explaining that without them, "the exhibition could not have been representative" of his work.[47] In the context of a retrospective at the Museum of Modern Art, the movable frescoes served a didactic purpose, illustrating the fresco technique. He painted them on location at the museum, as they "would scarcely have [withstood] a journey from Mexico." But did they need to be transportable? Could not the Museum of Modern Art, or its trustees, have commissioned actual frescoes? Rivera rationalized that he executed movable panels "because the Museum was then in temporary quarters, a floor of the Heckscher Building."[48] Given the lack of available museum walls for a fresco and Abby Aldrich Rockefeller's role as patron, perhaps other sites could have been found in New York.[49] Although that would hardly have been a satisfactory solution to the problem of exhibiting murals, it remains debatable whether such an option was ever considered. As if to reconcile such questions, Rivera later proposed that the movable frescoes were more than an exhibition strategy; they were appropriate for a country where "buildings stand for comparatively short periods."[50] Curiously, his comments imply that

at the same time he was actively pursuing and receiving mural commissions, he found it impractical to make permanent murals on walls in the United States. Was this an apology for the absence of a mural commission in New York, or perhaps a commercial gambit—a strategy to make the public murals of Mexico privately available in the United States—or his coming to terms with the particular aesthetic conditions of the United States?

Rivera's comments might seem strategic, yet they speak to an underlying current of the 1930s taking shape in relation to the production of murals in the Americas. While his portable panels broke with the tradition of muralism in Mexico, where audiences viewed monumental art integrated within an architectural matrix, the movable murals articulated the tensions developing in the Americas between large-scale easel painting and murals executed directly on the wall. Out of practical considerations and out of the desire to break free from the academic practice of wall painting as decoration, modern artists based in the United States, Arshile Gorky, for example, implored that "mural painting . . . not become part of the wall."[51] Gorky's plea was a reaction against the "academic" mural movement in the United States—wall painting in "churches, libraries, court houses, State Capitols, commercial establishments—and world fairs . . . justly called a 'kind of glorified wall-paper hanging.'"[52] French-born Mexican artist Jean Charlot expressed similar dissatisfaction with this movement when he described wall paintings in the United States as "large screens . . . painted in imperceptible gradations of grays, with statues and fountains, ponds and swans, all set in a fog-clogged Versailles."[53]

Whereas modern artists such as Charlot and Gorky vehemently opposed murals that propagated conventional imagery and served as mere architectural embellishment, in Mexico true fresco was directly tied to political and social expression. In Argentina and Cuba, artists such as Antonio Berni and Mario Carreño, influenced by the example of muralism—specifically, Siqueiros's large-scale paintings textured to produce a semifresco effect—turned to the portable mural or large-scale easel painting instead of the mural integrated with the wall as a means by which to comment on social issues. A lack of either government support or any systematic cultural agenda in these countries in the 1930s made walls inaccessible to artists. Berni and Carreño, therefore, seized on large easel paintings conceived independently of walls as a democratic means of mass visual communication. Translating the cultural nationalism (and, in the case of Berni, the leftism) of the Mexican muralists into their own idiom, they advanced their own brand of socially engaged modernism through portable media. The Mexican muralists' experiments with portable frescoes (and large-scale easel paintings) were crucial in this development. However, these movable murals necessarily precluded the fresco technique

that Rivera (and Orozco) had introduced to viewers in the early 1930s and that Orozco had proclaimed "a sign of revolution in artistic methods."[54]

Use of the fresco medium in the United States was sporadic during the nineteenth century, but it enjoyed a brief revival beginning in 1934 with the first of the New Deal art programs, the Public Works of Art Project (PWAP), when some artists, influenced by the example of the Mexican muralists, worked in true fresco in the Mural Division. Nonetheless, because of artists' inexperience with the medium and its prohibitive costs—an acute concern during the Depression—very few true frescoes were painted.[55] In addition to economics, the ephemeral nature of buildings in the United States was a consideration. Rivera's comments about this impermanence echoed those of the architect Frederick Kiesler, who in 1936 spoke of the necessity for mobile mural painting because of the short life of buildings in the United States.[56] Rivera's observations about the transience of architecture in the United States reveal his adaptation to a new context, one lacking many of the elements that were a given in Mexico: the permanence of institutions and buildings, a tradition of fresco painting, and radical, government-sponsored public art.

Rivera did not judge his experiment with the portable fresco to have been a success, precisely because of its failure to generate mural commissions. His next mural commission in the United States, at the Detroit Institute of Arts, had been in place before he even arrived in New York. And if the portable frescoes were meant as a "trial run" for work to be done in the RCA Building at Rockefeller Center, they appear to have caused hesitation.[57] Although officials at Todd, Robertson & Todd Engineering, which managed the development, asked Rivera to paint murals at the site soon after his MoMA exhibition, he did so only after Picasso and Matisse (not known for murals) rejected offers. In addition, the RCA Building commission did not become official until nine months after his MoMA exhibition, after no suitable candidates from the United States surfaced.

In direct response to the interest in "using mural paintings as decorations in office buildings [such as the RCA Building in Rockefeller Center]," Nelson Rockefeller and the Junior Advisory Committee of the Museum of Modern Art (which Rockefeller then chaired) initiated the exhibition "Murals by American Painters and Photographers," held from May 3 to May 31, 1932 (fig. 81). Conceived to appease growing (and xenophobic) concerns that no artists from the United States had been considered for the Rockefeller Center commission (rumors had spread that, in addition to Rivera, the Spanish artist José Maria Sert and the English artist Frank Brangwyn were being considered), the exhibition was organized very hastily by Lincoln Kirstein.[58] Featuring lesser-known artists, many of whom had no experience painting murals,

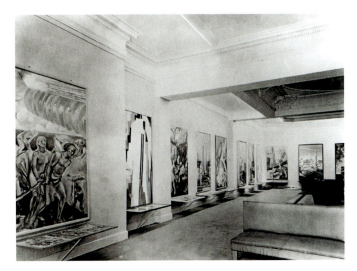

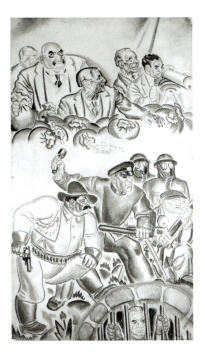

FIG. 81. *(above)* Installation view of "Murals by American Painters and Photographers," Museum of Modern Art, May 1932. © The Museum of Modern Art/Licensed by SCALA / Art Resource, New York.

FIG. 82. *(right)* Hugo Gellert, *Us Fellas Gotta Stick Together,* 1932. Figures at top from left to right depict Herbert Hoover, J. P. Morgan, John D. Rockefeller Sr., Henry Ford, and Al Capone. The Wolfsonian–Florida International University.

the exhibition was received poorly by museum officials, architects, and critics. Several artists contributed politically provocative and controversial paintings, some of which included offensive caricatures of prominent figures such as J. P. Morgan, Henry Ford, and Nelson's grandfather, John D. Rockefeller (fig. 82); in 1928, Rivera had satirized the very same figures in a third-floor panel at the SEP in Mexico City. Indeed, as the critic Henry McBride had warned in April 1931, Rivera's influence was dangerous. MoMA director Alfred H. Barr Jr. advised the younger Rockefeller that despite the failure of "Murals by American Painters and Photographers," the exhibition narrowed things down to two options for the RCA Building commission: choosing "from the academic School of Rome which can provide competent, safe but negligible mural painters" or from "outside the School [where the artists] would do paintings of character, paintings which may not be entirely safe."[59] Barr's comments underline the tensions surrounding the production of murals in the United States; the lack of artists with experience in modern innovative mural painting forced patrons to take risks. Only after Barr's prodding, and the failure of the "Murals by American Painters" exhibition to generate an appropriate candidate, did Rivera—the less safe option—receive the official commission for the RCA Building; his fresco fragments seem to have had little to do with the commission.

In his autobiography, Rivera stated that the movable panels neither gave "U.S. museum directors and architects a grasp of the character of mural painting" nor provided a sense of the "true uses of the medium."[60] Although the fresco fragments had the unintended effect of being read as easel paintings, they did not lend the practical advantages of what Rivera called the "hateful lined canvas."[61] Aside from any conceptual problems mentioned by the critics and the failure to generate mural commissions, the heavy slabs of plaster also presented complex marketing problems.

Shortly after the Rivera retrospective closed, Erhard Weyhe, proprietor of the Weyhe Gallery, who had hoped that the exhibition would feature fresco fragments, purchased all eight panels.[62] He told the *New York Herald Tribune* that although "several museums had shown interest in the paintings," he had made no plans for them. Yet less than a week after Weyhe made the purchase and five days before the newspaper announcement of it, Carl Zigrosser, the director of Weyhe's gallery, was already marketing the murals to the collector Duncan Phillips.[63] Shortly afterward, Zigrosser offered them to other gallery clients, including the Fogg Art Museum, whose associate director, Paul J. Sachs, was also a Museum of Modern Art trustee and a Rivera collector.[64] Despite his efforts, Zigrosser failed to find a buyer.

The first sale eventually took place through the agency of Jere Abbott, one of the organizers of Rivera's Museum of Modern Art retrospective. In 1934, Abbott borrowed one of the frescoes for a course he was teaching at Smith College, where he had been director of the school's Museum of Art since 1932.[65] Considering the larger frescoes "completely untransportable," he asked that the smaller *The Knight of the Tiger* be shipped to Northampton, Massachusetts. A few months later, Abbott purchased the work for the museum.[66] Even though Zigrosser tried repeatedly to sell the remaining murals, the small fresco was the only one that he sold in the 1930s.[67] It was not until three of the frescoes appeared in the exhibition "Twenty Centuries of Mexican Art" in 1940 that the Museum of Modern Art decided to purchase *Agrarian Leader Zapata*.[68] In 1943, *Sugar Cane* and *Liberation of the Peon* entered the collection of the Philadelphia Museum of Art (where Zigrosser had become curator of prints and drawings three years earlier), after they were featured in an exhibition there titled "Mexican Art Today." The remaining mural panels, *Uprising* and three with New York subjects, did not find buyers until 1977, when the Weyhe family sold them at auction.[69] As their provenance suggests, the portable frescoes were neither critically nor commercially viable in the 1930s or thereafter. Hardly portable, they did not have the practical advantages of easel paintings nor, given their inability to convey the monumentality of mural painting, did they function effectively as surrogates for the murals.[70] Then,

too, despite Rivera's international fame, the panels with New York subjects, which departed from his "usual" motifs, failed to generate market interest until the late 1970s, when auction houses in the United States helped generate a spurt of interest in Latin American art and Rivera's work in general became a valuable commodity.

The bad press surrounding the portable frescoes gave Rivera reason to pause and reflect. The fragments had failed to give an accurate picture of his celebrated murals in Mexico and therefore did not meet critical expectations. Rather than satisfy the museum-going public's curiosity about muralism, the portable frescoes only increased the awareness that a pilgrimage to Mexico was necessary for a more authentic encounter with the spatial and social realities of public mural painting.

Smoothing the Surface

Nonetheless, Rivera turned again to the portable fresco format after his Rockefeller Center mural, which included a portrait of Lenin, was censored (by being covered with a blank canvas in May 1933) and later destroyed (in February 1934). Significantly, however, he rethought the format and revamped the medium for *Portrait of America,* his mural cycle at the New Workers School, which was founded in 1919 by Jay Lovestone, leader of the Communist Party USA and run by Rivera's friend Bertram Wolfe. Offering to paint the mural for free with the money paid to him by the Rockefellers, Rivera hoped to re-create the Rockefeller Center mural, but the small scale of the site proved unsuitable. Instead, he chose to relate elements of U.S. history in a series of twenty-one smaller movable panels, measuring six by six feet or smaller. Having learned the lesson of "impermanence" from the Rockefeller Center mural scandal, Rivera decided to make the panels movable and thus prevent their future destruction in case the school had to be moved. In doing so, however, he manipulated only the portability of the medium, keeping the panels completely integrated with one another and arranging them flush with the wall. The cycle is executed in true fresco but is mounted on movable wood-framed steel-mesh panels designed by the artist.[71] *Portrait of America,* therefore, avoided the inherent conceptual problems of the portable fresco technique but rescued its inherent advantage—mobility—to re-strategize wall painting in the United States and Mexico.[72]

With the failure of portable frescoes and the limited opportunities to view Rivera's murals, easel paintings and drawings were sometimes recruited as mediating substitutes. Zigrosser's commission for color drawings of the murals notwithstanding, they were unlikely candidates for wholesale re-creations of the murals. Rivera and Zigrosser found a more suitable medium that would

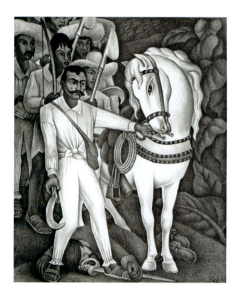

serve the illustrative purposes at hand: the lithographic print. An affordable, reproducible medium, it could more closely approximate the public accessibility at the heart of mural painting—an element that oil on canvas and drawing inherently lack—yet still maintain some of the feel of fresco painting lost in photographic reproductions.

After the MoMA retrospective closed on January 27, 1932, Rivera remained in New York for almost four months, despite anxious requests from Detroit Institute of Arts director Rudolph Valentiner that he begin his mural there. Rivera lingered in Philadelphia for the premiere on March 31 of *H.P. (Horse Power)*, a ballet-symphony in four scenes with music by Carlos Chávez and decor and costumes by Rivera. He delayed his departure for Detroit even further in order to make five lithographs for the Weyhe Gallery.[73] Immediately after the opening of *H.P. (Horse Power)*, Frida Kahlo told a friend, "Now, Diego is making some lithographs. That is why we [are] still here."[74] Each of the new lithographs from 1932—*Fruits of Labor, Open Air School, Boy and Dog, Zapata,* and *Sleep*—represents a detail from one of Rivera's murals in Mexico. Four of the lithographs appropriate small details from his SEP murals; the fifth, *Zapata* (fig. 83), replicates the MoMA fresco fragment *Agrarian Leader Zapata,* not the original mural panel in Cuernavaca, and is therefore a copy of a copy. As if responding to the criticism of the portable frescoes, a Weyhe Gallery brochure for the 1932 lithographs advertised that "[i]n addition to their intrinsic qualities, as lithographs, of beautiful draughtsmanship and technique, they give an idea—much better than any reproduction can possibly achieve—of the actual frescoes themselves, both in form and in content, and in monu-

mental design. They are a translation into a medium which many people, who have never been to Mexico, can possess and enjoy, by the very hand which first created the masterpiece."[75] As the brochure suggests, lithographs, in addition to providing affordable accessibility, maintained the handcrafted aura of the artist's own imprint. The lithographs, which, like the portable frescoes, were based on details of the Mexican murals, received much more favorable attention in the press when they were first publicly displayed at Weyhe.[76] One commentator suggested, "All of them, but especially the 'Zapato' [sic] and 'Sleep,' approach more nearly the monumental 'bigness' of Rivera's best work than do the easel paintings and fragmentary fresco that he has executed to order in New York."[77] While the Zapata print is an exact copy of the MoMA "fragmentary fresco," I believe it conveyed more successfully the monumentality of the mural. Curiously, small lithographs rather than the large portable frescoes were seen as more suitable proxies for the murals.

After the portable frescoes failed to achieve the desired response, the lithographs represented only one of the attempts to make Mexican murals possessable. As early as June 1931, before the exhibition at MoMA, Mrs. James B. Murphy, the collector of Mexican art who had lent *Baile en Tehuantepec* for the "Mexican Arts" exhibition, was searching for a way to reproduce Rivera's murals.[78] In the end, she produced a portfolio containing the first color reproductions of his murals.[79] Published by MoMA, the color plates were exhibited at the museum between February 20 and March 12, 1933. Promoted as an affordable package by the museum's department in charge of circulating exhibitions, the plates from *Frescoes of Diego Rivera* toured the country's smaller, more academic and educational museums from 1933 until 1939.[80] Rivera's frescoes had become even more portable; they were now "take-home" murals and collectibles.

Most of the color plates are quaint scenes of everyday life from the Mexican murals, such as *Indians Bathing* (fig. 84) or *Street Fair* (fig. 85), both details from the Secretaría de Educación Pública murals, or a detail of a market scene from Cuernavaca (fig. 86). One of the color details, *While the Poor Sleep* (fig. 87), reproduces a larger expanse of the SEP fresco on which Rivera's 1932 lithograph *Sleep* (fig. 88) was based. Both *Cane Workers* (fig. 89) and *Zapata* (fig. 90) further reduced and fragmented the original scenes from the Cuernavaca murals that had been used for the portable panels—*Sugar Cane* and *Agrarian Leader Zapata*—and were therefore details of details.[81] *Zapata* suffered the most radical reduction. With machete and wounded soldier cut from the scene, what little violence the portable panel evoked was erased. While the impulse to fragment, compartmentalize, and aestheticize Rivera's murals continued, the portfolio did not wholly repeat the mistakes of the past. Taking

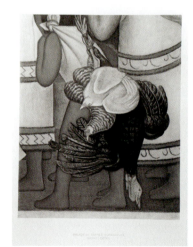

FIG. 84. *(above, left) Indians Bathing.* Color plate from *Frescoes of Diego Rivera* (New York: Museum of Modern Art, 1933). Detail from the Secretaría de Educación Pública, Mexico City. Photograph © Roberto Portillo, New York.

FIG. 85. *(above, right) Street Fair.* Color plate from *Frescoes of Diego Rivera* (New York: Museum of Modern Art, 1933). Detail from the Secretaría de Educación Pública, Mexico City. Photograph © Roberto Portillo, New York.

FIG. 86. *(right) Market Scene.* Color plate from *Frescoes of Diego Rivera* (New York: Museum of Modern Art, 1933). Detail from the Palacio de Cortés, Cuernavaca. Photograph © Roberto Portillo, New York.

Opposite page:

FIG. 87. *(top, left) While the Poor Sleep.* Color plate from *Frescoes of Diego Rivera* (New York: Museum of Modern Art, 1933). Detail from the Secretaría de Educación Pública, Mexico City. Photograph © Roberto Portillo, New York.

FIG. 88. *(top, right)* Rivera, *Sleep,* 1932. Lithograph. The Museum of Modern Art, New York. Gift of Mrs Henry Allen Moe, in memory of Dr. Henry Allen Moe. © 2008 Banco de México Diego Rivera & Frida Kahlo Museums Trust, Av. Cinco de Mayo no. 2, Col. Centro, Del. Cuauhtémoc 06059, México, D.F. Digital image © The Museum of Modern Art/Licensed by SCALA / Art Resource, New York.

FIG. 89. *(bottom, left) Cane Workers.* Color plate from *Frescoes of Diego Rivera* (New York: Museum of Modern Art, 1933). Detail from the Palacio de Cortés, Cuernavaca. Photograph © Roberto Portillo, New York.

FIG. 90. *(bottom, right) Zapata.* Color plate from *Frescoes of Diego Rivera* (New York: Museum of Modern Art, 1933). Detail from the Palacio de Cortés, Cuernavaca. Photograph © Roberto Portillo, New York.

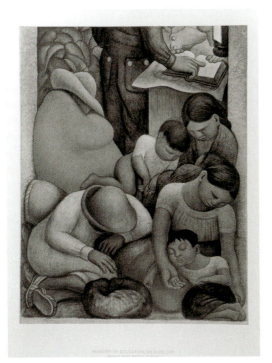

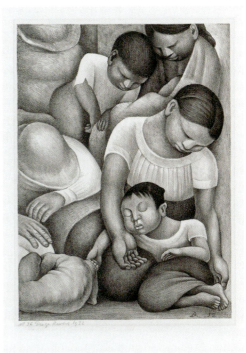

MINISTRY OF EDUCATION, MEXICO CITY
WHILE THE POOR SLEEP

nd 36 Diego Rivera 1936

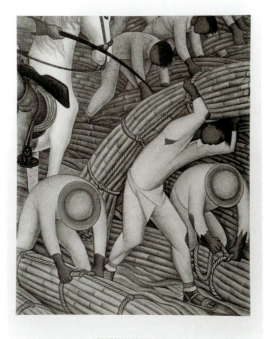

PALACE OF CORTEZ, CUERNAVACA
CANE WORKERS

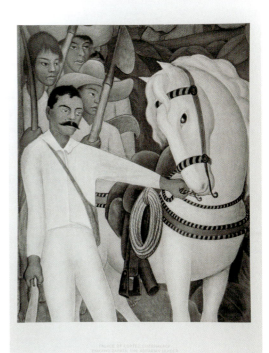

PALACE OF CORTEZ, CUERNAVACA
EMILIANO ZAPATA, THE AGRARIAN LEADER

heed of the criticisms of Rivera's retrospective exhibition, the producers of the portfolio included eighteen large color plates that reproduced only fragments of the various murals but supplemented them with twelve smaller monotones depicting the entire fresco from which the detail was taken and several greatly enlarged photographs of other frescoes by Rivera at the Palacio de Cortés in Cuernavaca.

Henry McBride, who had warned students not to follow Rivera's example, had voiced the opinion that Rivera's fresco adaptations simply did not work, and had judged the New York subjects too propagandistic, changed his tune after viewing the portfolio.[82] He stated that "any lingering doubts among northerners as to the greatness of Diego Rivera's murals in Mexico must be swept away by the portfolio of reproductions of these paintings just issued by the Museum of Modern Art. . . . [W]e have quite forgot that there can be such a thing as an art 'for the people, by the people, of the people.' . . . If Mexico, why not the United States, I ask?"[83] McBride's resounding call for a mural renaissance in the United States also surprisingly proclaims Mexican muralism's social and revolutionary grounding. The critic's ideological shift—and more significant, the circulation and distribution of Mexican muralism in reproducible form—anticipates Walter Benjamin's pronouncement in 1936 that mechanical reproduction inherently changes the reception of art.[84]

Before Rivera created his monumental mural cycles at the Detroit Institute of Art and Rockefeller Center and when awareness of his work was still limited, his portable frescoes were an important test for the muralist and for Mexican muralism in the United States. Though MoMA officials might have hoped to rid the "dangerous" artist of his radical politics through watered-down adaptations of his social realist murals, the portable fresco as conceived by him and the museum in 1931 was a critical failure. As seen in the critical responses, Rivera remained a politicized artist, and the exhibition demonstrated the impossibility of re-creating the Mexican frescoes in mural form; public wall painting would have to remain a separate entity. The public could not be fooled by fake, fragmentary panels, even if they approximated the feel and technique of the original frescoes; the inherently reproducible and graphic medium of lithography and color reproductions provided a solution. The large free-standing frescoes could not accomplish what smaller-scale prints and illustrations could. Lithographic and photographic reproductions for distribution not only made the murals in Mexico truly mobile and accessible to audiences in the United States but also recuperated through their mode of production the politics of muralism.

5

"EXPLAINING" MURALISM

During the 1930s, interest in Mexican culture grew in the United States, and controversial murals by Rivera, Orozco, and Siqueiros gained national attention. Siqueiros's *Tropical America* (1932) in Los Angeles was painted over because of its critique of U.S. imperialism, conservative critics condemned Orozco's cycle at Dartmouth College (1932–1934) as a foreign attack on U.S. culture, and Rivera's RCA Building mural in New York was intentionally destroyed, in part because of its inclusion of a portrait of Lenin.[1] These high-profile incidents made Mexican muralism more culturally conspicuous at the same time that social-viewpoint and leftist art were gaining currency.[2] The Mexican model of government patronage and socially based content inspired the New Deal art programs. Meyer Schapiro, among others, asserted the progressive role of the artist. Cultural workers concerned with social justice took up Rivera's battle cry that art should function as a "weapon of the revolution."[3] The decade of the 1930s was a "utopian moment in the history of socially concerned art in the United States."[4]

By the early 1940s, socially engaged modernism had a place even at mainstream institutions such as the Museum of Modern Art. Alfred H. Barr Jr.'s inaugural installation of the painting and sculpture collection in 1945 included a very large section of what he termed "socially conscious" art, which

mixed Latin American realism with leftist modernist art of the United States.[5] Works by Ben Shahn, Jacob Lawrence, William Gropper (all inspired by the muralists), and others shared space with those of Orozco, Rivera, Siqueiros, Cándido Portinari, Guillermo Meza, Mario Urteaga, and Camilo Egas in the galleries, alongside European modernist art. Despite traditional assumptions about the museum's promotion of high modernist abstraction, there was a time when abstract figuration and socially conscious art of all styles had a place within the historical trajectory of international modernism canonized by the museum.

Although some Mexican artists had been condemned as politically dangerous in the early 1930s, by the end of the decade—contrary to previous assessments—viewers in the United States *expected* Mexican painting to be monumental and politically resonant. By 1940, critics were censuring artists such as Rivera if they did not live up to these expectations. The shifting fortunes of radical and Mexican art in the United States—specifically, work by the muralists—can be gauged by the MoMA's "Twenty Centuries of Mexican Art" (May 15 to September 30, 1940), a landmark exhibition featuring several thousand pre-Columbian, colonial, folk, and modern Mexican objects. This exhibition came at a time when U.S. interest in Mexican culture had reached its apogee and just before socially engaged modernism was supplanted by international abstraction. As an "official" exhibition, organized in conjunction with the government of President Lázaro Cárdenas, it provides insights into the politics of the circulation, reception, and display of muralism. Only by reconsidering "Twenty Centuries" in relation to the 1930 exhibition and the debates surrounding nationalism, politics, and muralism can a possible explanation for the dramatic shift in perception across the decade be advanced.

Political Expediencies

Like the "Mexican Arts" exhibition at the beginning of the 1930s, "Twenty Centuries" was the result of various political and social forces. President Cárdenas's nationalization of Mexico's oil industry in 1938 directly affected interests in the United States, specifically, Rockefeller-owned Standard Oil. With the outbreak of World War II, President Franklin D. Roosevelt's Good Neighbor policy, which had been initiated in 1933, acquired a new urgency; hemispheric relations became an immediate priority as a means to combat the spread of fascism. On a pragmatic level, since institutions such as the Museum of Modern Art could no longer turn to a war-besieged Europe as a source for exhibitions, they directed their attention to the Americas. In his press release announcing the exhibition, the museum's president, Nelson Rockefeller, publicly and effectively dismissed "Mexican Arts" by failing to mention it as

one of the precedents for "Twenty Centuries." His private statements, however, show that he linked his cultural mission to the political and diplomatic origins of the earlier exhibition.[6] In handwritten notes outlining the show for museum trustees, he stated succinctly, "Nobody here to advise Cárdenas as Morrow advise[d] Calles."[7] Rockefeller willingly filled Morrow's shoes.

Holly Barnet-Sánchez has discussed how the inclusion of pre-Columbian art and culture in the "Twenty Centuries" exhibition intersected with the political and economic demands of Roosevelt's Good Neighbor policy as well as with the larger needs for hemispheric unity articulated by the diplomatic policies of pan-Americanism.[8] She argues that the exhibition did not present pre-Columbian art as "primitive" but carefully framed it as a shared American cultural legacy in order to contribute to U.S. foreign policy efforts to improve hemispheric relations. The exhibition's organizers expressly refrained from descriptions of horrific rituals and the "blood and guts" association with human sacrifices that would have characterized these works as primitive.[9] In an attempt to describe this art as a shared legacy, Barnet-Sánchez observes, efforts were made to make pre-Columbian art seem familiar to U.S. audiences.[10] Charity Mewburn, on the other hand, maintains that the exhibition expressly constructed modern Mexican art as "timeless, primitive and receptive," as a means to defuse U.S. anxieties about Mexico's perceived fascist and communist associations and thereby to facilitate Roosevelt's agenda. Although her argument is overstated and limited to an analysis of the "Twenty Centuries" exhibition catalogue, Mewburn addresses both pan-Americanism and the issue of expropriation of U.S. oil properties.[11]

While Barnet-Sánchez and Mewburn propose conflicting interpretations of the exhibition's thematics, they both approach it from the perspective of cultural diplomacy and political expediencies. Both hold that the ultimate goal of the exhibition was to co-opt Mexican culture as "American" during this specific historical period. For Barnet-Sánchez, pre-Columbian art presents an archaic vehicle by which to promote a common legacy; for Mewburn, the radicality of modern Mexican art is intentionally depoliticized and made to seem compliant with U.S. economic and diplomatic interests and therefore more acceptable as an American art form. Yet the foreword to the exhibition catalogue, written but not signed by Alfred H. Barr Jr., distinguishes the culture of Mexico from that of the United States. Not only does he acknowledge a difference between the two cultures, but he also adopts a rhetoric of opposition:

Mexican culture, as expressed in its art, seems in general to be more varied, more creative, and far more deeply rooted among the people, than ours. The Mexicans, of course, have one great advantage over us. They have an incomparably richer artistic past—two pasts, in fact—a European and a native, both of which survive

in modified form today. . . . When we admire with a certain envy and humility the art of modern Mexico, let us comfort ourselves by remembering that its artistic heritage is the result of the conflict and mingling of what was at that time the greatest empire of Europe with the most powerful empire of America. . . . Seen in New York, much of the varied art of Mexico will seem bizarre, amusing, picturesque. But to those who know and love Mexico its plastic forms are more than this: they are the symbols of a way of life which still preserves that gayety, serenity, and sense of human dignity which the world needs.[12]

Barr's statements counter the notion that the exhibition framed Mexican art as a "familiar" cultural legacy for Americans. Nonetheless, those statements clearly establish "Twenty Centuries" as a cultural staging of the Good Neighbor policy.[13] Further research in the Rockefeller Family Archives and the Museum of Modern Art Archives reinforces such an interpretation and demonstrates how the organizers themselves consciously perceived the process of organizing the exhibition as a form of goodwill collaboration. Rockefeller wrote Monroe Wheeler, the director of publications at MoMA, who was overseeing production of the catalogue in Mexico, to tell him that "this type of good will is not only of great value to the Museum itself but is of the utmost importance from the point of view of the United States, particularly at this time."[14]

While there is no doubt that the exhibition was the product of extra-aesthetic motivations and that it fostered a depoliticized representation of Mexican muralism, I depart from both Barnet-Sánchez's and Mewburn's assertions in my estimation of the exhibition and its import.[15] Although the pre-Columbian section promoted American values, I disagree with Barnet-Sánchez's opinion that the rest of the exhibition followed suit. Furthermore, even a cursory examination of the works by Rivera, Orozco, and Siqueiros included in the exhibition discredits Mewburn's suggestion that "Twenty Centuries" represented the wholesale "feminization" of the Mexican muralists. Rather, through its increased focus on the historical context of muralism, the exhibition directly responded to the fascination in the 1930s with Mexican culture and changing expectations of Mexicanness, muralism, and Mexican cultural modernity. The clearest gauge of the meanings produced by "Twenty Centuries" and the significant shifts in perception across the decade is its departure from the exhibition model of "Mexican Arts" and its conceptual revamping of the portable fresco medium.

The Museum of Modern Art and Mexican Art

Between Rivera's retrospective exhibition in 1931–1932 and "Twenty Centuries," the Museum of Modern Art had assembled an impressive body of work

by the Mexican muralists. The museum had begun its Latin American collection in 1935 by acquiring Orozco's *The Subway* (1928), donated by Abby Aldrich Rockefeller, who also gave substantial funds to collect works in all media from throughout Latin America. The following year, she gave the museum Rivera's *Flower Festival: Feast of Santa Anita* and *The Offering* (both 1931), which were included in the artist's 1931–1932 museum retrospective. In 1937, Stephen C. Clark, a trustee of the museum (and later its board chairman), anonymously donated four important works by Orozco, some of which he had purchased sight unseen from the artist: *Peace* (1930) and *Zapatistas, Barricade,* and *The Cemetery* (all from 1931).[16] That same year, Dr. Gregory Zilboorg donated Siqueiros's *Collective Suicide* (1936), and in the next two years the museum received gifts of the same artist's *Proletarian Victim* (1933), from the George Gershwin estate, and *Echo of a Scream* (1937), from Edward M. M. Warburg. In 1939, the museum rounded out its extensive Siqueiros collection by purchasing *Ethnography* (1939) with monies from the Abby Aldrich Rockefeller Fund. In "Twenty Centuries," many of these works supplemented those chosen in Mexico by the artist Miguel Covarrubias, who served as curator of the modern section of the exhibition.

Immediately before "Twenty Centuries," MoMA assembled the circulating exhibition "Three Mexican Artists," which traveled to museums and colleges around the country between October 1938 and June 1939. Comprising only six large works by Rivera, Orozco, and Siqueiros, the show included two works that would be displayed again for "Twenty Centuries."[17] While René d'Harnoncourt was assembling "Mexican Arts" for the Metropolitan Museum of Art, Frances Flynn Paine attempted, unsuccessfully, to persuade Abby Aldrich Rockefeller and other MoMA officials to grant Siqueiros an exhibition.[18] Between 1942 and 1946, there were several attempts to organize MoMA exhibitions devoted to the work of Siqueiros.[19] Shortly thereafter, Stephen Clark encouraged Orozco to paint large canvases expressly for exhibition at the museum. Clark, however, could not convince museum director Alfred H. Barr Jr., who favored Rivera, of Orozco's merits. According to the artist himself, Barr told Clark that Orozco was a "savage" and "very bad as a painter."[20] Yet by 1940, despite Barr's aesthetic preferences, Rivera's dominance had waned, and Orozco and Siqueiros took center stage at MoMA.

War, Oil, and an Exhibition Model

"Twenty Centuries of Mexican Art" was originally conceived as the "Exposition d'art mexicain ancien et moderne," a comprehensive exhibit planned for the Jeu de Paume in Paris by André Dezarrois, custodian of the National Museums of France. Significantly, MoMA officials absorbed many aspects of

Dezarrois's curatorial model for their exhibition, including the chronological and media-based themes and the division of curatorial labor among Mexican experts. Consisting of five sections—pre-Columbian art, colonial art, modern and contemporary art, popular art, and a historical and propaganda section—the plan based on the French model called for a Mexican organization committee, which would be headed by Alfonso Caso, the renowned Mexican archaeologist who made notable contributions to Mesoamerican studies and founded the Instituto Nacional de Antropología e Historia. Various Mexican officials and artists were to supervise the individual sections. Orozco and Rivera were to oversee the painting segment; Manuel Toussaint, director of the Instituto de Investigaciones Estéticas of the Universidad Autónoma de México and the leading scholar of colonial art who almost single-handedly revived interest in the art of viceregal Mexico, was to be in charge of colonial and indigenous Mexican painting; the modern artist Roberto Montenegro, who championed, promoted, and collected popular art and who received the first mural commissions, was slated to direct the popular art section; and Ignacio Asúnsolo, a sculptor whose academic naturalism garnered him many commissions for official public monuments, was listed as the organizer for the sculpture segment. A final, historical section was to focus on Franco-Mexican relations. Whereas the earlier "Mexican Arts" exhibition established an advisory board that included Mexican officials, collectors, and artists, the Dezarrois plan called for the first large-scale exhibition of Mexican art in the United States to incorporate Mexican experts as curators. Furthermore, the Dezarrois plan called for a specially commissioned fresco from Rivera, who would "have an entire room of the Jeu de Paume for his own works or reproductions of his great mural creations [and] for him to come to Paris and do a fresco there."[21]

John McAndrew, head of the Architecture Department at MoMA, learned of the Jeu de Paume exhibition from Diego Rivera in July 1939. In September, after Hitler invaded Poland and the exhibition in France was no longer feasible, McAndrew informed both Barr and John Abbott, the executive vice president of MoMA who would later head the organizing committee in Mexico, about the details of the French-planned exhibition, including the semi-chronological divisions and the need to borrow works directly from artists or from Inés Amor and Alberto Misrachi, the only dealers operating in Mexico in the late 1930s. According to McAndrew, the French had planned to divide the modern painting section into four groups, by artists and their styles: the popular graphics of José Guadalupe Posada; the early-twentieth-century aesthetic tendencies (*modernismo,* symbolism, and impressionism) of Julio Ruelas, Gonzalo Argüelles Bringas, and Alfredo Ramos Martínez, among others; *los tres grandes* of muralism, Orozco, Rivera, Siqueiros; and second-generation

artists associated at times with the Mexican school or other trends such as *estridentismo* and caricature, including such artists as Fermín Revueltas, Rufino Tamayo, Julio Castellanos, Manuel Rodríguez Lozano, Abraham Angel, Carlos Orozco Romero, Carlos Mérida, Ramón Alva de la Canal, Ramón Alva Guadarrama, Miguel Covarrubias, Nahuí Olín, and Adolfo Best Maugard.[22]

Shortly after McAndrew divulged the details of the Dezarrois plan, Nelson Rockefeller met with President Cárdenas in his hometown of Jiquílpan on October 14 and 15, 1939, to discuss the expropriation of oil and the negotiations under way between U.S. oil companies and the Mexican government. Although Rockefeller insisted he was there in an unofficial capacity, he and his family obviously had vested interests in the negotiations. According to Rockefeller,

[Cárdenas] stated that he felt the only way was for the government to negotiate directly with the companies. Frustrated that talks with [lawyer Donald R.] Richberg had been very unsatisfactory as Richberg had not understood the problem of Mexican point of view. He then asked in a rather hopeful way whether I thought companies would send another representative. I stated that I wanted to make clear that I was not in any way connected with the company representatives in Mexico and that I in no way represented them but that I understood the companies felt they had exhausted all possibilities of private negotiations and turned the problem over to the State Department. . . . We then left this subject and talked about comprehensive exhibition of Mexican art which I was anxious to arrange for this winter at the MoMA. He was most interested and promised all assistance. It was then time for dinner and we got up.[23]

"Twenty Centuries" served to assuage Cárdenas's frustration with U.S. industry's inability to understand the "Mexican point of view." The exhibition represented a strategy by which Rockefeller deflected attention from the oil negotiations and at the same time facilitated their progress.[24] While the broader negotiations effected a few compromises, Mexican oil remained nationalized. As many scholars have discussed, a complicated diplomatic situation resulted in restored relations between the two countries, partly because of Rockefeller's cultural efforts and the use of culture as a diplomatic tool.

The Museum of Modern Art had limited experience in structuring exhibitions according to geographical models. Before "Twenty Centuries of Mexican Art," the only exhibition to present a nation's cultural production was "Three Centuries of American Art," in 1938. Given the correspondence in titles, the 1940 exhibition of Mexican art not only expanded the curatorial rationale of the 1938 exhibition but also consciously forged a hemispheric alliance. While it would be rare to find exhibitions classified as "European" or to attempt an exhibition of, say, "Twenty Centuries of French Art," American and Mexican

art were singled out for encyclopedic presentations. As an anomalous curatorial framework within the history of the Museum of Modern Art, the model of a seamless historical continuity can be explained in part by the need to assert American independence. Far-reaching surveys such as "Twenty Centuries" consciously promoted static cultural absolutes in the attempt to link an autochthonous past with current production. The aesthetic and cultural motivations of Americanism in the late 1920s and the 1930s were replaced by the political and practical expediencies of World War II. Barr acknowledged the political motivations of this newfound pan-Americanism at MoMA at the end of the war:

Perhaps [we] might not have taken any great interest in South America had it not been for the war, the state of emergency, the necessity of establishing closer relations with the countries to the south. I think we were very conscious of the political background of our interests, and conscious, too, of the somewhat complicating nature of that political atmosphere. I know that we here in the Museum of Modern Art worked in considerable haste. Already, we begin to see that we made a good many errors, both of policy and taste. We entered the field in a spirit of discovery. I hope that the results have laid the foundation of a more profound study which may come in the future.[25]

The Exhibition

MoMA officials planned the New York exhibition according to the Dezarrois outline. They retained four of the original five sections; the historical/propaganda segment was scrapped. Somewhat in accordance with the French agreement, Alfonso Caso headed the organization committee and directed the pre-Columbian portion, and Manuel Toussaint and Roberto Montenegro oversaw the colonial and popular art sections. After several months, Miguel Covarrubias, a less controversial artist than Orozco or Rivera, joined the team to direct the modern segment. "Twenty Centuries" was one of the first (and remains to this day one of the few) exhibitions of Mexican art presented from the perspective of Mexican scholars and artists who were seeking to codify Mexican cultural nationalism at home and abroad.[26] A collaborative effort between MoMA and the Mexican government, the exhibition illustrated the Mexican state's increasing desire at midcentury to control presentations of its culture internationally. Although the Mexican government had a limited history of sponsoring exhibitions in other countries, the national exhibition model took on ever-greater urgency in the post-Cárdenas years with the increased institutionalization of the Revolution.

In the 1920s, artists with differing ideologies and in distinct movements proposed competing aesthetic projects, and this conflicting terrain of post-

Revolutionary discourse had only increased by 1940, as a new generation of artists entered the fray. This new generation included followers of the Mexican school as well as those who resisted what Rufino Tamayo considered its false engagement with Mexican themes. With the dominance of *los tres grandes* at home and abroad, it is no surprise that contemporary artists hesitated to participate in the "Twenty Centuries" exhibition, perhaps fearful that they might be forced into categories or groups. Officials in the United States called on Covarrubias, an artist associated with the earlier generation but one who always maintained his independence, to assist with the curatorial task.

Covarrubias's status as an established modern artist and caricaturist and his many influential connections in the United States and Mexico, as well as his interest in and collection and study of pre-Columbian and popular art, made him an appropriate candidate to curate the modern section of an exhibition with a sweeping view of Mexican culture and a host of diplomatic requirements.[27] Roberto Montenegro, who selected the more "inert" objects of popular art, avoided the jockeying for position, aesthetic battles, and competing allegiances associated with the modern art production of Mexico in the 1930s.[28] According to John Abbott, "The majority of the artists had at first refused to exhibit and had only been persuaded after considerable difficulty. [Covarrubias] had a tentative list but was by none assured how the final selection would work out."[29] Monroe Wheeler corroborated Abbott's assessment: "Most of [the artists] . . . imposed rigid conditions, such as being allowed to make their own choice, or that their work be hung in a particular manner, or that they be represented by the same number of pictures as certain other artists, etc. Others did not want to be in the exhibition at all."[30]

Covarrubias began tentatively, "afraid of making a hasty choice" for the catalogue (the reproductions needed to be determined first). Following the French agreement closely, he suggested this exhibition plan in mid-January 1940:

A comprehensive collection of pictures from about 1850 to the present: there are fine "naïve" or "primitive" pictures (portraits, still lifes, battles, etc.); three or four pictures of the best painters of the Academy; (a fine landscape of Velasco, an excellent still life of Parra and some interesting and little-known painters of the beginning of the century such as Clausell and Goytia [*sic*]). Follows a group of painters who rebelled against the Academy and from then on to the actual revolutionary, modern painters from Orozco, Rivera, Siqueiros, etc., down to the young artists that have sprung in the last few years of which there are more than one realizes at first. I want to include a group of graphic artists, lithographers and engravers, old and modern, such as Posada, Manilla, Mendez, etc., and a group of children's drawings. . . . There should be a small group of sculptures, and one of photographs, including some interesting old ones in Álvarez Bravo's collection.[31]

In his plan, Dezarrois had proposed a "Birth of National Art" subdivision, where the aesthetic practices of the nineteenth and twentieth centuries were seen as the culmination of traditions extending back to the sixteenth century. The nineteenth-century section of the French plan had comprised anonymous genre and academic painting (the latter subcategory containing works by José María Velasco, Santiago Rebull, and Félix Parra). It was followed by a nineteenth- and twentieth-century modern painting section that would have provided a context for the work of Rivera, Siqueiros, and Orozco.[32] Although less comprehensive than Dezarrois's plan, the plan for "Twenty Centuries" still relied on a few representative examples that bridged the nineteenth and twentieth centuries, in order to provide historical grounding for the birth of a national art. The modern segment of "Twenty Centuries," covering the period from 1821 to 1940, displayed such paintings as *Still Life* (1845) by Félix Parra and *The Valley of Mexico* (1891) by José María Velasco (fig. 91). Velasco's well-known landscapes of the Valley of Mexico are fervent visualizations of Mexican nationhood that, in the exhibition, gave a historical context to the nationalist rhetoric of the muralists. The exhibition broadened the concepts of nationalism and the history of Mexican art previously showcased in "Mexican Arts" to encompass European-informed academic painting as well as pre-Revolutionary modern Mexican art. In contradistinction to the "Mexican Arts" exhibition of 1930–1932, Mexican muralism was explained in "Twenty Centuries" as an outgrowth of a variety of aesthetic projects and not as merely the contemporary outgrowth of a long history of indigenous folk art. The exhibition was the first attempt by an institution such as the Museum of Modern Art to lengthen the timeline for modern art in Mexico and to position Mexican muralism as the product of a more complex visual culture.[33]

Statements in the *Bulletin of the Museum of Modern Art* consecrated the mythic, Revolutionary status of the muralists but did not deny the active, politically forceful nature of their work: "No restrictions were placed on subject matter though as a consequence the artists at times painted with guns on their hips. The murals celebrated heroes and incidents of the recent civil wars, the principles of Marxism, the glory and tragedy of Mexico's past, the beauty of the Mexican scene and the nobility and suffering of the Indian peons; and they attacked the landowners, industrialists and foreign invaders both military and economic."[34]

The display of modern Mexican art in "Twenty Centuries" represents a more historically informed perspective than that of "Mexican Arts" a decade earlier. With the advantage of critical distance, Covarrubias and MoMA officials had the opportunity to reflect on changes in the history of modern Mex-

FIG. 91. José María Velasco, *The Valley of Mexico*, 1891. Oil on canvas. Photograph courtesy the Museum of Modern Art Library/Art Resource, New York.

ican art, in perceptions of that history, and in exhibition practices over the course of two decades.

Whereas muralism was noticeably absent in "Mexican Arts," it occupied a substantial, if still not completely satisfactory, role in the modern segment of "Twenty Centuries." Literature accompanying the exhibition directed museum-goers to Orozco's mural cycle at the New School for Social Research (now the New School University) and to Rivera's murals then located at the New Workers School in New York. The exhibition also included several preparatory studies for murals as well as a section devoted to photographs of murals in Mexico. The French plan for the exhibition had called for a mural commission from Rivera. In making arrangements for "Twenty Centuries," however, Rockefeller greatly reduced the artist's role, commenting that the museum "wouldn't have . . . to give Diego Rivera a special gallery or commission."[35] Though it was six years after the Rockefeller Center mural controversy, the reluctance to showcase Rivera is not surprising. It would be another artist who would receive a special commission.

Portable Fresco Redux

Despite the disappointing experience with Rivera's portable mural, some nine years later the Museum of Modern Art commissioned one from Orozco. It is unclear, though, at what stage the organizers of "Twenty Centuries" or, more appropriately, the museum staff finally decided to invite one of the represented artists to create a portable fresco in New York. An article in the *New Yorker* suggests that John Abbott conceived the idea in January 1940, when he was in Mexico, but no mention of a mural commission is made either in his correspondence or that of director of publications Monroe Wheeler, Miguel

Covarrubias, Nelson Rockefeller, Alfred H. Barr Jr., or Architecture Department head John McAndrew during the early months of 1940, when the major preparations were under way.[36] Not until April 30, two weeks before the opening, did Orozco receive a telegram from Abbott offering him twenty-five hundred dollars, plus payment of all expenses, to come to New York to paint a fresco.[37] The date of the offer hints that the idea for the commission was an afterthought, a belated determination to enhance the display of muralism in the exhibition. Only when Orozco staked out a presence on the third floor of the museum and began painting *Dive Bomber and Tank* on site after the exhibition opened could muralism claim a significant territory in the exhibition.

By 1940, Orozco had become a viable alternative to Rivera, who had already "performed" the fresco technique for the public during his retrospective at the same museum. Less politically scandalous than Rivera and less politically orthodox than Siqueiros, Orozco was the sole safe choice among "the big three." In addition, his expressionism offered a stylistic alternative to the perceived didacticism and folkloric nativism of Rivera's illustrative compositions. Orozco had engaged the political exigencies of his day without devolving into propaganda.

Indicating their concern not to repeat past scandals, the trustees of the museum insisted before the commission was granted that "the subject matter must not be controversial and, if possible, sketches should be submitted for approval."[38] Orozco arrived in New York on May 10, 1940, and found that the museum staff had not prepared the portable panels.[39] The staff was busy installing the exhibition; the delay was also perhaps the result of the trustees' desire to see Orozco's preparatory sketches before he actually began work. Barr and the trustees did not approve the sketches until the end of the month, and Orozco did not begin painting the six-part mural until the second half of June.[40] For this second attempt at tackling the portable fresco medium, both the museum and Orozco took steps to address the complications Rivera had faced.

Dive Bomber and Tank (fig. 92), which Orozco painted in the presence of the museum public (fig. 93), measures nine by eighteen feet and is divided into six interchangeable panels, each three feet wide. The final product, as displayed in its traditional arrangement, represents the collision of two machines of war and the twisted, mangled ruins of the wreckage. The tail of an airplane in the top central portion, perhaps the most recognizable object depicted, gains emphasis from its red hue, contrasting with the monochromatic palette of the rest of the painting. Winglike structures extend from the sides of the pile of machinery, while crawling tank tracks are visible in the lower left and under the hanging chains at the bottom edge of the panel. Other identifiable

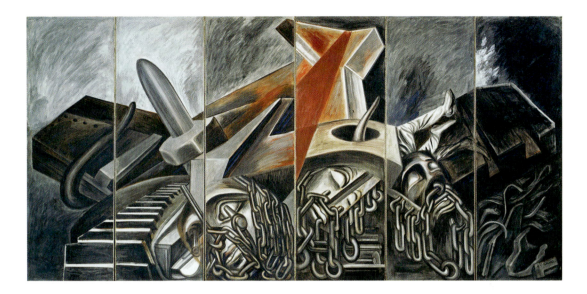

FIG. 92. *(above)* Orozco, *Dive Bomber and Tank*, 1940. Portable fresco. The Museum of Modern Art, New York. © Artists Rights Society (ARS), New York / SOMAAP, Mexico City.

FIG. 93. *(left)* Orozco painting *Dive Bomber and Tank* in view of the museum public, 1940. © The Museum of Modern Art/Licensed by SCALA / Art Resource, New York.

parts include a projectile bomb that balances the angular thrust of the tail, human legs jutting out of the ruins in the central right section, and a series of three masklike faces pierced by spikes and chains in the lower register.

While socially engaged modernism had gained currency in the art world, Orozco's expressionism afforded a fresh style for conveying socially relevant themes. Monumental and with politicized content, *Dive Bomber and Tank* renounces picturesque Mexican imagery such as that found in Rivera's portable frescoes. Disavowing what some perceived as the didacticism or native folkloricism of Rivera or the Mexican school, Orozco's work was powerful political art that used the modernist idiom of abstraction. One critic declared it a "spectacular marker of the transition from realism to abstraction" in the

cultural sphere of the United States.[41] Orozco seemed to have adopted the stylistic model for public art of Picasso's *Guernica,* then on view at the Museum of Modern Art. A modernist painting with socially compelling themes, Picasso's large-scale work defined the political aesthetics of the second half of the 1930s.

For Orozco, the very concept of a "portable" fresco at first seemed illogical; as he wrote to his wife, Margarita, "Of course it will fall into pieces, since fresco is a delicate thing that should not be moved."[42] Yet he willingly obliged the museum's request and later rationalized that a portable fresco could be protected from such disasters as earthquakes or even the destruction of war.[43] Because museum officials intended for "Twenty Centuries of Mexican Art" to travel, *Dive Bomber and Tank* needed to be easily moved.[44] According to Orozco, Rivera's portable frescoes were already in a bad state by 1940, so for the new exhibition the museum paid great attention to conservation concerns. Barr called on experts in metallic construction and plaster to detail the logistical and technological considerations of the commission in light of the problems associated with fresco.[45] The decision to divide the mural into six parts, therefore, was based on practical rather than thematic concerns. And in executing the commission, Orozco devoted careful thought to the exigencies of the medium.

Given the negotiations between the museum and Orozco, *Dive Bomber and Tank* should be considered in part a response to Rivera's failed attempts with portable fresco. Three of his frescoes hung on the walls of the museum when Orozco began his commission, some on the very same floor where the latter painted while the public looked on.[46] To counter the type of criticism directed at Rivera's portable murals, Orozco's fresco had to be large—much larger than Rivera's panels—so as to approximate more closely the scale of public mural painting. Despite the large proportions of the fresco, the division into separate panels still allowed the mural to be "moved, packed and shipped."[47]

Dividing the pictorial surface into equal fragments might have seemed an impediment, but Orozco turned technical necessity into formal experimentation by suggesting that the panels could be placed in various configurations (figs. 94 and 95). In the August 1940 issue of the *Bulletin of the Museum of Modern Art,* the artist proposed displaying the mural in six distinct arrangements, many of them more abstract than the "standard presentation," thus making the content of *Dive Bomber and Tank* more ambiguous. Asked to "explain" the mural, Orozco stated, "A painting is a Poem and nothing else. A poem made of relationships between words, sounds or ideas. Sculpture and architecture are also relationships between forms. . . . The order of the inter-

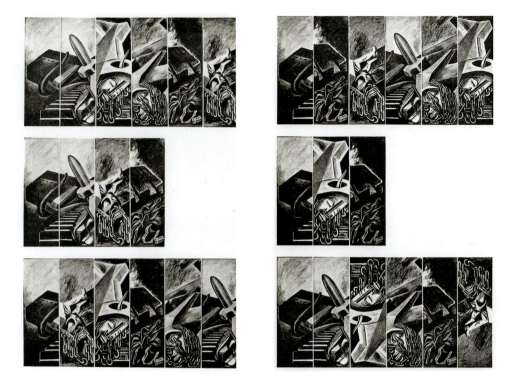

FIG. 94. *(left)* The first three of six possible configurations of the six panels of *Dive Bomber and Tank* preferred by Orozco, from the *Bulletin of the Museum of Modern Art* 7, no. 4 (August 1940): 10. The Museum of Modern Art Library, New York. Digital image © The Museum of Modern Art/Licensed by SCALA / Art Resource, New York.

FIG. 95. *(right)* The second three of six possible configurations of the six panels of *Dive Bomber and Tank* preferred by Orozco, from the *Bulletin of the Museum of Modern Art* 7, no. 4 (August 1940): 11. The Museum of Modern Art Library, New York. Digital image © The Museum of Modern Art/Licensed by SCALA / Art Resource, New York.

relations between . . . parts may be altered, but those relationships may stay the same in any order, and unexpected or expected possibilities may appear."[48]

James Oles rightly argues that *Dive Bomber and Tank* functions as a metaphor for plastic manipulations and that the stylistic and physical fragmentation in this fresco serves as an allegory for the fragmentation of war. He also proposes that the Mexican artist went beyond Picasso by "adding the possibility of physical fragmentation." In doing so, Orozco underscored his theme of the violence of World War II yet allowed his apocalyptic image of death and destruction to convey a general condemnation of war. The subject of the fresco is "chaotic fragmentation itself."[49] I would argue, along similar lines, that the alternative arrangements of the portable fresco operate as a complex exegesis on the process of reading a mural.

FIG. 96. General view of the Escuela Nacional Preparatoria with Orozco's mural cycle, Mexico City. © 2006 Artists Rights Society (ARS), New York / SOMAAP, Mexico City. Photograph by Schalkwijk / Art Resource, New York.

On a conceptual level, *Dive Bomber and Tank* replicated one of the many physical and visual conditions of mural painting in certain public buildings in Mexico, such as the Secretaría de Educación Pública, with its major mural cycle by Rivera, and the Escuela Nacional Preparatoria (fig. 96), where Orozco had executed his most famous and accomplished mural cycle to date. In baroque buildings such as the ENP, or even in twentieth-century edifices such as the SEP, constructed on the model of colonial Mexican architecture embodied by the ENP, the integrity of the mural cycle is maintained by distinct panels set between the arches of multistory loggias.

Painted in various stages, Orozco's cycle at the ENP does not form a linear narrative; panels close in theme, style, mood, and date of execution are scattered on the first and third courtyard floors. No particular sequence of viewing is privileged or encouraged. In order to digest the cycle from a distant or even a medium-range vantage point, a common approach, viewers must carry over the narrative from inset to inset and from wall to wall, in effect creating their own configuration. In this abstract process, thematic unity and close iconographic reading are often temporarily sacrificed. Similarly, the panels of

Dive Bomber and Tank can be interrelated in many ways. In the process, the forms depicted become even more abstracted, and the result is a multiplicity of meanings rather than strict coherence. Through the use of formal manipulation and abstraction as metaphors for the construction of vision in general, Orozco's work explicitly refers, on a smaller scale, to the experiential conditions of viewing a mural.

The absence of a cohesive narrative remained one of the primary stumbling blocks to the acceptance of Rivera's portable frescoes as appropriate examples of muralism. At the Museum of Modern Art, he attempted to replicate his Cuernavaca murals; the adaptations necessarily became isolated scenes when the artist merely ripped parts from a consecutive narrative and displayed them as large easel paintings instead of interrogating the unique formal and visual concerns of muralism and the problem of the "portable" mural itself. Orozco, rather than execute six individual frescoes, confronted the challenges, contradictions, and ambiguities of viewing murals and of the portable fresco medium.[50] He created a large composition that could indeed be read as a mural cycle, not necessarily consecutively or linearly, but episodically, just like the murals at the ENP. *Dive Bomber and Tank* avoided the pitfalls of Rivera's portable frescoes, as the socially conscious critic Elizabeth McCausland observed at the time:

The very idea of a portable mural militates against the mural per se. Murals are by their nature wall paintings in a specific architectural setting. To design a mural not knowing where it is to be hung is like painting in a vacuum; the plastic structure has to be created abstractly, without knowledge of the physical visual environment where the mural will function later. Orozco, being an honest man, has not been able to negate the integrity of his own character and creative gift. The result is that the panels emerge as a true mural, but without its wall and surrounding architectural matrix.[51]

McCausland not only reiterates the fundamental limitations of the portable fresco format but also suggests that *Dive Bomber and Tank*'s abstraction allows it to adapt to any architectural environment; in this it distinguishes itself from Rivera's murals, which appear like fragments torn from their context. The integrity and honesty she ascribes to the artist can also be characterized as his "staying true" to the medium (as opposed to Rivera's manipulations) and his superior use of it. Her response indicates that Orozco's mural proved much more effective in communicating the goals of Mexican public mural painting than had Rivera's panels.

Dive Bomber and Tank enabled the large crowds that came to see the "Twenty Centuries" exhibition to engage with a complex mural that in many ways defied the expectations placed on Mexican muralism and that simul-

taneously considered current aesthetic debates on the role of abstraction in public art. The positive reception of Orozco's mural in 1940 was related to the changing tide of artistic expression in the United States. Moving past realism and regional imagery in favor of the mythic themes and symbols introduced by Orozco, Rivera, and Latin American artists such as Joaquín Torres-García and Roberto Matta, painters from the United States, including Jackson Pollock and Adolph Gottlieb, eventually turned to abstraction as a preferred mode. Illustrative nationalism had become increasingly suspect, and the pragmatic motivations for the ascendancy of muralism in the United States—economic relief during the Great Depression—soon disappeared. Thus, despite Orozco's success with the format, the portable fresco did not thrive after 1940, when the prominence of the Mexican muralist movement and socially engaged modernism waned.[52] Yet the experiments with the movable murals of the 1930s laid the groundwork for artists associated with abstract expressionism, who would embrace the large-scale and experiential aspects of muralism.

The Ascendancy of Orozco and Siqueiros

Smaller-scale works by the muralists also functioned as surrogates for muralism in "Twenty Centuries." Five easel paintings came from Mexican collections—through the assistance of Inés Amor, director of the Galería de Arte Mexicano, who served as a behind-the-scenes advisor and contact for most of those who had modern works included in the exhibition. Covarrubias had said that the muralists' "important pictures are in the United States," and accordingly, twelve works (including portable frescoes) were borrowed from U.S. collections.[53] Seven of these came from MoMA or from patrons associated with the institution; the hurried nature of the exhibition probably necessitated this borrowing of works from sources close to MoMA rather than more diverse sources. The museum's *Bulletin* indicated that these works were chosen by museum staff, whereas it was Covarrubias who selected the five easel paintings from Mexico, including Rivera's large new *Kneeling Dancer* (fig. 97), which was "a nude figure of a Guatemalan negress" that John Abbott considered "amazingly good" and which Covarrubias chose as "the pick."[54] Covarrubias's association with the Harlem Renaissance in the 1920s explains his interest in Rivera's exaggeratedly sexualized and racial depiction of the African American dancer Modelle Boss, one of a series of works, both paintings and watercolors, that he produced on the theme in 1939. Decidedly nonpolitical and displaying problematic racial and gender signifiers, *Kneeling Dancer* exudes a facile primitivism.[55] Other easel paintings offered supporting evidence that Rivera had (temporarily) turned away from socially engaged subject matter: a rather saccharine portrait of the Mexican movie star Dolores

FIG. 97. Rivera, *Kneeling Dancer,* 1939. Oil on canvas. Museo Dolores Olmedo Patiño, Mexico City. © 2008 Banco de México Diego Rivera & Frida Kahlo Museums Trust, Av. Cinco de Mayo no. 2, Col. Centro, Del. Cuauhtémoc 06059, México, D.F. Photograph by Schalkwijk / Art Resource, New York.

FIG. 98. "Twenty Centuries of Mexican Art" (Rivera section), Museum of Modern Art, New York, 1940. The Museum of Modern Art Library, New York.

del Rio (fig. 98, second painting from left) and a surrealism-influenced landscape, *Copalli,* from the Brooklyn Museum of Art (fig. 98, painting on the far right). Yet three portable frescoes from 1931—*Agrarian Leader Zapata, Sugar Cane,* and *Liberation of the Peon*—were also included. Although they had been judged failed experiments in 1931, in the context of "Twenty Centuries" those three works were reminders of the more politicized and socially relevant subjects for which Rivera was equally well known.

In addition to *Dive Bomber and Tank,* Orozco contributed works from the early 1930s to "Twenty Centuries."[56] A month after the exhibition opened, even before he executed the mural, critics were already comparing his works with

those of Rivera. They argued that the exhibition proved Orozco a better artist and that Rivera, though more renowned, had declined in his aesthetic significance. With the benefit of reflection, critics reassessed Orozco's contribution and questioned Rivera's late style. At stake was the legacy of muralism:

It seems rather unfortunate that the exhibition should lay greater stress on Rivera than on Orozco by showing portable fresco panels of works by the former and only photographs of murals by the latter. At the time of the Rivera exhibition held at the museum in 1930 [sic], the writer held certain reservations about Rivera's creative contribution to contemporary culture. . . . Time has only strengthened the opinion. On the other hand, time makes it more certain that Orozco's is a major genius, fed on profound sincerity and devotion though necessarily rooted in the spiritual uncertainties and conflicts of his generation. The comparison is stressed, because the hanging of three large panels by Rivera at key points throughout the museum's three exhibition floors is likely to give the public the impression that Rivera has been the great master of mural painting in Mexico. On the contrary, of late years Rivera has produced little of interest; and the large 1939 oil "Kneeling Dancer," 47¾ by 67½ inches, seems to indicate a definite return on the part of this painter to preoccupations of the studio, to a rather personal, private, erotic art, of little communicative value.[57]

The increased visibility of Siqueiros signaled yet another shift in curatorial priorities. Unlike "Mexican Arts," in which works by both Rivera and Orozco overshadowed those by Siqueiros, "Twenty Centuries" presented the three in a more equitable manner: seven works by Orozco, including the portable mural; six by Rivera; and five by Siqueiros. For "Twenty Centuries," all three artists shared a room devoted to their work, reinforcing their broader canonization as *los tres grandes* of muralism. In the years between the two exhibitions, Siqueiros had exerted a profound influence on the New York art scene with his experimental workshop, where Jackson Pollock, among others, learned new techniques.[58] Several months before "Twenty Centuries" opened, the Pierre Matisse Gallery in New York featured an exhibition of Siqueiros's work. MoMA and Stephen Clark immediately purchased two works from that show, *Ethnography* and *The Sob,* which appeared later that year in "Twenty Centuries."[59] Of the five works by Siqueiros displayed in "Twenty Centuries" (fig. 99) alongside Rivera's *Liberation of the Peon,* three can be interpreted as powerful visual commentaries on contemporary political events: *Proletarian Victim* (1933), *Collective Suicide* (1936), and *The Sob* (1939).[60]

A very large work, *Proletarian Victim* (fig. 100) portrays an imposing nude female, her legs and arms bound by a tightly entwined rope, who has been executed with a shot to the head. Siqueiros conveys feelings of oppression, subjugation, and constriction by physically containing the figure within the canvas so that the top edge seems to press down on her. As James Oles has

FIG. 99. "Twenty Centuries of Mexican Art" (Siqueiros section, with Rivera's *Liberation of the Peon* on the right), Museum of Modern Art, New York, 1940. The Museum of Modern Art Library, New York.

FIG. 100. Siqueiros, *Proletarian Victim*, 1933. Enamel and oil on burlap. The Museum of Modern Art, New York. Gift of the Estate of George Gershwin. © Artists Rights Society (ARS), New York / SOMAAP, Mexico City. Photograph © The Museum of Modern Art/ Licensed by SCALA / Art Resource, New York.

FIG. 101. Siqueiros, *Collective Suicide*, 1936. Pyroxylin on wood. The Museum of Modern Art, New York. Gift of Dr. Gregory Zilboorg. © Artists Rights Society (ARS), New York / SOMAAP, Mexico City. Digital image © The Museum of Modern Art/Licensed by SCALA / Art Resource, New York.

revealed, when Siqueiros first showed the painting, in Buenos Aires in 1933, it carried the subtitle *In Contemporary China,* referring to the persecution of communists in China before Mao Zedong's ascent to power.[61] *Proletarian Victim* is the first work in which the artist applied what would be his trademark material, pyroxylin, an industrial enamel used for airplane and automobile exteriors and sold by DuPont under the registered name Duco. The unconventional medium, placed on an equally unusual burlap support, retouched with traditional oil paint, creates a rough texture that enhances the violence of the subject.

Collective Suicide (fig. 101), like *Proletarian Victim,* is a highly experimental work with a politicized theme. Here, Siqueiros again used pyroxylin, but without the aid of oil paint. Applied sculpted wooden forms project out into the viewer's space. The subject appears to be an abstract cataclysmic explosion, but minuscule figures cluster in the lower third of the canvas. Joan Handwerg has traced the source of the imagery to a historic sixteenth-century battle in Nueva Galicia and has analyzed the painting in accordance with the ideas of its patron, the psychiatrist Dr. Gregory Zilboorg. Handwerg's important findings notwithstanding, the profound apocalyptic imagery should also be read, as Olivier Debroise has suggested, in the context of the Spanish Civil War; Siqueiros was directly involved in the conflict.[62]

Similarly, while *The Sob* (fig. 102) is a moving portrait of human emotions in general (and of Siqueiros's third wife, Angélica Arenal, in particular), it can also be interpreted as a visualization of the feelings of anxiety and desperation surrounding recent political events: the fall of Spain's democratic republic and

FIG. 102. Siqueiros, *The Sob*, 1939. Pyroxylin on composition board. The Museum of Modern Art, New York. Anonymous gift. © Artists Rights Society (ARS), New York / SOMAAP, Mexico City. Photograph © The Museum of Modern Art/Licensed by SCALA / Art Resource, New York.

the Nazi invasion of Poland.[63] Distilled to a universal human gesture, the figure fills the composition and is monumentalized within a compressed space like that in *Proletarian Victim*. Again, as in the earlier picture, Siqueiros uses the female body, endowed with massive, muscular forms, as an allegorical vehicle.

Whereas New York critics censured Rivera's contributions to "Twenty Centuries" for not living up to his radical politics, they praised Orozco and Siqueiros for the bold, politicized easel paintings in the exhibition. Many critics singled out Siqueiros's stirring contributions. For some, his "striking" work represented a "nobler example of painting," while others pointed out his "strong bulky figures."[64] Although the majority of the critical assessments lambasted the modern section as the most disappointing of the exhibition, the works by Siqueiros and Orozco were noted as exceptions. For example, the art critic for the *New York World-Telegram*, Emily Genauer, who defended art's independence from politics yet introduced newspaper audiences to Mexican art, stated, "Only with the contemporary section of the exhibition have we a quarrel. . . . [There are] some brilliant easel pictures in the show; several works by Siqueiros, for instance, that have all the tremendous force, the emo-

tional punch, and the superb technique of anything done in the whole history of Mexican Art. . . . There are a couple of good Riveras . . . and some very dull Riveras, too. . . . There are some fine Orozcos, among them the Museum of Modern Art's brilliantly colored, sharply rhythmic, angular *Zapatistas*."[65]

Other critics took delight in disparaging Rivera's admittedly weak contributions, calling them "thinly disguised pornography," and praising Orozco's and Siqueiros's works in direct comparison.[66] In this exhibition, Rivera's work failed to live up to expectations that Mexican painting be monumental and politically significant. The critic from *Time* magazine wrote that the "strongest, technically most interesting contemporary items were a group of bronzed, sculptural-looking paintings done in Duco automobile paint by deep-dyed Revolutionist Siqueiros, a couple of violent scenes of violence by rugged Peasant-Painter Orozco. Biggest disappointment was a series of smart, sugary, sometimes pornographic paintings by Diego Rivera, onetime high priest of Mexican muralism." The *New York Post*'s art critic concurred that the easel painting in the exhibition, "shown at some length, is disappointing. Orozco's *Zapata* is one of the few impressive canvases. The large nude [*Proletarian Victim*] shows Siqueiros at his strongest. . . . As for the recent Riveras, they are incredibly bad painting and so crudely vulgar as to be an affront to the public."[67]

Orozco and Siqueiros's success relative to Rivera's indicates that it was no longer possible to foster a depoliticized, simplistic view of Mexican muralism or present a hygienic presentation of Mexican nationalism in museum exhibitions.

Exhibiting Muralism

Rivera's perceived "decline" signaled broader concerns for muralism, especially those related to its progressive politics. Elizabeth McCausland noted the retrospective quality of the modern segment of the exhibition, suggesting that this was the beginning of the end for the muralist movement: "The great decade of modern Mexican art was that of the 20s when a progressive government supported a large-scale program for murals and sculpture in public buildings. In recent years there seems to have been some falling off of activity and ideas. Whether this is due to the selection of work included in the modern section or whether it represents a real trend is not quite clear."[68] Statements accompanying the exhibition reinforced the idea that muralism, together with its accompanying Revolutionary, nationalist program, had already reached an apogee, and in that view, "Twenty Centuries" constituted not a culmination but a falling off: "During the last ten years—the second decade of the Mexican Renaissance—the original spirit of collective enterprise has all but disap-

peared. Mural painting has had to share a place with easel painting and with a flourishing movement in the graphic arts. Revolutionary subject matter has in part given ground to figure painting and scenes of ordinary life and, more recently, to surrealist fantasy."[69]

Although critics generally denounced the contemporary painting section of the exhibition, they were especially negative toward those "surrealist fantasies" of second-generation artists of the Mexican Renaissance. MoMA press releases had enthusiastically announced that the modern section of the exhibition would be dominated by relatively unknown artists in an attempt to broaden the story of modern Mexican art beyond muralism, but Jean Charlot found that this curatorial emphasis necessarily "gloss[ed] over the important period before," namely, the muralist generation. The emphasis on the 1930s, he said, resulted in an unsatisfactory portrayal of muralism. Furthermore, he lamented the exhibition's lack of curatorial response to the general problem of exhibiting muralism: "Even though murals cannot be transported for exhibition purposes, there exists a body of works closely related to them: geometric diagrams, studies of details from nature, full-scale tracings used on the wall. . . . The oversight of a bare five years punches a gigantic hole into the close-knit trend of those two thousand years of Mexican art."[70] Instead of including preparatory studies and sketches, which could serve as mediated proxies for the murals and, at the very least, provide insights into the fresco process, organizers of the exhibition dedicated one portion of the modern segment to photographs of murals in Mexico. The didactic display was intended to tackle the fundamental problem of exhibiting a movement defined by fixed murals. Although this display could have redressed gaps in past exhibitions, it only frustrated any attempts to place muralism in context.

A photograph of the exhibition's installation (fig. 103) shows that organizers crammed together relatively small—approximately eight-by-ten-inch—photographs of individual murals by a variety of artists, in some cases details of details, on one wall, in no apparent chronological or aesthetic order. Although the photograph crops the view of the entire installation, even this limited view suggests that there was no overall curatorial principle. A dense double row of photographs was complemented by an intermittent and arbitrary third row; no work by any one artist was grouped together, and the photographs did not trace common themes.[71] By no means substitutes for the physical and perceptual experience of viewing murals firsthand, these images nonetheless might have illuminated the spatial contexts of large mural cycles and thus introduced New York museum-goers to Mexican murals.

Exhibition organizers, however, relied on famed Mexican artist Manuel Álvarez Bravo's photographs, most of which he took when he worked for Fran-

FIG. 103. Installation view of "Twenty Centuries of Mexican Art" (photographs of Mexican murals), Museum of Modern Art, New York, 1940. The Museum of Modern Art Library, New York.

ces Toor's *Mexican Folkways,* a Mexican art and culture magazine aimed at audiences in the United States and other English-speaking areas.[72] Those black-and-white photographs, intended for small-format publications or distribution, were poor choices for museum didactics. Extensive mural cycles with numerous panels and sections were represented by only one small image, and isolated details of larger, complex narratives stood alone. Lost in translation from printed page to wall display, the photographs suffered further from their chaotic and random presentation. The choice of small photographs seems all the more strange when one considers that photomurals were among the most politically charged visual media of the late 1930s, the greatest example being the interior and exterior murals by Josep Renau that lined the Spanish Pavilion for the "Exposition internationale des arts et techniques dans la vie moderne" in Paris in 1937.[73] While institutional and logistical demands might have precluded enlargement of Álvarez Bravo's photographs for the MoMA exhibition, it was surely a missed opportunity not only to document muralism but also to base it in an aesthetic that reconciles spatial and social politics.

Álvarez Bravo's many photographs introduced muralism to audiences abroad, specifically with his extensive contributions to *Painted Walls of Mexico:*

From Prehistoric Times until Today, which Emily Edwards started in collaboration with the photographer in the 1930s but did not publish until 1966. At MoMA, however, exhibition organizers miscalculated the distance between distinct forms of viewing experiences. The intimacy and "tactility" of viewing printed photographs of murals could temper the disparity of scale. At the museum, those conditions necessarily disappeared; the small photographs gave a disjointed and confused impression of muralism. Edward Alden Jewell called them "ineffectual proxies. . . . What should prove the culminating note of the whole exhibition—a survey of modern mural achievement in Mexico—is, perforce, missing." Emily Genauer's estimation of the contemporary section as the most limited of the exhibition depended in part on her disappointment with the mural section: "The photographs . . . and details in the museum show are not nearly as phenomenal as we had expected."[74] Rather than illuminate the work of the muralists, the mural section merely frustrated viewers, and the photographs of murals were an exercise in public misapprehension. When the modern portion of "Twenty Centuries" was set to travel around the country between December 1940 and May 1941, MoMA officials suggested adding the museum's color portfolio of Rivera's murals in Mexico.[75] Just as the portfolio remedied the critical rejection of Rivera's portable murals of 1931–1932, it assuaged critics who favorably received "Modern Mexican Art," as the traveling section of modern art was called, during its national tour, reinforcing the centrality of mediation in the circulation and reception of Mexican modern art in the United States.[76]

Perhaps in direct response to the negative assessments of the mural section, Alfred H. Barr Jr. asked Orozco to "explain" *Dive Bomber and Tank* for the benefit of the public.[77] Barr expected a straightforward analysis that would describe not only the content of the picture but also the technique of fresco painting. Critical of the capacity of words to explain art, however, Orozco remained purposefully elusive; he did not want to describe his picture or fill in the curatorial gaps in the exhibition.[78]

Against the critical failure of the contemporary section stood the overriding opinion that the pre-Columbian section was the most important. For Henry McBride, the muralists appeared to "suffer strangely in comparison with the nobler efforts of the Aztec and Mayan workers"; indeed, the muralists were beginning to "wear thin." *Time* magazine's critic reported that "what really held Manhattan gallery-goers spellbound was the enormous collection of gaunt, contorted, monumental stone sculpture by long-forgotten Maya Toltec and Olmec craftsmen." The commentator from *Art Digest* suggested that "the inclusion of many of Mexico's most prized art treasures makes this pre-Spanish section probably the most important of the four."[79] And even Barr

FIG. 104. Installation of pre-Columbian sculptures in the Museum of Modern Art garden for "Twenty Centuries of Mexican Art." The Museum of Modern Art Library, New York.

himself considered, at the end of the exhibition, the "universal recognition" that "the pre-Spanish section . . . was unquestionably the most important and interesting part."[80] The presence of pre-Columbian art in the 1940 show (fig. 104) is key to the skewed perception of Mexican modernity. Strange and exotic, pre-Columbian art represents the only cultural production in which Mexico had no rivals, in which accusations of derivativeness did not apply. By linking Mexican modern art with antiquity, organizers promoted the notion of cultural continuity and aesthetic independence from Europe.

"Twenty Centuries" rejected René d'Harnoncourt's narrow nationalist agenda from 1930 by "telescop[ing] time and space" with the inclusion of both pre-Columbian and colonial art.[81] In this MoMA exhibition, modern art competed with the pageantry and spectacle of archaic monuments instead of the rural folk objects with which it had been paired in the "Mexican Arts" exhibit. Over the years, the U.S. public had come to expect from Mexican art less a hygienic presentation of Mexican nationalism than complex politics and social themes. Rivera may have faltered, but the forceful and politicized easel paint-

ings of Orozco and Siqueiros righted the balance. Rivera was not so much condemned for his communism as censured for not living up to his radical politics. Although through "Twenty Centuries" MoMA codified, even canonized, what would later be seen as a narrow view of Mexican modern art, it advanced exhibition strategies that had misled viewers a decade earlier. "Twenty Centuries" attempted to locate modern Mexican art and muralism by tracing the development of nationalism instead of presenting it as an innate racial characteristic.

Beyond Diplomatic Relations

During the 1930s, audiences in the United States experienced muralism indirectly, through a variety of media: lithographs, portable frescoes, prints, and photography. The portable fresco, as executed specifically for U.S. audiences by Rivera at the beginning of the decade, was a critical failure. After Rivera's ill-fated early experiments, the freestanding fresco became, in Orozco's hands, a viable vehicle for the display of muralism. An examination of the presentation, circulation, and reception of portable works by the muralists shows that the critical perception of Mexican muralism in the United States often reconciled political interpretations and specific formal concerns of public mural painting; diplomatic efforts, then, failed to usurp politicized art from Mexico. The Museum of Modern Art's well-documented involvement in promoting friendly U.S.–Latin American relations during the 1930s and 1940s has eclipsed and overdetermined discussions of the "Twenty Centuries" exhibition and Mexican art in general. While World War II, hemispheric relations, pan-Americanism, and oil interests all contributed to formulating the political exigencies that generated the exhibition and interest in Mexican art in general, scholarly focus on these motivations has obscured a systematic evaluation of the exhibition's display strategies and confused the ways in which Orozco's portable fresco intervened as an attempt to explain muralism to audiences in the United States. The history of the development of the portable fresco by Rivera and Orozco and a consideration of responses to "Twenty Centuries" challenges traditionally accepted assumptions about the hegemony of cultural institutions in the United States and their ability to use Mexican culture to serve ideological and political interests. It is commonly argued that Mexican muralism was effectively depoliticized in the United States during the 1930s, but this study highlights the expectations during that decade that Mexican art would indeed be politically engaged. It also addresses the general failure of U.S. institutions and patrons to co-opt and neutralize the socially engaged modernism of Mexican art. The responses to the exhibition culture of the 1930s, specifically with regard to the Museum of Modern Art, and the crisis of

the portable fresco itself, call for a reassessment of the politics of modern art and art history in Latin America and the United States.

The analysis presented here implies that we need to look beyond diplomatic relations in order to understand the transnational practices of the Mexican muralists. Although political expediencies unquestionably affected the history of modern Latin American art, by scrutinizing individual works of art, exhibition culture, reception, and institutional frameworks, we can determine that cultural diplomacy is often an incomplete interpretative tool; expanding this interpretative model redirects us to artists' working processes and their engagement with modernism.

The study of twentieth-century Latin American art in the United States, especially the art of Mexico, is challenged by the reinforcement of alleged oppositions between the political and the depoliticized, the local and the universal, the rural and the cosmopolitan. To this day, scholars are concerned on the one hand by tendencies to depoliticize Latin American art and, on the other, by the heightened expectation for a political agenda from it. The reception of Mexican art in the United States not only demonstrates how Mexican art history, specifically as elaborated in the United States, has been affected by such expectation and manipulation but also shows that the examination of the artistic, cultural, and political contexts framing that process suggests that such outmoded models of interpretation and understanding can be resisted.

The exhibition culture of the 1930s provides insights into the origins and legacy of the national exhibition model whereby received notions of national personality conform to static cultural clichés at home and abroad. While the model of a seamless historical continuity is often governed by political expediencies, geopolitical motivations continue to structure contemporary art exhibitions purporting to be global. The American nationalisms of the 1930s must be understood within their particular social and political contexts as responses to modernism and modernization and as manifestations of a heterogeneous tradition with various levels of mediation. As new canons are formed in opposition to the primacy of Mexican art within Latin American art history, and as the Museum of Modern Art reinvents its hegemonic role in this story, it is all the more important that we pay attention to the lessons learned from the 1930s and 1940s. Fundamentally, all narratives are constructed and call forth divergent levels of engagement and resistance; only with that in mind can we assess Mexico's contribution to international modernism and the legacy of socially engaged aesthetic practices.

NOTES

Chapter 1. Introduction

1. Among the many artists who painted murals in Mexico were Jean Charlot, Fernando Leal, Roberto Montenegro, Juan O'Gorman, Fermín Revueltas, and Rufino Tamayo. For simplicity and as an alternative to *"los tres grandes"* ("the big three"), as Rivera, Orozco, and Siqueiros are often called, I refer to them as "the muralists," although I acknowledge the need to amplify the parameters of "Mexican muralism."

2. Francisco Reyes Palma, "Mural Devices," in *José Clemente Orozco in the United States, 1927–1934*, exhibition catalogue, eds. Renato González Mello and Diane Miliotes (Hanover, NH, and New York: Hood Museum of Art, in association with Norton, 2002), 225.

3. See Helen Delpar, *The Enormous Vogue of Things Mexican: Cultural Relations between the United States and Mexico, 1920–1935* (Tuscaloosa: University of Alabama Press, 1992). For a more critical account of this era, see James Oles, *South of the Border: Mexico in the American Imagination, 1914–1947*, exhibition catalogue (New Haven: Yale University Art Gallery, 1993).

4. See Lynda Klich, "Revolution and Utopia: *Estridentismo* and the Visual Arts, 1921–27" (PhD diss., Institute of Fine Arts/New York University, 2008).

5. According to Olivier Debroise, Anita Brenner coined the term *"tres grandes"* ("big three" or "three great ones") in the speech she gave at the opening of the Siqueiros exhibition that she directed at the Casino Español in 1932. She stated, "We know that Mexico and the whole world have a great painter here, one of the greatest . . . one of the three great figures of modern Mexican art." Anita Brenner, "La exposición de David Alfaro Siqueiros," in *Vida y obra de David Alfaro Siqueiros*, ed. Angélica Arenal de Siqueiros (Mexico City: Fondo de Cultura Económica, 1975), 23–28, as cited in Olivier

Debroise, "Action Art: David Alfaro Siqueiros and the Artistic and Ideological Strategies of the 1930s," in *Portrait of a Decade: David Alfaro Siqueiros, 1930–1940* (Mexico City: Museo Nacional de Arte, Instituto Nacional de Bellas Artes, 1997), 43–44.

6. Mary K. Coffey, "Mural Art and Popular Reception: The Public Institution and Cultural Politics in Post-Revolutionary Mexico," in *La imagen política: XXV Coloquio Internacional de Historia del Arte,* ed. Cuauhtémoc Medina (Mexico City: Universidad Nacional Autónoma de México, 2006), 363–72.

7. Siqueiros's U.S. murals remained faithful to his Revolutionary ideals and principles. Those at the Chouinard School of Art and at the Plaza Art Center on Olvera Street in Los Angeles were whitewashed almost immediately after their execution because of their controversial political themes.

8. Aside from their anomalous subject matter, the U.S. murals by Rivera and Orozco, as vociferously indicated by Siqueiros, are all executed on "interior walls," unlike Siqueiros's experiments with exterior cement frescoes, those being *Workers' Meeting,* at the Chouinard School of Art; *Tropical America,* on Olvera Street; and the mural for the home of Dudley Murphy (now installed at the Santa Barbara Museum of Art).

9. Orozco first came to the United States in 1917, when he visited San Francisco and traveled to New York for a brief stay. He returned to New York in 1945 for another short period.

10. Clemente Orozco Valladares, *Orozco, verdad cronológica* (Guadalajara: Universidad de Guadalajara, 1983), 183.

11. José Juan Tablada, "Diego Rivera—Mexican Painter," *Arts* 4 (October 1923): 267–76; José Juan Tablada, "Mexican Painting Today," *International Studio* 76, no. 308 (January 1923): 272.

12. José Juan Tablada, "Orozco, the Mexican Goya," *International Studio* 78, no. 322 (March 1924): 492–500.

13. Tablada to Orozco, May 16, 1927, cited in Orozco Valladares, *Orozco, verdad cronológica,* 172.

14. Renato González Mello, "Public Painting and Private Painting: Easel Paintings, Drawings, Graphic Arts, and Mural Studies," in *José Clemente Orozco in the United States, 1927–1934,* eds. González Mello and Miliotes, 62–97.

15. Although chapter 3 considers critical responses in various U.S. cities, my overall analysis relies on the more extensive and documented New York context.

16. Coffey, "Mural Art and Popular Reception," 363.

17. Thomas E. Crow, *Painters and Public Life in Eighteenth-Century Paris* (New Haven: Yale University Press, 1985), 5 (first quote), 3 (second quote), respectively.

18. Helen Langa, *Radical Art: Printmaking and the Left in 1930s New York* (Berkeley: University of California Press, 2004), 9.

Chapter 2. *Horrores*

1. Diego Rivera was in Europe from March 1909 until the summer of 1910 and between June 1911 and June 1921.

2. José Clemente Orozco, *José Clemente Orozco: An Autobiography* (Austin: University of Texas Press, 1962), 40.

3. Orozco, interview by José Gómez Sicre, February 13, 1946, in Alejandro Anreus,

Orozco in Gringoland: The Years in New York (Albuquerque: University of New Mexico Press, 2001), 63–64.

4. John Hutton, "'If I Am to Die Tomorrow': Roots and Meanings of Orozco's *Zapata Entering a Peasant's Hut,*" *Art Institute of Chicago Museum Studies* 2, no. 1 (fall 1984): 49.

5. The Escuela Nacional Preparatoria, originally the Colegio de San Ildefonso, a Jesuit school founded in the early eighteenth century, had been incorporated into the system of free secular education initiated by Benito Juárez during the restored republic of the 1860s. It was still one of the nation's most elite schools in the early 1900s.

6. Leonard Folgarait, *Mural Painting and Social Revolution in Mexico, 1920–1940: Art of the New Order* (Cambridge: Cambridge University Press, 1998), 63.

7. Brenner diaries, September 6, 1926, Anita Brenner Archives, Harry Ransom Humanities Research Center, University of Texas at Austin.

8. Brenner to Charlot, January 16, 1947, Jean Charlot Collection, University of Hawai'i at Mānoa, Honolulu. Orozco's caricatures for *L'ABC* were all published between August 23, 1925, and January 17, 1926—several months before the *Horrores* commission.

9. Brenner quoted in Jean Charlot, "Orozco's Stylistic Evolution," in *An Artist on Art,* ed. Jean Charlot (Honolulu: University Press of Hawaii, 1972), 279.

10. While she was organizing her book materials for publication in 1927 and 1928, Brenner's original illustration lists included more than three hundred images, among them the *Horrores* images. With the support of the Universidad Nacional Autónoma de México in Mexico City, she had commissioned Edward Weston and Tina Modotti to photograph the works and images to be featured in the book. Once in New York, Brenner encountered resistance from publishing houses, despite the great interest in her manuscript. Some editors felt there were too many illustrations: "Went over [to] Knopf's. Bloch says my book is 'swell.' But no chance of publishing unless I cut way down on the pictures" (Brenner diaries, January 23, 1928). Brenner compromised and agreed to reduce the number of illustrations substantially. In the end, two *Horrores* images remained—*Dance of the Top Hat* (later renamed by Alma Reed as *An Aristocrat Dances*) and the lithographic version of *The Flag.*

11. Brenner diaries, January 6, 1926.

12. Charlot, "Orozco's Stylistic Evolution," 286. In another article, Charlot says that Brenner took twelve drawings with her to New York. See Charlot, "Orozco in New York," in *An Artist on Art,* ed. Charlot, 290.

13. Brenner diaries, September 19, 1926. On September 27, Brenner wrote, "Got home rather late, found Orozco here. Seems *tres amable* and interested in the exhibition I proposed." It is clear that Brenner wanted this series to be exhibited separately from Orozco's other work. A typed manuscript in the Anita Brenner Archives lists ideas for "articles or monographs" and "exposiciones." Among the exhibitions she planned were "Orozco, rev." and "Orozco, painting," while the list of articles/monographs included "Orozco, album rev." and "Orozco, other work." Notable here is her desire to highlight the series by separating it from the rest of Orozco's oeuvre.

14. Charlot, "Orozco's Stylistic Evolution," 286–87. About the replicas of the drawings, Brenner commented, "I have noticed with mixed feelings that someone

advised Orozco badly, and that he has made copies not only of [the first six drawings] but of several of the others in the series, which have been sold as originals, since they so appear in books and catalogues of Orozco's work." Brenner to Charlot, January 16, 1947, Jean Charlot Collection. Many thanks to Lynda Klich for finding this letter in the archive and providing me with a copy.

15. Forty-four drawings were reproduced in *José Clemente Orozco,* introduction by Alma Reed (New York: Delphic Studios, 1932), which likely included most of the images made in New York. I am deducing that approximately fifty-five to sixty drawings were produced in all, on the basis of the forty-six that were published in Reed's 1932 work, five replicas I have found to date, and other drawings identified in various collections and other publications.

16. Charlot, "Orozco's Stylistic Evolution." Among those who have misdated the series are Octavio Paz, who dated them to 1920; see his "Concealment and Discovery of Orozco," in *Essays on Mexican Art,* ed. Octavio Paz (New York: Harcourt Brace, 1993). In an exhibition catalogue that reproduced a number of the drawings, the captions for those from the Museo Franz Mayer in Mexico City and from a private collection date them to 1913–1917; see Luis Martín Lozano, *Arte moderno de México, 1900–1950* (Mexico City: Antiguo Colegio de San Ildefonso, 2000).

17. Quoted in Alma Reed, *Orozco* (New York: Oxford University Press, 1956), 44.

18. Susannah Joel Glusker, *Anita Brenner: A Mind of Her Own* (Austin: University of Texas Press, 1998), 12.

19. Brenner diaries, January 14, 1926.

20. Ibid., December 26, 1925.

21. Ibid., April 7, 1927.

22. Anita Brenner, "La Cucaracha," unpublished manuscript, Anita Brenner Archives. The manuscript is not dated, and therefore it cannot be determined whether Brenner wrote it before or after Orozco's drawings were made, yet it reveals an intense exchange between the two. Whether or not she suggested this particular theme, Brenner was intimately involved with the development of the series.

23. Dr. Atl to Orozco, March 15, 1926, in Clemente Orozco Valladares, *Orozco, verdad cronológica* (Guadalajara: Universidad de Guadalajara, 1983), 159.

24. Ibid.

25. Orozco's description of the Zapatistas emphasizes the notion that for him the Revolution was not about a specific program but about the inevitability of death: "I personally did not have a bad time during the revolution, but I saw much brutality, devastation, betrayal. . . . I was with the Carranza forces, and I saw their defeated victims like the poor Zapatista peasants brought in to be executed. There was something suicidal about those Zapatistas, like their leader, they were marked for doom, death." Orozco, interview by José Gómez Sicre, February 13, 1946, quoted in Anreus, *Orozco in Gringoland,* 63–64.

26. Brenner diaries, September 19, 1926.

27. Justino Fernández, *José Clemente Orozco: Forma e idea* (Mexico City: Porrúa, 1942), 38–39 [my translation].

28. Jean Charlot, "José Clemente Orozco," in *An Artist on Art,* ed. Charlot, 251.

29. Paz, "Concealment and Discovery of Orozco," 171.

30. Jordana Mendelson, *Documenting Spain: Artists, Exhibition Culture, and the Modern Nation, 1929–1939* (University Park: Pennsylvania State University Press, 2005), xxiii.

31. John Beverley has theorized the literary and cultural practice of *testimonio*. See his *Testimonio: On the Politics of Truth* (Minneapolis: University of Minnesota Press, 2004).

32. John E. Englekirk, "The Discovery of *Los de abajo*," *Hispania* 18, no. 1 (February 1935): 53. Azuela served under President Francisco Madero as chief of political affairs in Lagos de Moreno, Jalisco, his hometown. After Madero's death, Azuela joined the military forces of Julián Medina, a follower of Pancho Villa, and worked as a field doctor. He later was forced to immigrate temporarily to El Paso, where he wrote *Los de abajo*.

33. Mariano Azuela, *The Underdogs: A Novel of the Mexican Revolution*, trans. E. Munguía Jr. (New York: Brentano's, 1929), 31. Orozco illustrated the English translation of the novel with drawings developed from the *Horrores* series.

34. Englekirk, "Discovery of *Los de abajo*," 60–62.

35. See Olivier Debroise, *Mexican Suite: A History of Photography in Mexico*, trans. and rev. Stella de Sá Rego (Austin: University of Texas Press, 2001); and Charles Merewether, "Mexico: From Empire to Revolution," http://www.getty.edu/research/conducting_research/digitized_collections/mexico/.

36. Debroise, *Mexican Suite*, 181.

37. Ibid., 178. See also Paul J. Vanderwood and Frank N. Samponaro, *Border Fury: A Picture Postcard Record of Mexico's Revolution and U.S. War Preparedness, 1910–1917* (Albuquerque: University of New Mexico Press, 1988).

38. Debroise, *Mexican Suite*, 186.

39. Carlos Monsiváis, "Notas sobre la historia de la fotografía en México," *Revista de la Universidad de México* 35 (1980); and Susan Sontag, *On Photography* (London: Penguin, 1977), 20.

40. Mary K. Coffey, "The 'Mexican Problem': Nation and 'Native' in Mexico Muralism and Cultural Discourse," in *The Social and the Real: Political Art of the 1930s in the Western Hemisphere*, ed. Alejandro Anreus, Diana L. Linden, and Jonathan Weinberg (University Park: Pennsylvania State University Press, 2006), 49.

41. There are seven panels on the third floor, and all of them date to 1926. Although painted in 1924, *The Trinity* bridges the two different styles in the ENP. Since it was painted in 1926, *The Trench* relates to the seven panels on the third floor despite its spatial separation.

42. Olav Münzberg and Michael Nungesser, "The Preparatory School Murals, 1923–6: Between Allegory, Caricature and Historical Depiction," trans. Jennifer Lanyon, in *Orozco! 1883–1949*, exhibition catalogue (Oxford: Museum of Modern Art, 1980), 30. See also Bernard S. Myers, *Mexican Painting in Our Time* (New York: Oxford University Press, 1956), 93.

43. Folgarait, *Mural Painting and Social Revolution in Mexico, 1920–1940*, 64.

44. Ibid., 65.

45. Myers, *Mexican Painting in Our Time*, 93–94.

46. Hutton, "'If I Am to Die Tomorrow,'" 44.

47. It should be noted that the later murals are indeed more politicized and show more direct images of "warfare." An exception in the early murals is Rivera's panel *Death of the Peon* at the Secretaria de Educación Pública, which shows a hacienda burning in the background.

48. Folgarait, *Mural Painting and Social Revolution in Mexico, 1920–1940*, 69 (first quote), 73 (second and third quotes).

49. José Juan Tablada, *El universal*, October 21, 1928.

50. Brenner diaries, March 7, 1927 (emphasis added).

51. The ENP murals are dark but less overtly cynical than the drawings.

52. Paz, "Concealment and Discovery of Orozco," 188.

53. Myers, *Mexican Painting in Our Time*, 100.

54. Alma Reed recalled that "despite the admiration and active friendship of individual officials of the caliber of Dr. Pruneda, [Orozco] fully realized [that] a political and aesthetic period had closed with the completion of the Preparatoria murals. He was aware, he said, that if he wished to continue painting in Mexico he would have to 'live dangerously' in the vortex of direct action and be prepared, like Siqueiros and other artists of the unstable twenties, to defend his person and his creations from physical violence. In his own case, the attacks were both from the left and [from] the right." Reed, *Orozco*, 12.

55. Brenner diaries, August 21, 1927.

56. Perhaps it also gave pleasure to Brenner to deny Atl access to the drawings, given his anti-Semitic rhetoric.

57. Reed, *Orozco*, 41.

58. The U.S. architect William Spratling, then living in Mexico, wrote of the drawings that "the tremendous emotional force is the result of . . . deep concern for something greater than himself." Spratling, "Orozco," *New York Herald Tribune*, April 14, 1929. Another critic commented that Orozco's pessimistic outlook should not be confused with fatalism: "Orozco is never gay. But he is never bitter. That bitterness which is part and parcel of the futilitarian's goods is not his. There is a deep note of pity and a sense of emotion." Lillian Semons, "Mexican and American Share Gallery Honors," *Brooklyn Daily Times*, August 4, 1929.

59. Myers, *Mexican Painting in Our Time*, 53.

60. Anita Brenner, *Idols behind Altars: Modern Mexican Art and Its Cultural Roots* (New York: Payson & Clarke, 1929), 268.

61. See Luis Leal, *Mariano Azuela* (New York: Twayne, 1971), 66–71, 110–11. Bernard Myers notes that the "closest analogue [of the *Horrores*] is the desperate, mystical, and fatalistic prose of Azuela." Myers, *Mexican Painting in Our Time*, 100. Brenner deemed *Los de abajo* "the literary counterpart of Orozco's blacks and whites of the revolution." Brenner, *Idols behind Altars*, 324.

62. Brenner, *Idols behind Altars*, 276.

63. In a review of *Idols behind Altars*, Carleton Beals states that Brenner's criticism is "in accordance with some special dispensation of ex-cathedra mysticism of which lesser critical mortals know naught of the rites." Beals, "Goat's Head on a Martyr: *Idols Behind Altars*," *Saturday Review of Literature*, December 7, 1929, originally published as "Idols behind Altars," *Mexican Folkways* 5, no. 4 (October–December 1929). Renato

González Mello has analyzed *Idols behind Altars*, keeping in mind a literary tradition based on biblical concepts of prophecy, idolatry, history, and redemption; see his "Anita Brenner: Ídolos tras los altares," in *Arte, historia e identidad en América: visiones comparativas*, XVII Coloquio Internacional de Historia del Arte, ed. Gustavo Curiel, Renato González Mello, and Juana Gutiérrez Haces (Mexico City: Universidad Nacional Autónoma de México, IIE, 1994), 599–610.

64. Brenner, *Idols behind Altars*, 324.

65. Anita Brenner, "A Mexican Rebel," *Arts*, October 1927.

66. González Mello, "Anita Brenner: Ídolos tras los altares," 604.

67. Renato González Mello, *Orozco ¿Pintor revolucionario?* (Mexico City: Universidad Nacional Autónoma de México, 1995), 60.

68. See Hayden Herrera's catalogue entry for Goitia's *Tata Jesucristo in Mexico: Splendors of Thirty Centuries*, exhibition catalogue (New York: Metropolitan Museum of Art, 1990), 570–72; Antonio Luna Arroyo, *Francisco Goitia: Total* (Mexico City: Universidad Nacional Autónoma de México, 1987); and González Mello, *Orozco ¿Pintor revolucionario?* 60–62.

69. "I paint rapidly, but for a moment of work I need one month or six, or more, of meditation." Goitia, quoted in Brenner diaries, December 26, 1925.

70. Orozco's *Requiem,* the caricature on which it is based, and several later oil paintings made in the United States represent the theme of a wake, with mourning indigenous figures as the focal point.

71. Goitia told Brenner how he had changed the concept of the famous *Tata Jesucristo* after the model recalled something sorrowful, which made her wail with pain and twist her foot in the position depicted. Brenner diaries, December 26, 1925. When Brenner visited Goitia and saw his latest work, depicting the bleeding back of a Revolutionary, she wrote, "He speaks of the thing as being an exceedingly difficult problem. Rag and a copper-colored wounded back—and told me that he got real blood and pours it on his model's back to see how it ought to look." Brenner diaries, April 13, 1927. As further proof of his conscious application of Revolutionary themes after the actual events, he told Brenner that he decided to "give himself entirely into the theme of the revolution." Brenner diaries, January 20, 1927.

72. When she could, Brenner would pay for Goitia's models, and she collected payments for his paintings. See her diary entries for April 1, July 1, and August 25, 1927. Brenner mused that if she had had more money, she could have provided salaries for Orozco and Goitia: "No matter how much [money] I had I would still have to work just as hard. . . . One could always buy pictures! And pension Clemente and Goitia!" Brenner diaries, October 15, 1927.

73. Susannah Joel Glusker, "Anita Brenner's Relationship to Artists in Mexico and the United States" (unpublished paper, 1992), 5. Charlot and Rivera are the other artists most frequently mentioned. In his review of *Idols behind Altars,* Carleton Beals mentions how Brenner should have focused more on Rivera than on an artist like Goitia: "Her space emphasis irritates. Goitia is given more pages than the majestic Diego Rivera. Goitia, after all, is outside the main current. He is an ivory-tower painter, even though his ivory tower be an Indian hut smelly with pigs and clattering with chickens who let white guana [sic] fall on his canvasses [sic]. After all Don Diego is the

only arduous survivor of the group." Beals, "Goat's Head on a Martyr." Brenner clearly favored Goitia and saw the chapter on his work as the denouement of the book: "Began Diego chapter, and it is coming out in his own sweet spirit of cold analysis with a dash of *mala fe* [bad faith]. Strikes another note and makes a good plane after the dash of Orozco and [Siqueiros]. And before the *ascent* of Goitia" (emphasis added). Brenner diaries, August 17, 1927.

74. Brenner's diaries from September 1923 to early November 1925 are lost. In the surviving diaries, Goitia's name first appears on November 25, 1925, when Brenner recounts Charlot telling her that Goitia is "possibly the greatest painter living." There is no record of when she met Orozco.

75. Brenner diaries, December 12, 1925.

76. Brenner diaries, December 26, 1925. Brenner eventually wrote a broad history of the Mexican Revolution, which was published with historical photographs assembled by George R. Leighton: Anita Brenner, *The Wind That Swept Mexico: The History of the Mexican Revolution, 1910–1942* (New York: Harper & Brothers, 1943).

77. Brenner diaries, August 8, 1927.

78. About Orozco's canvas, Brenner writes, "Orozco painted a picture to put in the book, a scene of the revolution. It is a palette of four colors he has gotten to, black, white, burnt sienna, and natural yellow. They are tierras—that is[,] correspond to what he has been doing in fresco. With the black and white he gets a fine dull blue. The whole thing is rich and full of emotion." Brenner diaries, September 12, 1926. I believe this painting is the work now called *Revolution*. One of the original lists of illustrations for *Idols behind Altars* identifies as number 173 a "color plate: Pause in the march. Painting by J. C. Orozco . . . of the revolution," which I assume to be the painting mentioned in the diary entry; it is the only painting of the Revolution on the list. A painting titled *Pause in March—Mexican Revolution* was shown at the Art Center at 65 East Fifty-sixth Street in 1928 (in an exhibition titled "Mexican Art," January 19–February 14); the painting was on loan from Brenner. Alma Reed, who retitled most of Orozco's works, noted in her 1956 monograph that the artist had displayed *Revolution* at the Art Center. Reed, *Orozco*. A review of the exhibition, in fact, illustrates the painting now called *Revolution* with the caption "*Pause in March.*" Elizabeth Cary, "Mexican Paintings Range from Rebellious to Tractable—Terra Cotta Sculpture," *New York Times,* January 22, 1928.

79. Brenner diaries, August 27, 1927; May 26, 1927.

80. Brenner, *Renaissance,* February 1928, quoted in Reed, *Orozco,* 119 (emphasis added).

81. Brenner diaries, February 1, 1926. Ernestine Evans later published *The Frescoes of Diego Rivera* (New York: Harcourt, Brace, 1929), the earliest English-language monograph on Rivera's work.

82. Brenner diaries, March 30, 1927; October 20, 1927.

83. Brenner diaries, August 25, 1927.

84. Quoted in Charlot, "Orozco's Stylistic Evolution," 286.

85. Tablada to Orozco, May 16, 1927, in Orozco Valladares, *Orozco, verdad cronológica,* 172, 174. Orozco wanted to leave Mexico because Rivera had come to dominate all of the mural commissions in the Plutarco Calles era. "For a while now,"

Tablada wrote to Orozco, "I have cultivated here an atmosphere that you deserve and if you leave Mexico, don't go to California, come here, not to give up, but to work, so that you get the justice you desire" Ibid., 172. Orozco eventually lost faith in Tablada and felt that his efforts helped him little. Orozco's feelings about Tablada may be better understood in light of the fact that he eventually became estranged from everyone: "As to the 'friends' (?) I had here, I've sent them all to the devil, because they treated me with scorn and humiliated me. I am completely isolated, but happily I don't need 'protectors,' 'guardians,' 'managers,' 'critics,' 'papas,' 'prodders,' or 'helpers,' they are all a flock of false and self-seeking persons who only see one as a object to be exploited." Orozco to Charlot, February 23, 1928, in José Clemente Orozco, *The Artist in New York: Letters to Jean Charlot and Unpublished Writings, 1925–1929,* ed. Jean Charlot, trans. Ruth L. C. Simms (Austin: University of Texas Press, 1974), 38.

86. Brenner diaries, October 20, 1927; December 20, 1927.

87. Brenner must have brought these paintings from Mexico. As mentioned earlier, she had said that Orozco did not bring any work with him to New York. Alma Reed mentions seeing six oils in his studio: *The White House, El muerto, Revolución (Revolution), Railroad Track, Driftwood,* and *The Child.* All of these have Mexican themes, some directly related to the Revolution. These must have been the themes Kraushaar found disagreeable. Reed, *Orozco,* 25.

88. By 1929, having begun to adapt to his new environment, Orozco was painting scenes of New York. Edith Halpert had specifically commissioned an exhibition of New York subjects for the Downtown Gallery; the paintings were of tragic, depressing subjects. The exhibition at that Rockefeller-funded gallery, located at 113 West Thirteenth Street in Manhattan, was held from March 26 through April 15, 1929. Orozco's exhibition at the Delphic Studios, February 3–25, 1930, consisted of new, more colorful, semi-abstract work, devoid of the Mexican or Manhattan tragedies, and was considered a "happier" collection overall.

89. See Walter Pach, "Impresiones sobre el arte actual de México," *México moderno,* October 1922. Pach included a gouache by Rivera, watercolors of prostitutes by Orozco, and an oil painting by Carlos Mérida in the 1923 Society of Independent Artists exhibition.

90. Walter Pach, *Ananias, or The False Artist* (New York and London: Harper & Brothers, 1928), 205 (first quote); Brenner diaries, November 19, 1927 (second and third quotes).

91. Susan Noyes Platt, *Modernism in the 1920s: Interpretations of Modern Art in New York from Expressionism to Constructivism* (Ann Arbor, MI: UMI Research Press, 1985).

92. Carl Zigrosser, *A World of Art and Museums* (Philadelphia: Art Alliance Press, 1975), 93. Years later, Orozco's wife stated that the *Horrores* images disconcerted New York critics, especially when compared with the artist's New York work, which was much less "*tormentosa.*" Margarita Valladares de Orozco, "Memorias," in José Clemente Orozco, *Cartas a Margarita* (Mexico City: Ediciones Era, 1987), 60.

93. Brenner noted in her diary, "Afternoon, Max [Gorelik] came over with a friend of his, [from the] Anderson Galleries—showed him stuff and he said they'd show Orozco in the spring and whatever other thing I'd want to show. That solves Orozco problem

I think. Sigh of relief. Temporary." Brenner diaries, December 4, 1927. The Anderson exhibition never came about, however. In reference to the Weyhe Gallery, she mentioned, "Weyhe came in the morning to see the art. He wants Jean's water-colors, some Pacheco and the Orozco drawings. They say he is the best bet to sell things, so have decided to send them there," and "[a]lso went to Weyhe's to leave things of Orozco's." Brenner diaries, January 10, January 22, 1928. In 1947, Brenner told Charlot that "the only dealer of those I saw who opened his eyes and immediately made an offer, was Carl Zigrosser, who at that time handled the gallery for Weyhe. He offered to buy them all outright for $25 a piece, and I refused in Orozco's name." Brenner to Charlot, January 16, 1947, Jean Charlot Collection. The drawings from the series now in the Philadelphia Museum of Art, *The Rape* and *Dynamited Train,* were purchased from the Carl Zigrosser estate in 1976.

94. Brenner diaries, October 20, 1927. Brenner was also feeling the urgency of fulfilling her obligation to Orozco.

95. "The New Masses: A Prospectus," December 1925, quoted in Virginia Hagelstein Marquardt, "New Masses and John Reed Club Artists, 1926–1936: Evolution of Ideology, Subject Matter, and Style," *Journal of Decorative and Propaganda Arts* 12 (spring 1989): 58; Andrew Hemingway, *Artists on the Left: American Artists and the Communist Movement, 1926–1956* (New Haven: Yale University Press, 2002).

96. Brenner diaries, February 1, 1928.

97. Anita Brenner, "A Mexican Renascence," *Arts* 8, no. 3 (September 1925).

98. Orozco to Brenner, May 10, 1926; Brenner to Orozco, May 11, 1926, both from excerpts published in Orozco Valladares, *Orozco, verdad cronológica,* 161–62. Orozco had tried to bar Tablada from writing about his work, and the latter responded by saying that such an idea was "infantile": "[W]hat right did he have to prohibit him from writing whatever he wants[?]" Tablada to Orozco, May 16, 1927, in ibid., 172–74.

99. Brenner wrote about Orozco's general belligerence: "He lives in self-created loneliness, because he cannot stomach cant and hypocrisy. He is very easily hurt. . . . As a rule, he is either unhappy or furious. . . . He will not attach himself to a class, a movement, or a school. . . . Destroying and creating, he suffers. He has a habit of pain." Brenner, "A Mexican Rebel," 209.

100. Brenner's diary even suggests Orozco's unhappiness upon arriving. "Orozco in this evening. He is very lonely, poor chap. It embarrasses me a little. But I have so little time to Orozco the man, and the time I am permitted for Orozco should go for Orozco the *obra* [work]—in whatever little I can help." Brenner diaries, January 12, 1928. Orozco was also upset about an article Brenner had written for the *New York World.* "Also went to Weyhe's to leave things of Orozco's, Jean's and Pacheco. Orozco met me

there. He is just furious about my article in the *World* ["Mexico Revives Art, Dormant 400 Years," *New York World,* January 22, 1928, 14E]. Doesn't want to be considered part of a movement, of a group, of anything. . . . Just himself—that it isn't a movement. Just politica personalista of Diego's—just a fanatic—it is awfully hard to help him, even as little as I can. He won't recognize the way things are, or he wants absolute values. Anyway it was very upsetting." Brenner diaries, January 22, 1928.

101. Brenner diaries, February 2, 1928. See also entry for February 4, 1928.

102. Orozco to Charlot, February 23, 1928, in Orozco, *Artist in New York,* 37–41.

Orozco had expressed the same sentiments to Manuel Rodríguez Lozano in a letter dated February 14, 1928, Centro Nacional de Investigación, Documentación e Información de Artes Plásticas (CENIDIAP) archive, Mexico City.

103. Orozco to Charlot, in Orozco, *Artist in New York*, 57; Renato González Mello, "Orozco in the United States: An Essay on the History of Ideas," in *José Clemente Orozco in the United States, 1927–1934*, exhibition catalogue, eds. Renato González Mello and Diane Miliotes (Hanover, NH, and New York: Hood Museum of Art, in association with Norton, 2002), 31.

104. Brenner questioned her ability as an art promoter: "The Mexican show . . . isn't going well, meaning that things don't sell. . . . I am very tired of putting my foot into it with art, as I seem to be often doing. I like the stuff and of course think it is good, but the actual handling of it in this system I am not capable of." Brenner diaries, February 4, 1928.

105. Orozco to Charlot, April 30, 1928, in Orozco, *Artist in New York*, 49.

106. González Mello, "Orozco in the United States," 29.

107. Orozco to Laurence Schmeckebier, May 15, 1939, Archives of American Art (hereafter AAA), Smithsonian Institution, Washington, DC, excerpt quoted in Alicia Azuela, Renato González Mello, and James Oles, "Anthology of Critical Reception," in *José Clemente Orozco in the United States, 1927–1934*, eds. González Mello and Miliotes, 313.

108. Brenner diaries, June 25, 1928. See also Reed, *Orozco*, 32–34.

109. Reed, *Orozco*, 39–40 (including first quote), 29 (second quote). See also Antoinette May, *Passionate Pilgrim: The Extraordinary Life of Alma Reed* (New York: Paragon House, 1993). Though it is one of the few sources on Reed, May's book is unfortunately marred with inaccuracies, exaggerations, and false information. After Brenner showed Reed the Orozco drawings, Reed wrote a letter to the artist, telling him she was a profound admirer of his and that "'the entire series on the Mexican revolution holds a very intimate appeal to me.'" She was particularly interested in *Cemetery Scene* and "'enclosed twenty dollars toward the purchase price of $100 for the drawing.'" Orozco (quoting Reed's letter) to Margarita V. de Orozco, August 2, 1928, in Orozco, *Cartas a Margarita*, 121–22.

110. The name "Ashram" referred to the dwelling and teaching center of Mahatma Gandhi. As the name implies, Reed and Sikelianos had ties to the nationalist cause in India. Orozco described the environment to his wife: "You can't image the kind of people that visit Alma, not only people of talent, but also very socially distinguished and rich people, notable people from around world, Romanian princesses, Hindu poets, millionaires, etc. The most amusing parade." Orozco, *Cartas a Margarita*, 147.

111. "Ink and Pencil Drawings from a Series *Mexico in Revolution* by José Clemente Orozco," Galleries of Marie Sterner, 9 East Fifty-seventh Street, October 10–22, 1928, reproduced in Orozco Valladares, *Orozco, verdad cronológica*, 201. Reed later told Orozco that Sterner had asked her for a guarantee of two hundred dollars for the exhibition. Orozco, *Cartas a Margarita*, 147. The exhibition apparently went unnoticed. A review of Orozco's later exhibition at the Downtown Gallery stated that "as far as we know it is the first show this Mexican, famous for his murals, has held [in New York]." "The Art Galleries," *New Yorker* 5, no. 8 (April 13, 1929).

112. Tablada, "Nueva York de día y de noche," October 1928, in Orozco Valladares, *Orozco, verdad cronológica*, 205.

113. Reed, *Orozco*, 77–79.

114. Orozco, *Artist in New York*, 75, 82 (original emphasis). In the same letter, Orozco told Charlot that he thought "the exhibition at the Marie Sterner Gallery has been an artistic success"; evidence suggests the contrary. Ibid., 82.

115. See Gaston Poulain, "Orozco peintre de la revolution mexicaine," *Comoedia* (Paris), February 28, 1929; Poulain, "Orozco: un peintre du Mexique en revolution," *A.B.C. artistique et litteraire* 5, no. 54 (June 1929). The series is mentioned briefly in a review of the Art Center exhibition; see Elizabeth Cary, "Mexican Paintings Range from Rebellious to Tractable—Terra Cotta Sculpture," *New York Times*, January 22, 1928, 12. It is likewise mentioned in a review of Orozco's exhibition at the Little Gallery of Contemporary Art at the New Students League in Philadelphia; see Dorothy Grafly, "Emotional Attitude vs. Pictorial Aptitude: Art Notes," *Public Ledger*, February 17, 1929; and Grafly, "Is Caricature Art?" *Public Ledger*, February 24, 1929. For the Mexican journalist's reaction, see Ortega, "Los mexicanos contra México—Exposición de sus obras en París," *El universal*, April 3, 1929. Ortega's vigorous invective earned him infamy as *El universal*'s resident rabble rouser.

116. Brenner, *Idols behind Altars*, 343.

117. Arens to Brenner, January 13, [1928], Anita Brenner Archives.

118. The drawings that illustrated the article were *The Flag, Adios, The Return,* and *Eviction.* Brenner had captioned them, respectively, *The Flag Bearer, The Protector of the Lowly, Two Women and a Soldier,* and *The Oppressor Must Go!* Anita Brenner, "Orozco the Rebel," *New Masses*, January–February 1928.

119. Reed states, "The drawings to which, with the artist's approval, I later affixed titles were: *The Return; Refuge; Loot; Adiós; Bandera (The Flag); Against the Wall; Mexican Hills; El Mayordomo; Ruined House; Lagrimas (Tears); Cucaracha Nos. 1, 2, and 3; Battlefield No. 2; Casa Quemada (Burned House); Weeping Women; El Ahorcado (The Hanged One); The Sack; Piedad; The Grave Digger; Planning; The Rear Guard; Requiem; Three Women; Train Hold-up; Dynamited Train; The General's Wedding; The Wounded; The Strike; Explosion; War; El Fusilado (The Executed);* and *Under the Maguey.*" Reed, *Orozco*, 38. Reed's titles are taken directly from the captions in the 1932 book of Orozco's works published by her Delphic Studies. Her list follows the sequence of the reproductions and has gaps for those drawings sold (to Juliana Force and Alejandro Quijano of Mexico) before her involvement with Orozco. Six of the drawings missing from her 1956 monograph on Orozco were not listed as sold in the 1932 book: *Common Grave, Eviction, Cementerio, The Battle, In Vain,* and *Proletarians.* It is not clear, therefore, who assigned these titles.

120. Charlot said that he and Brenner came up with the title. See Orozco, *Artist in New York*, 75n58.

121. Orozco, *Cartas a Margarita*, 101. See also Orozco to Charlot, February 23, 1928, in Orozco, *Artist in New York*. Orozco told Charlot that he used the George Miller studio for his first prints.

122. Orozco, *Cartas a Margarita*, 104–5.

123. *Illustrated Catalogue of Lithographs, Engravings, and Etchings Published by the Weyhe Gallery*, September 1928, 16.

124. Breuning, *New York Evening Post*, January 7, 1928, clipping from Weyhe Gallery scrapbooks, vol. 3, p. 156, Weyhe Gallery Papers, AAA.

125. Orozco Valladares, *Orozco, verdad cronológica*, 209–10.

126. Orozco, *Cartas a Margarita*, 152–53. Charlot noted that afterward, the price, "with help from Weyhe who now owned the edition, rose to two hundred dollars per print." Orozco, *Artist in New York*, 44n28. Reba White Williams clarifies that "no verification of the $200 . . . price for *Requiem* has been discovered, but in 1933 the print was offered at $150." Williams, "The Weyhe Gallery between the Wars, 1919–1940" (PhD diss., City University of New York, 1996). In 1936, the price dropped to seventy-five dollars, according to Weyhe Gallery catalogue no. 77, *Fine Prints, Drawings, Water-colors, Stencils, Paintings and Sculpture*, December 1936, 9. In 1940, the gallery admitted that "during the past couple of years there has been a slump in the sale of Mexican work." Weyhe Gallery (unsigned) to Miss Elsi McDougall, May 11, 1940, Weyhe Gallery Papers.

127. Orozco, *Cartas a Margarita*, 153.

128. Ibid., 157; Charlot to Weston, June 20, 1929, folder 16, AG38, box 1, Edward Weston Archive, Center for Creative Photography, University of Arizona, Tucson. With the permission of the Jean Charlot Estate, LLC.

129. Brenner diaries, July 7, 1929; C. J. Bulliet, "Mexico's Revolutionary Art Is Introduced Here," *Chicago Evening Post*, December 31, 1929; Tom Vickerman, "Variety Is Keynote of Institute Shows," *Chicago Evening Post*, December 24, 1929.

130. Orozco's strategic maneuverings take on militaristic terms: "I am awaiting the photographs for the offensive I shall launch against the galleries next week." Orozco, *Artist in New York*, 71.

131. Orozco, *Artist in New York*, 69, 77.

132. Ibid., 76 (original emphasis). As Charlot comments in a footnote, Modotti was simultaneously taking photographs of Diego Rivera's murals. Orozco was also seeking to distinguish himself from Rivera in the competition for mural commissions in the United States. Ibid.

133. "Orozco and Revolution," *New York Times*, April 21, 1929, XII; Edward Alden Jewell, "Orozco Exhibits," *New York Times*, February 9, 1930.

134. Margaret Breuning, "Other Art Events," *New York Evening Post*, March 30, 1929; "Mexico," *New York Herald Tribune*, May 8, 1932; *New York Times*, March 10, 1929, clipping in Weyhe Gallery scrapbooks, vol. 4, p. 8, Weyhe Gallery Papers.

135. In addition to the lithographs, Orozco would later make painted versions of some of the *Horrores* drawings. *The Cemetery* (1931) is based on the drawing of the same name, and *Burnt House* (1930) is the easel version of the drawing *War*. Many other paintings contain elements of the *Horrores*, but these two are apparently the only direct appropriations.

136. Orozco, *Artist in New York*, 77.

137. A detail of the right side of the panel was turned into the 1930 oil on canvas titled *Peace*.

138. For the Courvoisier Gallery exhibition, see Esther Johnson, "History Is Guide

for Rebel Artist," *San Francisco News,* June 27, 1930; Nadia Lavrova, "Orozco, Mexican Muralist, Visiting Here," *San Francisco Examiner,* June 29, 1930; "Mexico Mural Artist's Work Shown Here," *San Francisco Call Bulletin,* June 28, 1930; "Orozco's Art," *Art Digest* 4, no. 18 (July 1930). Arthur Millier wrote a brief introductory paragraph for the pamphlet of the exhibition in Los Angeles: "Lithographs by José Clemente Orozco," Los Angeles Museum (now Los Angeles County Museum of Art), Exposition Park, October 1930.

139. Weston wrote on May 4, 1926, "Sunday, Anita [Brenner] and I went to Coyoacán for a visit with Orozco the painter. I had hardly known his work before, which I found fine and strong. His cartoons—splendid drawings, in which he spared no one, neither capitalist nor revolutionary leader—were scathing satires, quite as helpful in destroying a 'cause,' heroes and villains alike, as a machine gun. I would place Orozco among the first four or five painters in Mexico, perhaps higher. Monday eve he came to see my work. I have no complaint over his response. I wish I had known him sooner,—now it is almost too late." Edward Weston, *The Daybooks of Edward Weston* (New York: Aperture, 1990), vol. 1, p. 158.

140. Weston daybook quoted in Amy Conger, *Edward Weston: Photographs from the Collection of the Center for Creative Photography* (n.p., 1930), entry for figure 599; Edward Weston, "Orozco in Carmel," *Carmelite,* July 31, 1930.

141. Reed to Weston, April 11, 1931, AG38, box 4, Edward Weston Archive.

142. Williams, "Weyhe Gallery between the Wars, 1919–1940," 138; Brenner diaries, June 20, 1928. Brenner continued, "But in the meantime his problem is serious. This evening [Frances Flynn] Paine came over and I made this clear and set the burden (or attempted to) on her shoulders, since she is incorporated to 'foment' Mexican art. (Rockefeller, 15,000.)." Ibid.

143. It was architect William Spratling who brokered the production of prints by Rivera and Siqueiros. Correspondence between Spratling and Zigrosser documents the former's role as a liaison between Rivera, Siqueiros, and other Mexican artists and the Weyhe Gallery. Spratling also suggested that Dwight Morrow commission Rivera to paint the mural cycle at the Palacio de Cortés in Cuernavaca (1929). See Carl Zigrosser Papers, AAA; and Williams, "Weyhe Gallery between the Wars, 1919–1940."

144. Perhaps realizing the success that Orozco achieved with his lithographic versions of the ENP cycle, Brenner and Charlot compelled Siqueiros to give it a try when he was in New York on his way from Argentina: "Jean and I [Brenner] removed [Siqueiros's] coat and gave him a lithographic zinc and sat him down on a hard chair and gave him some photos of his frescoes and told him to do a [lithograph], and the combination of elements fermented in the terrific [summer] heat so that the lith is swell!" Brenner diaries, July 10, 1929. The lithograph Siqueiros produced is *Cabeza* (1929), reproduced in *Portrait of a Decade: David Alfaro Siqueiros, 1930–1940* (Mexico City: Museo Nacional de Arte, Instituto Nacional de Bellas Artes, 1997). The image is derived from *A Call to Liberty,* one of his panels in the ENP.

145. The Delphic Studios, like the Weyhe Gallery, published lithographs by Orozco, including *Maguey* (1929), *Paisaje mexicano* (1930), and *Pueblo mexicano* (1930).

146. Helen Langa, *Radical Art: Printmaking and the Left in 1930s New York* (Berkeley: University of California Press, 2004), 18.

147. González Mello, "An Essay on the History of Ideas," in *José Clemente Orozco in the United States, 1927–1934,* eds. González Mello and Miliotes, 32–34.

148. Brenner wrote that "Clemente [Orozco] is acting very funnily these triumphing days. He's written up in every art mag[azine] and always gets a very respectful break from the critics, and is altogether 'made.' The first result was to make him 'delirio de grandeza' with money; (like mex) and to make him a fairly frequent guest at parties; and to take away his sense of *vacilada* in all the neo-Greek and Buddha business at Alma's; and to make him proclaim that now he was never going to be shown in a group with Mexicans again. There was a show planned at Harvard which I was asked to help arrange; and also I wanted to put out a special edition of my book with an Orozco lith; on both these points we had a very insane interview. We got all tangled up in each other's emotions and now he doesn't speak to me and magnificently sends me 'regalos' of drawings and such things, (through Alma) He is shaky with Jean. The down curve is that he is ill, afraid, angry, and feeling persecuted. He is getting the money he needs from Weyhe, for lithographs." Brenner diaries, May 31, 1929.

149. *Broken Columns* is a 1930 oil on canvas by Orozco with a neo-Greek theme.

150. Anita Brenner, "Orozco," *New Masses* 8, no. 7 (February 1933): 22.

151. González Mello, "Essay on the History of Ideas," 34–35.

152. Brenner, "Orozco the Rebel."

Chapter 3. Mexican Curios

1. Guillermo Rivas [pseudonym for Howard Philips], "Notes of the Carnegie Exhibit," *Mexican Life* (August 1930): 23.

2. In the original plan for the exhibition, colonial painting was to be included, but early in the development phase it was deemed extraneous to the nationalist parameters defined by the organizers as the "authentic spirit" of Mexico. See correspondence from Homer Saint-Gaudens to Robert W. de Forest, November 14, 1929, Metropolitan Museum of Art Archives, New York, NY. In other words, colonial painting was seen as imitative of Spanish and European art and therefore less authentically Mexican. This logic would later be elaborated repeatedly as the curatorial rationale of the "exhibition of Mexican arts, not of arts in Mexico."

3. For a selected history of the way Mexican folk art was presented in the nineteenth and early twentieth centuries, see James Oles, "For Business or Pleasure: Exhibiting Mexican Folk Art, 1820–1930, " in *Casa Mañana: The Morrow Collection of Mexican Popular Arts,* ed. Susan Danly (Amherst, MA, and Albuquerque: Mead Art Museum, Amherst College/University of New Mexico Press, 2002).

4. Anthony W. Lee, *Painting on the Left: Diego Rivera, Radical Politics, and San Francisco's Public Murals* (Berkeley: University of California Press, 1999), 54. According to the official record, it was Morrow, ambassador from 1927 to 1930, who conceived the exhibition sometime in the summer of 1929. Morrow, a former J. P. Morgan banker, contacted Frederick Keppel, president of the Carnegie Corporation and acting director of the American Federation of Arts, about the possibility of mounting an exhibition of Mexican art. See the correspondence between Morrow and Frederick Keppel, reel 34, series I, Dwight W. Morrow Papers, Archives and Special Collections, Amherst College Library, Amherst, MA. Keppel later claimed that he, not Morrow, conceived the

idea for the exhibition: "What really happened was that I persuaded Dwight Morrow that he thought of it himself back in 1930." Keppel to Nelson A. Rockefeller, March 1, 1940, folder 1354, box 138, Personal Projects: MoMA exhibition, Mexican 1939–1941, Record Group 4, Nelson A Rockefeller Papers, Rockefeller Family Archives, Rockefeller Archives Center, Sleepy Hollow, NY (hereafter, RAC).

5. Ernestine Evans, *The Frescoes of Diego Rivera* (New York: Harcourt, Brace, 1929).

6. Between 1918 and the "Mexican Arts" exhibition, Siqueiros's work had been exhibited only once—by Brenner at the Art Center exhibition of 1928. One work by Siqueiros was included in that 1928 exhibition: *The Revolution*, a study for the ENP mural. Brenner also devoted a chapter to Siqueiros in *Idols behind Altars*.

7. For Orozco and Siqueiros, who did not receive favors or mural commissions from the Elías Plutarco Calles regime as Rivera had, seeking patrons and audiences outside of Mexico was a matter of livelihood.

8. An early exhibition proposal noted that Rivera "wishes to paint exclusively for exhibition including one small transportable fresco. Probably will not be ready in time, in which case plans are made to borrow." Undated exhibition proposal, "Mexican Arts" exhibition file, Corcoran Gallery of Art Archives, Washington, DC. For more on the portable frescoes, see chapter 4.

9. There is evidence to suggest that although the commission may have been meant as a birthday present for Dwight Morrow, Rivera executed the fresco specifically with the "Mexican Arts" exhibition in mind. The portable fresco almost immediately left the hands of the Morrows, touring the United States from 1930 to 1932 as part of the "Mexican Arts" exhibition; afterward, it remained on display at the Metropolitan Museum of Art in New York for six months. After "Mexican Arts" finished its tour in the United States, *Market Scene* was exhibited at the Metropolitan Museum of Art from July to December 1932. See H. E. Winlock to Elizabeth Morrow, July 20, 1932, in frame 185, reel 65, series I, Dwight W. Morrow Papers.

10. Eyler Simpson, *The Ejido: Mexico's Way Out* (Chapel Hill: University of North Carolina Press, 1937), 581–82, quoted in Stanley Ross, "Dwight Morrow and the Mexican Revolution," *Hispanic American Historical Review* 38, no. 4 (1958): 506–28. For a summary of Dwight Morrow's activities in Mexico, see Rick A. López, "The Morrows in Mexico: Nationalist Politics, Foreign Patronage, and the Promotion of Mexican Popular Arts," in *Casa Mañana*, ed. Danly, 47–63 (English), 65–79 (Spanish). See also Robert Freeman Smith, *The United States and Revolutionary Nationalism in Mexico, 1916–1932* (Chicago: University of Chicago Press, 1972).

11. Lee, *Painting on the Left,* 54–56.

12. In addition to the Palacio de Cortés commission, Dwight Morrow was also involved with the patronage of Orozco's mural at the New School. See José Clemente Orozco, *Cartas a Margarita* (Mexico City: Ediciones Era, 1987), 225.

13. According to Elizabeth Morrow, it was she who had first invited Rivera to tea at the U.S. Embassy in July 1929. Elizabeth Morrow to Stanton Catlin, "Draft of Mrs. Morrow's Account [of the Cuernavaca Commission]," August 8, 1949, and Elizabeth Morrow to Stanton Catlin, January 12, 1950, Diego Rivera file, Morrow Family Papers, Sophia Smith Collection, Smith College, Northampton, MA.

14. René d'Harnoncourt, "The Carnegie Project: Rene d'Harnoncourt," interview

by Isabel Grossner, May 23, 1968, transcript, 2, 10, Oral History Office, Columbia University, New York.

15. Although the property rights issue was never overtly mentioned in conjunction with the exhibition, it surfaced in one not-so-subtle newspaper commentary: "Americans used to thinking of Mexico in terms of blood and oil will be pained at the showing gotten together by the Carnegie Foundation." Grace D. Rutenburg, "J. B. Speed Museum Notes," *Louisville Courier-Journal,* June 28, 1931.

16. Mexican government officials embraced the exhibition's goals and commented on its sensitive diplomatic mission: "The transcendence of ["Mexican Arts"] is so great, its vision is to dissipate prejudices and to create a new eagerness to know us; its presentation is so delicate and Mr. d'Harnoncourt takes its mission with such interest." Eduardo Soriano Bravo, Mexican consul general in Boston, to Secretario de Relaciones Exteriores, December 12, 1930, Archivo Histórico Genaro Estrada, Secretaría de Relaciones Exteriores, Mexico City.

17. Alicia Azuela, "The Making and Reception of the Imaginary of Artistic and Revolutionary Mexico," in *José Clemente Orozco in the United States, 1927–1934,* exhibition catalogue, eds. Renato González Mello and Diane Miliotes (Hanover, NH, and New York: Hood Museum of Art, in association with Norton, 2002), 212.

18. Jean Charlot, *Mexican Mural Renaissance* (New Haven: Yale University Press, 1963), 217.

19. Raziel Cabildo, "La exposición de la escuela nacional de bellas artes," *Revista de Revistas,* May 7, 1916; Mari-Carmen Ramirez, "The Ideology and Politics of the Mexican Mural Movement: 1920–1925" (PhD diss., University of Chicago, 1989), 74–75.

20. Copy of letter from Robert W. de Forest to Homer Saint-Gaudens, November 22, 1929, Metropolitan Museum of Art Archives.

21. Frederick Keppel and Robert Lester, *Grants in the Arts* (New York: Carnegie Corporation, 1932); D'Harnoncourt, "Carnegie Project," 11.

22. Members of New York's regional oligarchy, Dwight Morrow and Robert de Forest participated simultaneously in various corporate endeavors and often served together on trustee boards.

23. The primary institutions that lent folk art objects were the Museo Nacional de México and the state museum of Guadalajara. Miguel Covarrubias, William Spratling, Jorge Enciso, Frederick Davis, Frances Toor, Diego Rivera, and René d'Harnoncourt himself were among the private lenders. The Morrows lent approximately thirty-four objects, mostly textiles and lacquerware.

24. Keppel to Morrow, September 10, 1929, frame 582; and Saint-Gaudens to Keppel, September 7, 1929, frames 583–84, both on reel 34, series I, Dwight W. Morrow Papers.

25. Geoffrey T. Hellman, "Profiles: Imperturbable Noble," *New Yorker,* May 7, 1960; Robert Fay Schrader, *The Indian Arts and Crafts Board: An Aspect of New Deal Indian Policy* (Albuquerque: University of New Mexico Press, 1986), 124–28.

26. For more information on the Morrows' collection of popular art and their Cuernavaca home, see the essays in *Casa Mañana,* ed. Danly.

27. After spending only two weeks in Mexico, Saint-Gaudens wrote the first schematic outline for the exhibition in a letter to de Forest. Although signed by

Saint-Gaudens, much of the plan undoubtedly represented the ideas of d'Harnoncourt and was "the first concrete definition of Morrow's and Keppel's general idea of a Mexican exhibition." Robert W. de Forest to Homer Saint-Gaudens (with a carbon copy to E. Robinson), November 22, 1929, Metropolitan Museum of Art Archives. According to de Forest, Morrow and Keppel had the ultimate authority as to the scope of the exhibition. Keppel in particular was in charge of making decisions in relation to matters of expense since the Carnegie Corporation was the principal financial backer of the exhibition.

28. Homer Saint-Gaudens to Robert W. de Forest, November 14, 1929, Metropolitan Museum of Art Archives.

29. René d'Harnoncourt, introduction to *Mexican Arts: Catalogue of an Exhibition Organized for and Circulated by the American Federation of Arts* (Portland, ME: Southworth Press, 1930), xi, xiii. *Talavera de Puebla* is a tin-enameled earthenware known in Europe as maiolica or faience and made in Puebla, Mexico, a prominent center of pottery production. The name *talavera* alludes to the city of Talavera de la Reina, the major producer of maiolica in Spain from the sixteenth to mid-eighteenth century.

30. David A. Brading, "Manuel Gamio and Official Indigenismo in Mexico," *Bulletin of Latin American Research* 7, no. 1 (1988): 80 (first quote), 76 (second quote), 87.

31. D'Harnoncourt, "Carnegie Project," 6. Prior to being shipped to the United States, the "Mexican Arts" exhibition was first displayed at the Secretaría de Educación Pública in Mexico City (June 25–July 5, 1930), with much official pomp and circumstance. Although Dr. Atl perhaps provided little actual assistance, many of his ideas shaped the exhibition's organizing and ideological principles.

32. See Rick Lopez, "*Lo mas mexicano de México:* Popular Arts, Indians, and Urban Intellectuals in the Ethnicization of Postrevolutionary National Culture, 1920–1972" (PhD diss., Yale University, 2001).

33. Ibid., 37.

34. For more information on the 1921 and 1922 exhibitions of popular art, see Oles, "For Business or Pleasure," 18–22; Helen Delpar, *The Enormous Vogue of Things Mexican: Cultural Relations between the United States and Mexico, 1920–1935* (Tuscaloosa: University of Alabama Press, 1992), 135–36; Hank Lopez, "A Country and Some People I Love: An Interview with Katherine Anne Porter," *Harper's* 231 (September 1965): 60–62; and "Mexican Art Exhibit Opens," *Los Angeles Times,* November 11, 1922.

35. A concurrent exhibition included watercolors and drawings by modern artists Adolfo Best Maugard and Xavier Guerrero.

36. Delpar, *Enormous Vogue of Things Mexican,* 84.

37. In the "Mexican Arts" exhibition brochure, Frank Crowninshield heralds the 1928 exhibition in New York's Art Center as an aesthetic counterpart to the goodwill efforts of Morrow and speaks of artists as "ambassadors."

38. See Lopez, "*Lo más mexicano de México.*"

39. Copy of Paine's report to Alon Bement, director of the Art Center, May 18, 1928, 2–3, Mexican Arts Association folder, Morrow Family Papers.

40. Paine's contemporaries commented on her aggressive business tactics. For example, William Spratling noticed the following: "Mrs. Paine seems to have the organizing-managing complex. It's very funny to see her in action in a country like

Mexico. Her hobby seems to be to run down (and put to use) cabinet ministers and Rockefellers, etc. She does it very thoroughly, and it's alright if one doesn't have to witness the process, then it's tiresome. Even Mr. St. Gaudens [sic] was more candid than Mrs. Paine." Spratling to Elizabeth Morrow, January 31, 1931, William Spratling folder, Morrow Family Papers.

41. In October 1927, the Rockefeller Foundation approved the five-thousand-dollar appropriation for the General Education Board to underwrite the cost of purchasing a collection of "Mexican industrial arts" to be exhibited at the Art Center in January 1928. Alon Bement to Charles R. Richards, director of industrial art, General Education Board, Rockefeller Foundation, September 23, 1927; and Bement to Brierley, secretary of the General Education Board, October 26, 1927, folder 3342, box 321, General Education Board Archives, RAC. The money was transferred to Mexico City by late November 1927; Paine's purchases were to be "checked by a representative of the Department of Education in Mexico and some person or persons chosen by Mrs. Dwight Morrow." Bement to Brierley, November 21, 1927, in ibid.

The total number of objects Paine procured was 3,214; of these, 83 were on loan and 3,131 were purchased. Paine was in Mexico from December 16, 1927, to March 12, 1928. Among the places she visited were Puebla, Veracruz, Oaxaca, Michoacán, Morelos, Guerrero, Guanajuato, San Luis Potosí, Jalisco, and the Federal District. Copy of Paine's report to Alon Bement, May 18, 1928, 2–3, Mexican Arts Association folder, box 36, Morrow Family Papers. For the travel itinerary of the exhibition see Bement to Brierley, April 4, 1933, folder 3342, box 321, General Education Board Archives, RAC. The exhibition of "Mexican pottery" did not return to New York until 1933; the remaining 70 objects were donated to several institutions: the Fine Arts Department, Pratt Institute; Teachers College, Columbia University; and Newark Public School of Fine and Industrial Art. Bement to Brierley, July 13, 1933, folder 3342, box 321, General Education Board Archives, RAC.

42. Anita Brenner diaries, September 27, 1927, Anita Brenner Archives, Harry Ransom Humanities Research Center, University of Texas at Austin. Brenner had arrived in New York around September 22, 1927.

43. Brenner diaries, October 15, 1927.

44. "Big Mexican Exhibition," *Art Digest* 2, no. 7 (January 1, 1928): 4. The exhibition of modern art was held January 19–February 14, 1928, at the Art Center, 65 East Fifty-sixth Street, in New York. It is seems likely that even prior to Paine's delay in Mexico, it was decided the exhibitions of fine art and applied art were to be held separately. As early as December 2, 1927, Bement informed Charles Richards, based on a telegram from Paine, that the fine art objects would arrive in New York City on or about January 15 and that the applied art would arrive on February 29 for separate exhibitions. Bement to Richards, December 2, 1927, folder 3342, box 321, General Education Board Archives, RAC.

45. Brenner diaries, January 18, January 31, February 4, 1928.

46. All of the objects were for sale, although apparently only one painting in the first exhibition was sold: Jean Charlot's *Dance of the Malinches*, to Frank Crowninshield. José Clemente Orozco, *The Artist in New York: Letters to Jean Charlot and Unpublished Writings, 1925–1929*, trans. Ruth L. C. Simms (Austin: University of Texas Press, 1974), 34.

47. Orozco, *Artist in New York,* 37 (first quote), 35 (second quote).

48. "Big Mexican Exhibition," *Art Digest,* 4 (emphasis added).

49. Paine to Elizabeth Morrow, January 11, 1929, Mexican Arts Association folder, box 36, Morrow Family Papers.

50. Copy of Paine's report to Alon Bement, May 18, 1928, 2–3.

51. The general term "Mexican art" was often used in place of specific terminology such as "folk/applied" or "modern/fine art." For example, Elizabeth Morrow is told in a letter that Paine is to leave for Mexico to bring back "a collection of Mexican art" for the Art Center. Helen Sargent Hitchcock to Elizabeth Morrow, December 11, 1928, Morrow Family Papers.

52. Brenner diaries, December 13, 1927.

53. In a report regarding the relative success of the exhibition of folk art at the Art Center, Paine outlined her detailed strategy for marketing Mexican crafts: "The exhibition has proven, among other things, that the material appeals to the people of the United States and that they will purchase it. The Indians will, if encouraged, produce it and can become economically independent through their work. Lack of markets and the consequent unemployment are the cause of much suffering in Mexico. The Indians are enthusiastic and highly artistic craftsmen and the utilization of their one talent is, I believe, the logical solution of their pressing needs." She continued by delineating three requirements that must be met for her plan to succeed. The first was that a Mexican craft guild must be organized, "membership to be on a cooperative basis, which would encourage them and give them back their former pride in their craftsmanship." Second, a ceramics expert must be sent to make tests of clays, to make pottery more durable. Third, representatives of the guild (in the United States) should "understand the Indians and speak their language and also know how to encourage them to work. These crafts, if introduced into the United States under a Guild name, would educate the people here to an appreciation of them." She noted interest on the part of museums and magazines. Copy of letter from Paine to Charles Richards, May 19, 1928, Morrow Family Papers.

54. Brenner diaries, April 7, 1928. See also chap. 2, note 142.

55. Orozco, *Artist in New York,* 56–57.

56. "Rockefeller Gift Aids Mexican Art," *New York Times,* June 17, 1928.

57. Thomas B. Appleget for John D. Rockefeller Jr. (JDR) to Paine, June 12, 1928, Morrow Family Papers. The contributions were for the years 1928–1930. See also Richards to Thomas B. Appleget, May 23, 1928; Appleget, memoranda to JDR Jr., June 5 and June 9, 1928, and June 27, 1929, folder 961, box 107, Cultural Interests, Record Group 2, Rockefeller Family Archives. In 1929, Paine asked Rockefeller for an increase in the annual amount and received seven thousand dollars.

58. Paine to Elizabeth Morrow, September 14, 1928, Mexican Arts Association folder, Morrow Family Papers.

59. Madame Charlot, Jean Charlot's mother, served as part-time guide for the display. Paine to Elizabeth Morrow, November 20, 1928, Mexican Arts Association folder, Morrow Family Papers.

60. Appleget, memorandum to JDR Jr., June 27, 1929; Appleget, Memo of Conversation with JDR Jr., June 27, 1929, both in folder 961, box 107, Cultural Interests, Record

Group 2, Rockefeller Family Archives. According to Robert W. de Forest, "[Mr. Morrow] was a little afraid that he might be investing in a money-making scheme and might be called up for a congressional investigation or something like that. We told Mrs. Paine that Mr. Morrow would have to make up his own mind. We tried to impress upon Mrs. Paine the importance of being incorporated." In addition, de Forest expressed concern about the Mexican Arts Association turning into "a general information bureau or charity bureau to help Mexicans come into the United States." Robert W. de Forest to Thomas Debevoise, May 28, 1930, in ibid.

61. See Elizabeth Morrow to Paine, February 27, 1929; Paine to Elizabeth Morrow, March 14, 1929; Elizabeth Morrow to Paine and Mrs. [Abby Aldrich] Rockefeller, July 16, 1929, all in Morrow Family Papers; Paine to Abby Aldrich Rockefeller (AAR), Aug 1, 1929, folder 97, box 7, Record Group 2, series I, AAR Correspondence, General Office file, Paine Mexican Arts Association, 1928–1931, Abby Aldrich Rockefeller Papers (hereafter, AAR Papers), Rockefeller Family Archives. The Morrows were concerned that Paine would financially benefit from the association's business dealings. Hoping to prevent such an outcome, the Morrows suggested to Paine and Mrs. Rockefeller that the association be "free to deal with any dealers or promoters of Mexican art and not merely be an adjunct to the art business of any individual or any corporation," that is, Frances Flynn Paine. To the chagrin of Abby Aldrich Rockefeller and John D. Rockefeller Jr., the first meeting of the Mexican Arts Association, which was held in their New York home, was reported the following day in the newspaper: "Organize to Foster Artistry in Mexico," *New York Times*, December 10, 1930. The Rockefellers did not appreciate the publicity. The tone of Abby Aldrich Rockefeller's letter to Paine the next day insinuates that Paine was responsible for the news "leak." Paine denied any responsibility for the incident. AAR to Paine, December 11, 1930, and Paine to AAR, December 11, 1930, both in folder 97, box 7, AAR Papers.

62. Enrique D. Ruíz, New York consul general, to Secretario de Relaciones Exteriores, October 16, 1930; and Eduardo Soriano Bravo, Boston consul general, to Secretario de Relaciones Exteriores, December 3, 1930, both in Archivo Histórico Genaro Estrada.

63. Keppel to Robinson and Trustees of the Metropolitan, December 26, 1929, Metropolitan Museum of Art Archives. Keppel was also quick to point out in the same letter that "it is not a government exhibit," despite Morrow's reliance on the Mexican government to facilitate loans and provide an official seal of approval.

64. D'Harnoncourt, "Carnegie Project," 3.

65. See Robinson to de Forest, November 20, 1929; de Forest to Robinson, November 21, 1929; and de Forest to Saint-Gaudens, November 22, 1929, all in Metropolitan Museum of Art Archives. According to d'Harnoncourt, because of the reluctance to have the exhibition at the Metropolitan, he was left to operate independently, and de Forest was careful not to identify himself as being closely connected with the exhibition. Later, when the crates were unpacked at the Metropolitan in the absence of d'Harnoncourt, the case with the toys was opened first. Robinson wrote a letter to de Forest stating the exhibition would ruin the reputation of the Metropolitan. D'Harnoncourt, "Carnegie Project," 8. D'Harnoncourt came to New York in August 1930 to begin preparations for the exhibition. Carl Zigrosser, *A World of Art and Museums* (Philadelphia: Art Alliance Press, 1975), 253.

66. The stigma of the market in relation to folk art has been addressed by Mary K. Coffey, who has suggested that despite protests of individuals such as d'Harnoncourt, "the folk canon itself was constituted within a nexus of market considerations, from international economic and cultural exchange to national development initiatives to local attempts to negotiate the impact of these forces." Mary K. Coffey, "Marketing Mexico's Great Masters: Folk Art Tourism and the Neoliberal Politics of Exhibition," in *Holiday in Mexico,* ed. Dina Berger, Eric Schantz, and Andrew Wood (Durham, NC: Duke University Press, forthcoming).

67. After the Art Center exhibit, Paine believed it was necessary to hire "an expert on ceramics to be sent to make tests of clays used and suggest a process for making the pottery more durable." Paine to Dr. Richards, May 19, 1928, Mexican Arts Association folder, box 36, Morrow Family Papers. See also Paine's letter to Elizabeth Morrow, January 11, 1929, in ibid., regarding the many problems she encountered in transporting the fragile materials.

68. D'Harnoncourt quoted in "Members of Art League and 100 Guests at Private Showing of Mexican Exhibition at University," *Albuquerque Journal,* November 16, 1931, copy in Archivo Histórico Genaro Estrada.

69. One criticism often launched about the aestheticization of Mexican popular art by non-Mexicans is the tendency to dissociate it from the people who produced it. Elizabeth Morrow, however, seems to have been very aware of the labor behind a particular object. For example, she described the lacquer designs of *batea*s (shallow wooden bowls) as being filled with "the rich deep colors and soft luster that only patient rubbing can produce. . . . It requires about six weeks, a whole family working, to make one large bowl. Think of the tired thumbs!" Elizabeth Morrow, *Casa Mañana* (Croton Falls, NY: Spiral Press, ca. 1932). Seemingly cognizant of labor issues in Mexico and unwilling to romanticize the life of the peon, Morrow criticized Stuart Chase's idealization of machineless Mexico in a review of his book, *A Study of Two Americas.* Elizabeth Morrow, "The Cause of Machineless Mexico," *New York Herald Tribune,* August 9, 1931.

70. See Coffey, "Marketing Mexico's Great Masters."

71. Copy of Paine's report to Bement, May 18, 1928, Mexican Arts Association folder, Morrow Family Papers.

72. See, e.g., *House and Garden,* January 1928, and Frances Flynn Paine, "La Casita en Cuernavaca: The Mexican Home of Dwight W. Morrow," *House Beautiful,* October 1931.

73. Copy of letter from Paine to Charles R. Richards, May 19, 1928; Paine to Elizabeth Morrow, November 20, 1928, September 14, 1928 (quote), all in Mexican Arts Association folder, Morrow Family Papers.

74. William Leach, *Land of Desire: Merchants, Power, and the Rise of a New American Culture* (New York: Vintage Books, 1993), 136; De Forest quoted in Zelda F. Poplin, "Art: Three Aisles Over," *Outlook and Independent* 156, no.13 (November 26, 1930): 515.

75. Leach, *Land of Desire,* 136.

76. In May 1937, for example, Macy's held a comprehensive exhibition of Mexican art in conjunction with a large display of craft work in the store's "Casa Mexicana."

77. Although the intimate relationship between art and market forces is com-

monplace today, such institutional alliances between museums and big business, for instance, began in this period. See Leach, *Land of Desire,* 164–73.

78. For an account of the founding of the new wing, see Marshall B. Davidson and Elizabeth Stillinger Davidson, *The American Wing at the Metropolitan Museum of Art* (New York: Metropolitan Museum of Art and Knopf, 1985); Calvin Tomkins, *Merchants and Masterpieces: The Story of the Metropolitan Museum of Art* (New York: Dutton, 1970).

79. Leach, *Land of Desire,* 318.

80. Wanda M. Corn, *The Great American Thing: Modern Art and National Identity, 1915–1935* (Berkeley: University of California Press, 1999).

81. Ibid., 309.

82. Ibid., 298, 314, 323.

83. Ibid., 314.

84. See correspondence between Paine and Abby Aldrich Rockefeller, June–August 1931, folder 97, box 7, AAR Papers; and Marion Oettinger Jr., *Folk Treasures of Mexico* (New York: Abrams, 1990), 38.

85. For a detailed discussion of pan-Americanism as an official foreign policy utilized by the U.S. government in the realm of culture, specifically, in the domestic promotion of pre-Columbian art, see Holly Barnet-Sánchez, "The Necessity of Pre-Columbian Art: U.S. Museums and the Role of Foreign Policy in the Appropriation and Transformation of Mexican Heritage, 1933–1944" (PhD diss., University of California, 1993).

86. The "Mexican Arts" exhibition was held in conjunction with the "Pan-American Round Table" in San Antonio in August 1931. One commentator observed, "When the present exhibition closes [d'Harnoncourt] plans to travel through South America collecting indigenous art and follow that with a similar journey through Alaska and the Yukon, his aim being to bring together collections from which students can decipher the language of an indigenous Pan-American culture." Arthur Millier, "Mexican Arts Exhibit Gained," *Los Angeles Times,* September 27, 1931.

87. Many artists and intellectuals in the United States, disgusted with their country's capitalism, industrialization, modernization, and materialistic values, looked to Latin America's indigenous communities as a form of escape from the "evils of the civilized world." Aldous Huxley, "Mexico: The Industrial and the Primitive," *Spectator,* no. 152 (April 13, 1934); Delpar, *Enormous Vogue of Things Mexican;* James Oles, *South of the Border: Mexico in the American Imagination, 1914–1947,* exhibition catalogue (New Haven: Yale University Art Gallery, 1993).

88. Shifra M. Goldman, "Painting, Petroleum, Politics, Profits: U.S.–Mexico Cultural Exchange," *Left Curve,* no. 12 (1987): 12–22. See also Catha Paquette, "Public Duties, Private Interests: Mexican Art at New York's Museum of Modern Art, 1929–1954" (PhD diss., University of California, Santa Barbara, 2002).

89. For more information on Zelia Nuttall see Delpar, *Enormous Vogue of Things Mexican,* 96, 98, 102.

90. Wall text label in "Arts of the Spanish Americas, 1550–1850: Works from the Museum's Collection," October 11, 2002–April 6, 2003, Henry R. Luce Center for the Study of American Art, American Wing, Metropolitan Museum of Art, New

York, NY. For more on the de Forest collection of Mexican ceramics, see Edwin Atlee Barber, *Catalogue of Mexican Maiolica Belonging to Mrs. Robert W. de Forest, Exhibited by the Hispanic Society of America, February 18 to March 19, 1911* (New York: Hispanic Society of America, 1911); Edwin Atlee Barber, *The Emily Johnston de Forest Collection of Mexican Maiolica* (New York: Gilliass Press, 1918).

91. De Forest to Morrow, December 2, 1927, in frame 1532–34, reel 2, series X, Dwight W. Morrow Papers.

92. De Forest and Morrow had served together on various trustee boards and participated in several corporate, civic, and philanthropic projects over the years in the New York area. Morrow had attended Columbia University's law school with the de Forests' son (López, "Morrows in Mexico," in *Casa Mañana*, ed. Danly, 60). In fact, before Morrow left for Mexico, de Forest had recommended that he contact Zelia Nuttall as a social connection. De Forest to Morrow, October 18, 1927, frame 1530, reel 2, series X, Dwight W. Morrow Papers.

93. Morrow to de Forest, January 8, 1928, frame 1535, reel 2, series X, Dwight W. Morrow Papers. One of the more famous controversies was Edward H. Thompson's archaeological investigations at Chichen Itza. In the 1880s, Thompson accepted the American Antiquarian Society's proposition that he go to the Yucatán as consul and also conduct research on behalf of the society and the Peabody Museum. Thompson began dredging the cenote at Chichen Itza in 1904 and continued until 1911, although he resigned his post as consul in 1909. Thompson illegally removed the archaeological objects he found in the cenote and deposited them at the Peabody Museum. The Mexican government began legal action against Thompson in July 1926. The dispute was still unresolved at the time of his death in 1935, but his heirs finally settled. See Delpar, *Enormous Vogue of Things Mexican*, 95–106.

94. In addition to the correspondence found in the Dwight W. Morrow Papers at Amherst, see also de Forest's letters to Morrow, October 24, 1927, and January 18, 1928, Morrow Family Papers.

95. De Forest wrote, "Parenthetically, I am anxious to use this opportunity of getting these objects of mine now in Mexico here so that I may present them to the Metropolitan, if the Metropolitan wants them." De Forest to Saint-Gaudens, November 22, 1929 (copy to E. Robinson), Metropolitan Museum of Art Archives.

96. By the time de Forest wrote to Morrow on August 28, 1929, the Carnegie Corporation had already made a grant for the loan exhibition and had arranged for Homer Saint-Gaudens to travel to Mexico in the fall to arrange the exhibit. Morrow expressed confidence that the Mexican government would lend objects through its national and some of its local museums and that Saint-Gaudens was going down with the idea of picking out that material. Morrow to de Forest, September 2, 1929, frame 577, reel 34, series I, Dwight W. Morrow Papers.

97. Robert de Forest to Dwight Morrow, August 28, 1929, frame 575, reel 34, series I, Dwight W. Morrow Papers.

98. Paine to Charles R. Richards, May 19, 1928, Cultural Interests, Mexican Arts Association folder, box 36, Morrow Family Papers; Richards to Thomas B. Appleget, May 23, 1928, Rockefeller Family Archives.

99. De Forest to Morrow, October 24, 1927, Morrow Family Papers.

100. Morrow, *Casa Mañana*.

101. Paine, "La Casita en Cuernavaca," 328.

102. Susan Danly, "Casa Mañana," in *Casa Mañana*, ed. Danly, 106.

103. Orozco, *Artist in New York*, 89–90.

104. David Alfaro Siqueiros, "Rectificaciones sobre las artes plasticas en Mexico," in *Palabras de Siqueiros,* ed. Raquel Tibol (Mexico City: Fondo de Cultura Económica, 1996), 48–61.

105. Zigrosser, *World of Art and Museums,* 254. Many of the painters actually had exhibited together (probably unknowingly) at the Art Center exhibition of 1928. The painters included in "Mexican Arts" besides the "big three" were Abraham Angel, Abelardo Avilar, Pablo Camareno, Julio Castellanos, Jean Charlot, Joaquín Clausell, Miguel Covarrubias, Dosamantes, María Izquierdo, Agustín Lazo, Manuel Rodríguez Lozano, Ignacio Márquez, Carlos Mérida, Roberto Montenegro, Paul O'Higgins, Carlos Orozco Romero, Máximo Pacheco, Everardo Ramírez, Fermín Revueltas, Rufino Tamayo, and Isabel Villaseñor.

106. A statement similar to Zigrosser's was made by Guillermo Rivas in an article announcing the "Mexican Arts" exhibition. He stated the group of painters had "heretofore staunchly avoided joint showings." Rivas, "Notes of the Carnegie Exhibit." See also "Variety of Mexican Art Is Seen in Museum Display," *Houston Post,* April 3, 1932. Those painters who were in both the 1928 Art Center and the "Mexican Arts" exhibitions were: Angel, Castellanos, Charlot, Covarrubias, O'Higgins, Mérida, Orozco, Pacheco, Revueltas, Rodríguez Lozano, and Tamayo. Even prior to the Art Center exhibition, twenty-nine Mexican artists exhibited together in the First Pan-American Exhibition of Oil Paintings, Los Angeles Museum, November 27, 1925–January 31, 1926, although neither Orozco nor Siqueiros was included.

107. Saint-Gaudens to Robert de Forest, November 14, 1929, Metropolitan Museum of Art Archives.

108. An undated prospectus for the exhibition can be found in the archives of the Corcoran Gallery of Art, Washington, DC, and the Speed Art Museum, Louisville, Kentucky.

109. René d'Harnoncourt, "The Exposition of Mexican Art," *International Studio* 97 (October 1930): 51.

110. It should be noted that apart from the works by Orozco, Rivera, Siqueiros, Mérida, and Charlot, the majority of the other modern paintings were lent by the artists themselves. Besides Frederick Davis's Sonora News Company and Frances Toor's studios, there were few stable commercial galleries or dealers in Mexico at this time. Artists could find the occasional buyer, especially government officials, such as Genaro Estrada in Orozco's case. Moisés Sáenz also owned works by modern artists and lent several paintings to the exhibition, including works by Castellanos (*Two Women and Child*), Covarrubias (*The School Teacher,* sold at Sotheby's, November 2002), and Siqueiros (*Troop Train,* discussed later in chapter 3). Yet the lack of an established art market in Mexico made all the difference between art patronage there and in the United States.

111. See Orozco's letter to Jorge Juan de la Crespo, October 5, 1930, cited in Luis Cardoza y Aragón, *Orozco* (Mexico City: Universidad Nacional Autónoma de México, 1959), 283.

112. Hellman, "Profiles: Imperturbable Noble." Contrary to d'Harnoncourt's assertion that there were many paintings by Orozco included, the exhibition catalogue for the Mexico City venue lists only one work, an oil painting owned by Genaro Estrada, most likely *Combat,* now in the collection of the Museo de Arte Alvar y Carmen T. de Carrillo Gil. Although d'Harnoncourt might have been mistaken as to the quantity of paintings by Orozco in the Mexico City exhibition, his account of Rivera's self-promotion in regard to the exhibition installation is nonetheless still believable.

113. The other panel is *Ribbon Dance,* located at the western end of the court. Another dance scene on the same wall, *Battle Dance* or *Los Santiagos,* two panels to the left of *La Zandunga,* was painted by Amado de la Cueva.

114. Made from gold coins accumulated over time as a result of one's own labor, the gold necklace serves as a Tehuana's dowry.

115. Frances Toor, *A Treasury of Mexican Folkways* (New York: Crown Publishers, 1947), 375.

116. Ibid.

117. In 1924, José Juan Tablada organized an exhibition of Covarrubias's caricatures at the Whitney Studio Club, and this exhibition also included wax sculptures by Luis Hidalgo and works by Orozco. Hidalgo had a studio on Forty-eighth Street and Fifth Avenue that served as a gathering place for Mexican expatriates in the early 1920s. His satirical wax figurines of prominent political figures, celebrities, and leading personalities such as President Coolidge, Charles Lindbergh, Charlie Chaplin, Frank Crowninshield, and Helen Hayes, among others, garnered him much success. Adriana Williams, *Covarrubias* (Austin: University of Texas Press, 1994), 18.

118. After traveling to Montevideo, Uruguay, in May 1929 to participate in the Latin American Syndicate Congress, Siqueiros returned that summer to Mexico and continued his political activities until they became too dangerous. In the beginning of 1930, he took refuge in the home of Angel Falco, the Uruguayan consul, and also may have gone to Taxco, during which time he returned to painting. After an assassination attempt on President Pascual Ortiz Rubio, anti-communist sentiment in Mexico, as well as the Partido Comunista Mexicano's campaign against Blanca Luz Brum—Siqueiros's companion, whom he had met in Buenos Aires and brought back with him to Mexico—forced him into hiding. See *Portrait of a Decade: David Alfaro Siqueiros, 1930–1940* (Mexico City: Museo Nacional de Arte, Instituto Nacional de Bellas Artes, 1997).

119. The reproduction of *Mother and Child* in the fine art volume *Portrait of a Decade,* page 199, is cut off at the bottom, but a more complete image is reproduced in René d'Harnoncourt, "The Loan Exhibition of Mexican Arts," *Bulletin of the Metropolitan Museum of Art* 25, no. 10 (October 1930). The illustration in the *Bulletin* shows the signature accompanied by the date and place of execution, "Mex Feb 1930." Regarding how Siqueiros conceived the "portrait of Mexico" cycle, see Graciela Amador to Anita Brenner, March 6, 1930, cited in Olivier Debroise, "Action Art: David Alfaro Siqueiros and the Artistic and Ideological Strategies of the 1930s," in *Portrait of a Decade,* 33.

120. José Juan Tablada, "Nueva York de día y de noche," *El universal,* November 23, 1930.

121. Ibid., 3.

122. Quoted in Cardoza y Aragón, *Orozco,* 282.

123. For an in-depth analysis of Orozco's *Zapata,* see John Hutton, "'If I Am to Die Tomorrow': Roots and Meanings of Orozco's *Zapata Entering a Peasant's Hut," Art Institute of Chicago Museum Studies* 2, no. 1 (fall 1984). It is interesting, in terms of popular culture, that this painting, which evokes fear and horror, was once owned by Vincent Price, Hollywood actor and master of the macabre.

124. *Study for Zapata,* 1930, oil on canvas, 14½ x 9 in. (37 x 23 cm), Museo de Arte Alvar y Carmen T. de Carrillo Gil, Mexico City/INBA 17265, provenance: Delphic Studios, New York; Dr. MacKinley Helm, Boston, United States. According to Justino Fernández, the Carrillo Gil owns another version of *Zapata,* a tempera on paper that Moisés Sáenz once owned. See Fernández, *Obras de José Clemente Orozco en la colección Carrillo Gil—Mexico* (Mexico: private edition published by Alvar Carrillo Gil, 1949). It is not listed, however, in Museo de Arte Alvar y Carmen T. de Carrillo Gil, *Orozco en la colección Carrillo Gil* (Mexico City: INBA/Museo de Arte Alvar y Carmen T. de Carrillo Gil, 1999). A gouache study for the painting was sold at Christie's on November 16, 1994, lot 49. It is reproduced in the exhibition catalogue, González Mello and Miliotes, eds., *José Clemente Orozco in the United States, 1927–1934,* 289.

125. What appears to be another disembodied arm is also added to the finished painting, accentuating the ferocious gesticulations of the devastated figures and the strong diagonals of the composition.

126. The halo is only barely suggested, as opposed to Rivera's glowing *mandorla* around Zapata in the SEP version. Reed noted that Zapata's wide-brimmed sombrero suggests a martyr's halo. Alma M. Reed, *Orozco* (New York: Oxford University Press, 1956), 193.

127. Hutton, "'If I Am to Die Tomorrow,'" 41–42, 45. Vincent Price interpreted Zapata as "the Robin Hood Bandit of Mexico" and "one of the fathers of Mexican democracy—a national hero." For Price, the figures depicted in Orozco's painting were happy to see Zapata. Price described the picture as "allegorical—two peasants being freed—and the soldiers, supporting Zapata—which I believe happened—part of the army went over to him." Price to Frederick A. Sweet, letter received November 4, 1941, Art Institute of Chicago curatorial files, courtesy Stephanie d'Alessandro, Gary C. and Frances Comer Curator of Modern Art, Department of Medieval through Modern European Painting and Sculpture and the Art Institute of Chicago Institutional Archives.

In his autobiographical account of his interest in art and his collecting practices, Price stated that "the Zapata stands in a cave entrance, daylight behind him, and the people (represented by three tortuous figures) beg him for deliverance. The blues, browns, and reds are superb, and it speaks eloquently for the freedom of the Mexican people. It moved me very much, and word had it that Orozco himself considered it his greatest easel painting—which, indeed, it is." He purchased the painting from Alma Reed, whose gallery he would visit three or four times a month. See Vincent Price, *I Like What I Know: A Visual Autobiography* (New York: Doubleday, 1959), 126–28. Price

later acquired a significant collection of pre-Columbian art, most of which he donated to East Los Angeles College.

128. Reed, *Orozco*, 193.

129. Renato González Mello, "Orozco in the United States: An Essay on the History of Ideas," in *José Clemente Orozco in the United States, 1927–1934*, eds. González Mello and Miliotes, 56.

130. Chronology in *José Clemente Orozco in the United States, 1927–1934*, eds. González Mello and Miliotes, 300.

131. Cardoza y Aragón, *Orozco*, 280.

132. Some semblance of this presentation must have been repeated by d'Harnoncourt at other venues because reviews often mentioned that the exhibition had three sections.

133. Oles, "For Business or Pleasure," 27. The market or thrift store style of display continued in other venues. D'Harnoncourt's fanciful sketches (presumably for the exhibition's stop in Washington, DC) of different display solutions for the various objects of the popular arts section reiterate the same folksy conventions. See d'Harnoncourt's sketches in Exhibition file, Corcoran Gallery of Art Archives, Washington, DC.

134. Unlike Rivera's *Baile en Tehuantepec*, which was stacked high above the much smaller *Head of a Tehuana* and *Reclining Nude with Snake*, Orozco's *Zapata* was hung at eye level. Its sheer size made it extend above the partitions.

135. Based on d'Harnoncourt's sketches in the Corcoran Gallery archives, one could presume that the installation at the Metropolitan served as a template for the other venues. Saint-Gaudens encouraged the director of the Museum of Fine Arts in Boston to follow the Metropolitan's lead: "If by any possibility you could go on to New York and see the exhibition at the Metropolitan, or send somebody on there before it closes, it would be a very wise move, as the entire appearance of the collection depends on the manner in which it is installed, and the Metropolitan has done an excellent job." Saint-Gaudens to Edward J. Holmes, October 22, 1930, Office of the Director, archives of the Museum of Fine Arts, Boston.

136. Ella S. Siple, "Art in America: Exhibitions from Mexico and South America," *Burlington Magazine* 58, no. 336 (March 1931).

137. "Mexico at the Metropolitan," *New York Herald Tribune*, October 16, 1930; Albert Franz Cochrane, "Ancient Mexican Culture Persists in Native Arts and Crafts," *Boston Evening Transcript*, November 29, 1930. The Boston review continued, "When the exhibition was being installed [in Boston] I thought it better suited to a natural history museum than to one of fine arts—a view which even a subsequent visit has not entirely altered."

138. Avis Berman, *Rebels on Eighth Street: Juliana Force and the Whitney Museum of American Art* (New York: Atheneum Books, 1989), 201, 202.

139. Arthur F. Egner, foreword to *American Folk Sculpture*, exhibition catalogue (Newark, NJ: Newark Museum, 1931); Holger Cahill quoted in ibid.

140. Holger Cahill, *American Folk Art: The Art of the Common Man in America, 1750–1900*, exhibition catalogue (New York: Museum of Modern Art, 1932), 27. Despite Cahill's statement about the lack of public folk art collections, the Elie and Viola Nadelman Collection of Folk Art had been open to the public by appointment

since November 1926. The Nadelmans had built a museum on the grounds of their Riverdale estate to house their collection. Photographs of the gallery installations in the Museum of Folk Arts reveal that the collection was displayed within the context of a domestic environment. Contrary to most museum displays, which aestheticize such objects and isolate them from the environments in which they were used, the Nadelmans presented folk art within the realm of material culture. For information on the collection and photographs of the gallery installations, see "Sculptor in the Open Air: Elie Nadelman and the Folk and Popular Arts," in *Elie Nadelman: Classical Folk,* ed. Suzanne Ramljak (New York: American Federation of Arts, 2001), 74–78.

141. One review offers a brief description of Rivera's subjects in the exhibition, including a "festive dance," which is a reference to *Baile en Tehuantepec.* Florence Davies, "Mexico Shows a Friendly Art," *Detroit News,* October 15, 1930. Another review states, "The largest painting, 'Tehunos' [*sic*] is brilliant in color, strikingly composed [in which] lies the life and gaiety of a fiesta." Ada Rainey, "Mexican and Brazilian Art Exhibits Are Open for Inspection by Visitors," *Washington News,* April 1931, clipping in Rene d'Harnoncourt Papers, Archives of American Art (hereafter, AAA), Smithsonian Institution, Washington, DC. Although José Juan Tablada described Rivera's painting in his review of the exhibition for *El universal,* his column was of course not accessible to U.S. readers. Tablada, "Nueva York de día y de noche," *El universal,* November 23, 1930.

142. The only article in which d'Harnoncourt mentions a modern artist by name is "The Exposition of Mexican Art," *International Studio* 97 (October 1930), where he refers to Orozco and Rivera as the leaders of a new movement.

143. René d'Harnoncourt, "Exhibition of Mexican Arts," *Carnegie Magazine* 4, no. 8 (January 1931): 232.

144. In a letter to the author dated November 12, 2001, Anne d'Harnoncourt related her mother's memory of the contemporary art section. I visited Anne d'Harnoncourt at the Philadelphia Museum of Art on July 10, 2001, and she was able to relay a few of my questions to her mother, Sarah d'Harnoncourt, before her death on August 7, 2001.

145. D'Harnoncourt, "Exposition of Mexican Art," 51.

146. Anne Webb Karnaghan, "Exhibition of Mexican Art," *Bulletin of the Museum of Fine Arts* (Boston) 28, no. 170 (December 1930): 113, 115–16. Despite this article's flaws, it is still one of the few that actually discuss the work of both Rivera and Orozco at some length.

147. Edward Alden Jewell, "Mexican Exhibition at Metropolitan: Deep Well of Culture," *New York Times,* October 19, 1930; Royal Cortissoz, "The Native Art of Modern Mexico: An Absorbing Show at the Metropolitan," *New York Herald Tribune,* October 12, 1930, 10.

148. On Orozco and Rivera see, for example, Helen Appleton Read, "The History of Mexico Is Told in Terms of Art at Metropolitan Museum Exhibition," *Brooklyn Daily Eagle,* October 12, 1930; Robert Bordner, "Mexican Art Is Exhibited in Cleveland," *Cleveland Press,* February 21, 1931; Ada Rainey, "Mexican and Brazilian Art Exhibits Are Open for Inspection by Visitors," *Washington News,* April 1931. A Houston review mistakenly mentions "the powerful sculptural lithographs by David Alfaro Siqueiros"; see "Forceful, Imaginative Art Found in Mexican Exhibit on View at

Houston Museum," *Houston Chronicle,* March 20, 1932. The only other reference to Siqueiros's contributions I have found is Arthur Millier's: "Examine Siqueiros, seen here in comparatively small pictures—small because, as a revolutionary leader much of his time was spent in jails—the color and design which distinguish his work have a deep harmony only possible to one who rises above his agony and merges his personal ambition with his racial longing." Arthur Millier, "Mexico's Indigenous Arts," *Los Angeles Times,* October 4, 1931.

149. Davies, "Mexico Shows a Friendly Art." See also Felix Schwarz, "Art of Mexico Reflects Tragic Mood in Show," *Washington News,* April 4, 1931.

150. Joseph J. Cloud, "Mexican Arts Show Opens at Museum Here," *Pittsburgh Press,* January 25, 1931.

151. Jewell, "Mexican Exhibition at Metropolitan"; Karnaghan, "Exhibition of Mexican Art."

152. Read, "History of Mexico Is Told in Terms of Art"; Margaret Breuning, "Exhibitions at the Metropolitan and the Modern Museums," *New York Evening Post,* October 18, 1930.

153. Rivera created eight portable mural panels for his retrospective at the Museum of Modern Art precisely because critics lamented the inability of "Mexican Arts" to showcase muralism. See the discussion of Rivera's portable panels in chapter 4.

154. Such reproductions were featured in two later exhibitions: "Murals by American Painters and Photographers," May 3–31, 1932, and "Twenty Centuries of Mexican Art," May 15–September 30, 1940, both at the Museum of Modern Art, New York. For a discussion of the latter exhibition, see chapter 5.

155. It should also be noted that the newspapers neglected to connect "Mexican Arts" with Diego Rivera's concurrent retrospective exhibition at MoMA.

156. Breuning, "Exhibitions at the Metropolitan and the Modern Museums."

157. D'Harnoncourt, "Four Hundred Years of Mexican Art," *Art and Archaeology* 33, no. 2 (March–April 1932): 77; Oles, "For Business or Pleasure," 27.

158. The original exhibition proposal from late 1929 suggested the possibility of extending the tour for another year: "The circuit for the first year is filled tentatively, but we have many more applications than can be included on one winter's circuit, and we are therefore hoping that we may keep the things for a longer period." Homer Saint-Gaudens to Arnold Strode-Jackson, director, Louisville Art Association, January 20, 1930, exhibition file, Speed Art Museum, Louisville, KY. Among the many institutions requesting the exhibition were the Little Gallery in Cedar Rapids, Iowa, and the public library of St. Paul, Minnesota. See microfilm reel 3830, René d'Harnoncourt Papers.

159. According to d'Harnoncourt, "[Carnegie Corporation president] Keppel very enthusiastically provided money for a second year." D'Harnoncourt, "Carnegie Project," 11. Elizabeth Morrow wrote d'Harnoncourt the day the extension was approved, "I am very happy about the extension. We have just had the word today that the Mexican Government has given its permission as far as its exhibits are concerned." Elizabeth Morrow to d'Harnoncourt, February 27, 1931, Morrow Family Papers.

160. Whiting to Mr. James Chillman Jr., director, Museum of Fine Arts, Houston, December 26, 1930, "Mexican Arts" exhibition file, Archives, Museum of Fine Arts, Houston.

161. The governor of New Mexico wrote d'Harnoncourt, "I note . . . that you will . . . take up with the proper authorities the matter of having the Mexican Art Exhibit shown in Santa Fe before it is returned to the Republic of Mexico. If this arrangement can be made you will have the lasting appreciation of the people of Santa Fe, who are taking an active interest in reviving Spanish-American, Mexican and Indian arts in this country. Indeed Santa Fe considers herself the largest center of this character in the United States and it would be a pity to have the Mexican Art Exhibit pass by our door without stopping." Arthur Seligman to d'Harnoncourt, November 25, 1931, frame 549, reel 3830, René d'Harnoncourt Papers.

162. "Morrow-Sponsored Mexico Art Exhibit Opens Here Thursday," *St. Louis Globe,* January 30, 1932.

163. As a result of these attendance figures, the Mexican consul general suggested that the public in Boston was more cultivated than that of New York. Eduardo Soriano Bravo to Secretario de Relaciones Exteriores, December 12, 1930, Archivo Histórico Genaro Estrada.

164. The two Sundays in question were August 16 and August 23, 1931. See Florence Griswold to Dwight Morrow, August 17, 1931, frame 160, reel 65, series I, Dwight W. Morrow Papers; and newspaper clippings, frame 0030, reel 3831, René d'Harnoncourt Papers.

165. Mayd Durlin, El Paso Public Library, to d'Harnoncourt, June 11, 1932, frame 556, reel 3830, René d'Harnoncourt Papers.

166. Arthur Millier, *Los Angeles Times,* June 10, 1932, cited in translation of news clippings to be sent to Mexico, frame 556, reel 3830, René d'Harnoncourt Papers; McBride to Weyhe, February 24, 1931, file M-1931, box 1, Weyhe Gallery Papers, AAA; "Forceful, Imaginative Art Found in Mexican Exhibit on View at Houston Museum," *Houston Chronicle,* March 20, 1932.

167. Brewer & Warren, Inc., Publishers (formerly Payson and Clarke) to Anita Brenner, October 29, 1930, Anita Brenner Archives.

168. See, for example, "Forceful, Imaginative Art Found in Mexican Exhibit," *Houston Chronicle,* March 20, 1932; Ina Gillespie, "Art Exhibits from Remote Sections of Mexico Displayed," Archives, Museum of Fine Arts, Houston; Fred Hogue, "History Illuminated by Art," *Los Angeles Times,* October 25, 1931; Eleanor Jewett, "Art Institute Opens Several Exhibitions," *Chicago Daily Tribune,* December 23, 1931; "Primitive Pottery Now on Display at the Cleveland Museum of Art," *Cleveland Case Tech,* 1931, reel 3830, René d'Harnoncourt Papers.

169. "Mexican Art Here for Second Show," *Washington Star,* September 4, 1932; "Mexican Crafts on View at Telfair Academy: Objects Assembled by Count Rene d'Harnoncourt Illustrate the Art of Native Craftsmen in Articles for Domestic Use," *Savannah (GA) News,* undated news clipping, frame 1085, reel 3830, René d'Harnoncourt Papers.

170. "Mexican Art Exhibition Is Being Shown," *Houston Post,* March 27, 1932.

171. Eleanor Jewett, "Art Institute Opens Several Exhibitions," *Chicago Daily Tribune,* December 23, 1931.

172. Although the stereotypical character of the "greaser," or rapacious bandit, of American films had largely disappeared by 1928, equally negative stereotypes emerged

in the 1930s. See George Hadley-Garcia, *Hollywood Hispano: Los latinos en el mundo del cine* (New York: Citadel Press, 1991); Arthur G. Pettit, *Images of the Mexican American in Fiction and Film* (College Station: Texas A&M University Press, 1980); Allen L. Woll, *The Latin Image in American Film,* 2nd ed. (Los Angeles: UCLA Latin American Center Publications, 1977).

173. Quoted in "Below the Border," *Art Digest* 11, no. 16 (May 15, 1937). See also "Native Crafts of Mexico Come to Us: A Current Exhibition in New York Offers Some New Ideas in Decoration for the Interiors of American Homes," *New York Times Magazine,* October 26, 1930.

174. Frances Toor, *Mexican Popular Arts* (Mexico City: Frances Toor Studios, 1939), 12.

175. Ibid.

176. Hellman, "Profiles: Imperturbable Noble," 50.

177. D'Harnoncourt to Elizabeth Morrow, February 2, 1930, Morrow Family Papers.

178. Grace Davidson, "Road to Fame in His Mexican Art—Titled Austrian Artist, Discovered by Dwight Morrow Family Has Romantic, Colorful Career," *Boston Post,* November 25, 1930; Roslyne Kuminir, "He Rode Donkeys over Mountains and Carried Pottery on His Back for Art: Mexican Exhibition Being Shown by Count from Vienna," *Houston Press,* March 17, 1932; Louis Sherwin, "Impoverished by Old Vienna's Collapse, Nobleman went to Mexico and Put Bullfights on Canvas," *New York Evening Post,* October 17, 1930; Joseph J. Cloud, "Mexican Arts Show Opens at Museum Here," *Pittsburgh Press,* January 25, 1931; Mason Ham, "Boston Personalities," *Boston Herald,* November 25, 1930; Louis Sherwin, "Count D'harnoncourt, Austrian, Brings Us Mexican Art Exhibit," *New York Evening Post,* October 17, 1930.

179. Zigrosser, *World of Art and Museums,* 256 (emphasis added).

Chapter 4. Mural Gambits

1. Anthony Lee has examined and interpreted Rivera's San Francisco murals and their place in a dialogue between radical politics and public art in the Bay Area. See Lee, *Painting on the Left: Diego Rivera, Radical Politics, and San Francisco's Public Murals* (Berkeley: University of California Press, 1999).

2. Among the many articles that discussed and reproduced murals in Mexico are Walter Pach, "The Evolution of Diego Rivera," *Creative Art* 4, no. 1 (1929); and Herman George Scheffauer, "Diego Rivera: The Raphael of Communism," *Creative Art* 7 (July 1930).

3. The exhibition catalog lists 120 works, but a letter dated November 25, 1930, from Lloyd LaPage Rollins to Reginald Poland, director of the Fine Arts Gallery of Balboa Park, San Diego, mentions 27 paintings (14 from Mexico City) and 160 drawings (90 from private collections and 60 from Rivera—including 48 sketches he made during a visit to Russia). California Palace of the Legion of Honor Exhibition Archives, courtesy Fine Arts Museums of San Francisco.

4. Lloyd LaPage Rollins to Robert B. Harshe, director, Art Institute of Chicago, October 1, 1930, California Palace of the Legion of Honor Exhibition Archives.

5. Ibid.

6. The exhibition catalogue lists only two sketches for frescoes, but they are for the Secretaría de Educación Pública, not the Palacio de Cortés in Cuernavaca.

7. The January 1931 issue of *Fortune* magazine reproduced three panels (one of which would be adapted for Rivera's Museum of Modern Art retrospective exhibition) from Rivera's Palacio de Cortés mural cycle and published a photograph of the artist standing in front of his work. Given that the U.S. ambassador to Mexico, Dwight Morrow, commissioned the Cuernavaca cycle as a gesture of "diplomatic goodwill" and that this commission formulated part of his larger plan to promote Mexican culture for reasons other than "cultural"—that is, to use the commission to stimulate trade and protect U.S. investments in the country—it is not surprising that Rivera was featured in a trade publication like *Fortune* at this time.

8. Critical assessments of the exhibition in the leading architecture journals of the day seem to have ignored Rivera's contribution. "Awarded Prizes at the Fourth Biennial Architectural and Allied Arts Exposition," *American Architect and Architecture* 139 (June 1931): 34–35; "Fourth Biennial Architectural and Allied Arts Exposition, New York," *Architectural Forum* 54 (May 1931): 647–48; "Fourth Biennial Architectural and Allied Arts Exposition," *Art Digest* 5 (May 1, 1931): 17; and "Pictorial Survey of the Architectural League Exhibition," *Architecture: The Professional Architect's Monthly* 63 (June 1931): 342–46. The same issue of *Creative Art* that featured a laudatory essay on Rivera's Pacific Stock Exchange mural, however, also included a reproduction of one of the grisaille panels at Cuernavaca. Emily Joseph, "Rivera Murals in San Francisco," and Walter Knowlton, "Around the Galleries," both in *Creative Art* 8, no. 5 (1931).

9. Henry McBride, "The Palette Knife," *Creative Art* 8, no. 5 (1931): 323.

10. Lee, *Painting on the Left,* xix.

11. Helen Appleton Read, "The Rivera Murals in Mexico," *Vogue,* November 10, 1930, 126. While Read reported that the panels would be very large-scale canvases, in actuality Rivera painted small fresco copies of his murals. The average size of the portable frescoes is 8 by 5 feet, but one is only 3½ by 4½ feet, significantly smaller than the 1928 large-scale easel painting *Baile en Tehuantepec* (6½ by 5¼ feet).

12. Carl Zigrosser to William Spratling, September 14, 1931, frame 68, reel 4642, Carl Zigrosser Papers, Archives of American Art (hereafter, AAA), Smithsonian Institution, Washington, DC.

13. See Ralph Flint, "Rivera Frescoes Seen at Museum of Modern Art," *Art News* 29 (December 26, 1931); "The Frescoer," *New Yorker,* December 26, 1931, 9–10; and Edward Alden Jewell, "An Impressive Exhibition," *New York Times,* December 22, 1931.

14. Dorothy Dayton, "Diego Rivera Talks of His Art," *New York Sun,* November 17, 1931.

15. See Francis V. O'Connor, "A History of Painting in True Fresco in the United States: 1825 to 1945," in *Fresco: A Contemporary Perspective,* exhibition catalogue (Staten Island, NY: Newhouse Center for Contemporary Art, Snug Harbor Cultural Center, 1994), 6–8.

16. "Exhibitions in New York: Diego Rivera, Museum of Modern Art," *Art News* 30 (January 16, 1932).

17. *New York Sun,* January 7, 1932; "Frescoes Added to Rivera Show," *New York Times,* January 7, 1932; and "Rivera Depicts Life of City in 'Frozen Assets,'" *New York Herald Tribune,* January 7, 1932.

18. Margaret Breuning, "Modern Museum Shows Rivera Fresco," *New York Evening Post,* December 26, 1931.

19. Reviewing the New York–themed portable frescoes, Henry McBride stated, "They seem unofficial and secondhand. They seem to be the fruit of too much reading in the communist newspapers in the railroad train on the way up—a preconceived notion of 'showing New York up,' rather than a matter of personal observation. And New York, like Mexico, can only be properly 'shown up' by someone who has it in the blood. I admit that New York is not as thematic pictorially as it might be, yet just the same, our life has its moments. How electrified we might have been, had Rivera chosen instead to do a fresco of our handsome Mayor Walker hurling defiances at the Seabury committee (investigating political corruption in New York City and state) from a cactus garden in California; or [Police] Inspector Mulrooney and his platoons of huskies capturing that little boy murderer—I have already forgotten his name—up in West End Avenue; or Miss Belle Livingstone triumphantly receiving her friends after a month's stay in jail for the most popular infringement of the law that we have. Oh, we don't lack material, but you can see it is not good stuff for strangers. It takes someone who has known us before and after to employ it adequately." McBride, "The Palette Knife," *Creative Art* 10, no. 2 (1932): 93.

20. See Sabine Mabardi, "The Politics of the Primitive and the Modern: Diego Rivera at MoMA in 1931," *Curare,* no. 9 (fall 1996).

21. Stanton L. Catlin, "Mural Census," in *Diego Rivera: A Retrospective,* ed. Cynthia Newman Helms (New York: Founders Society, Detroit Institute of Arts, in association with Norton, 1986), 271.

22. One critic noted that *Agrarian Leader Zapata* is "a picture in which the horse is as important as the man." Royal Cortissoz, "The Art of Jose Maria Sert and Diego Rivera: Two Foreign Types of Decorative Art," *New York Herald Tribune,* December 27, 1931.

23. Mabardi, "Politics of the Primitive and the Modern," 11–13.

24. Ibid., 15.

25. I thank Pedro Ramirez and my entire undergraduate Modern Mexican Art class at City College of New York, fall 2007, for noticing this detail about the clothing.

26. I would like to acknowledge Gabriela Baeza, in Miriam Basilio's Museum Studies class at New York University, spring 2007, for pointing out this detail about the foreman during a lecture I gave there.

27. Catlin, "Mural Census," 270 (emphasis added).

28. Anthony W. Lee, "Painting a Spark of Hope: Diego Rivera's History of Cuernavaca and Morelos," in *Casa Mañana: The Morrow Collection of Mexican Popular Arts,* ed. Susan Danly (Amherst, MA, and Albuquerque: Mead Art Museum, Amherst College/University of New Mexico Press, 2002), 144.

29. Ibid., 141–42.

30. Cortissoz, "The Art of Jose Maria Sert and Diego Rivera"; "The Frescoer," *New Yorker,* December 26, 1931; and Jewell, "An Impressive Exhibition"; "Diego Rivera Show Opens Tomorrow at Pennsylvania Museum," *Chicago Evening Post,* February 2, 1932; "Museum Displays Rivera's Art Work," *Philadelphia Evening Public Ledger,* February 3, 1932.

31. Mabardi, "Politics of the Primitive and the Modern," 14–15.

32. Ibid. While Mabardi concentrates on the portable frescoes, Anthony Lee mentions them briefly in a broader discussion of Rivera's position as a radical artist in the United States caught between his capitalist patrons, fellow artists of the Left, and the debating public. Lee, *Painting on the Left*, 115–17.

33. Breuning, "Modern Museum Shows Rivera Fresco."

34. Helen Appleton Read, "Six Murals by Diego Rivera," *Brooklyn Daily Eagle*, December 27, 1931.

35. Paul Rosenfeld, "The Rivera Exhibition," *New Republic*, January 6, 1932.

36. "Diego Rivera Show Opens Tomorrow at Pennsylvania Museum," *Chicago Evening Post*, February 2, 1932.

37. Rosenfeld, "Rivera Exhibition."

38. Years earlier, Rivera had depicted Zapata in a way similar to the MoMA panel. A drawing by Rivera illustrated in the *estridentista* journal *Horizonte* (March 1927) shows Zapata beside his horse with a sword in one hand and a wrapped flag in the other. Beside the horse is tropical vegetation, and the drawing is inscribed with the motto, "Tierra y Libertad." The drawing is similar to the MoMA panel in that it isolates the figure of Zapata with his horse, yet it does not include the figure of the dead body under his feet. The similarity between the early drawing and the MoMA panel suggests that the artist, not MoMA officials, controlled the content of the frescoes.

39. "Rivera Portrays a Bitter Mexico," *New York Evening Post*, December 23, 1931.

40. Jewell, "An Impressive Exhibition"; "The Frescoer," *New Yorker*, December 26, 1931, 9.

41. "The Diego Rivera Mural, California School of Fine Arts," *Creative Art* 10 (January 1932): 56.

42. "There has been some caustic criticism of Diego's stuff as being all old, etc." David Glusker to Anita Brenner, December 26, 1931, Anita Brenner Archives, Harry Ransom Humanities Research Center, University of Texas at Austin. Brenner later offered her own condemnation of Rivera's portable frescoes, setting them in opposition to Orozco's more "meaningful" murals: "[E]ntirely counter to the solemn insistence on continuity between architecture and murals, more often than not the 'murals' turn out to be merely big canvases fastened into an empty panel and removable to some other place and panel. The supreme example of this sort of pretension was the Rivera show at the Modern Museum—frescos painted each in an arch of a Mexican patio, repeated on isolated portions of 'wall' framed in iron, and exhibited as examples of mural art in a gallery built for pictures and sculptures not intended for a particular light, position or place." Anita Brenner, "Orozco, Murals with Meaning," *Creative Art* 12, no. 2 (February 1933): 134–35.

43. "Frescoes Added to Rivera Show," *New York Times*, January 7, 1932; Rivera quoted in "Rivera Here, Ready for Painting Show," *New York Times*, November 15, 1931.

44. *Uprising*, which is a scene of urban strife alternately described as depicting a strike scene from the Mexican Revolution, does not, as one critic noticed, "repeat any fresco previously painted, but incorporates ideas that frequently have figured in Rivera's work." Jewell, "An Impressive Exhibition."

45. Lee, *Painting on the Left*, 117; "Exhibitions in New York: Diego Rivera, Museum of Modern Art," *Art News* 30 (January 16, 1932); Henry McBride, "The Palette Knife," *Creative Art* 10, no. 2 (1932).

46. "Frescoes Added to Rivera Show," *New York Times*, January 7, 1932; "Rivera Depicts Life of City in 'Frozen Assets,'" *New York Herald Tribune*, January 7, 1932; "Rivera's New Sociological Frescoes of New York Are Acclaimed," *Art Digest* 6, no. 8 (January 15, 1932).

47. Diego Rivera, quoted in "Rivera Here, Ready for Painting Show," *New York Times*, November 15, 1931.

48. Diego Rivera, with Gladys March, *My Art, My Life* (New York: Citadel, 1960), 180.

49. According to Bernice Kert, Abby Aldrich Rockefeller paid Rivera's expenses while he stayed in New York. Kert, *Abby Aldrich Rockefeller: The Woman in the Family* (New York: Random House, 1993), 350.

50. Rivera with March, *My Art, My Life*, 180.

51. Francis V. O'Connor, "Arshile Gorky's Newark Airport Murals: The History of Their Making," in *Murals without Walls: Arshile Gorky's Aviation Murals Rediscovered*, exhibition catalogue, ed. Ruth Bowman (Newark, NJ: Newark Museum, 1978), 17.

52. O'Connor, "A History of Painting in True Fresco," 6.

53. Jean Charlot, quoted in José Clemente Orozco, *The Artist in New York: Letters to Jean Charlot and Unpublished Writings, 1925–1929*, trans. Ruth L. C. Simms (Austin: University of Texas Press, 1974), 21. Indeed, when Orozco learned of Rivera's mural *Allegory of California* in San Francisco, which depicts the state's "prosperity or fecundity as a lady with Greco-Roman clothing with a Greek nose, high bosoms, hips and everything, with fruits and other attributes," he accused Rivera "of the worst American academicism, the kind that fills banks, State Capitols, and other skyscrapers by the square mile." Orozco to Jorge Juan Crespo de la Serna, January 31, 1931, in Luis Cardoza y Aragón, *Orozco* (Mexico City: UNAM-IIE, 1959), 284–85, reprinted in "Anthology of Critical Reception," trans. A. Azuela, R. González Mello, and J. Oles, in *José Clemente Orozco in the United States, 1927–1934*, exhibition catalogue, eds. Renato González Mello and Diane Miliotes (Hanover, NH, and New York: Hood Museum of Art, in association with Norton, 2002), 313.

54. Orozco, unpublished text prepared for the introduction to Gardner Hale's *Fresco Painting: A Technical Manual* (New York: William Edwin Rudge, 1933), quoted in Justino Fernández, *Textos de Orozco*, 2nd ed. (Mexico City: UNAM-IIE, 1983), 46. Orozco's and Rivera's murals in the United States—portable or otherwise—provided artists with firsthand awareness of the fresco technique. Although Siqueiros's work had a profound effect on artists in the United States, South America, and Cuba, he had abandoned the fresco technique relatively early. Siqueiros's significant contribution, beginning in the early 1930s, came in the form of experimentation with innovative techniques, such as the use of airbrushes, compressors, synthetic and industrial paints, projectors, the mapping of movements by the spectator, and photo montages.

55. O'Connor, "A History of Painting in True Fresco," 9.

56. Frederick Kiesler, "Murals without Walls: Relating to Gorky's Newark Project," *Art Front*, December 1936, reprinted in *Murals without Walls*, ed. Bowman, 30–33.

57. For the RCA Building project, see Mabardi, "Politics of the Primitive and the Modern," 28.

58. "The Mural Tempest," *Art Digest*, February 15, 1932; Nelson A. Rockefeller to Abbott Lawrence Lowell, April 28, 1932, folder 197, box 20, Cultural Interests, Record Group 2, Office of the Messrs. Rockefeller (OMR), Rockefeller Family Archives, Rockefeller Archive Center, Sleepy Hollow, NY. Todd, Robertson & Todd Engineering and the architects of Rockefeller Center put up six hundred dollars to print the catalogue of the "Murals by American Painters and Photographers" exhibition. Nelson A. Rockefeller to Stephen Clark, June 2, 1932, ibid. See also James Wechsler, "From World War I to the Popular Front: The Art and Activism of Hugo Gellert," *Journal of Decorative and Propaganda Arts* 24 (2002): 218–25. According to Lincoln Kirstein, the exhibition was his idea, but he did not originally intend it to be a competition. Martin Duberman, "Seeing Red at MoMA," *ARTnews* (May 2007): 145; and Duberman, *The Worlds of Lincoln Kirstein* (New York: Knopf, 2007), 112–17.

59. Alfred H. Barr Jr. to Nelson A. Rockefeller, May 11, 1932, folder 197, box 20, Cultural Interests, Record Group 2, OMR, Rockefeller Family Archives.

60. Rivera with March, *My Art, My Life*, 180.

61. Diego Rivera to Abby Aldrich Rockefeller, November 5, 1932, regarding the Rockefeller Center commission, folder 706, box 94, Business Interests, Record Group 2, Diego Rivera (1933–1950), Rockefeller Family Archives. Rivera and other artists associated with the Syndicate of Technical Workers, Painters, and Sculptors in Mexico had originally rejected easel painting as bourgeois.

62. Rivera to Abby Aldrich Rockefeller, February 6, 1932, folder 706, box 94, Business Interests, Record Group 2, Diego Rivera (1933–1950), Rockefeller Family Archives.

63. Carl Zigrosser to Duncan Phillips, February 12, 1932, Weyhe Gallery Papers, AAA; and Reba White Williams, "Prints and Muralism," in *Mexican Prints from the Collection of Reba and Dave Williams* (New York: Reba and Dave Williams, 1998), 49–50.

64. Carl Zigrosser to Paul J. Sachs, Fogg Art Museum, June 16, 1932, Weyhe Gallery Papers, AAA.

65. Williams, "Prints and Muralism," 50.

66. Jere Abbott to Carl Zigrosser, August 27, 1934, Smith College Museum of Art, quoted in Williams, "Prints and Muralism," 53.

67. In 1937, Zigrosser attempted to sell some of the frescoes to architect Alfred Shaw. Carl Zigrosser to Alfred Shaw, May 8, 1937, Weyhe Gallery Papers, AAA. The next year he tried to sell *Electric Welding* (or, as he called it, *Electric Power*) to General Electric. Even though the fresco heroically depicts workers in a General Electric plant and would thus seem an appropriate subject for the corporation, the chairman of the board was not interested in acquiring Rivera's vision of industry in the United States. Zigrosser to Alfred Shaw, October 7, 1938, frame 811, reel 4638, Carl Zigrosser Papers, AAA.

68. *Agrarian Leader Zapata* became part of the Museum of Modern Art's collection on May 28, 1940, during the run of the "Twenty Centuries" exhibition, from May 15 to September 30. In the exhibition catalogue, it was still listed as belonging to the Weyhe Gallery. The museum purchased the work with monies from the Abby Aldrich

Rockefeller Fund. The other two frescoes featured in "Twenty Centuries of Mexican Art" were *Sugar Cane* and *Liberation of the Peon*.

69. Sotheby Parke Bernet, *Modern Mexican Paintings, Drawings, Sculpture and Prints*, sale catalogue, May 26, 1977, lots 19–22.

70. Stanton Loomis Catlin, "Movable Frescoes and Other Large-Scale Public Works," in *Diego Rivera: A Retrospective*, ed. Helms, 331.

71. Catlin, "Mural Census," in *Diego Rivera: A Retrospective*, ed. Helms, 301.

72. The majority of Rivera's murals after the MoMA retrospective and the Rockefeller Center scandal were true fresco panels on movable steel frames. For example, at the Hotel Reforma in 1936 he created four vertical movable panels, and his later frescoes at the Golden Gate International Exposition in San Francisco (1940, now located at City College of San Francisco) and the Instituto Nacional de Cardiología (1943–1944, located in Mexico City) are also done in true fresco technique on movable frames. The Palacio de Bellas Artes is filled with movable murals by *los tres grandes* in a variety of materials: Rivera's *Man at the Crossroads* (1934); Orozco's *Catharsis* (1934); and Siqueiros's triptych of *The New Democracy, The Victims of War,* and *The Victims of Fascism* (1944) plus *The Apotheosis and Resurrection of Cuauhtémoc* (1950). Unlike the experiments in New York, the movable murals are all very large in scale and presented as if they were actually integrated with the wall—that is, they are built into the wall so as to appear flush with it. Therefore, they depart radically from the spatial and ideological inconsistencies of portable frescoes.

73. Rivera had made an initial set of five lithographs at the urging of Zigrosser in 1930. See Judith Keller, "Rivera's Prints: Notes on the Weyhe Lithographs, 1930–1932," in *The Fath Collection: Selected Prints from the United States and Mexico, 1915–1950* (Austin: Archer M. Huntington Art Gallery, University of Texas, 1986); Reba White Williams, "The Weyhe Gallery between the Wars, 1919–1940" (PhD diss., City University of New York, 1996); and Williams, "Prints and Muralism."

74. Kahlo to Galka Scheyer, April 11, 1932, frame 541, reel 1905, Blue Four Galka Scheyer Collection Archives, AAA. Courtesy Norton Simon Museum.

75. *Diego Rivera: Five New Lithographs* (New York: Weyhe Gallery, 1932), in Weyhe Gallery Papers, AAA.

76. "Mexican Graphic Art," May 2–14, 1932, Weyhe Gallery, 794 Lexington Avenue, New York. See exhibition reviews in Weyhe Gallery Scrapbooks, vols. 6 and 8, Weyhe Gallery Papers, AAA, for example: *New York Evening Post*, May 7, 1932; Eleanor Jewett, "Diego Rivera Work Placed on Exhibition," *Chicago Tribune*, May 21, 1932; "Mexico," *New York Herald Tribune*, May 8, 1932; "Mexico as Viewed by Artists," *New York Times*, May 9, 1932.

77. "Mexico as Viewed by Artists," *New York Times*, May 9, 1932.

78. Max Jaffé, a fine art printer in Vienna, asked Zigrosser for advice on how much he should charge Murphy for such a project. Jaffé to Zigrosser, care of the Art Institute of Chicago, June 4, 1931, box 1, Weyhe Gallery Papers, AAA.

79. Both Zigrosser and Spratling assisted Murphy with the project. By September 1931, they had found a printer in Berlin, Ganymede, and had already obtained proofs of images from the SEP, Chapingo, and Cuernavaca and four images from the Palacio Nacional. Zigrosser to Spratling, September 14, 1931, and Spratling to Zigrosser,

September 24, 1931, frames 68 and 69, reel 4642, Carl Zigrosser Papers, AAA. In March 1932, a month and a half after Rivera's MoMA exhibition closed, Alfred H. Barr Jr. presented Murphy's proposal to the MoMA Board of Trustees. She suggested that the portfolio be published under the museum's name but that she would absorb all the costs. Barr wrote to Nelson A. Rockefeller that "the Trustees did not respond very enthusiastically," but, Barr added, "Mrs. Murphy at one time had in mind the possibility of giving the Museum quite a large amount of money." Murphy asked Barr to write a short foreword, but he instead recommended that Jere Abbott write "a description of the technical processes and colors used by Rivera," much like his essay for the retrospective exhibition catalogue. In May, Barr looked over the proofs of the color prints, and by June, Abbott had "the matter in hand." Barr's summary of a letter to Murphy, March 16, 1932, cited in Barr to Nelson A. Rockefeller, June 23, 1932, folder 197, box 20, Cultural Interests, Record Group 2, MoMA 1929–1933, Rockefeller Family Archives.

80. *Frescoes of Diego Rivera* (New York: Museum of Modern Art, 1933); *Color Reproductions of Mexican Frescos by Rivera*, 1933–1939, Department of Circulating Exhibitions Records, II.1.97.6, MoMA Archives, New York, NY.

81. The title *Cane Workers*, in contrast to *Sugar Cane*, at least reaffirms the primacy of the labor depicted yet still is significantly less strident than the original *Slavery in the Sugar Mill*.

82. "There was so much magic in the Cuernavaca and Mexico City decorations that I suppose Rivera's friends were not too naive in thinking it would operate here also. But alas, it didn't!" McBride, "Palette Knife," *Creative Art* 10, no. 2 (1932): 93.

83. Henry McBride, "Color Reproductions of Rivera's Mexican Murals at Museum of Modern Art: Exhibition Justifies General Enthusiasm for the Painter," *New York Sun*, February 25, 1933.

84. Walter Benjamin, "The Work of Art in the Age of Mechanical Reproduction" (1936) in Benjamin, *Illuminations: Essays and Reflections*, ed. Hannah Arendt (New York: Schocken Books, 1968), 217–52.

Chapter 5. "Explaining" Muralism

1. See Anna Indych-López, "Mexican Muralism in the United States: The Controversies and Paradoxes of Patronage and Reception," in *Mexican Muralism: A Critical History*, ed. Alejandro Anreus, Leonard Folgarait, and Robin Greeley (Berkeley: University of California Press, forthcoming).

2. See Andrew Hemingway, *Artists on the Left: American Artists and the Communist Movement, 1926–1956* (New Haven: Yale University Press, 2002); and Helen Langa, *Radical Art: Printmaking and the Left in 1930s New York* (Berkeley: University of California Press, 2004).

3. Meyer Schapiro, "The Social Bases of Art," in *Artists against War and Fascism: Papers of the First American Artists' Congress*, introduction by Matthew Baigell and Julia Williams (1936; New Brunswick, NJ: Rutgers University Press, 1986), 105; Diego Rivera, "The Revolutionary Spirit in Modern Art," *Modern Quarterly* 6, no. 3 (autumn 1932): 53.

4. Langa, *Radical Art*, 223.

5. Miriam Basilio, "Reflecting on a History of Collecting and Exhibiting Work by Artists from Latin America," in *Latin American & Caribbean Art: MoMA at El Museo,* ed. Miriam Basilio, Fatima Bercht, Deborah Cullen, Gary Garrels, and Luis Enrique Pérez-Oramas (New York: El Museo del Barrio and the Museum of Modern Art, 2004).

6. While he acknowledged previous exhibitions of Mexican art, Nelson Rockefeller named only the Museum of Modern Art's activities in Mexican culture: "In assembling and presenting the exhibition Twenty Centuries of Mexican Art, in cooperation with the Mexican Government, the Museum of Modern Art is attempting to do something that has never been done, even in Mexico, on so comprehensive a scale. There have, of course, been previous Mexican exhibitions. In 1931–1932 the Museum itself presented a large exhibition of the work of Diego Rivera, and a year later it showed pre-Spanish Mexican sculpture in its exhibition of Incan, Aztec and Mayan Art. The Museum's Permanent Collection includes a large group of paintings by the greatest modern Mexican artists." The Museum of Modern Art, press release, February 21, 1940, 2, MoMA Library, New York, NY.

7. Folder 1354, box 138, Personal Projects: MoMA exhibition, Mexican 1939–1941, Record Group 4, Nelson A. Rockefeller (NAR) Papers, Rockefeller Family Archives, Rockefeller Archive Center, Sleepy Hollow, NY.

8. Holly Barnet-Sánchez, "The Necessity of Pre-Columbian Art in the United States: Appropriations and Transformations of Heritage, 1933–1945," in *Collecting the Pre-Columbian Past: A Symposium at Dumbarton Oaks, October 6–7, 1990,* ed. Elizabeth Hill Boone (Washington, DC: Dumbarton Oaks Research Library and Collection, 1993); Holly Barnet-Sánchez, "The Necessity of Pre-Columbian Art: U.S. Museums and the Role of Foreign Policy in the Appropriation and Transformation of Mexican Heritage, 1933–1944" (PhD diss., University of California, Los Angeles, 1993).

9. At least one commentator, however, saw violence as a leitmotif of the exhibition: "Two common denominators linked Mexico's three periods . . . 1) the folk art of the peons who, in 1910, were still making artistic mud pies, as they had 2,000 years ago; 2) a love of blood and entrails that showed in the sacrificial chopping blocks of the Aztecs and the gory Crucifixions of colonial times, the sluggings and bayoneting of Orozco's frescoes." *Time,* May 27, 1940.

10. Barnet-Sánchez's argument is well stated, and her thorough analysis of pan-Americanism and the Good Neighbor policy in relation to exhibitions of Mexican art is unprecedented. Unfortunately, in her discussions of the economic interests at play, she never links Nelson Rockefeller's interest in an exhibition of Mexican art with the 1938 nationalization of the oil industry in Mexico. Instead, she relegates this fact to a brief note in her dissertation. Barnet-Sánchez, "Necessity of Pre-Columbian Art," 142n25.

11. Charity Mewburn, "Oil, Art, and Politics: The Feminization of Mexico," *Anales del Instituto de Investigaciones Estéticas* 20, no. 72 (spring 1998): 75. Aside from her failure to analyze the exhibition itself, Mewburn's argument is not supported by archival research; it depends solely on research in secondary sources.

12. Foreword to *Twenty Centuries of Mexican Art* (New York and Mexico City: Museum of Modern Art and Instituto Nacional de Antropología e Historia de México, 1940). A copy of an unedited typescript version of the preface, similar to but still somewhat different from the published version, can be found in folder 1354, box 138,

Personal Projects: MoMA exhibition, Mexican 1939–1941, Record Group 4, NAR Papers. A handwritten note on this typescript states, "Dear Nelson: Here's preface which Monroe [Wheeler] wants for the catalog. I don't care for it—if you don't, wire him to scrap it. Alfred, Monday night, 3/11/40." Further correspondence in this folder suggests that the exhibition organizers chose between prefaces written by Barr and Rockefeller; see Dick [John Abbott] to Rockefeller, March 7, 1940; Rockefeller, unsigned memo notes regarding Abbott's letter of March 7, 1940, ibid.

13. See also Eva Cockroft, "The United States and Socially Concerned Latin American Art: 1920–1970," in *The Latin American Spirit: Art and Artists in the United States, 1920–1970* (New York: Bronx Museum of the Arts, in association with Harry N. Abrams, 1988), 192; James Oles, "For Business or Pleasure: Exhibiting Mexican Folk Art, 1820–1930," in *Casa Mañana: The Morrow Collection of Mexican Popular Arts,* ed. Susan Danly (Amherst, MA, and Albuquerque: Mead Art Museum, Amherst College, and University of New Mexico Press, 2002), 29; James Oles, "Orozco at War: Context and Fragment in *Dive Bomber and Tank* (1940)," in *José Clemente Orozco in the United States, 1927–1934,* exhibition catalogue, eds. Renato González Mello and Diane Miliotes (Hanover, NH, and New York: Hood Museum of Art, in association with Norton, 2002), 92–96; Shifra Goldman, "Metropolitan Splendors," and "Ten Thousand Years of Mexican Art," in *Dimensions of the Americas: Art and Social Change in Latin America and the United States* (Chicago: University of Chicago Press, 1994), 326–43.

14. Nelson A. Rockefeller, unsigned typescript to Monroe Wheeler, March 12, 1940, folder 1354, box 138, Personal Projects: MoMA exhibition, Mexican 1939–1941, Record Group 4, NAR Papers.

15. Indeed, many critics assessed "Twenty Centuries" as a heavy-handed goodwill gesture. Although cynical about such "official" shows, Emily Genauer seemed willing to accommodate the political agenda of "Twenty Centuries": "If all the sonorous, sententious verbiage with which pompous officials have opened various international art exhibitions and hailed culture as a force for promoting world peace were heard simultaneously it would still be drowned out by the explosion of a single hand grenade. . . . And yet, despite the apparent futility of such gestures, despite the entirely reasonable pessimism of the cynics, we cannot help but feel that the sponsors of the current exhibition . . . are justified in believing that this show really will strengthen the bonds between the countries on each side of the Rio Grande. . . . Will it promote lasting peace and friendship between the two nations? One can only pray so, and know that between the peoples at least there will be mutual respect." Emily Genauer, "Mexican Exhibit Rich in Artistic Tradition," *New York World-Telegram,* May 18, 1940. See also Elizabeth McCausland, "20 Centuries of Mexican Art at Modern Museum," *Springfield (MA) Sunday Union and Republican,* May 19, 1940, and "Centuries of Mexican Art: Another Good-Will Show Opens in New York," *Boston Post,* May 12, 1940.

16. According to Orozco, "Clark came in the early morning; he likes many of the pictures I am doing. . . . He will buy five or six or more for $2,500 each for his collection, that later will be given to a museum. He will forward $1,500 for the first in a couple of days. . . . He told Alma [Reed] that he would like to buy a picture from [Rivera] to have a collection of Mexican painting, but he does not like any of the paintings there are in New York, and instead, he buys works from me even before I make them!

Clark is enchanted with me." José Clemente Orozco, *Cartas a Margarita* (Mexico City: Ediciones Era, 1987), 241. The Museum of Modern Art deaccessioned *The Cemetery* and *Peace* in 1966.

17. A copy of the exhibition itinerary and press release can be found in CE,II.1.110.4, MoMA Archives. "Three Mexican Artists" included the recently donated *Proletarian Victim* (1933) by Siqueiros; *Flower Festival: Feast of Santa Anita* and *The Offering* (both 1931) by Rivera; and *Peace* (1930) and *Barricade* and *The Cemetery* (both 1931) by Orozco. "Twenty Centuries" also included *Proletarian Victim* and *The Cemetery*. MoMA missed an opportunity to bring muralism to its walls when it neglected to display Orozco's *Barricade,* one of the few easel paintings (along with *Baile en Tehuantepec*) that is a direct copy of a fragment of a mural (*The Trench,* from Orozco's Escuela Nacional Preparatoria mural cycle). *Barricade* was one of a series of easel paintings that MoMA trustee Stephen Clark kept in his private collection throughout most of the 1930s. Donated to the museum in 1937, the painting circulated in the United States in the 1938–1939 exhibition "Three Mexican Artists." None of the reviews of that traveling exhibition mentions the origins of *Barricade's* imagery, and even though the painting was back at the museum in time for "Twenty Centuries," it was not featured with other variants of Mexican frescoes.

18. Paine to Abby Aldrich Rockefeller, August 13, 1930, folder 961, box 197, Cultural Interests, Record Group 2, Rockefeller Family Archives.

19. Basilio, "Reflecting on a History of Collecting and Exhibiting," 55.

20. Orozco, *Cartas a Margarita,* 241.

21. A copy of the exhibition agreement between the Jeu de Paume and the Mexican government can be found in folder 1354, box 138, Personal Projects: MoMA exhibition, Mexican 1939–1941, Record Group 4, NAR Papers. The translated quotation can be found in a memorandum from John McAndrew to John Abbott and Alfred Barr, September 1937, Department Material folder, Twenty Centuries of Mexican Art, Registrar Exhibition file, Exh. #106, MoMA Archives.

22. McAndrew memo to Abbott and Barr, September 1937.

23. Memorandum of conversation between General Lázaro Cárdenas, president of Mexico, and Nelson A. Rockefeller, in the presence of Walter Douglas, Jiquílpan, Michoacán, Mexico, October 14 and 15, 1939, "Oil Expropriation" 1939, box 52, Personal, Countries, Mexico, Record Group 4, NAR Papers. For an anecdotal account of the meeting, see also Joe Alex Morris, *Nelson Rockefeller: A Biography* (New York: Harper & Brothers, 1960), 122–25.

24. Oles, "Orozco at War," 195.

25. Alfred H. Barr Jr., "Problems of Research and Documentation in Contemporary Latin American Art," in *Studies in Latin American Art: Proceedings of a Conference Held in the Museum of Modern Art, New York, May 28–31, 1945* (Washington, DC: American Council of Learned Societies, 1949), 38. As Miriam Basilio has observed, contrary to previous assumptions, interest in Latin American art did not subside after the war, and in fact Barr began to view art collected from this region "within the context of the Museum collection as a whole." Basilio, "Reflecting on a History of Collecting and Exhibiting," 56.

26. A Mexican organization committee assisted by Abbott oversaw the curatorial details. Monroe Wheeler supervised the printing of the catalogue in Mexico, and MoMA personnel installed the exhibition.

27. On Covarrubias, see Lucía García-Noriega, ed., *Miguel Covarrubias* (Mexico City: Centro Cultural/Arte Contemporáneo, 1986); and Adriana Williams, *Covarrubias* (Austin: University of Texas Press, 1994). At the outset of the organizational process, Covarrubias and his wife, Rose Roland, proved instrumental. Although Cárdenas had agreed in principle to the exhibition during the meeting in Jiquílpan, for several months the Mexican government did not respond to Rockefeller's official requests for confirmation despite the intervention of several mediators. In mid-December 1939, Rockefeller enlisted Covarrubias and his wife to help draft a telegram pleading with Cárdenas to confirm Mexico's commitment to the exhibition. Typescript, December 15, 1939, and handwritten notes, folder 1354, box 138, Personal Projects: MoMA exhibition, Mexican 1939–41, Record Group 4, NAR Papers. Covarrubias and his wife in turn beseeched Rockefeller "to use all personal influence," as they believed the show was "tremendously important for Mexico." Ibid. Furthermore, the exhibition had to be organized hurriedly, in only a few months, an extraordinarily short span of time for such a monumental task.

28. The folk objects that Montenegro assembled for exhibition were purchased for Rockefeller's personal collection—a more straightforward mandate than negotiating among fellow artists.

29. Abbott to Barr, February 15, 1940, folder 1354, box 138, Personal Projects: MoMA exhibition, Mexican 1939–1941, Record Group 4, NAR Papers.

30. Monroe Wheeler to Nelson Rockefeller, May 1, 1940, folder 1354, box 138, Personal Projects: MoMA exhibition, Mexican 1939–1941, Record Group 4, NAR Papers.

31. Covarrubias to Abbott, January 18, 1940, Registrar Exhibition file, Exh. #106, MoMA Archives.

32. André Dezarrois, "L'exposition d'art mexicain ancien et moderne," folder 1354, box 138, Personal Projects: MoMA exhibition, Mexican 1939–1941, Record Group 4, NAR Papers; and McAndrew to Abbott and Barr, September 1937, Department Material folder, Registrar Exhibition file, Exh. #106, MoMA Archives.

33. "Twenty Centuries of Mexican Art," *Bulletin of the Museum of Modern Art* 7, nos. 2–3 (May 1940).

34. Ibid.

35. Rockefeller to Abbott, undated, received by MoMA October 13, 1939, Registrar Exhibition file, Exh. #106, MoMA Archives.

36. "Interchangeable Dive Bomber," *New Yorker,* July 6, 1940.

37. Clemente Orozco Vallardes, *Orozco, verdad cronológica* (Guadalajara: Universidad de Guadalajara, 1983), 388. The artist responded with a telegram in the affirmative, indicating he would arrive within two weeks. Orozco to Abbott, May 1, 1940, Registrar Exhibition file, Exh. #106, MoMA Archives. Despite the lack of written evidence, it is possible that Abbott had informally discussed the prospect of a portable mural commission with Orozco when he was in Mexico in January 1940 and only later offered the formal invitation. Nonetheless, the last-minute confirmation suggests an institutional delay and/or tentativeness.

38. Betty Chamberlain, "History of MoMA," 206, manuscript, 1953–1954, box 2, filing unit 14, MoMA Archives.

39. For details of the commission, see Orozco, *Cartas a Margarita*, 300–309; and Alejandro Anreus, *Orozco in Gringoland: The Years in New York* (Albuquerque: University of New Mexico Press, 2001), 118–22.

40. Orozco, *Cartas a Margarita*, 303. According to Chamberlain, the sketches were approved by an acquisitions committee that supervised the commission. Chamberlain, "History of MoMA," 206. On June 10, Orozco wrote his wife that he would begin painting within a week. Orozco, *Cartas a Margarita*, 306. A Museum of Modern Art press release invited art and news editors to a press conference the following day and to "possibly photograph him [Orozco] starting the fresco." The press release indicates the artist would not start work until June 18. Museum of Modern Art press release, June 17, 1940, MoMA Archives. The museum *Bulletin* that featured Orozco's "explanation" of the mural, however, states that "he started work at the Museum on June 21. . . . The fresco was completed on June 30." José Clemente Orozco, "Orozco 'Explains,'" *Bulletin of the Museum of Modern Art* 7, no. 4 (August 1940), reprinted in *José Clemente Orozco in the United States, 1927–1934*, eds. González Mello and Miliotes, 302–11.

41. Oles, "Orozco at War," 205.

42. Orozco, *Cartas a Margarita*, 302.

43. Orozco, "Orozco 'Explains,'" 307. As others have noted, *Dive Bomber and Tank* was not the first freestanding fresco by Orozco; he had previously made one for the Palacio de Bellas Artes in Mexico City. At 538 square feet, the Bellas Artes mural was by no means transportable but merely disengaged from the wall.

44. In 1940–1941, only a reduced version of the modern art section of "Twenty Centuries" circulated to four cities, and it was promoted under the title "Modern Mexican Art."

45. Orozco, *Cartas a Margarita*, 302. For details on the technical processes used to enhance the stability of the fresco, see "Technical Record of Fresco Painted by José Clemente Orozco, the Museum of Modern Art, June 1940," Museum Collection File, Department of Painting and Sculpture, MoMA.

46. For a comparison of the public performances of Rivera and Orozco in relation to their Museum of Modern Art commissions, see Oles, "Orozco at War," 189–92. Orozco's antipathy toward the public spectacle on which Rivera thrived is epitomized by this observation in *Time* magazine: "[Orozco] apparently did not like all those people looking over his shoulder. . . . Being shy, partly deaf, disinclined to talk about his work, he found it hard going. Then he took to painting in the mornings, behind closed curtains." "A Gallery Watching," *Time* (date unknown), reprinted in *Quincy (IL) Herald-Whig*, July 23, 1940.

47. Orozco, *Cartas a Margarita*, 302.

48. Orozco, "Orozco 'Explains,'" 308–9.

49. Oles, "Orozco at War," 203.

50. Although his 1940 essay for the *Bulletin of the Museum of Modern Art* indicated configurations with as few as three panels, and Orozco suggested in public statements that any selection of a few panels could be shown together, in any order, he never recommended displaying the panels individually.

51. Elizabeth McCausland, "'Dive Bomber and Tank,' Orozco's Portable Mural at the Modern Museum," *Springfield (MA) Sunday Union and Republican*, July 14, 1940.

52. Although artists later worked sporadically in the medium, 1940 represented the effective end of the portable fresco experiment for the muralists. That year, Rivera created movable murals for the Golden Gate International Exposition in San Francisco (panels now housed at the City College of San Francisco), but he executed no major mural commissions in the format thereafter. In 1941, he returned to the medium (in a much-reduced scale) for a private commission: a three-by-four-foot portrait of the Santa Barbara artist Frances Rich, daughter of film actress Irene Rich. Correspondence between Frances Rich and Rivera, December 1940–January 1941, folder 3, box 5, Frances Rich Papers, Getty Research Institute, Los Angeles. Institutions in the United States no longer commissioned portable frescoes, since they were hard to move. It should be noted that the Museum of Modern Art almost never lends Rivera's *Agrarian Leader Zapata* or Orozco's *Dive Bomber and Tank,* not even for local New York exhibitions.
Another Mexican artist, Rufino Tamayo, did continue the experiments with portable murals (not frescoes). He created *Homage to the Indian Race* in 1952 and two murals at the Palacio de Bellas Artes in Mexico City: *Birth of Our Nationality* (1952) and *Mexico Today* (1953), which are both on canvas covered with vinylite.

53. Covarrubias to Abbott, January 18, 1940, Registrar Exhibition file, Exh. #106, MoMA Archives.

54. "Twenty Centuries of Mexican Art," *Bulletin of the Museum of Modern Art* 7, nos. 2–3 (May 1940): 9; Abbott to Nelson Rockefeller, February 2, 1940, folder 1354, box 138, Record Group 4, Personal Projects: MoMA exhibition, Mexican 1939–1941, NAR Papers, Rockefeller Family Archives.

55. Mewburn, "Oil, Art, and Politics," 122–24; Anreus, *Orozco in Gringoland*, 121.

56. Orozco's *Zapata*, previously featured in the "Mexican Arts" exhibition and a familiar work to New York audiences, appeared once again for "Twenty Centuries," as did two recent additions to the MoMA collection: *The Cemetery* and *Zapatistas*, both donated by Stephen Clark.

57. McCausland, "20 Centuries of Mexican Art at Modern Museum."

58. Pollock's experimentations in the workshop, for example, ultimately informed his famous "drip" method of painting, developed in the 1940s. See Robert Storr, "A Piece of the Action," in *Jackson Pollock: New Approaches*, ed. Kirk Varnedoe and Pepe Karmel (New York: Museum of Modern Art, 1999).

59. Clark donated *The Sob* to MoMA the following year.

60. Notably absent from the "Twenty Centuries" exhibition was one of Siqueiros's most forceful works, *Echo of a Scream* (1937), which MoMA had recently acquired as a gift from Edward Warburg.

61. James Oles et al., "Catalogue," in *Portrait of a Decade: David Alfaro Siqueiros, 1930–1940* (Mexico City: Museo Nacional de Arte, Instituto Nacional de Bellas Artes, 1997), 156.

62. Joan Handwerg, "La conquista como Kairos (¿O será quiasma?) y el paradigma Zilboorgiano primitivista," in *Otras rutas hacia Siqueiros*, ed. Olivier Debroise (Mexico City: INBA/Curare, 1996); Olivier Debroise, "Action Art: David Alfaro Siqueiros and the Artistic and Ideological Strategies of the 1930s," in *Portrait of a Decade*, 58.

63. Oles et al., "Catalogue," in *Portrait of a Decade*, 186.

64. Unidentified clipping from uncatalogued albums, Galería de Arte Mexicano Archives, Mexico City; and Jerome Klein, "Art," *Direction*, summer 1940.

65. Genauer, "Mexican Exhibit Rich in Artistic Tradition."

66. Klein, "Art."

67. *Time*, May 27, 1940; Jerome Klein, "20 Centuries of Mexican Art: Historic Spectacle at Museum of Modern Art," *New York Post*, May 18, 1940. See also Carlyle Burrows, "Twenty Centuries of Mexican Art," *New York Herald Tribune*, May 19, 1940; James Johnson Sweeney, "Mexican Painting and Ours," *New Republic*, June 24, 1940.

68. McCausland, "20 Centuries of Mexican Art at Modern Museum."

69. Ibid.

70. Jean Charlot, "Twenty Centuries of Mexican Art," *Magazine of Art* 33 (June 1940): 443.

71. The installation photograph (fig. 103) shows eighteen photographs documenting diverse murals (two of these photographic documentations are cut off at the edge and are thus illegible). The murals documented in the photographs are as follows: Orozco's Hospicio Cabañas dome (*Man of Fire*) and Assembly Hall dome, both in Guadalajara; his *Revolutionaries* and *The Franciscan*, both at the ENP; and a small detail of *Catharsis* from the Palacio de Bellas Artes; Rivera's *Slavery in the Sugar Mill* and two other Cuernavaca panels in one photograph; his central staircase at the Palacio Nacional; and his murals from the Hotel Reforma and Palacio de Bellas Artes; Siqueiros's *Burial of a Worker* at the ENP; Amado de la Cueva's *El torito* at the SEP; and Jean Charlot's *Lavanderas* at the SEP. A list in the MoMA Archives confirms that twenty-three different mural cycles by twelve artists were documented in the exhibition. "Negatives of Frescoes Ordered from Manuel Alvarez Bravo," PA Exh. #106, MoMA Archives.

72. "Negatives of Frescoes Ordered from Manuel Alvarez Bravo," PA Exh. #106, MoMA Archives. Alvarez Bravo had replaced Tina Modotti on the *Mexican Folkways* staff after she was deported from Mexico in 1930; he became a contributing editor in 1932. Susan Kismaric, *Manuel Alvarez Bravo* (New York: Museum of Modern Art, 1997), 21.

73. For a discussion of Renau and the Spanish Pavilion in Paris, see Jordana Mendelson, *Documenting Spain: Artists, Exhibition Culture, and the Modern Nation, 1929–1939* (University Park: Pennsylvania State University Press, 2005), 125–82.

74. Edward Alden Jewell, "The Realm of Art: Mexico," *New York Times*, May 19, 1940; Genauer, "Mexican Exhibit Rich in Artistic Tradition." Genauer mistakenly refers to preparatory studies in the exhibition. As is clear from Charlot's more reliable assessment, the exhibition did not include any mural studies.

75. The modern section of "Twenty Centuries" traveled to the City Art Museum, St. Louis; the William Rockhill Nelson Gallery of Art and Atkins Museum, Kansas City, Missouri; the University of New Mexico, Albuquerque; and the Carnegie Institute, Pittsburgh. A form letter sent to the director of the Nelson Gallery indicates some of the shortcomings of the mural section: "Without the Orozco frescos, the mural section consists of enlarged photographs only. Unfortunately, these photographs were made in Mexico and they are far from adequate reproductions." Unsigned letter to Paul Gardner, January 3, 1941, CE II.1.80.5, MoMA Archives.

76. From the beginning of negotiations with the Mexican government, Nelson Rockefeller intended that the entire exhibition would travel around the country, with possible showings in Chicago, Philadelphia, and San Francisco. Rockefeller to Caso, memorandum, October 17, 1939, folder 1354, box 138, Personal Projects, MoMA exhibition, Mexican 1939–1941, Record Group 4, NAR Papers. Even before the exhibition was mounted at MoMA, there were requests from venues in Worcester, Massachusetts, Cleveland, and Toronto to host the exhibit. Form letter, CE II.1.80.5, MoMA Archives. In August 1940, however, the Mexican government decided that its pre-Columbian and colonial objects needed to be returned. Barr to Abby Aldrich Rockefeller, August 23, 1940, folder 113, box 8, Museum Correspondence, series I, Record Group 2, Office of the Messieurs Rockefeller, Abby Aldrich Rockefeller Papers, Rockefeller Family Archives. Although MoMA officials would not be able to circulate the entirety of "Twenty Centuries," they gathered permissions from the modern artists to keep their paintings in the United States for a national tour. See correspondence in CE II.1.80.5, MoMA Archives.

Because Rivera did not respond to this request in time—he was then working on his mural *Pan American Unity* as part of the Art-in-Action program at the Golden Gate International Exposition—MoMA staff replaced his *Kneeling Dancer* with works from MoMA's collection, including *Flower Festival* and *The Offering*. Rivera suggested belatedly that MoMA officials add to the list of works for the traveling exhibition *Sitting Dancer*, the companion to *Kneeling Dancer*, which had been exhibited at the San Francisco exposition. Diego Rivera to MoMA, October 24, 1940, Registrar Exhibition file, Exh. #106, MoMA Archives. Although the San Francisco exposition had officially ended on September 29, 1940, Rivera did not finish his *Pan American Unity* mural until December. He had begun working on it, in public, in June, the same month that Orozco initiated work on *Dive Bomber and Tank*. For an analysis of *Pan American Unity* and its ultimate failure to unite public art and radical politics, see Anthony W. Lee, *Painting on the Left: Diego Rivera, Radical Politics, and San Francisco's Public Murals* (Berkeley: University of California Press, 1999), 184–215. Elodie Courter, the director of circulating exhibitions, included in the smaller traveling exhibit, in addition to the paintings from the collection, three prints by Rivera: *Self-Portrait, Fruits of Labor,* and *Market Place,* which had also been featured in "Twenty Centuries." Elodie Courter (unsigned) to Diego Rivera, November 4, 1940, CE II.1.80.5, MoMA Archives. For the critical reception of the traveling segment, see the clippings in CE Album 3(38), MoMA Archives.

77. Anreus cites an unpublished letter from Orozco to his wife, July 5, 1940, as the source for Barr's requesting that Orozco write the essay "Orozco 'Explains'" for the MoMA *Bulletin*. Anreus, *Orozco in Gringoland*, 124, 165n37.

78. A disclaimer in the museum's *Bulletin* states that "this 'explanation' was written by Mr. Orozco. The quotation marks in his title indicate his feeling that explanations are unnecessary." For an analysis of Orozco's essay, see Oles, "Orozco at War," 200–203.

79. *Time*, May 27, 1940; "Mexico's Art through Twenty Centuries Installed in Modern Museum," *Art Digest* 14, no. 17 (June 1, 1940).

80. Barr (unsigned) to George Vaillant, American Museum of Natural History,

November 1, 1940, Correspondence A-M, Registrar Exhibition file, Exh. #106, MoMA Archives. Other responses included: "I think if the Mexican people could see the comparison of the great art of their early days and the present frivolous creations, it might have a tendency to revive some of their inspirational early work." W. Brown Keiffer to Nelson Rockefeller, May 21, 1940, folder 1354, box 138, Personal Projects: MoMA exhibition, Mexican 1939–1941, Record Group 4, NAR Papers. See also Vladimir G. Simkhovitch to Barr, May 18, 1940, folder 1354, box 138, Personal Projects, MoMA exhibition, Mexican 1939–1941, Record Group 4, NAR Papers. In contrast, Rockefeller maintained at the outset that folk art "is going to be the most interesting and important." Rockefeller to Covarrubias, January 27, 1940, ibid. Others have discussed how folk art played a central, unifying role in the exhibition. See Oles, "For Business or Pleasure," 29; and Mewburn, "Oil, Art, and Politics," 105.

According to the annual report to MoMA's board of trustees for the fiscal year from June 30, 1939, to July 1, 1940, more than half a million visitors viewed "Twenty Centuries" between May 15 and June 30, 1940. Despite this impressive number, Barr was unsatisfied and reported to Abbott, "It seems that with the effort expended regarding the Mexican Exhibit the attendance does not seem to do it justice, although it seems to be about equal to last summer's attendance of Art in Our Time. Reason #1: many persons daily come to the Museum and leave without seeing the Mexican Exhibit stating that they were not interested in Mexican Art. Many other visitors are disappointed not being able to see our permanent collection. There have been hundreds of visitors that have praised the Mexican exhibit and its installation. Many who have seen much of it in Mexico." Barr to Abbott, July 10, 1940, handwritten memorandum, Registrar Exhibition file, Exh. #106, MoMA Archives.

81. MoMA press release, February 21, 1940, 2.

INDEX

Note: page numbers in italics represent images.